LOUIS VUITTON CITY BAGS: A NATURAL HISTORY

LOUIS VUITTON CITY BAGS: A NATURAL HISTORY

JEAN-CLAUDE KAUFMANN, IAN LUNA, FLORENCE MÜLLER, MARIKO NISHITANI, COLOMBE PRINGLE AND DEYAN SUDJIC

CONTRIBUTIONS BY REI KAWAKUBO, YAYOI KUSAMA AND TAKASHI MURAKAMI

RIZZOLI
NEW YORK

New York · Paris · London · Milan

BIOGRAPHIES

CONTRIBUTING AUTHORS

JEAN-CLAUDE KAUFMANN is a French sociologist. A specialist in the quotidian, he has re-contextualized his principal subject of analysis within the larger question of identity, bringing new insight to the subject through his contributions. As part of his work for the National Center for Scientific Research (CNRS), which he joined in 1977, he also studies socialization and subjectivity with the Research Center for Social Connections at Paris Descartes University. Notable among his written work is *Le Sac. Un petit monde d'amour (The Bag: A Little World of Love)*, published by Les Éditions Jean-Claude Lattès.

IAN LUNA is a writer and critic based in New York and is the author of several books on architecture, design and fashion. Most recently, he was general editor and contributing author to *Pharrell Williams: Places & Spaces I've Seen* (2012). His previous books include *Louis Vuitton: Architecture & Interiors* (2011); *Louis Vuitton: Art, Fashion and Architecture* (2009); *A Bathing Ape* (2008) with NIGO®; *Tokyolife: Art and Design* (2008), with Toshiko Mori; *On the Edge: Ten Architects from China* (2007), with Yung Ho Chang; *Retail: Architecture and Shopping* (2005); *Imagining Ground Zero: The Official and Unofficial Proposals for the World Trade Center Site* (2004), with Suzanne Stephens; and *New New York: Architecture of a City* (2003). He has lectured on urbanism and architectural history at the MIT School of Architecture and Planning and the Yale School of Architecture, and is an occasional critic and correspondent for a number of publications in Japan and China, including the print and digital editions of *Studio Voice, High Fashion* and *Tokion.*

FLORENCE MÜLLER is a French fashion historian. She received her degree from the École du Louvre and the Institute of Art and Archaeology, and was the director and curator of the Union Française des Arts du Costume from 1987 to 1993. She now curates exhibitions in France and abroad. An associate professor at the Institut Français de la Mode, she teaches historic and contemporary fashion culture. She is the author of several reference books on fashion and style.

MARIKO NISHITANI is a fashion editor and journalist based in Tokyo and Kyoto. Nishitani served as an editor from 1974 to 2012 at Bunka Publishing Bureau (BPB), an influential publisher of fashion periodicals in Japan. She served as Paris correspondent for BPB early in her career, and was most recently deputy editor at *Soen* (1994-1999), *High Fashion* (2001-2011), and was editor-in-chief of High Fashion Online through 2012. She has curated or co-curated a number of exhibitions on contemporary fashion design, the most recent of which was *Feel and Think: A New Era of Tokyo Fashion* at Tokyo Opera City Art Gallery (2011). She is also the author and editor of several books on fashion, including *Sotai-sei Comme des Garçons (The Relativism of Comme des Garçons*, 2012) and *Fashion wa Katarihajimeta (Fashion Begins to Talk*, 2011), a critical anthology on influential Japanese brands like A Bathing Ape and Undercover. She is currently a professor at Kyoto Seika University, and teaches courses on fashion history and popular culture.

COLOMBE PRINGLE is a Franco-British journalist. She began as a fashion writer at *Elle* magazine, for which she served as associate editor from 1982 to 1986. For three years she also covered the Cannes Film Festival for the publication *Le Film Français*. In 1987, she became editor-in-chief of *Vogue Paris* before joining *L'Express* as an international correspondent in 1996. At the same time, she became chief editor of the decorating magazine *Maison Française*, where she continued until 2003. The following year, she began her current position as Editor-in-Chief of the weekly magazine *Point de Vue*. She is the author of *Telles qu'Elle, 50 ans d'histoire des femmes à travers le journal Elle (Telles qu'Elle: 50 Years of Women's History Through Elle Magazine)*, published by Éditions Grasset in 1995, and a biography of Roger Vivier in the Mémoire de la Mode series (Éditions Assouline, 1999). She recently contributed to the monograph *Roger Vivier*, for Rizzoli (2013).

DEYAN SUDJIC is the director of the Design Museum in London. He was formerly the dean of the Faculty of Art, Architecture and Design at the University of Kingston in London, and the architecture critic for the British newspaper *The Observer* from 2001 to 2005, while also serving as editor-in-chief of the magazine *Domus* from 2000 to 2004 and founding editor of the magazine *Blueprint*. In 2002, he directed the Venice Biennale. He is the author of a number of monographs on design, including the landmark book *Rei Kawakubo & Comme des Garçons* (Rizzoli/Blueprint, 1990).

BOOK DESIGN

PATRICK LI is the founder and creative director of Li, Inc., a multi-disciplinary design studio founded in 2000. He is also creative director of *T Magazine* from *The New York Times*. Li, Inc. has developed brand and image strategies for some of the leading references within the fashion, beauty and art industries. Clients and projects include brand identity for Jason Wu, Alexander Wang, Frédéric Malle and the Museum of Contemporary Art as well as advertising and design projects for H&M, Sephora, and The Estée Lauder Companies. Li, Inc. has designed numerous monographs on art and design, including *Louis Vuitton: Architecture & Interiors* (2011) and *Louis Vuitton: Art, Fashion, Architecture* (2009) both published by Rizzoli; *Rodarte, Catherine Opie, Alec Soth* (JRP/Ringier, 2010); *Kaws* (Skira/Rizzoli, 2010); and *Pharrell Williams: Places & Spaces I've Seen* (Rizzoli, 2012). Mr. Li was also the art director at large for *Vogue China* from the magazine's inception through 2013. He studied architecture at the University of California at Berkeley.

ILLUSTRATION & PRINCIPAL PHOTOGRAPHY

PATRICK GRIES is a photographer from Luxembourg. In the 1980s, he contributed to various art and design magazines in New York before publishing his first documentary work on post-Communist Romania in 1990. Since then, he has been collaborating with luxury brands, artists and institutions dedicated to art and design, notably the Fondation Cartier and the Quai Branly Museum in Paris. His photographs capture changing social realities, and have been presented in international exhibitions and numerous publications. He recently authored *Evolution* with Jean-Baptiste de Panafieu for Éditions Xavier Barral (2011).

MARTIN MÖRCK is a Norwegian engraver. He divides his time between Sweden and Copenhagen. After studying fine art, he learned the art of engraving under the direction of Arne Wallhorn of the Swedish Post Office. His first engraved postage stamp was produced in 1977 in Sweden. Since then, he has worked principally for the postal administrations of the Nordic countries, but also for other countries such as France and China. As an illustrator, he collaborates regularly with the British magazine *Monocle* and the Danish magazine *Euroman*. In partnership with the Chinese postal services, he founded the Beijing School of Engraving. His engravings and watercolors have been featured in a number of prestigious magazines and publications.

MARTINE RUPERT is a French illustrator. She divides her time between Paris and Berlin, collaborating with publisher teNeues for the collection "City Journal," the Exacompta Clairefontaine Group and the Institut du Monde Arabe, among others. Her drawings have been exhibited at the Council of Europe, the headquarters of the Franco-German television channel Arte and in galleries in Geneva and London.

NICK VEASEY is a British photographer. He began his career producing images for advertising and television before dedicating his practice to x-ray photography. He has created various campaigns for international brands, and his works have been exhibited notably at the Victoria and Albert Museum in London and the Illinois Institute of Technology in Chicago, as well as included in the British Collection of Photography. His work has received various awards and been the subject of numerous publications throughout the world.

CONTENTS

Foreword...................................*Page 7*

PART I: GENESIS

In the Beginning Essay by Florence Müller...................................*Page 22*

Common Ancestors: The Vanity, The Alzer, The Steamer & The Keepall...................................*Page 38*

The Heart of the Self: The Bag and Personal Identity Essay by Jean-Claude Kaufmann...................................*Page 58*

PART II: FAMILIES

Profiles by Colombe Pringle

Chapter I: Speedy/Papillon...................................*Page 66*
Chapter II: Alma/Lockit...................................*Page 116*
Chapter III: Noé/Bucket...................................*Page 162*
Chapter IV: Sac Plat/Neverfull...................................*Page 202*
Chapter V: Pochettes/Minaudières...................................*Page 246*
Chapter VI: Mutations...................................*Page 280*

Mutagenesis Essay by Ian Luna...................................*Page 284*

CdG x LV By Rei Kawakubo...................................*Page 316*

A Conversation with Yayoi Kusama With Isao Takakura and Mariko Nishitani...................................*Page 320*

A Conversation with Takashi Murakami With Mariko Nishitani...................................*Page 326*

Invasive Species: Louis Vuitton in Japan Essay by Mariko Nishitani...................................*Page 332*

PART III: CODES

Honest Error Essay by Deyan Sudjic...................................*Page 344*

Sites of Manufacture, Materials & Processes...................................*Pages 350*

Idiomatic Expressions and Common Proverbs...................................*Page 394*

Illustration Credits*Page 397*

ACKNOWLEDGMENTS

A deluxe edition of this work is sold exclusively in Louis Vuitton stores and online at louisvuitton.com

FOR RIZZOLI INTERNATIONAL PUBLICATIONS
Publisher: Charles Miers
Editor: Ian Luna
Editorial Coordination: Julie Schumacher, Daniel Melamud and Monica A. Davis
Editorial Management: Lynn Scrabis
Permissions Management: Kristen Roeder
Production: Maria Pia Gramaglia and Kayleigh Jankowski
Translation Services: Rebecca Cavanaugh, Marie Iida, Rita di Lorenzo
and Kana Kawanishi
Proofreader: Mary Ellen Wilson

Book Design: Li, Inc.

FOR LOUIS VUITTON
Director of the Heritage Department: Antoine Jarrier
Editorial Director: Julien Guerrier
Editor: Valérie Viscardi
Editorial Officer: Anthony Vessot
Junior Editorial Officer: Sara Villa

Louis Vuitton would like to thank its team, in particular: Grégoire Alessandrini,
Karima Arrat, Jérémy Arthaud, Estelle Aveline, Caroline Bellemare,
Lionel Berruyer, Stéphane Besset, Benjamin Bomy, Luc Bonnot, Elise Bracq,
Michael Burke, Adrien Bureau, Karim Chuillet, Philippine De Lencquesaing,
Xavier Dixsaut, Julie Doisteau, Frédéric Dugardin, Nicolas Dumontier,
Chloé Farman, Hélène Favrel, Marie-Laure Fourt, Isabelle Franchet,
Anne-Céline Fuchs, Jun Fujiwara, Séverine Gatti, Nathalie Grimaud,
Jean Guillarme, Rachel Gully, Maylis Henri de Villeneuve, Bénédicte Houssais,
Jean-Charles Jabet, Edith Jarboua, Christopher Kah, Nicholas Knightly,
Sarah Lagrevol, William Lambourg, Robin Langlais, Elsa Lasserre, Éric Lerou,
Florence Lesché, Claire Lorrain, Jean-Marc Mansvelt, Diana Marquette,
Bleue-Marine Massard, Aude Mesrié, Hélène Moreau, Benjamin Moussa,
Émilie Pouget, Solène Reymond, Nathalie Riasse, Eva Rica, David Rodrigues,
Delphine Rousset, Mari Saito, Anne-Laure Sardin, Imed Soussi, Élodie Spitz,
Frédéric Treillou, Yann Vaternelle, Frédéric Winckler, Marie Wurry.

And a special thanks to Gérald Chevalier, Robert D'Elia,
Françoise et Erwan De Fligué, Hervé Dolant, Thomas Gauthier,
Didier Ludot, Éric Pujalet-Plaà, Patrick Rémy.

Rizzoli International Publications and Ian Luna would like to extend
their gratitude to the following individuals: Patrick Li, Daniel Wagner,
Bettina Sorg, Christina Yang, Seth Zucker, Masako Iida, Brad Plumb,
Chigako Takeda, Maya Shiboh, Virginie Mouzat, Isao Takakura,
Kyojiro Hata, Mikako L'Oliva, Casey Kenyon, Betsy Biscone,
Matthew Moneypenny, Alina Zakaite, Michael Van Horne, Jordan Shipenberg,
Maryse le Mestique, Gregory Spencer, Maria E. Murguia, Troy Bailey and
Nic Lamb, Rosie Niku, Elizabeth Kerr, Bruce Barelly and
Carol Lambert, Ashlee Couldwell, Michael Udasin, Dean Cleary Patterson,
Didier Fernandez, Lorenzo Re, Sherwood Gregg Fricke, James Breese,
Craig Bankey, Natalie Smith, Tasha Banks, Ryan McDonald, Jody Gordon,
Kevin Kelly, Sarah Lynch, Tiziana Nenezic, Khadijat Oseni,
Connie Hansen, Howard Schwartz, Valentina Nourse, Markyus O'Neill,
Lisa Benson, Anne Nelson, Frida Gustavsson, Connie Tsang, Maja Chiesi,
Dionne Thornton, George Speros, Gregg Christensen, Karen Diamond,
Jenny Ade, Leigh Crystal, Kim Morey, Martyna Pawlak,
Scott Lipps, Oneta Jackson, Kristin Mautone, Betsy Biscone,
Lina Bey, Lucy Baxter, Daniel Perez, Victoria Sullivan, Lauren Switzer,
Ann Lee Caceres, Caroline Poznanski, David Kim, Christopher Michael,
Gabriel Ruas Santos-Rocha, Patty Sicular, Maureen Chung, Lisa Jacobson,
Valerie Duchemin, Steven DeLuca, Jessica DeJesus, Ali Kavoussi,
Heather Hughes, Azzurra Sarnelli, Liz Rosen, Ellen Nidy, Mandy DeLucia,
Livia Sawyer, Supriya Malik, Maria Fazio, Mary L. Kinsella,
Britta Ritter-Armour, Maggie Goff, Hindy & Gippy Tantoco
and Lauren A. Gould.

And a special thanks to Marc Jacobs, Loïc Prigent, and Nicolas Newbold.

LOUIS VUITTON CITY BAGS: A NATURAL HISTORY

First published in the United States of America
by Rizzoli International Publications, Inc.
300 Park Avenue South, New York, NY 10010
www.rizzoliusa.com

Printed in Italy
2021 2022 2023 / 10 9 8 7 6 5

Library of Congress Control Number: 2013944527
ISBN: 978-0-8478-4087-8

FOREWORD

This book is the first comprehensive taxonomy of
Louis Vuitton's City Bags, a range of women's handbags
that date back to the turn of the 20th century. Featuring
the trademarks of the House, City Bags represent the most
successful line of accessories in the history of
modern fashion—and were instrumental in making
Louis Vuitton synonymous with modern luxury.

These soft-sided bags grew out of the various pieces of portable
luggage that were themselves packed inside
the trunks and wardrobes that had long ago represented the
heritage of the company, and in a hundred years diversified to
body forth every conceivable function demanded by the
modern woman. Profoundly influential, they are now known to
many by name—Speedy, Papillon, Alma, Lockit, Noé, Bucket,
Neverfull, Sac Plat and The Pochette.

Taking a page from attempts to organize entire classes of
industrial design objects in the previous century,
this volume chronicles the development of the City Bags
through a system mimicking the scientific classification of
plants and animals. Tracing the origins and history
of these bag "families" from the four pieces of hand-carried
luggage that served as their direct, generative "ancestors"—
the Steamer, the Vanity, the Alzer & the Keepall—the book
carefully examines the earliest specimens of City Bag through
today's most sought-after collectibles. Apart from providing
as complete a genealogy for each of the main handbag
"families," the book examines how the artistic collaborations
engaged by Louis Vuitton in the last two decades have
hastened the evolution of City Bags, transforming the basic
types into increasingly divergent forms.

ISABELLE DÉGRA

PASSENGER'S NAME U65

31 October LEHAVRE – PARIS

SAILING FINAL DESTINATION

CABI

PRINTED IN U.S.A.

FRAN

NES

UNITED

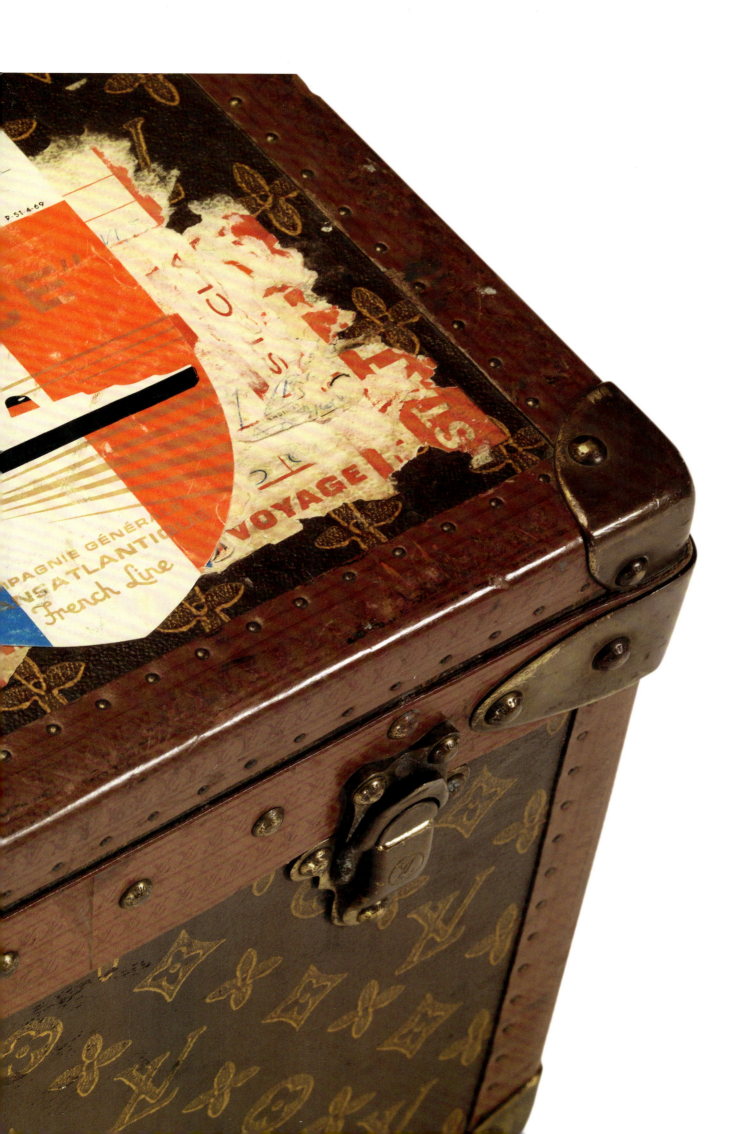

PART I: GENESIS

The Malle trunk is the predecessor for the City Bags families on all three pages to the right.

1854
MALLE

1890
TROUSSE DE
TOILETTE,
MODÈLE PLURIBUS

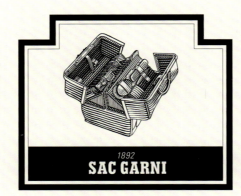

1892
SAC GARNI

1892
SAC À MAIN POUR DAME

1960
VANITY CASE

FROM TOP TO BOTTOM,
LEFT TO RIGHT

Pluribus toiletry box,
Fitted bag, Ladies'
Handbag, Vanity Case,
Minaudière,
and the Pochette
Accessoires

2006
MINAUDIÈRE

1992
POCHETTE
ACCESSOIRES

The Malle-Armoire trunk is the predecessor for the City Bags families below.

1875
MALLE-ARMOIRE

c. 1875
PORTE-HABITS RIGIDE

FROM TOP TO BOTTOM,
LEFT TO RIGHT

Wardrobe trunk, Rigid suitcase, Gusseted suitcase, Large Flat bag, Alzer suitcase, Beach bag, Neverfull, Sac Plat, Porte-documents Voyage, Cotteville suitcase

1892
PORTE-HABITS
À SOUFFLET

1903
SAC PLAT GRAND MODÈLE

c.1950
ALZER SUITCASE

1927
SAC MARIN

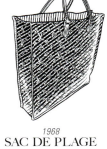

1968
SAC DE PLAGE

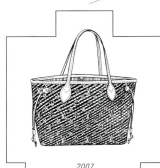

2007
NEVERFULL

1968
SAC PLAT

1981
PORTE-DOCUMENTS
VOYAGE

1999
VALISE COTTEVILLE

Preceding double page spreads: Pages 8–9: Detail, Alzer suitcase in Monogram canvas, 1956, 82 × 27 × 54 cm, 9.4 kg. Louis Vuitton Collection
Pages 10–11: Detail, Champs-Élysées bag in canvas, c. 1950, 50 × 39 × 23 cm, 1.8 kg. Louis Vuitton Collection
Pages 12–13: Detail, Square Mouth travel bag in crocodile leather, 1931, 63 cm × 40 cm × 34 cm, 8.5 kg. Louis Vuitton Collection
Pages 14–15: Detail, Overnight Bag in leather, c. 1910, 55 × 36 × 31 cm, 5.1 kg. Louis Vuitton Collection
Page 16: Detail of a python skin, *Broghammerus reticulatus*, dyed pink to a brilliant finish (see p. 355)

IN THE BEGINNING
FLORENCE MÜLLER

The launch of the first Louis Vuitton city bag coincided with the accessory's attribution as an indispensable item at the turn of the 20th century. The phenomenon of women's irresistible attachment to this object later prompted the writer Pierre Daninos to say: "Crazy—that's what a woman thinks she'll become if she can't find her bag."[1] Crowning the flourishing activity of the trunk-maker founded in 1854, the introduction of Louis Vuitton leather goods increased the House's ability to translate the evolution of society and its mores into a product at the pinnacle of technological progress. In 1880, Georges Vuitton founded a leather goods department in Asnières-sur-Seine, in an annex of one of his ateliers. The ladies' handbag appeared in the Louis Vuitton product catalogue in 1892, the oldest catalogue referenced in the House's archives. Between these two dates, the House oriented its production towards baggage, foreshadowing an entire line of iconic bags for the brand. Following in his father's footsteps, the founder's son, George Vuitton, threw himself into the task of designing a new accessory for the female wardrobe that was destined for a promising future: the handbag. From that moment on, the House would engage in an unrelenting quest to bring this object of desire in line with the spirit of the times. Faithful to the principle of coherence that makes its products unique, the brand would inscribe these city bags into a vast genealogy of forms and functions, allowing contemporary models to enter into an intimate and inspiring dialogue with the creations of the past.

Conditions were favorable for the development of this line of leather goods: travel was modernizing, and evolutions were occurring in dress forms and shopping practices. Louis Vuitton responded to the modernization of transport by train, automobile and ocean liner with inventions that married modularity, portability and practicality. Leather hand baggage with handles, which could be kept close at hand by the traveller, complemented the canvas covered wooden steamer trunks. A Gladstone Bag from 1885, preserved in the House's heritage collections, represents a prelude to this production of portable luggage.[2] Like the Sac de nuit presented in the 1892 catalogue, the Gladstone Bag illustrates the first steps towards research into semi-supple leather baggage. More modular still, the Steamer Bag launched around 1900 could be folded and stored in a trunk. This flexibility made it the perfect occasional bag for storing linens or souvenirs in a transatlantic ship's cabin. For automobile travel, the toiletry kits sold as of 1890, the fitted bags and the Sac de nuit, and even the canvas linens Sac à linge (laundry bag), all present in the 1892 catalogue, were natural complements to the trunk, which would remain in the back of the car. This luggage, however, still required the services of a porter, as it was relatively heavy. At the same time, another type of smaller, lighter container became necessary. When traveling by train, passengers were confined to compartments that made no accommodations for comfort and conveniences. The comtesse Jean de Pange recalls her childhood memories of the Belle Époque: "Although the journey from Paris to Dieppe was only four hours, we set ourselves up as if we were going to China. We brought several baskets of provisions and a whole battery of so-called 'travel' utensils."[3] The duchesse de Broglie, her mother, "carried a small leather bag with a shoulder strap for the occasion, filled with keys, money and papers."[4] This detail, which reveals a new kind of usage, bears witness to the appearance of the ladies' handbag as an indispensable accessory in womenswear. Around 1900, the new fashion for "fitted", hip-hugging skirts made it impossible to incorporate inside pockets, which had previously been buried within the underskirts, allowing the wearer to carry small objects. The ladies' bag was a substitute for these primitive cloth bags suspended from the waist under the petticoats. The magazine Femina attests to the handbag's "entrance into habitual usage" in 1901.[5] As of 1892, Louis Vuitton proved its ability to respond to this fashion evolution by including the "L.V.'s Ladies' Hand Bag" in its catalogue. The description revealed another new trend: shopping, not yet an urban sport, but already a desirable occupation. Under this pretext, women escaped from the family home and succumbed to the joy of window shopping and freely surveying the offerings at department stores. The architect Rem Koolhaas even sees this practice as a

A still of Penelope Cruz from Rob Marshall's *Nine* (2009). On the right are two Alzer suitcases, a Cotteville suitcase, a hatbox and a Nice vanity case in Monogram canvas. Photograph by David James for The Weinstein Company.

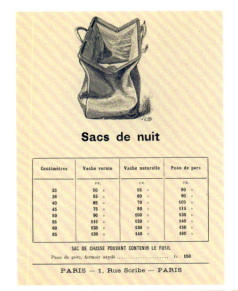

pre-liberation of women from the status of wife, mother and guardian of the household.[6] The handbag, containing keys, handkerchiefs, coins and small objects, played a reassuring intermediary role between the intimacy of the home and the dangers of public space. In the 1903 catalogue, Louis Vuitton offers a ladies' handbag in black Morocco leather or pigskin, available in four sizes—20, 25, 30 and 35 centimeters—depending on the quantity of "small purchases" to be made that day. For automobile outings, the flat handbag was also offered in several dimensions, allowing its owner to keep small personal effects or a travel wrap to hand. The House clearly foresaw the modulation of an object that would inspire Alfred Capus to say that "words are like bags: they take the shape of what we put inside them."[7] As of this period, particular attention was given to the choice of name given to a bag or a line, referring less often to the object itself—its capacity, its characteristics—than to the spirit of travel and escape: historic streets, prestigious neighborhoods, rivers, holiday destinations and exotic capitals.

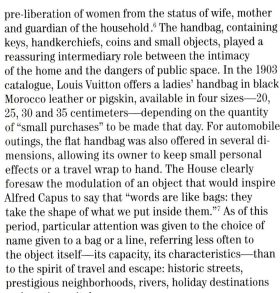

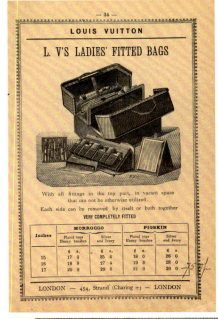

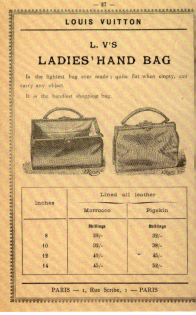

Around 1906, the influence of the great couturier Paul Poiret initiated a turning point in fashion by putting an end to the Belle Époque silhouette. His style, inspired by the classical-style tunics of the Napoleonic period, was built around the elimination of the corset. His "i-shaped" silhouette, high-waisted and with a straight, column-like skirt, was accompanied by the reappearance of the reticule, a long-handled bag deriving its name from the ancient Roman *reticulum*, whose resurgence was noted in the magazine *Femina* in 1908.[8] Louis Vuitton responded to this change of fashion by presenting a number of reticules in his catalogue "La Promenade des Élégants" in 1910. The drawings by Pierre-Émile Legrain showcase these bags in leather, sealskin, lizard and snakeskin, carried by elegant ladies in skirt-suits; they are also shown cut from tussore, velvet, "Japanese" silk or antique embroidered silks, and worn with dresses for the theater. The closures are in copper, bronze, silver or gold; the handles are trimmed with fringed tassels. The catalogue states that "the elegant woman is no longer content to possess one single bag" and offers a "veritable 'array' of ladies' bags."[9] The day bags are divided into large, square or rectangular models for shopping and the "very elegant" city bag, which retains its flat shape and boasts "an incomparable lightness;"[10] a distinguished woman, often accompanied by a chauffeur, could leave her cumbersome personal effects in her car.

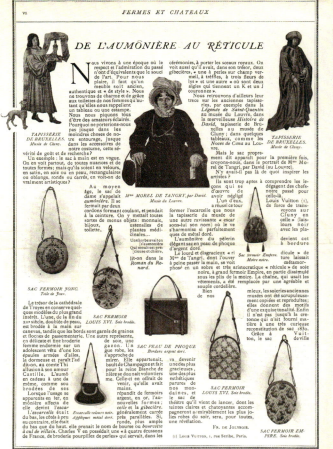

The year 1914 was marked by the inauguration of the magnificent Louis Vuitton building on the Champs-Élysées, the largest luggage store in the world. A major 65-page catalogue celebrated the event with innumerable ladies' bags. But very soon after, the House's activities would be significantly reduced by the onset of the the Great War. Despite the store's opening on the most beautiful avenue in the world, the sale of flat bags, empty or equipped with accessories, slowed considerably. Responding to the shortage of metal locks, Louis Vuitton launched a bag called the Polonais, which would be discontinued around 1922.

At the outbreak of the war, the general catalogue was replaced by seductive little booklets specialized by product. Painstakingly illustrated and composed, they placed the handbag within a new artistic context, enhancing it with references taken from art history. They highlighted the pleasure of gift-giving and bestowed the handbag with a new, creative dimension. Its utilitarian status was transcended in favor of its participation in a look—on the same level as clothing, hair-styles, makeup and jewelry—and in the celebration of feminine sophistication. From that moment on, Louis Vuitton bags would appear in the pages of *Femina*, *L'Art et la Mode* and *Excelsior*. Gaston-Louis Vuitton, the grandson of the founder, was quoted in *L'Art et la Mode* issuing a warning against the dangers of fashion: "a tastefully designed bag will always be in fashion, while a 'fashionable' bag might have a ghastly effect."[11]

The "Roaring Twenties", with their immoderate taste for partying and dancing, called for dazzling evening attire. The accessories rivaled one another in their refinement, accompanying dresses designed for dancing the Tango or the Charleston that sparkled in the lights with their abundant embroidery of sequins and fringes. In nightclubs, where rivers of extra-dry champagne flowed, the *garçonnes* developed a new relationship to makeup with the help of precious minaudières that kept it close at hand. Louis Vuitton catalogues offered the Vanity Case bag and the Feuille model, containing a mirror and compartments for powder, lipstick, handkerchiefs, pins,

money holders and cigarettes. By day, armed with their clutches, liberated young women set out without a chaperone to conquer the city. Their dresses, constructed with simple geometric forms, harmonized with the Art Déco style. Louis Vuitton accessories sported these same motifs on flat pochettes, as well as on fashionable shoulder bags, such as the Dauphine. The most beautiful of these appeared in a July 1925 issue of *Mobilier et Décoration*, or were presented during the Exposition des Arts Décoratifs of the same year. The House interpreted the diversity of occupations amongst these modern, liberated women by offering separate bags for the theater, dancing, the city, sports, and other activities.

In the 1920s, being fashionable meant being modern. To be modern, one had to be sporty, skiing in winter and playing tennis or golf in the summer. Young women drove their own car, and some female champions broke records in racecar driving with speeds of up to 100 kilometers per hour. Amongst Gaston-Louis Vuitton's distinguished clients were great names of haute couture such as Jean Patou, Paul Poiret, Jeanne Lanvin and Gabrielle Chanel. The couturière of rue Cambon wore trousers and striped sailor shirts, and all of the fashion houses launched their own lines of sportswear. Louis Vuitton created a sac Marin (seaside bag) that recalled the form of the Sac à linge. In a context where modernity was expressed by the speed of movement, the Keepall in cotton canvas, also known as the "Tient-Tout" (hold-all) or "Globe-Trotter," as well as the Speedy, introduced around 1930, were true pioneers in weekend baggage. The House offered other lightweight bags such as the 1934 Squire Bag, the ancestor of the Alma, as well as the Sac de plage and other bucket bags. In the early 1930s, high society was discovering air travel, a mode of transport that was still tinged with the scent of adventure. Aboard the airplanes of the new airline Air France, founded in 1933, the total weight of passengers and baggage was verified before takeoff; the flight attendant could weigh no more than sixty kilos, and if an overly corpulent passenger came on board, he risked having to stay on the ground.[12] With the Second World War, the opportunities for traveling for pleasure diminished, but hold-all bags continued to be increasingly indispensable.

In 1959, the invention of Monogram canvas—initially launched in 1896 for rigid luggage—in a supple version would bring a new luster to the design of Louis Vuitton city bags. This new canvas, which was less expensive, lighter and more malleable, made the brand more accessible for a wider clientele. Its use brought an evolution in the functionality and form of bags like the Speedy and the Keepall. One of the first iconic bags to benefit from this new material was the Noé. Created in leather in 1932 for transporting five bottles of champagne, it was brought up to date with the Monogram canvas around 1960, thereby metamorphosing into an object of fashion. It enjoyed a vast success, which was echoed in women's magazines. The Bucket, its twin, was created in Monogram canvas in 1968 to respond to the demand from American clients in particular.

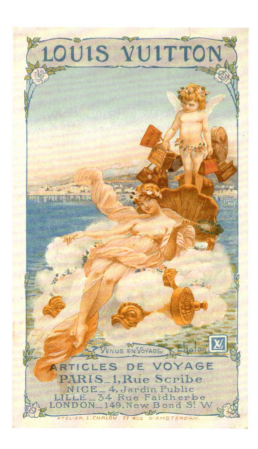

"Venus on Vacation." Advertising card produced for the opening of the Nice store. Artwork by Chalon, 1908
Louis Vuitton Archives

FROM TOP TO BOTTOM

"Pack Your Trunks!"
Article by Flossie on
the art of packing a
steamer trunk, featuring
the model Paz Ferrer
Photographs by Félix,
Femina, July 1912,
p. 406
Louis Vuitton Archives

Page dedicated to the
Dauphine bag in shot
silk or in kid-reindeer,
with silver- or gold-
plated clasps, and the
Flou bag with tortoise-
shell clasp
Louis Vuitton gift
catalogue, 1928, p. 5
Louis Vuitton Archives

"On Gifts: The Right
Way…" Advertising
insert for a perfume
bottle case, a powder
compact, the Acacias,
Dauphine, Pré Catelan
and Feuilles ladies'
bags, and the perfume
Heures d'absence.
Femina, December 1927
Louis Vuitton Archives

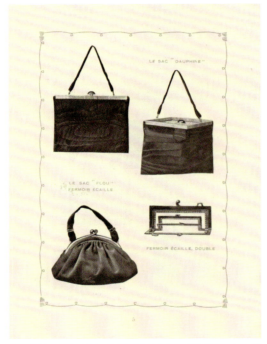

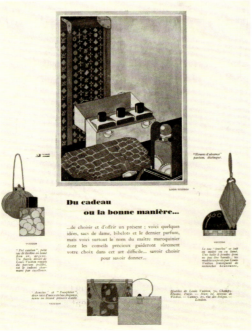

In the 1960s, youth culture stood in opposition to preceding generations by claiming a new lifestyle founded on a hedonistic vision of society. Young women gave up their handbags, which were stigmatized by a bourgeois air associated with times past. They replaced them with tote bags and satchels that gave them a breezy silhouette. Louis Vuitton developed bags that expressed the freedom of the times, brought by the events of May 1968. The leisure society extended its reach, leading the pleasure-seekers to the beaches of the Mediterranean in droves during the summer months. In Capri or Saint-Tropez, beach bags were flaunted on the arms of the beautiful people who fed the dreams of the masses at the cinema or on magazine covers. Audrey Hepburn made the Speedy famous by ordering a personalized version. The model Twiggy largely contributed to the success of the Papillon handbag designed in 1966 as a variation on the theme of the Keepall. In the 1970s, the vogue for the return to nature and the aspiration towards a life outside the norm led certain urbanites to the countryside, or places further afield, in search of harmony. Bags with shoulder straps—symbols of this "cool" attitude—proliferated, accompanying bellbottom pants, shorts and long skirts. Louis Vuitton even launched the Randonnée bag in 1978, designed for nature-loving hikers.

The late 1970s was a pivotal period for the brand as it sought to conquer new terrain: it developed its network of stores and enlarged its global clientele. Louis Vuitton opened its first Japanese store in Tokyo in 1978, and in New York in 1981. This initiative gave new momentum to the spirit of research and innovation upon which the brand was founded. The House designed new products that responded to the usages of different cultures. One of the keys to its success was that each product contained familiar elements identifiable to faithful clients, while still being a new and accessible object. In general, women owned several handbags for the different seasons or for day and evening use, which were meant to last as long as possible—ten years, or more if their owner took good care of them. Around 1978, Louis Vuitton decided to differentiate itself from this old-fashioned vision of leather goods. The brand entered into prestigious collaborations with Ettore Sottsass, Gae Aulenti, Mario Bellini and Clino Castelli, bringing a breath of fresh air to the collections. They also called upon the talents of an independent stylist, Camille Unglik, who was already famous as a shoe designer. The latter introduced her *savoir-faire* for shoes into the realm of handbags, creating a productive symbiosis resulting in new designs. This mixed approach gave rise to the Saint-Cloud, Chantilly and Senlis models. In 1982, the designer Xavier Dixsaut made his entrance into the House, setting up an integrated design department. He remembers having been impressed by the famous designers who preceded him. With an inventor's curiosity, he created a veritable laboratory, assembling a team that undertook research in new technologies and composite materials. Pioneers in the use of Kevlar and carbon fiber, the designers married traditional bag-making techniques with these

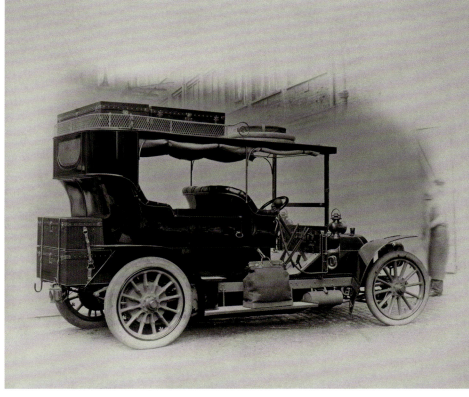

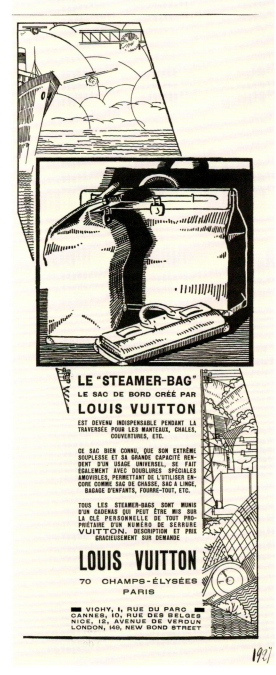

revolutionary elements. When *Desperately Seeking Susan,* starring Madonna, was released in 1985, the Louis Vuitton hatbox she carries in the film sparked a surprising fashion phenomenon. Orders for hatboxes exploded, but the clients never suspected that they, too, would benefit from the House's high-tech expertise: the carbon fiber hidden within the lids made them lighter and more resistant.

The great successes of the 1980s responded to the taste for a dynamic image expressed by contemporary heroes: career women, golden boys, sports gods and rock stars. Jogging became a popular practice, spreading from the United States to Europe. The aspiration to sculpt a healthy and strong body, the symbol of an accomplished individual, translated into a need for city bags that left the hands free. Louis Vuitton backpacks became highly fashionable, as well as the small Bébé Saint-Cloud purse, the Secrets pochette, the Marly and the Houston bags. The Epi leather line was launched in 1985, expressing a vigorous and reassuring design. This resistant, grained leather used for rigid bags led to the creation of graphic models such as the Saint-Jacques, Cluny, and Gobelin. A long-lasting success, the Epi line sparked a color revolution at Louis Vuitton that corresponded with the 1980s taste for "*chic et choc*". It was also presented in shades of black, the other fashion phenomenon of the period. The attaché case from 1983, the Porte-documents Voyage (briefcase) from 1984 and the Epi leather *sacoche* from 1986 enjoyed great success with accomplished men and women.

FROM TOP TO BOTTOM, LEFT TO RIGHT

Drawing by Libis for a promotional article on suitcases.
Vogue UK, 1931
Louis Vuitton Archives

"The 'Steamer Bag': The onboard bag created by Louis Vuitton."
Advertising insert for the Steamer Bag, shown folded and unfolded with an ocean liner, a car and a railway platform in the background.
L'Illustration, April 30, 1927
Louis Vuitton Archives

A canvas Steamer Bag placed on the footboard of a 30 HP Mercedes, with the coach built by J. Rothschild and Sons, 1906
Louis Vuitton Archives

In the early 1990s, emblematic bags like the Steamer Bag, the Keepall and the Speedy underwent a transformation into authentic city bags. The Speedy, once a traveling bag, became the hold-all handbag that remains popular today. The cache-plaid became a briefcase in the Voyage model. The explorer's camera bag mutated into the Amazone bag. The Fieldbag saddlebag made its great comeback in 1996. In 1994, after the vogue for black, the yellow Triangle bag and the red Cannes bag heralded a renewal of bright colors. Finally, the Alma, launched in 1992, confirmed its status as an iconic model. The nineties, with the expansion of airports and airlines and the process of economic globalization, saw an increasing number of frequent travellers. Louis Vuitton sought a practical solution for its professional luggage. Inspired by Asian passengers who used luggage equipped with about fifteen different organizing pockets, Louis Vuitton created a hybrid between this approach and its historic practice of creating baggage-containers filled with removable secondary bags. Applied to the city bag, this idea led to the success of the Pochette Accessoires. Following the same principle, a small cylindrical case, similar to a golf ball case, was also added to the Papillon. The Japanese were the first to hang this accessory on the bag's exterior by the Papillon's shoulder strap—an unthinkable practice for theft-conscious Europeans. At lunchtime, the Japanese women would detach this more practical little pocket and use it as a separate bag. In the rest of the world, it was only after four or five years that clients would begin adopting this inside appendage as an autonomous city bag. These externalized accessories, appreciated by both mothers and daughters alike, would become one of the major fashion trends of the 1990s. For young women, the Louis Vuitton pochette represented an entrée into luxury products, a playful initiation into the sophistication of a small handbag, similar to an evening bag and wearable on the shoulder. Carried under the arm, it remains the very image of the youthful reinvention of the ladies' handbag. The Louis Vuitton pochette has played a rejuvenating role in the history of the handbag, and especially in the history of the House.

In the 1990s, the brand transformed the notion of products defined by their functionality into a contemporary concept of lines with clearly identifiable signatures. The Monsouris backpack, therefore, was composed of a base from the Randonnée, a body from the Noé and a flap from the Beverly bag. This attention to coherence also assured the success of the Fleuve line, with the Danube, Amazone, Trocadéro and Nil models. The Sellier line, represented by the Monceau bag, is also very recognizable by its saddle stitching, its pure edges and its S-lock. But it was at the initiative of Bernard Arnault, CEO of the LVMH group, that the House would undergo a profound metamorphosis by introducing ready-to-wear, which would have a stimulating effect on traditional handbag sales. With Yves Carcelle, to whom Bernard Arnault would entrust the directorship from 1990 to 2012, Louis Vuitton would become a modern corporation endowed with a rich heritage and transformed into a major

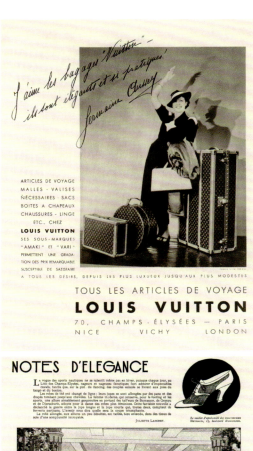

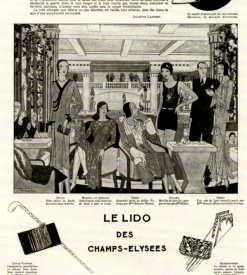

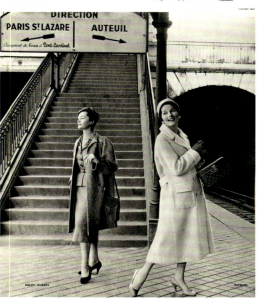

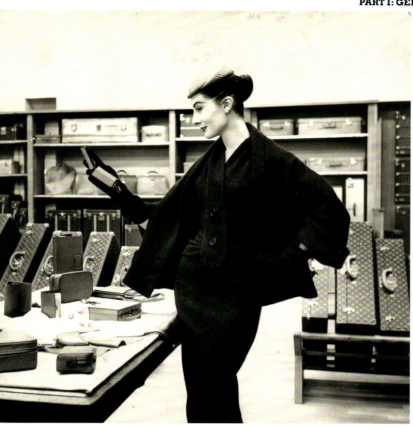

actor in the fashion and luxury markets. A graduate of the École Polytechnique, Carcelle became the Director of Strategy and Development, accomplishing the audacious gamble of marrying the notion of the ephemeral with a long-term vision.

The first stage of this evolution occurred at the centennial of the Monogram canvas in 1996. A consultation was organized between Jean-Marc Loubier and Jean-Jacques Picart, assisted by the young Hedi Slimane. Seven of the most talented independent designers—Azzedine Alaïa, Vivienne Westwood, Manolo Blahnik, Helmut Lang, Romeo Gigli, Sybilla and Isaac Mizrahi—were given carte blanche to create a bag. These high-profile personalities would partake in a surprising and innovative game of creation in which they were given absolute freedom to design a bag in Monogram canvas. Azzedine Alaïa stunned the Louis Vuitton team by immediately imagining an Alma based on a panther motif. Armed with a pair of scissors, the designer cut the fabric without a pattern and then knotted it. The prototype of the bag appeared as if by magic: an Alma without handles, wrapped up in a sort of bundle in panther-printed ponyskin. For Helmut Lang, the departure point was a telephone case that the designer developed into the DJ Vinyl Box, in the spirit of the fashionable hip-hop scene. In January 1996, Jérôme Savary organized a sensational party at the Trocadéro, in which Naomi Campbell appeared beside a baby giraffe… The message was clearly received: Louis Vuitton is a house capable of fantasy and originality, qualities that are indeed compatible with its serious image as a traditional luggage and leather goods brand. Bernard Arnault further affirmed the brand's affinity with the fashion world by enlisting the designer Marc Jacobs for the development of a ready-to-wear department in 1997. In 1998, only one white bag came

down the runway during the first show. Marc Jacobs understood that at Louis Vuitton, his wildest dreams could be realized, thanks to the technical capabilities and experience accumulated by the brand over time. In 1998, he began designing Monogram bags in embossed patent leather. "Louis Vuitton is a luxury brand—it's functional, but it's also a status accessory. I decided status would be done my way, which is to say invisibly. That means the Louis Vuitton logo is embossed on a Messenger bag, white on white," he explained to *Vogue* magazine.[13] Since then, the women's handbag has experienced a creative explosion, becoming an identity accessory and an influential player in seasonal fashions.

As Marc Jacobs organized his new handbag studio, the original studio was concentrating on the permanent lines. The House revisited its genealogy by reinterpreting the great ancestors in new proportions adapted for an urbanite clientele. A legacy of the 1960s beach bag, the 2007 Neverfull developed into a bag of medium volume. The Nice vanity case looked back to the Vanity Case of the 1920s. While the techno phenomenon and raves sparked a trend for DJ bags, Louis Vuitton revisited several classic bags, adding shoulder straps to create models such as the 1999 Looping and the Néo-Messenger. In 2001, Marc Jacobs made a foray into the art world, inviting the American Stephen Sprouse to collaborate on a series of bags for the runway. The graffiti with which the artist covered the Monogram canvas gave the brand's image an impertinent boost. Takashi Murakami (2003), Richard Prince (2007), Sofia Coppola (2009) and Yayoi Kusama (2012) continued this dialogue between art and fashion. The success of the logo revisited by Japanese artist Takashi Murakami corresponded exactly with Marc Jacobs' vision for the brand: a phenomenon akin to

FROM TOP TO BOTTOM

Model in the Louis Vuitton store on Avenue Marceau in Paris, a minaudière in her hand, surrounded by Alzer suitcases and travel kits, 1954 Louis Vuitton Archives

"Young America." Advertising insert for Crouch & Fitzgerald, a Louis Vuitton reseller in New York: an elegant lady poses with luggage in Monogram canvas in front of a delivery vehicle. *The New York Times Magazine*, 1955 Louis Vuitton Archives

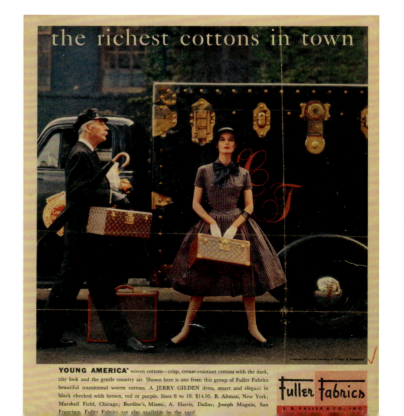

"Hello Kitty… for jet-set children."[14] In 2006, the exhibition "Icons" at Louis Vuitton's Espace Culturel on the Champs-Élysées presented interpretations of iconic bags by selected artists, including Sylvie Fleury (the Keepall), Zaha Hadid (the Bucket), Andrée Putman (the Steamer Bag) and Shigeru Ban (the Papillon).

With the dawning of the new decade in 2010, Louis Vuitton's city bags were collectively toned down, appealing to the dominant neo-minimalist trend. The bags were reduced in size, and the logos and codes became more discreet. The Monogram Empreinte was subtly embossed on soft calfskin leather. Emphasis was placed on the sophistication of materials, rare and exotic leathers, and reinterpretations of fundamental forms. The Lockit, born in 2006 as a direct descendant of the 1958 Fourre-tout bag, underwent luxurious developments in crocodile and other precious leathers. The latest research carried out by Design Director of Leather Goods, Nicholas Knightly, and his team was based on top quality leathers, details, proportions and new evolutions of the Alma, the Noé, the Speedy, the Keepall and the Neverfull. For this last, the

Epi line has been adapted to give it a supple finish in 2013, a real challenge for this inherently rigid material. The Lockit is only created to order in dedicated Haute Maroquinerie salons. Inspired by small bags from the 1980s, the Juliette, with its gold jewelry, has "the slightly old-fashioned accent of true, traditional *maroquinerie.*"[15] It is in line with the new way that people wear bags in the city: functional but nevertheless recognizable. It can be worn in the evening, stored during the day in a large hold-all bag, or worn while riding a bicycle. Here, the logo is retained like a decorative element, a wink in the form of an ornament. Today, the closures that guarantee security suggest the poetry of the secret.

The research undertaken in the House's archives not only provides Nicholas Knightly's team with inspiration for their designs, but also feeds the creativity that Marc Jacobs demonstrates season after season on the runway. Information provided by a vast network of stores and consumers throughout the world helps the team to anticipate their clients' desires. In the product development department, the designers present their ideas in collaboration with pattern makers and leather specialists. Quality standards are extremely high, and numerous tests are performed on each new product. Sometimes an idea goes through fifty permutations before it comes to fruition, but other times, a bag is born on the first try, as was the case with the Artsy. This chain of specialists ensures that every detail in the piece counts. A new model cannot allow itself to be purely decorative and risk losing the hallmarks of its membership in the Louis Vuitton family; while this luxury brand has made its own contributions to the vibrations of fashion, its history tells the story of a brand that has always remained respectful of its origins. The city bags, through their styles and their usages, are part of this genealogy that reinvents the foundations of its memory with each new era.

The model is seated on a Ruban Bleu suitcase in Monogram canvas. Photograph by David Bailey, *Vogue UK*, 1969

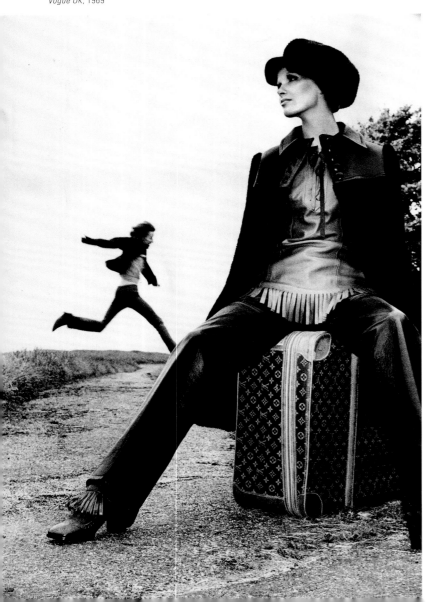

[1] Pierre Daninos, *Le Jacassin* (Paris: Hachette, 1962), n.p.
[2] The bag's date is based on the address of the store, which appears on the lock. The London Louis Vuitton store opened at 289 Oxford Street in 1885.
[3] Comtesse Jean de Pange, *Comment j'ai vu 1900* (Paris: Éditions Bernard Grasset), pp. 74–75.
[4] Ibid., p. 74.
[5] Fanchon, *Femina*, February 15, 1901, p. 15.
[6] Rem Koolhaas, "A New Activity," in *The Harvard Design School Guide to Shopping* (Cologne: Taschen, 2002), p. 506.
[7] Alfred Capus, *Les Pensées* (Paris: Editions du Cherche-Midi, 1988).
[8] *Femina*, April 1, 1908.
[9] Catalogue "La Promenade des élégants," Louis Vuitton, Paris, 1910, pp. 6–7.
[10] Ibid., pp. 6–7.
[11] "Le 'caractère' du sac de dames," *L'Art et la Mode*, December 1920.
[12] Florence Müller, *Élégances aériennes: une histoire des uniformes d'Air France* (Paris: Air France, 2004), p. 14.
[13] "Backstage News & Notes: Marc on Vuitton," *Vogue*, July 1998.
[14] "Portraits of Style," *Vogue*, September 1998.
[15] Interview with Nicholas Knightly, Leather Goods Design Director, March 7, 2013.

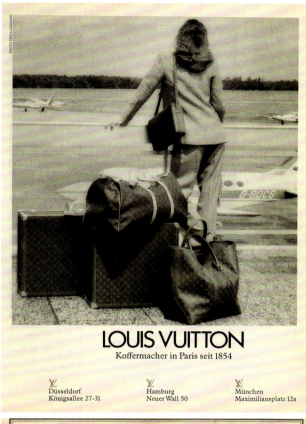

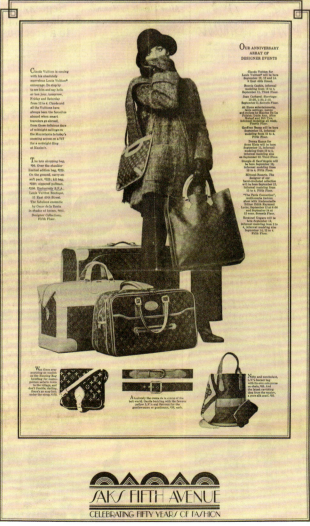

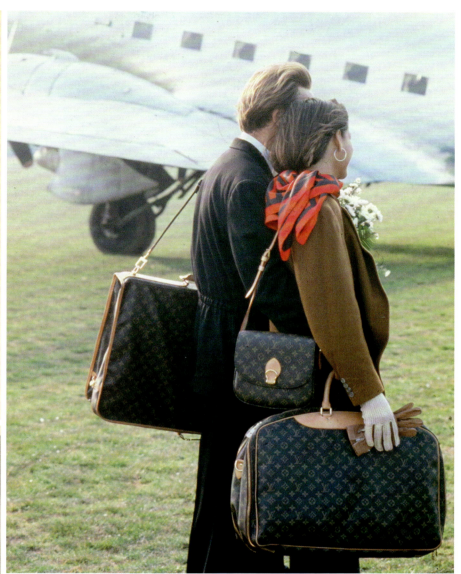

FROM TOP TO BOTTOM,
LEFT TO RIGHT

Advertising insert for the
Louis Vuitton stores in
Düsseldorf, Munich and
Hamburg: the model is
surrounded by a Keepall,
an Alzer suitcase, a
Week-End bag and a
Super Président Classeur
attaché case, all in
Monogram canvas,
Photograph by Erica
Lennard, 1980
Louis Vuitton Archives

Advertising insert for
Saks Fifth Avenue, a
Louis Vuitton reseller in
New York: the model
carries a Shopping bag
and a flat pochette with
a strap; in the fore-
ground, to the left, is a
Cartouchière bag, and to
the right is a Bucket,
all in Monogram canvas
The New York Times,
September 11, 1974
Louis Vuitton Archives

"The Spirit of Travel."
Advertising insert: the
woman carries a
Saint-Cloud bag and an
Alizé bag in Monogram
canvas, Photograph by
Sacha, 1991

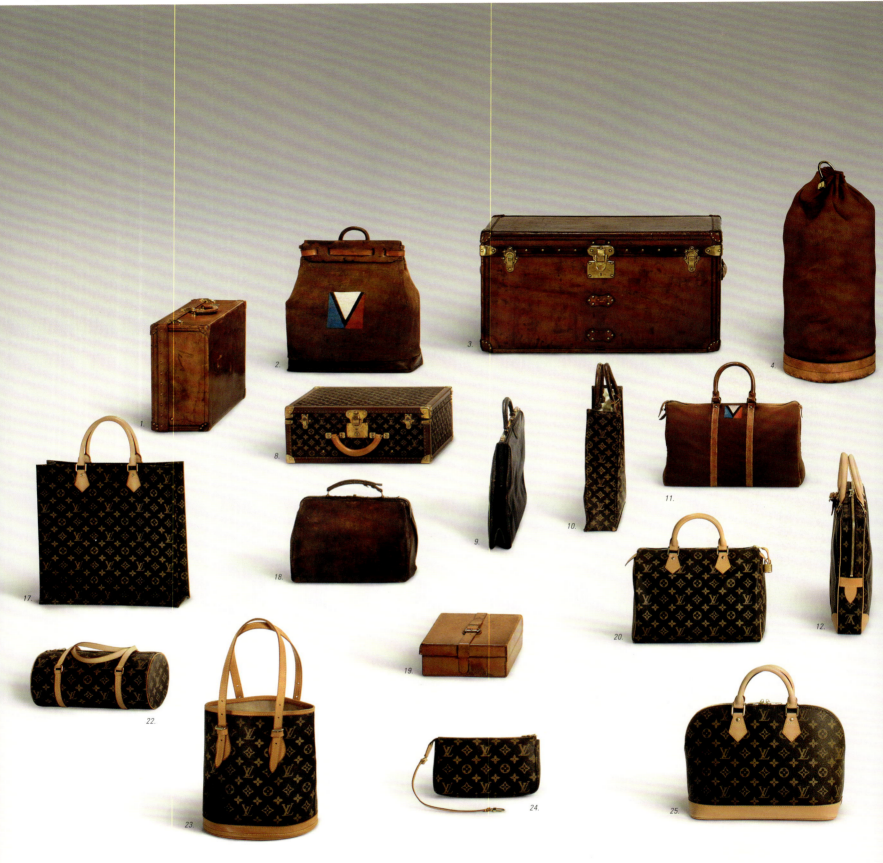

The iconic bags are pictured in the foreground; their "ancestors" are in the background. 1. Suitcase in natural cowhide leather, 1912, 65 × 21 × 42 cm, 5.7 kg. Louis Vuitton Collection — 2. Steamer Bag
in canvas, 1910, 51 × 60 × 23 cm, 2.7 kg. Louis Vuitton Collection — 3. Mail trunk in natural cowhide leather, 1900, 97 × 54 × 51 cm, 25.3 kg. Louis Vuitton Collection — 4. Navy bag in canvas,
1929, 41 × 103 × 41 cm — 5. Alzer suitcase in Monogram canvas, 1956, 82 × 27 × 54 cm, 9.4 kg. Louis Vuitton Collection — 6. Wardrobe trunk in Monogram canvas, c. 1905, 57 × 129 × 59 cm, 43.8 kg.
Louis Vuitton Collection — 7. Overnight bag in leather, 1890, 71 × 47 × 32 cm, 4.9 kg. Louis Vuitton Collection — 8. Cotteville suitcase in Monogram canvas, 1999, 51.5 × 21 × 40 cm, 4.7 kg.
Louis Vuitton Collection — 9. Large Flat bag in leather, c. 1910, 55 × 42 × 13 cm, 1.9 kg. Louis Vuitton Collection — 10. Beach bag in Monogram canvas, 1968, 38 × 36.5 × 12 cm. Louis Vuitton
Collection — 11. Keepall in cotton canvas, c. 1930, 50 × 28 × 23 cm, 1.2 kg. Louis Vuitton Collection — 12. Porte-documents Voyage in Monogram canvas, 1984, 16.5 × 13 × 3.5 cm. Louis Vuitton Collection —
13. Gusseted Suitcase in leather, 1891, 71 × 22 × 36 cm, 7.2 kg. Louis Vuitton Collection — 14. Royal fitted bag in leather, c. 1910, 41 × 31 × 29 cm, 7.2 kg. Louis Vuitton Collection —

FAMILY PORTRAIT: FROM THE TRUNK TO THE CITY BAG

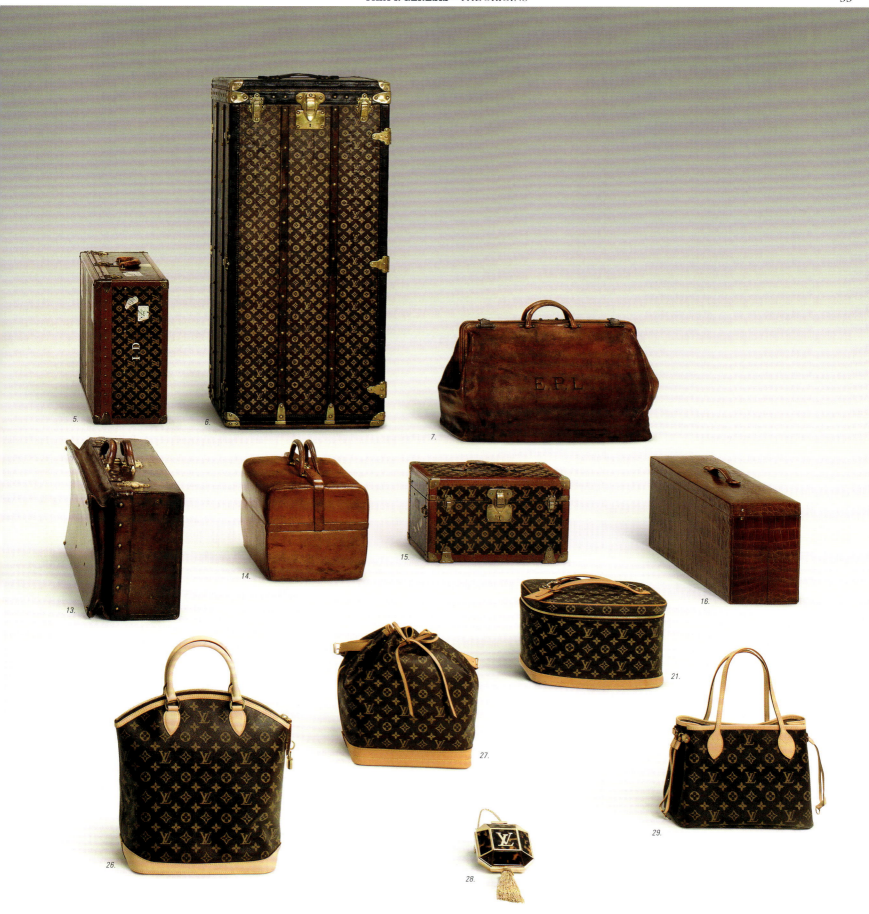

15. Toiletry kit in Monogram canvas, 1958, 44 × 27 × 25 cm, 8.6 kg. Louis Vuitton Collection — 16. Marthe Chenal toiletry kit in crocodile leather, 1926, 62 × 32 × 20 cm, 15 kg. Louis Vuitton Collection — 17. Sac Plat in Monogram canvas, 1968, 38 × 36.5 × 9 cm — 18. Ladies' fitted bag in pigskin leather, c. 1910, 32 × 26 × 15 cm. Louis Vuitton Collection — 19. Pluribus toiletry box in leather, c. 1910, 26 × 9 × 20 cm, 0.7 kg. Louis Vuitton Collection — 20. Speedy 30 in Monogram canvas, 1983, 30 × 21 × 17 cm. Louis Vuitton Collection — 21. Nice vanity case in Monogram canvas, c. 1995, 32 × 21 × 20 cm, 1.5 kg. Louis Vuitton Collection — 22. Large Papillon in Monogram canvas, 2002, 30 × 15 × 15 cm. Louis Vuitton Collection — 23. Small Bucket in Monogram canvas, 1980, 23 × 26 × 16 cm — 24. Pochette Accessoires in Monogram canvas, 1998, 21 × 13 × 3 cm. Louis Vuitton Collection — 25. Small Alma in Monogram canvas, 1992, 32.6 × 25 × 15.3 cm. Louis Vuitton Collection — 26. Lockit Vertical in Monogram canvas, 2007, 36 × 37 × 15 cm. Louis Vuitton Collection — 27. Noé in Monogram canvas, 1983, 26 × 34 × 20 cm. Louis Vuitton Collection — 28. Petit Bijou minaudière in acetate, 2011, 10 × 11 × 5.5 cm. Louis Vuitton Collection — 29. Small Neverfull in Monogram canvas, 2007, 29 × 22 × 13 cm. Louis Vuitton Collection. Photograph by Patrick Gries, 2013

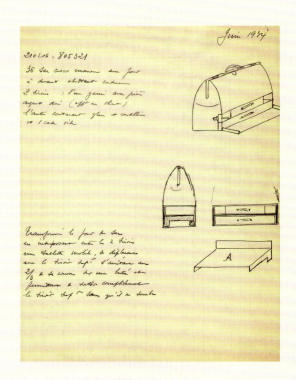

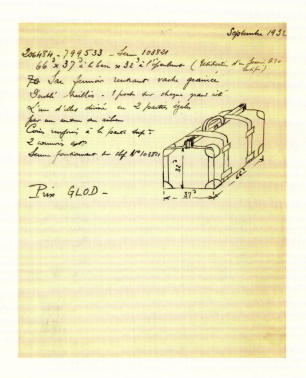

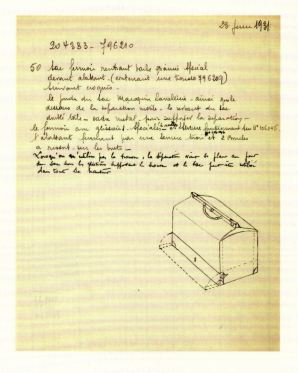

From left to right, top to bottom: Order specifications for a travel bag in pigskin leather and canvas with a zip closure and inside pockets, 45 × 32 × 20 cm, October 1937 — Order specifications for a crocodile leather travel bag and accessories, with two hidden drawers in the base, June 1934 — Order specifications for a travel bag in grained cowhide leather with inset closure and reinforced in corners, 66 × 37 × 32 cm, September 1932 — Order specifications for a bag in grained cowhide leather with inset closure and a hidden drawer in the base, January 1931. Louis Vuitton Archives

ORDER SPECIFICATION SHEETS

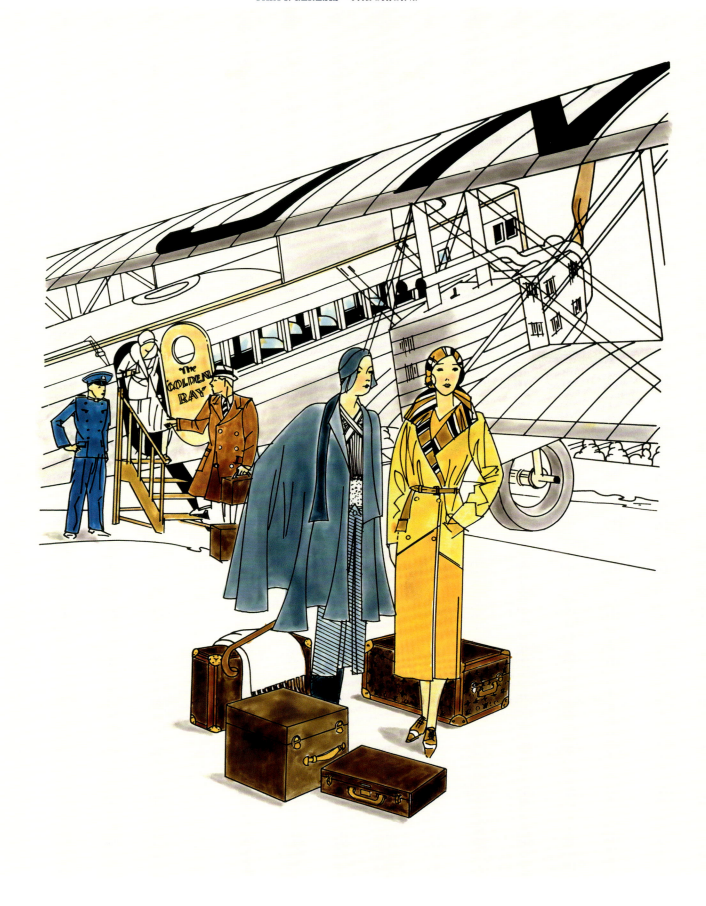

"Notes on elegance — The Golden Ray at Le Bourget." Illustration for advertising insert.
In the foreground, two women are surrounded by Migrator and Butterfly suitcases, a trunk and a hatbox.
Drawing taken from *L'Illustration*, July 12, 1930. Louis Vuitton Archives

Following double page spread: Women on a runway, one of whom, on the far right, is carrying a Vanity Case
in Monogram canvas. Photograph by William Klein, *Vogue Paris*, 1958

TRAVEL BY AIR

LADIES' HANDBAG 1924

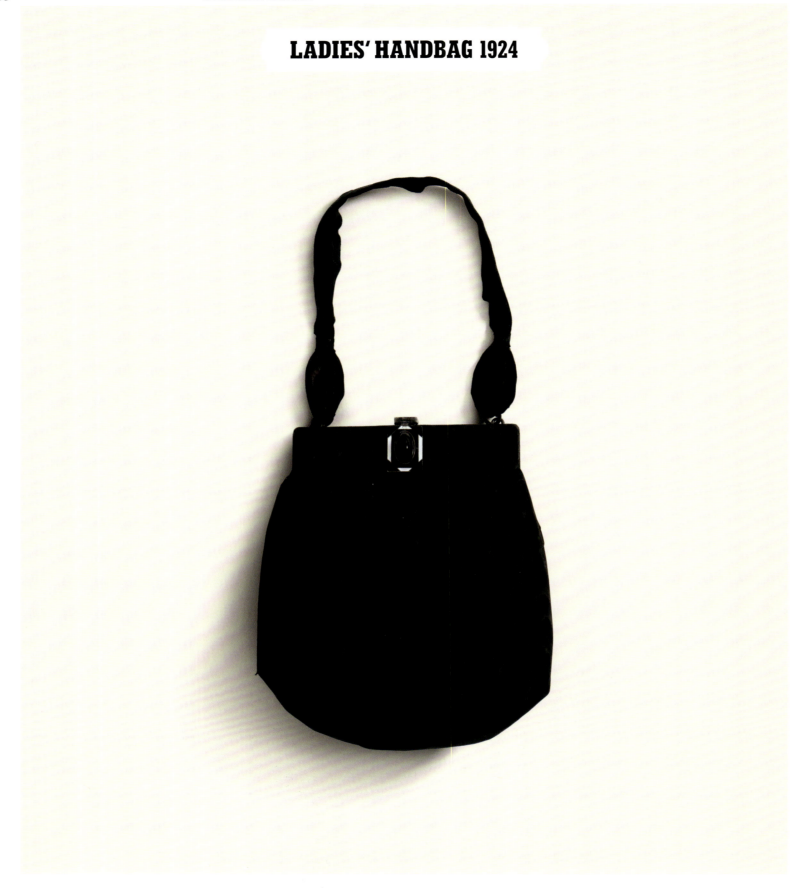

Ladies' handbag in shot silk with a marcasite cabochon clasp, 1924, 14 × 17 × 3 cm. Louis Vuitton Collection

THE CITY BAG MAKES ITS DÉBUT

MINAUDIÈRE C. 1920

Vanity Case bag in silk crêpe and Lurex, c. 1920, 10 × 15.5 × 1.5 cm. Louis Vuitton Collection

FITTED BAG C. 1910

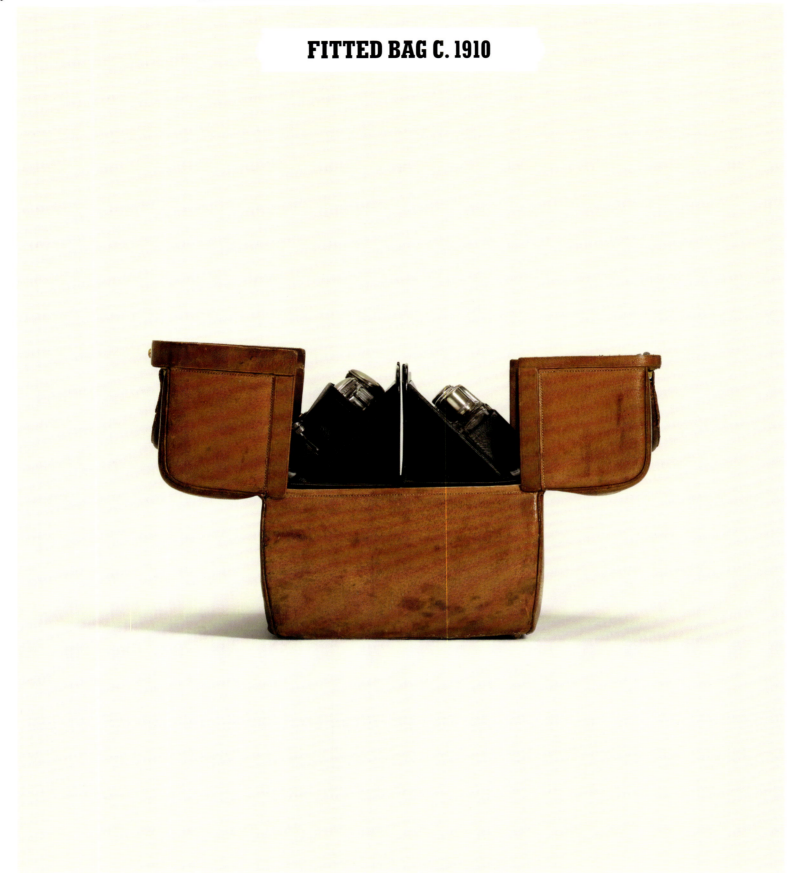

Royal fitted bag in leather, c. 1910, 41 × 31 × 29 cm, 7.2 kg. Louis Vuitton Collection

THE EVOLUTION OF THE FITTED BAG

VANITY CASE 2000

Large Vanity Case in Monogram canvas, 2000, 48 × 40 × 27 cm. Louis Vuitton Collection
Model designed by Sharon Stone to benefit amfAR, the American Foundation for AIDS Research. One out of two was
sold at auction during the 57th Venice Film Festival, August 31, 2000.

CURVED LINES

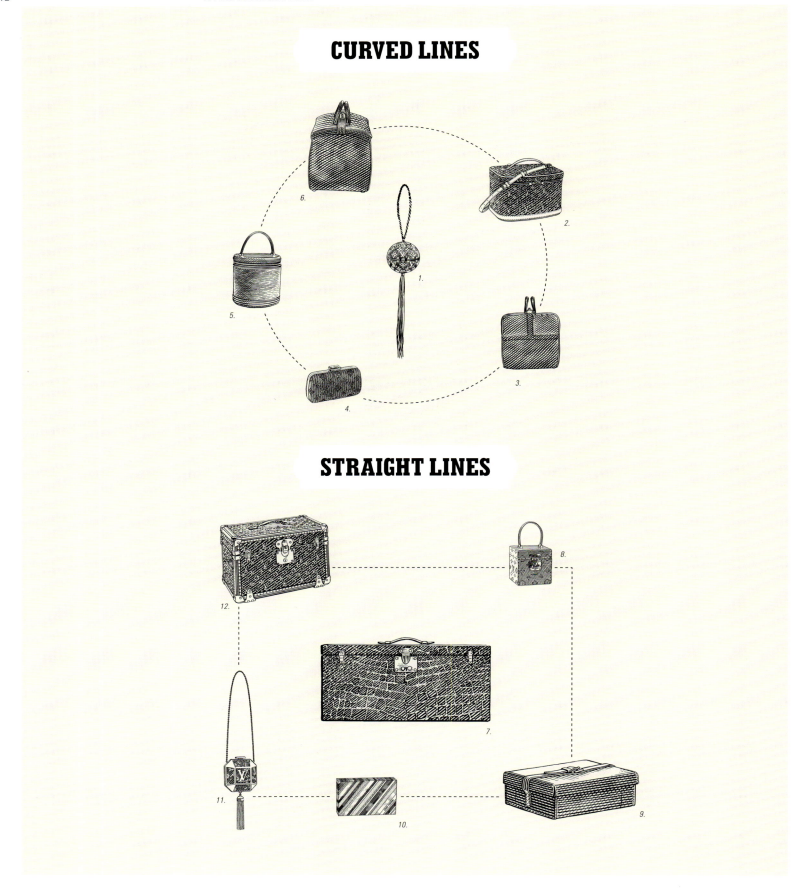

STRAIGHT LINES

Since it first appeared in the Louis Vuitton catalogue at the end of the 19th century, the fitted bag has evolved continually, adapting and becoming progressively smaller with the changing fashions. Ceding its place to the toiletry kit between the years 1920 and 1950, it became softer and shed its accessories as of the 1960s to become the vanity or beauty case, and then finally, the minaudière of modern times. Above: the two diagrams show two principal formal typologies that can be found from the first fitted bags to the present-day minaudières: curved lines and straight lines.

Opposite: the two diagrams show two principal opening typologies: V openings and hood openings. All drawings by Martin Mörck, 2013

FROM THE FITTED BAG TO THE MINAUDIÈRE: FORMS AND OPENINGS

V OPENINGS

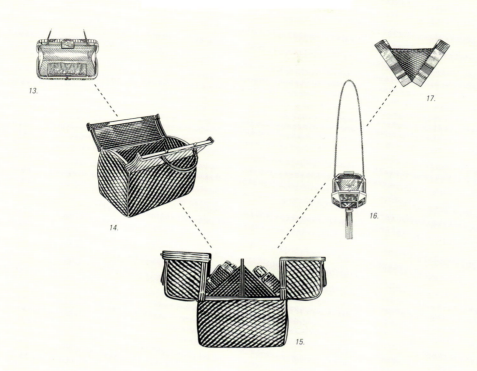

HOOD OPENINGS

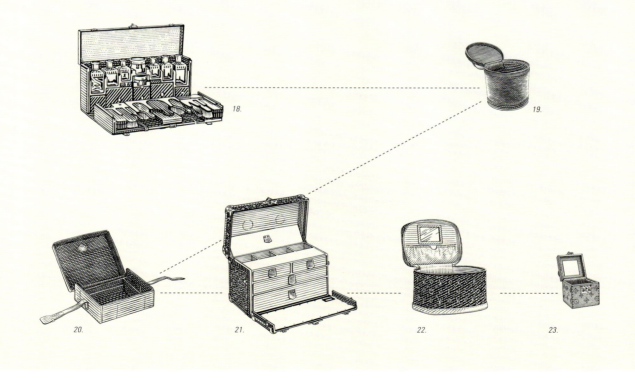

1. Sphère minaudière, 2011, 13 × 63 cm. Louis Vuitton Collection — 2. and 22. Nice vanity case, c. 1995, 32 × 21 × 20 cm. Louis Vuitton Collection — 3. and 15. Royal fitted bag, c. 1910, 41 × 31 × 29 cm. Louis Vuitton Collection — 4. and 13. Antic minaudière, 2008, 17.5 × 11 × 6 cm. Louis Vuitton Collection — 5. and 19. Cannes bag, c. 1993, 20 × 37 × 20 cm. Louis Vuitton Collection — 6. and 14. US travel bag, c. 1910, 36 × 26 × 26 cm. Louis Vuitton Collection — 7. and 18. Marthe Chenal toiletry kit, 1926, 62 × 32 × 20 cm. Louis Vuitton Collection — 8. and 23. Bleecker vanity case, 1998, 11 × 20 × 11 cm. Louis Vuitton Collection — 9. and 20. Pluribus toiletry box, c. 1910, 26 × 9 × 20 cm. Louis Vuitton Collection — 10. and 17. Berlingot minaudière, 2010, 16.1 × 11 × 4 cm. Louis Vuitton Collection — 11. and 16. Petit Bijou minaudière, 2011, 10 × 11 × 5.5 cm. Louis Vuitton Collection — 12. and 21. Beauty case, 1959, 43 × 25 × 30 cm. Louis Vuitton Collection

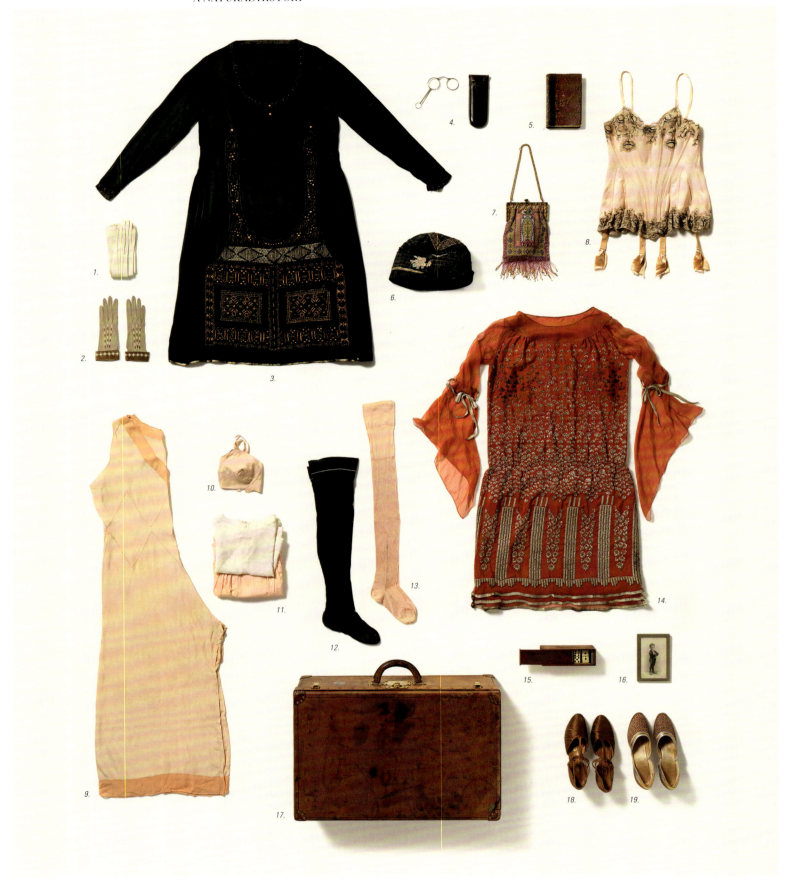

Belongings that an elegant lady might have brought for a short sojourn with friends around 1920. 1. Pair of gloves in white leather — 2. Pair of gloves in embroidered brown leather. Fonds Falbalas — 3. Dress in embroidered black silk crepe by Paul Poiret, c. 1922. Didier Ludot Archives — 4. Lorgnette and protective case in black leather — 5. *Le Sceptre d'or*, volume 2, a novel by Paul Margueritte, Flammarion, Paris, 1921 — 6. Cloche hat in black embroidered silk taffeta. Fonds Falbalas — 7. Pearled handbag, 1925. Didier Ludot Archives — 8. Corset and garter in pink silk satin. Fonds Falbalas — 9. Pajamas in pink silk pongée. Fonds Falbalas — 10. Brassiere in pink cotton — 11. Underwear in cotton and silk — 12. Black stockings — 13. Embroidered stockings in pink silk. Fonds Falbalas — 14. Dress in red chiffon with silver embroidery. Didier Ludot Archives — 15. Game of dominos with wooden box — 16. Silver framed photographic portrait of a child in a torero costume — 17. Suitcase in natural cowhide leather, 1912, 65 × 21 × 42 cm, 5.7 kg. Louis Vuitton Collection — 18. Pair of T-strap shoes in brown satin by Ch. Robat — 19. Pair of pumps in silk and gold leather, 1925. Didier Ludot Archives. Photograph by Patrick Gries, 2013

INSIDE A SUITCASE, 1920s

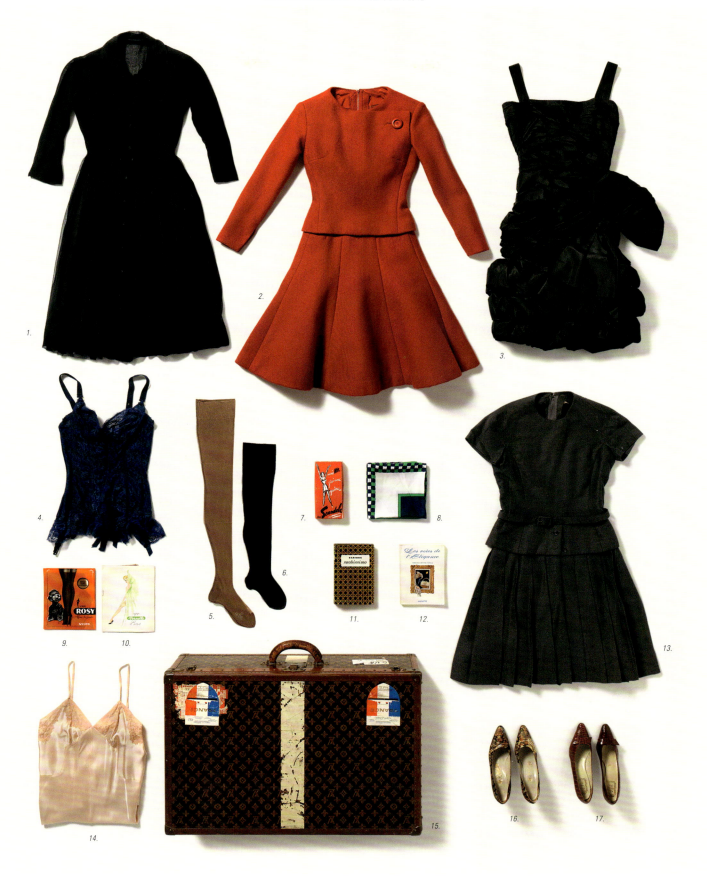

Belongings that an elegant lady might have brought to attend a cocktail party in the provinces around 1960. 1. Christian Dior day dress in brown chiffon, c. 1955. Didier Ludot Archives — 2. Christian Dior Green Park day ensemble in red wool, 1961. Christian Dior Collection — 3. Draped cocktail dress in silk taffeta, Christian Dior by Yves Saint Laurent, 1960. Didier Ludot Archives — 4. Blue lace bustier. Fonds Falbalas — 5. Beige silk stockings — 6. Black silk stockings — 7. Scandale girdle in its box. Fonds Falbalas — 8. Scarf in printed twill — 9. Rosy nylon stockings in original packaging. Fonds Falbalas — 10. Pernelle stockings in original packaging — 11. *Snobissimo*, comic essay by Pierre Daninos, Hachette, Paris, 1964 — 12. *Les Voies de l'élégance*, elegance manual by Geneviève Antoine-Dariaux, Hachette, Paris, 1965 — 13. Christian Dior day ensemble in gray wool, 1955. Didier Ludot Archives — 14. Pink satin sleepwear — 15. Alzer suitcase in Monogram canvas, 1956, 82 × 27 × 54 cm, 9.4 kg. Louis Vuitton Collection — 16. Pair of shoes in warp-printed taffeta, c. 1956. Didier Ludot Archives — 17. Pair of shoes in fawny colored crocodile leather with bow, c. 1954. Didier Ludot Archives. Photograph by Patrick Gries, 2013

INSIDE AN ALZER SUITCASE, 1960s

The model carries a Vanity Case in Monogram canvas, with a Cotteville suitcase and an Alzer suitcase in Monogram canvas at her side. Photograph by Henry Clarke, *Vogue Paris*, 1955

THE ALZER SUITCASE: CONSTRUCTION AND DIMENSIONS

ALZER: STEP-BY-STEP

1.

2.

3.

4.

5.

6.

ALZER: DIMENSIONS

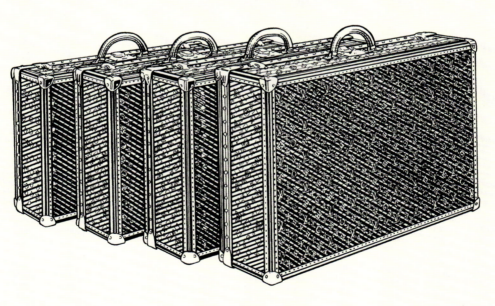

7.–10.

Step-by-Step: The Making of the Alzer. 1. The Alzer suitcase is composed of two parts made of a combination of two woods: okoumé from Gabon, for its resistance, and poplar for its lightness — 2. The cover and base are assembled — 3. The Monogram canvas is stretched over the entire structure making sure that the motif is perfectly aligned at each seam or juncture — 4. The suitcase is edged with lozine, a highly durable, heat-treated fiber combining cardboard, fabric and wood. Affixed with nearly a thousand nails, the lozine reinforces and protects the edges of the Alzer suitcase — 5. The brass angles and corners are positioned throughout the suitcase. The brass buckles and lock are also affixed. The handle in natural vegetable tanned cowhide leather is added to the suitcase. The inside of the Alzer suitcase is lined with Vuittonite canvas, a treated canvas originally created in 1904 for automobile luggage — 6. The Alzer suitcase is completed with a removable poplar frame canvased in linen and fitted with two fabric straps. An address tag in natural vegetable tanned cowhide leather is attached to the suitcase's handle. 7.–10. Dimensions: The Alzer suitcase exists in six standard sizes: 55 (55 × 22 × 39 cm), 60 (60 × 22 × 42 cm), 65 (65 × 22 × 44 cm), 70 (70 × 22 × 47 cm), 75 (75 × 22 × 49 cm) and 80 (80 × 22 × 52 cm). Four out of the six models are represented here. Drawings by Martin Mörck, 2013

ALZER SUITCASE

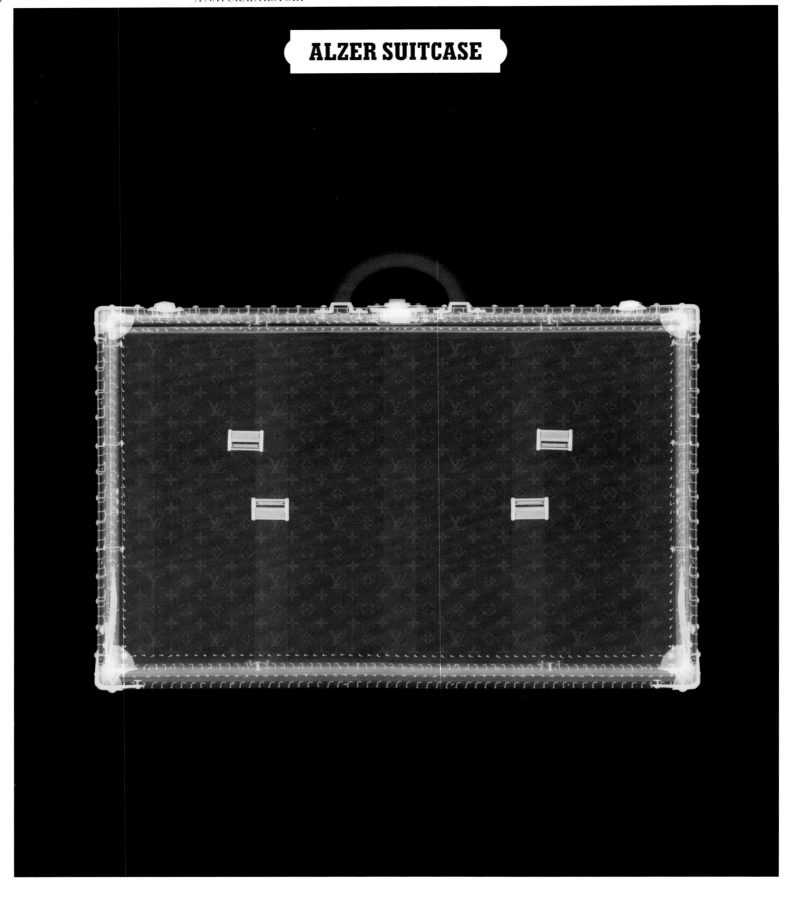

Alzer suitcase in Monogram canvas, 75 × 22 × 49 cm. The x-ray shows the luggage's rigid structure, as well as its metallic elements, including the rivets and nails along its edges, the brass corner pieces, the lock on the top and the buckles on the straps in the center. The Monogram motif is also visible. Photograph by Nick Veasey, 2013

X-RAYS OF HAND-CARRIED BAGGAGE

STEAMER BAG

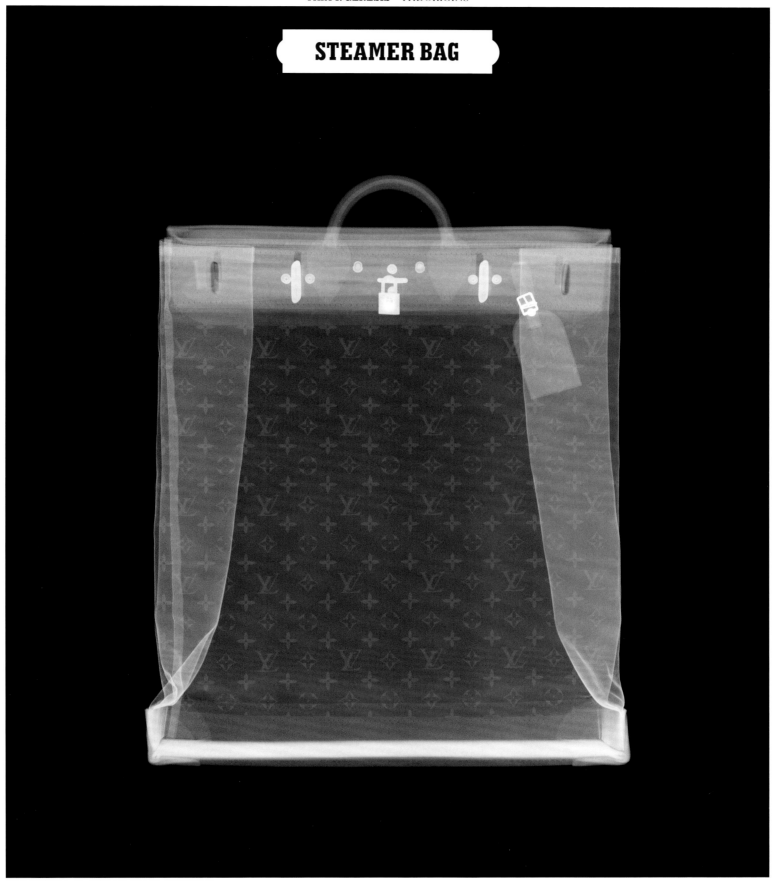

Steamer Bag in Monogram canvas, 45 × 52 × 20 cm. The x-ray shows the bag's supple structure, as well as
its metallic elements, including the padlock, the nails, the clasps, and the buckle of the address tag. The reinforced
leather base and the Monogram motif are also visible. Photograph by Nick Veasey, 2013

STEAMER BAG 1910

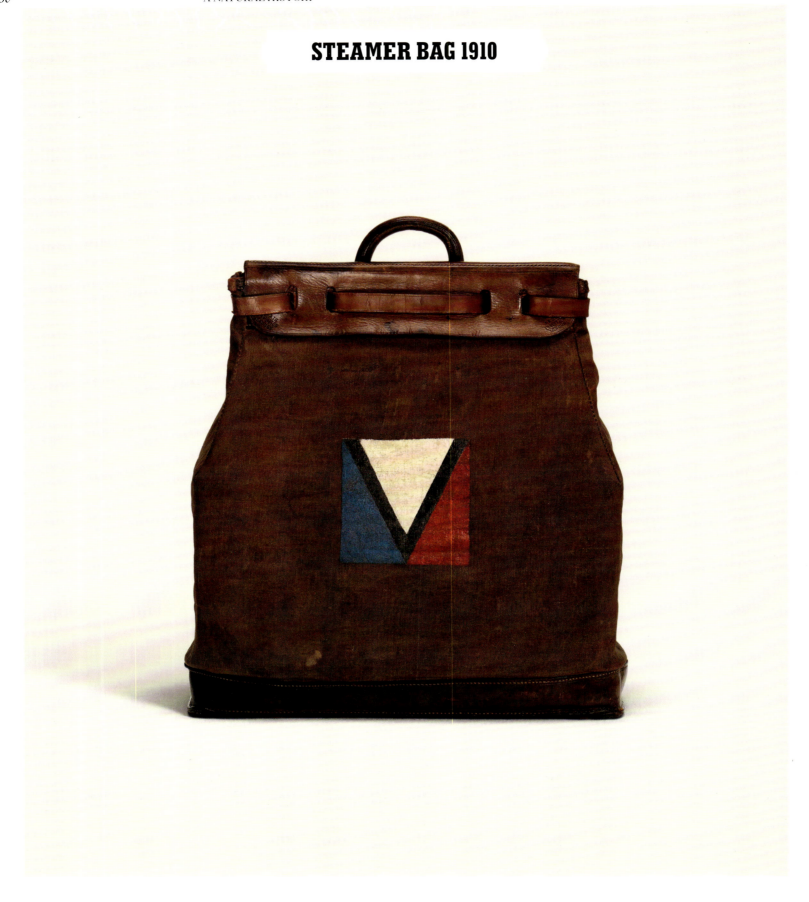

Steamer Bag in canvas, personalized by Gaston-Louis Vuitton, 1910, 51 × 60 × 23 cm, 2.7 kg.
Louis Vuitton Collection

THE EVOLUTION OF A SOFT BAG

STEAMER BAG 1999

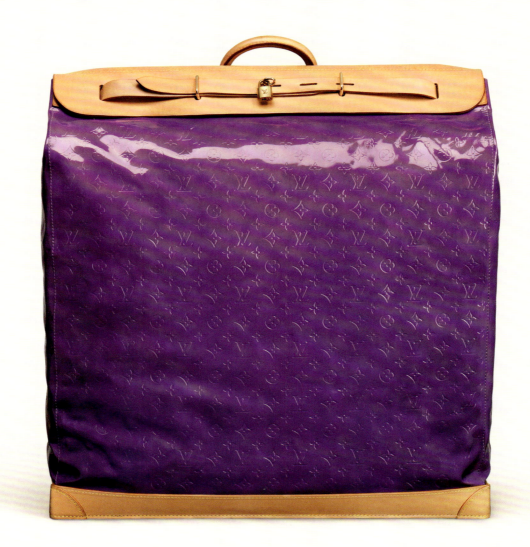

Steamer Bag in purple Monogram vernis, designed by Marc Jacobs, 1999, 64 × 68 × 33 cm, 2.7 kg.
Louis Vuitton Collection

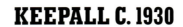

KEEPALL C. 1930

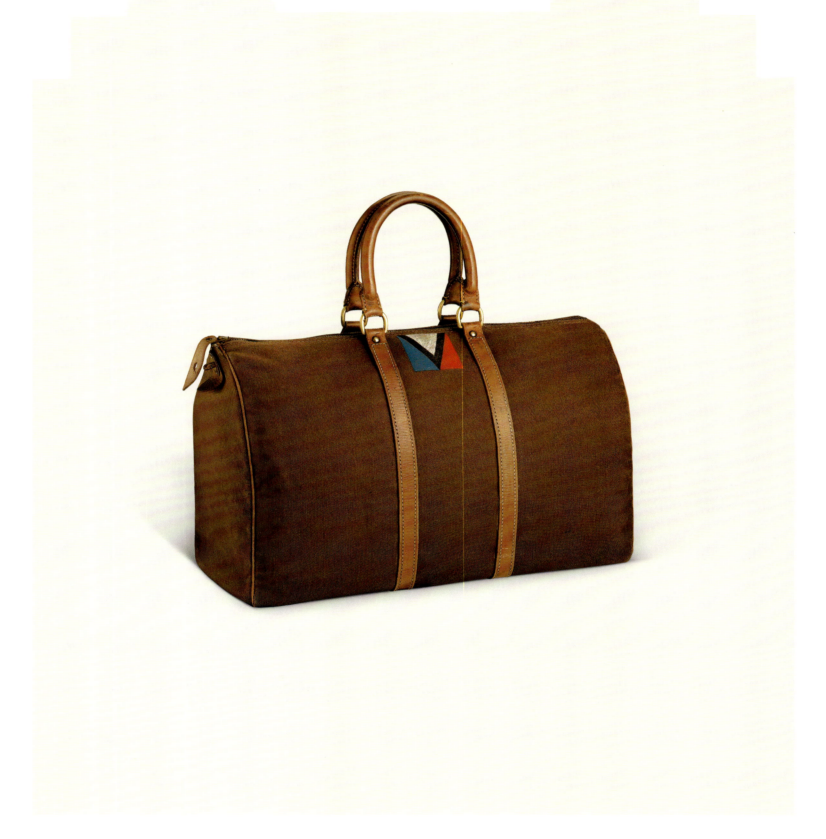

Keepall in cotton canvas, personalized by Gaston-Louis Vuitton, c. 1930, 50 × 28 × 23 cm, 1.2 kg. Louis Vuitton Collection.
The prototype of all the weekend bags, the Keepall was designed by Gaston-Louis Vuitton around 1930, first as an
occasional bag in cotton canvas, and then in Monogram canvas as of the 1960s. It was quickly adopted by travellers on short
sojourns and adventure seekers alike.

THE KEEPALL MAKES ITS DÉBUT

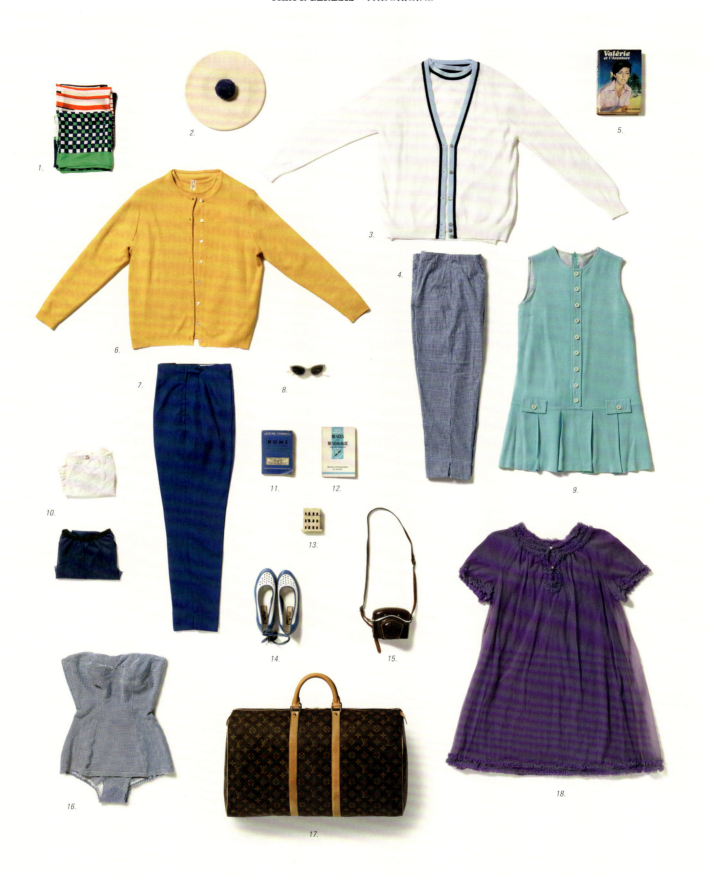

Belongings that a young woman might have brought in a Keepall for a short stay in Rome around 1965. 1. Printed silk scarves — 2. White felt beret — 3. White twin-set in cotton jersey with blue trim — 4. Short slacks in white and blue vichy cotton — 5. *Valérie et l'aventure*, romance novel, Gautier-Languereau, Paris, 1968 — 6. Twin-set in ochre jersey — 7. Stirrup pants in royal blue flannel — 8. Blue and white striped sunglasses — 9. Mini dress in sky blue linen — 10. Elasticated cotton underwear — 11. *Rome et ses environs*, guide book, Enrico Verdesi, Rome, 1954 — 12. *Musées et muséologie*, essay by Luc Benoist, in the collection Que sais-je?, Presses universitaires de France, Paris, 1960 — 13. Miniature souvenir of the Palazzo della Civiltà del Lavoro, the Square Colosseum, a building erected in 1920 in the EUR district of Rome — 14. White and blue tie-on ballerinas in leather and rubber — 15. Zeiss Ikon Contessamat SBE camera in its brown leather case — 16. Bustier bathing suit in elasticated cotton with white and blue stripes — 17. Keepall 50 in Monogram canvas, 50 × 29 × 22 cm, 1962 — 18. Baby doll in sheer purple polyamide. Photograph by Patrick Gries, 2013

INSIDE A KEEPALL, 1960s

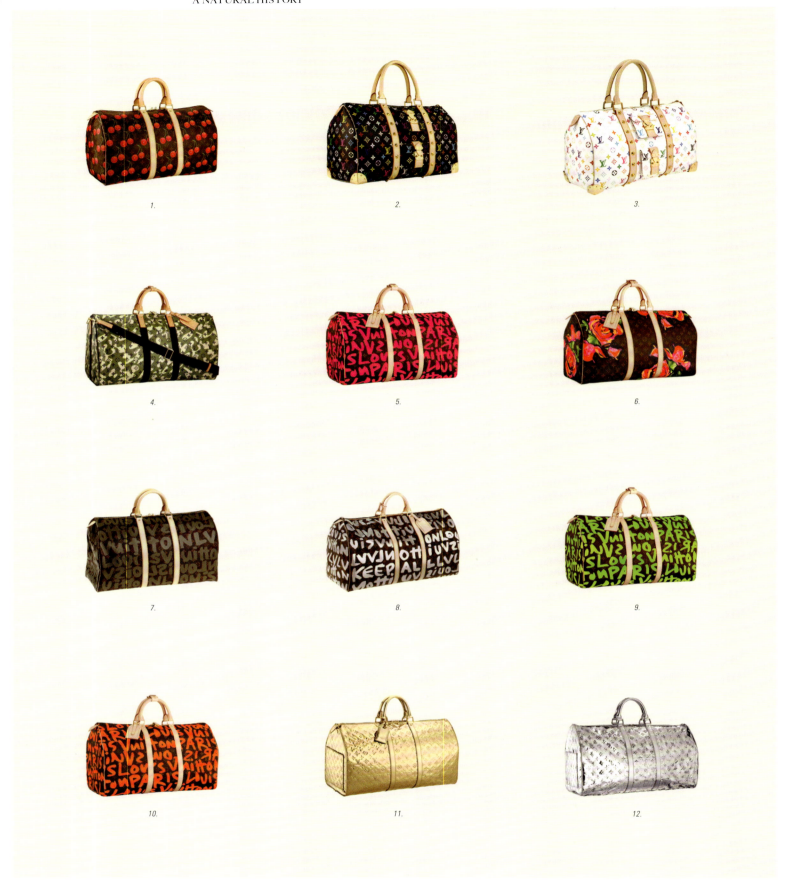

1.

2.

3.

4.

5.

6.

7.

8.

9.

10.

11.

12.

In collaboration with Takashi Murakami: 1. Keepall 50 in Monogram Cerises, 2005 — 2. Keepall 45 in black Monogram Multicolore, 2003 —
3. Keepall 45 in white Monogram Multicolore, 2003 — 4. Keepall 55 in Monogramouflage, 2008. In collaboration with Stephen Sprouse: 5. Keepall
50 in fuchsia Monogram Graffiti, 2009 — 6. Keepall 50 in Monogram Roses, 2009 — 7. Keepall 50 in khaki Monogram Graffiti, 2001 —
8. Keepall 50 in silver Monogram Graffiti, 2001 — 9. Keepall 50 in green Monogram Graffiti, 2009 — 10. Keepall 50 in orange Monogram Graffiti,
2009. In collaboration with Sylvie Fleury: 11. Keepall 55 in gold Monogram Miroir, 2006 — 12. Keepall 55 in silver Monogram Miroir, 2006

ARTISTIC VARIATIONS: THE KEEPALL

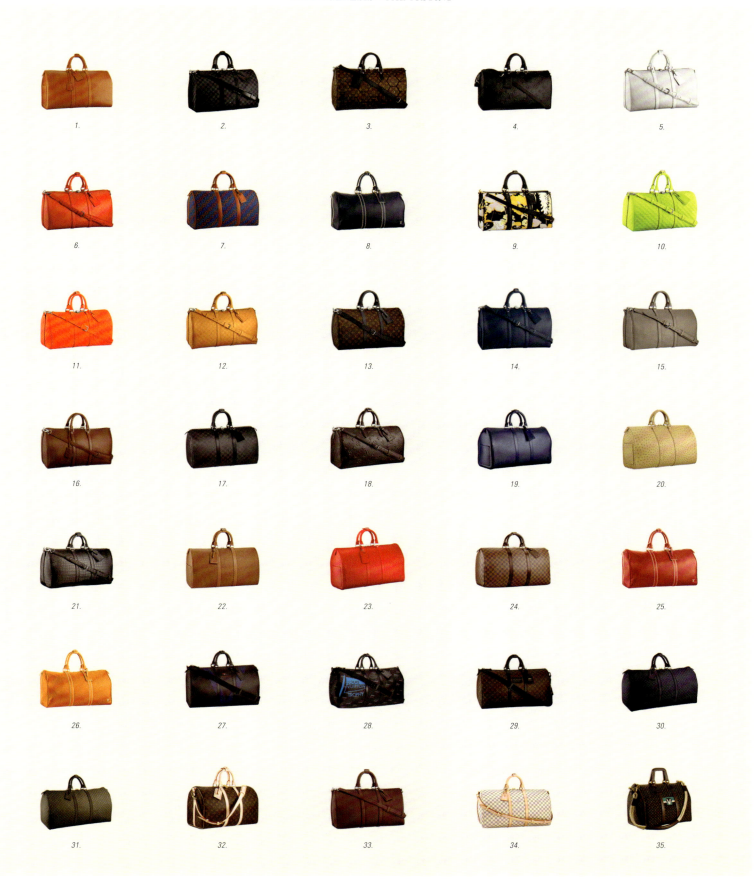

1. Keepall 50 in caramel Nomade leather, 2006 — 2. Keepall 45 in Damier Graphite, 2009 — 3. Keepall 45 in Monogram Hexagone, 2009 — 4. Keepall 45 in black Monogram Révélation, 2009 — 5. Keepall 45 in arctic Damier Infini, 2011 — 6. Keepall 45 in fusion Damier Infini, 2011 — 7. Keepall 50 in Ouvéa canvas, 2006 — 8. Keepall 50 in marine Tobago cowhide leather, 2006 — 9. Keepall 50 in Canwan canvas, 2007 — 10. Keepall 45 in fluorescent yellow Damier Infini, 2013 — 11. Keepall 45 in fluorescent orange Damier Infini, 2013 — 12. Keepall 45 in solar Damier Infini, 2013 — 13. Keepall 55 in Monogram Macassar, 2009 — 14. Keepall 45 in onyx Damier Infini, 2011 — 15. Keepall 45 in taupe Naxos calfskin leather, 2009 — 16. Keepall 45 in cèdre Naxos calfskin leather, 2009 — 17. Keepall 45 in Damier Carbone, 2011 — 18. Keepall 45 in brown Monogram Révélation, 2011 — 19. Keepall 45 in myrtille Epi leather, 2004 — 20. Keepall 45 in beige ostrich leather, 2007 — 21. Keepall 45 in black alligator leather, 2009 — 22. Keepall 45 in cannelle Epi leather, 2006 — 23. Keepall 55 in red Epi leather, 2003 — 24. Keepall 50 in Damier Ébène canvas, 2006 — 25. Keepall 50 in red Tobago cowhide leather, 2006 — 26. Keepall 50 in yellow Tobago cowhide leather, 2006 — 27. Keepall 55 in black Waterproof LV Cup canvas, 2012 — 28. Keepall 55 in blue Monogram Waterproof LV Trophy Dubaï, 2010 — 29. Keepall 55 in Monogram Waterproof LV Trophy La Maddalena, 2010 — 30. Keepall 60 in blue-on-blue Monogram Mini, 2003 — 31. Keepall 60 in khaki-on-khaki Monogram Mini, 2003 — 32. Keepall 45 in Monogram canvas, 2002 — 33. Keepall 45 in bordeaux Naxos calfskin leather, 2009 — 34. Keepall 55 in Damier Azur canvas, 2006 — 35. Keepall 45 in ébène Monogram Mini Initiales, 2005

BIODIVERSITY: THE KEEPALL

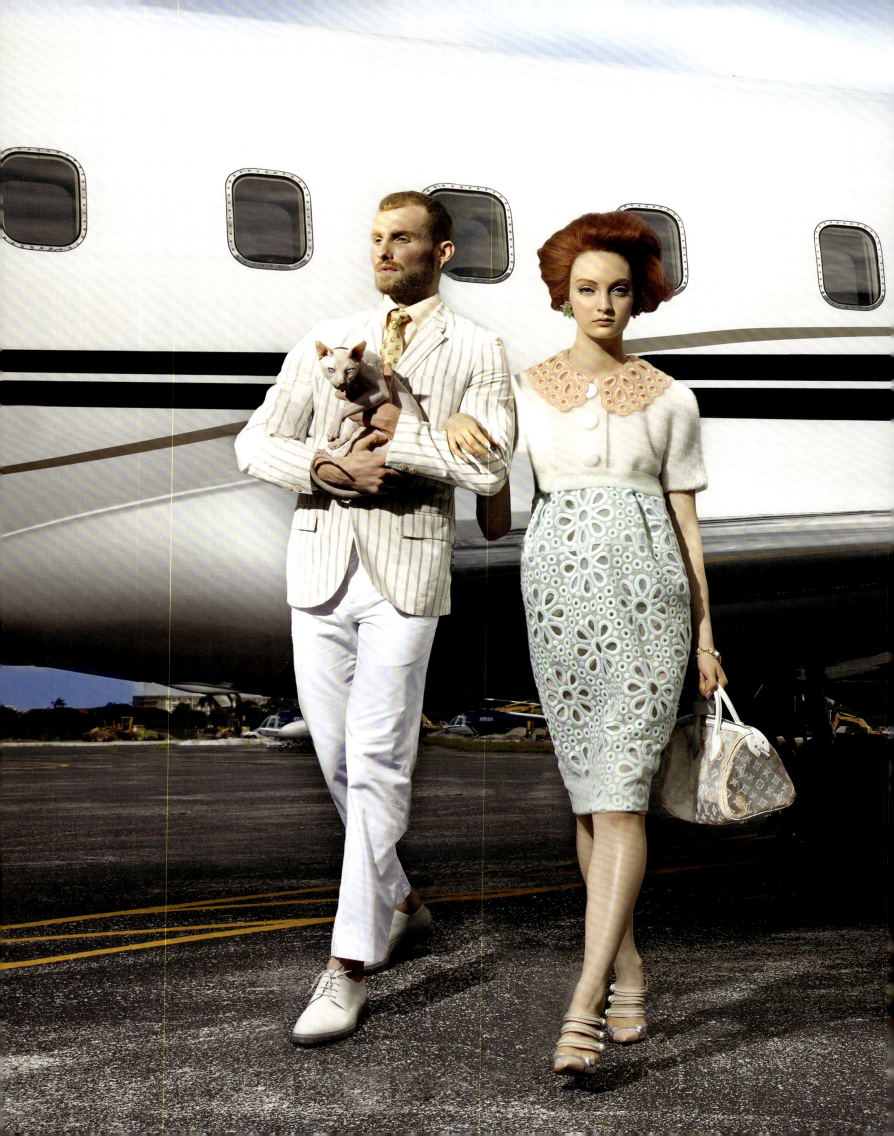

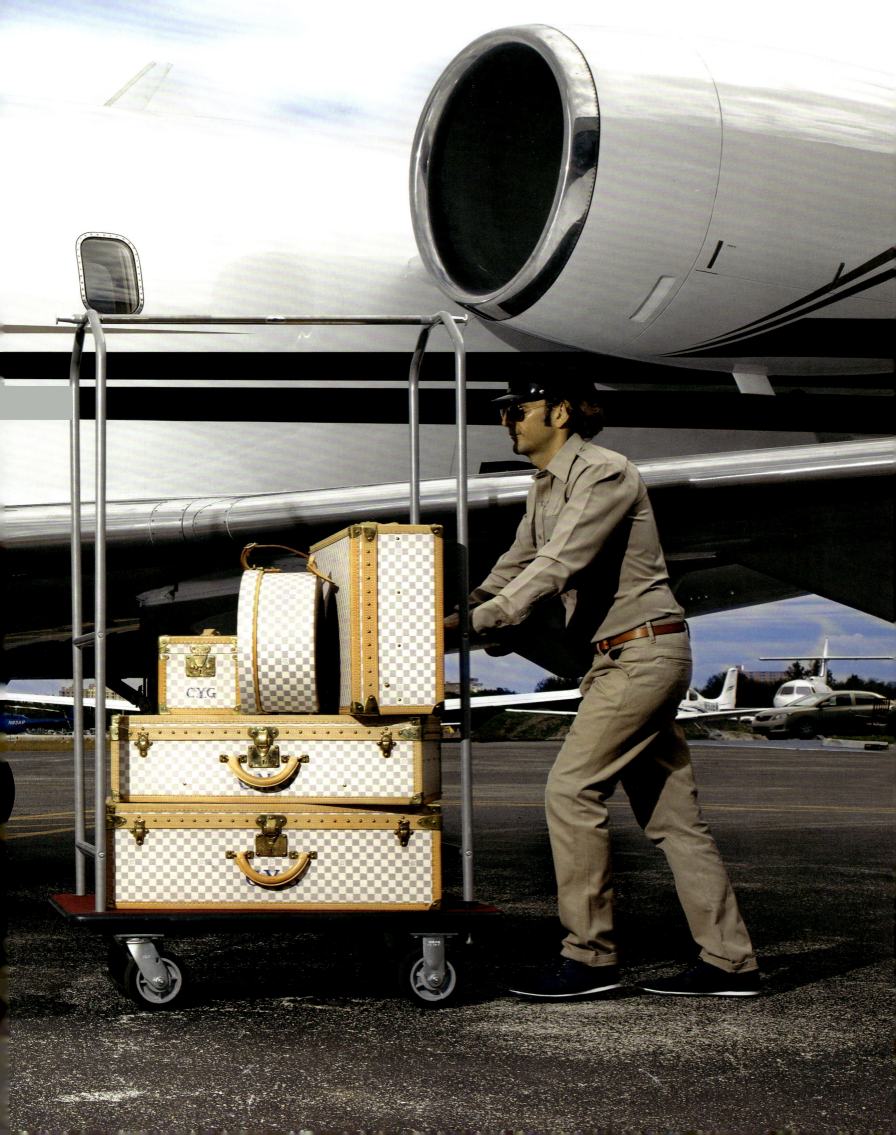

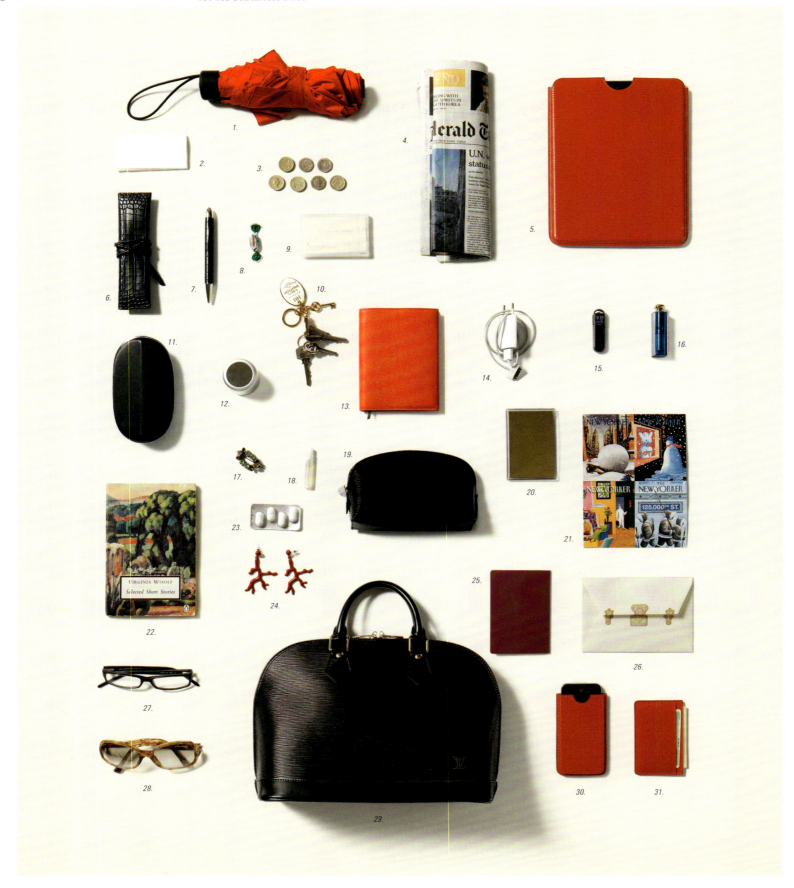

1. Red umbrella with telescopic handle and wrist strap — 2. White paper handkerchief — 3. Coins — 4. Newspaper — 5. Digital tablet in a red Epi leather case —
6. Connaisseur pencil case in black alligator leather — 7. Connaisseur ballpoint pen in black alligator leather — 8. Mint candy — 9. White cotton handkerchief — 10. Keys
and white Maison des Champs-Élysées keychain — 11. Glasses case — 12. Powder compact with mirror — 13. Coral pink SC calfskin leather notebook — 14. Charger for
digital tablet — 15. USB key — 16. Lipstick — 17. Green diamanté hair clips — 18. Perfume sample — 19. Pochette Cosmétiques in electric black Epi leather —
20. Company badge in a gold case — 21. Invitation card — 22. *Selected Short Stories* by Virginia Woolf, Penguin Classics, London, 1993 — 23. Medication — 24. Pair of red
coral-shaped earrings — 25. Passport — 26. Connaisseur envelope in white vellum — 27. Reading glasses with black frames — 28. Tortoise-shell sunglasses —
29. Mid-sized Alma in black Epi leather, 38.5 × 28.5 × 18.5 cm — 30. Cell phone in a red Epi leather case — 31. Card holder in red Epi leather. Photograph by Patrick Gries, 2013

INSIDE AN ALMA

THE HEART OF THE SELF:
THE BAG AND PERSONAL IDENTITY

JEAN-CLAUDE KAUFMANN

The bag opens up an entire series of important existential questions. Take the theme of identity. It is regularly at the center of fiery debates, the cultural and political impact of which is crucial. The intensity of these polemics is a product of hazy definitions;[1] the perceptions of what identity is are multiple and highly contrasted. Historically, the first usages of the term arose with the emergence of the nation-state: in the villages of the *Ancien Régime*, everybody knew everybody else, so there was no need for identity papers. It was when the centralized state developed, growing increasingly distant from the people, that this became necessary. From the point of view of the state, identity isn't complicated. It is determined by the small amount of data summarized in the documents, which prevent one individual from being confused with another. But is that really what identity is? Do we know everything about an individual once we've been told that they're a man or a woman, born in 1945 or 2002 in Paris or in Argenton-sur-Creuse? Isn't identity also, above all, what gives meaning to our lives—the choices continually made by each of us in response to the question: "who am I really?"

As bizarre as it may seem, the bag crystallizes this debate about identity very intimately. I've especially observed this during dramatic episodes when a bag has been stolen or lost. What is unbearable is not only that a part of oneself is missing (a physical sensation), but that this part is the most precious, the most intimate. This is why we have the impression, after such a drama, that we are no longer completely ourselves, that we have been emptied of our existential substance. Because, more than anywhere else, the two aforementioned identities are closely intermingled in the bag, giving us the very strong impression that it is at the heart of the self: that it *is* the heart of the self. Of course, this often begins with one's identity papers, since their loss is always a shock, and the harbinger of trying ordeals to come. But beyond the factual inconveniences, the sensations resonate in the deepest parts of our being, conjuring images of nudity and vacuity. Who was I without my papers, asked the novelist Carol Shields after her bag was stolen in the metro? "Nobody."[2] Nobody, because we need our papers in order to be recognized, especially when we feel lost in a foreign city. But nobody also—and much more profoundly—because of the loss of familiar markers, and the feeling of pain caused by this inner emptiness. Because not only does the bag contain our identity papers. It is also a private world of one's own: a carrier of the memories, the treasures of affection, which ensure that we are what we are each day. Take Paul Ricoeur's analysis:[3] we are constantly telling ourselves stories in order to piece together

PRECEDING DOUBLE
PAGE SPREAD

A couple on an airplane runway: the woman carries the Speedy Monogram Transparence, from the Spring-Summer 2012 collection; on the baggage trolley: three Alzer suitcases, a hatbox and a Vanity Case, all in Damier Azur canvas. Photograph by Greg Lotus, *Vogue Italia*, May 2012

the scattered bits of meaning in our lives, creating a narrative identity that is constructed visually through our daydreams—our little inner cinema where we project scenarios for a possible future. But it is also constructed more poignantly by scraps of biographical writing, omnipresent in the bag (in digital form, or still very often handwritten in notebooks, lists of resolutions or other various pieces of paper). Even hastily scrawled on a train or in a waiting room, these phrases say a lot about who we want to be tomorrow. They are at the center of the individual's transformative actions upon himself. The loss of the bag is an inner collapse because it is at the center of the construction of the self.

But let's forget these sad episodes, since the bag is above all about happiness, pleasure and love. For example, we often find therein a whole series of minuscule, seemingly useless objects. Charms and cuddly toys, of course, but those have a vague protective or soothing function. But objects that truly have no use: shells, little pebbles, stones in a bag? I've found many a stone in women's bags. Why would anyone spend years carrying rocks around, when they will only end up weighing them down? What is the use of that? It is impossible to understand a woman's bag if one thinks only of utility. Because first and foremost come emotions, memories—an entire world of sentiments and relationships. We cannot calculate affection; there is no sense in weighing love. The little stones or shells are gathered one day, almost by accident, in a moment of delight that warms the heart. They are placed within the bag in a deliciously pleasurable gesture, as if to defy time and mark this happiness. Then they are left there, existing henceforth like sacred objects. The bag is a little world of love. Its world is sacred.

Sometimes, certain women are abusively intoxicated by the secret happiness of these little objects, just for them. They accumulate them without limit, and the bag becomes heavy, *too* heavy. Especially if we add the infinite list of more useful objects that might be needed "just in case." The medication for a potential headache, the apple for calming a hypothetical hunger pang, the bottle of water for thirst, the change of clothes in case of a fortuitous meeting, etc.—an entire arsenal that gives a sense of being well armed against varied and unexpected situations. Every woman has her own future scenarios that sometimes compel her to put surprising objects in her bag. Contents inventories have revealed: a bicycle pump, a small folding stool, a pair of high-heeled shoes and a large corkscrew. And all of this is without counting what devoted women carry for their loved ones, putting themselves at the service of their children, their husband, and even the friends around them. A woman carries out of love, ensuring that these people never lack anything they need, even at the risk of feeling this weight on her shoulder. It can happen, then, that the bag becomes too heavy, *much* too heavy. Whence comes the desire to sort it out, relentlessly—to evacuate anything that doesn't seem strictly necessary. Whence comes the dream of lightness, of liberty, of fluid gestures—to have a bag that finds its rightful place, harmonizing with her silhouette, without

excess, without heaviness. Beautiful, of course, both beautiful and easy, magnificent and comfortable, adding gracefulness to her gestures and not the contrary. But can one separate oneself so easily from the little fetish objects, the "just in case" scenarios, and the many things that might be useful for so many people in one's circle? For some it is truly impossible, even unthinkable; they need this whole universe stuck to their skin to feel comfortable with themselves. For others, the opposite is true: they must cut to the quick, violently if necessary, to achieve physical and existential lightness and maintain a pure aesthetic. But for most, each day, it's hesitation that prevails: the difficulty of deciding about the slightest knick-knack. Do I bring the umbrella, or risk a few raindrops? Can I manage to separate myself from the little notebook grandma gave me? Should I have a backup pen in case the first one runs out of ink? These microdecisions might seem ridiculous. They are not. Because with each one, it is a philosophy of life that is in question—a way of constructing one's future identity. A wellfilled bag projects the self towards values of tranquil security and overflowing love. It's a way of being and existing that deeply roots its owner, enveloping her within a comforting entourage. A very light bag propels its owner towards airy images of youth and adventure, of a supple body that defies the weight of the world, of little moments of audacity that add some spice to life.

Another existential dilemma separates the supporters of identity continuity from those who prefer to invent multiple ones. The former get attached to their familiar bag, always the same, a complicit and constant point of reference, faithfully riveted to its place, as near to the body as possible. Identity can thus be constructed singly (or at least give that impression), by reassuringly repeating the markers that give life a sense of meaning. The latter are more interested in the quest for innovation and surprise. For them, identity is not fixed, unique or inalterable. It can, on the contrary, diffract into infinite, very different facets. Everyone has the possibility to enlarge and intensify their scope of existence by playing with the images of self that they present to others.

We have a false idea about self-images. It is too often stated that they are external, or even superficial, contrasting with a so-called "real" and "profound" identity. This perception is totally erroneous. We are nothing without others; we exist only in the eyes of others, through a permanent transaction in which, by projecting an image, we ask that they recognize us as we would like to be recognized. Through this social process, we succeed in actually playing with our identity via images that we present to the people around us. Choosing highheeled shoes, or a relaxed dress rather than an elegant one, can completely change that presentation. And especially choosing a bag. The bag is the most accommodating way of reinventing oneself, because it dresses things up all on its own. One can, for example, pull on a simple pair of jeans but, by sporting a superb Alma in patent leather, place oneself very high up in the hierarchy of distinction and refinement. Many women confess

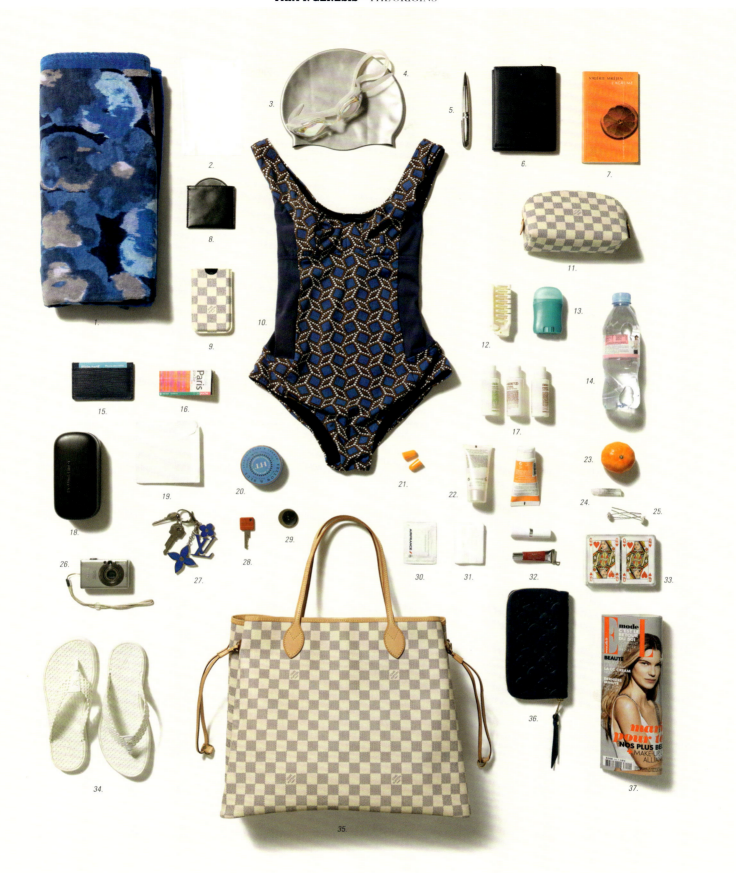

1. Summer Ikat towel in blue cotton — 2. Pochette in transparent plastic — 3. Swimming cap in silver silicone — 4. Swimming goggles in white silicone — 5. Ballpoint pen in palladium Néo Damier — 6. Black SC calfskin leather notepad — 7. *L'Agrume*, novel by Valérie Mréjen, Allia, Paris, 2001 — 8. Pocket mirror in a black leather case — 9. Cell phone in a Damier Azur canvas case — 10. Louis Vuitton Cruise swimsuit in jersey — 11. Pochette Cosmétiques in Damier Azur canvas — 12. White folding hairbrush — 13. Travel-size deodorant — 14. Bottle of still water — 15. Card holder in black Epi leather — 16. RATP metro map for the city of Paris — 17. Travel-size shampoo and conditioner — 18. Glasses case — 19. Mail — 20. Box of herbal teabags — 21. Earplugs — 22. Tubes of moisturizer for face and body — 23. Clementine — 24. Perfume sample — 25. Hair pins with white diamanté detail — 26. Digital camera — 27. Set of keys and blue Fleur d'Epi bag with charm — 28. Bicycle lock key — 29. Jacket button — 30. Refreshing wipe — 31. White paper handkerchiefs — 32. Lip balm and lip gloss — 33. Playing cards — 34. White Tattoo flip flops — 35. Large Neverfull in Damier Azur canvas, 40 × 33 × 22 cm — 36. Secrète Long wallet in céleste Monogram Empreinte — 37. Women's magazine. Photograph by Patrick Gries, 2013

INSIDE A NEVERFULL

to building their silhouette around their bag. The bag first and foremost. Did they wake up in a good mood? Did they have more vital energy than usual? If so, they were inclined towards a lively, colorful, audacious bag. A Monceau in Indian pink patent leather? The rest of the clothes should follow it, harmonize with it, stay within that mood. This option will result in a state of being and an ethical environment for the entire day: it will be necessary to live up to this image of vivacity. Because others, in perceiving the colors, will bring you back to the idea that you must be this way, that you can be this way: lively and bubbly. Self-image participates actively in creating the day's identity. The following morning, the good mood and vital energy will, alas, have disappeared, and it will seem preferable to strike a more tranquil note with a Speedy Monogram Empreinte in *aurore* purple. The entourage, upon seeing a more discreet outfit and bag, will intuitively understand and respond.

A bag's ability to play an essential role in variations of identity explains, for many, the strength of emotion felt upon meeting a new partner. It is a "partner" indeed, because many women speak about it using words of human love. They had experienced not just a simple feeling of attraction, but a veritable *coup de foudre*, upon seeing a Noé in Epi leather, for example. Love at first sight. A shock that made their hearts race. They imagine themselves in their new life with it, and the mirror tells them how this new love renders them marvelously different. Then they touch it, gently; they caress its finely textured skin and feel the excitement of this most intimate relationship. Some of them even have the audacity to say that bags are better than men! Because for the truly passionate, emotions can almost vibrate. But also, and above all, because the love of old bags never dies. With men, every new love affair provokes abominable crises and painful, unpleasant separations. Not so with bags. The new passion is dazzling and incomparable, of course, but the old ones never die. The love for an ex (bag) is a sweet nostalgia. Two rather different types of memories are mixed up in it. Take the Noé, again, for example. At first there is an encounter, a passion, the magnificent beauty of another time, the memories it evokes. Then, there is the more secret complicity experienced with the bag, all the shared intimate moments, the gentle caresses and the discreet manipulations. This is why we never throw a bag away, or rarely. We store it a little to the side when a new partner makes its flamboyant arrival, and then a little further still. But we never throw it away. We even secretly tell ourselves that one day, maybe, we might go out with it again.

To each their passions. Many men like football and can buzz exuberantly in the stadium for the duration of a match. Their wives sometimes have difficulty understanding these strange outbursts of emotion. They prefer more gentle but intense sensations. The bag occupies a choice place amongst these intimate passions, which can, on occasion, become very powerful. We're now entering into a world where living without personal passions is becoming impossible. Each of us is constantly telling the story of our life in order to give it coherent meaning despite its changes of direction, but it's not always easy to adhere to this narrative, to create motivation, to pour out vital energy, to feel fully alive. Personal passions help us reach this ideal. Upon the occasion of an encounter with a new bag, a first evening out with it, life feels fuller and more whole, radiating happiness.

The handbag doesn't have a very long history. Even though it appeared at the end of the Middle Ages, it has only been widely used in daily life for about half a century. Ladies in the countryside in the 1950s didn't need a handbag during the week; they only went out on Sundays. Ever since women's liberation in the 1960s, it has been a fixture in their silhouette, for all women, every day, to the point of becoming an essential sign that marks the female identity—a way of saying "I'm a woman" and showing it off. The contents have also become ever richer in these last years. In effect, we have become autonomous and complex individuals who need to be part of a circle and supported in our various activities.

Whether it's as an accomplice that gets them out of a bind, or as a fashion accessory that makes their image shine, the bag never ceases to occupy an increasingly important place in women's lives. A vital place. Because it is at the heart of the self.

[1] Jean-Claude Kaufmann, *L'Invention de soi. Une théorie de l'identité* (Paris: Armand Colin, 2004) n.p.
[2] Carol Shields, "A Purse of One's Own," in Kirsty Dunseath, *A Second Skin: Women Write About Clothes* (London & Minneapolis: Women's Press, 1998) n.p.
[3] Paul Ricœur, *Soi-même comme un autre* (Paris: Points/Le Seuil, 1990). n.p.

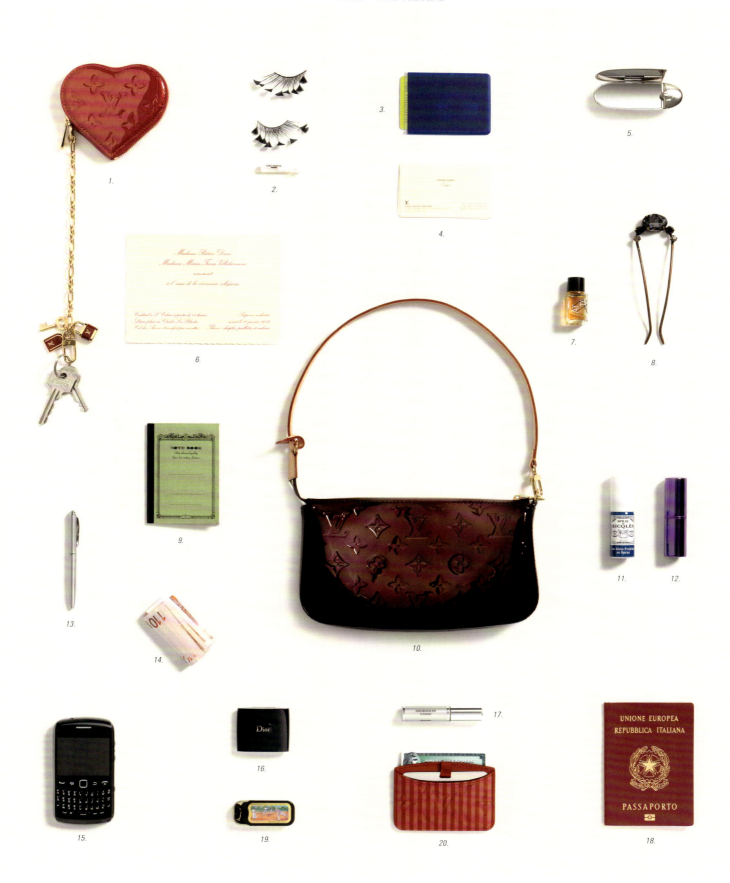

1. Cœur change purse in pomme d'amour Monogram Vernis — 2. False eyelashes and eyelash glue — 3. Transport card in a case —
4. Business cards — 5. Lipstick with mirror — 6. Invitation — 7. *Attache-moi*, travel size perfume by Iconofly —
8. Hair pin — 9. Notebook — 10. Pochette Accessoires in amaranth Monogram Vernis, 21 × 13 × 3 cm — 11. Refreshing mint spray —
12. Makeup brush — 13. Ballpoint pen — 14. Bank notes — 15. Cell phone — 16. Powder blush — 17. Mascara —
18. Passport — 19. Licorice candies — 20. Mirror case in amaranth Monogram Vernis Rayures. Photograph by Patrick Gries, 2013

INSIDE A POCHETTE ACCESSOIRES

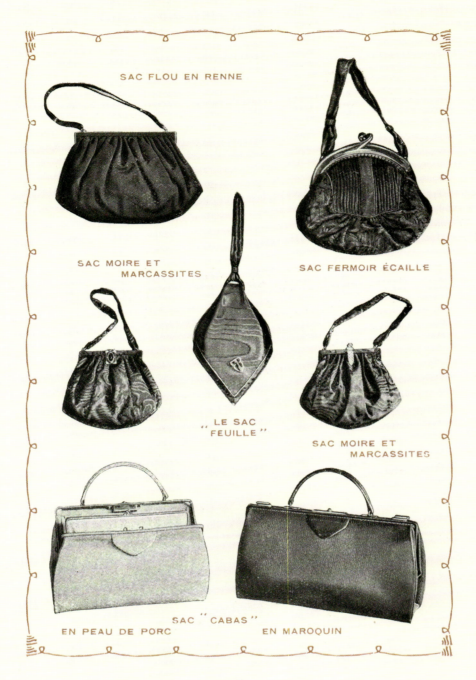

SAC FLOU EN RENNE

SAC MOIRE ET
MARCASSITES

SAC FERMOIR ÉCAILLE

„ LE SAC
" FEUILLE "

SAC MOIRE ET
MARCASSITES

SAC " CABAS "
EN PEAU DE PORC EN MAROQUIN

5

Page dedicated to ladies' handbags: Flou (in reindeer), Fermoir écaille,
Moire et Marcassites, Feuille, and Cabas (in pigskin or Moroccan leather). *Du cadeau ou la bonne manière*,
Louis Vuitton catalogue, 1924, p. 5. Louis Vuitton Archives

PART II: FAMILIES

SPEEDY 30
In Monogram canvas

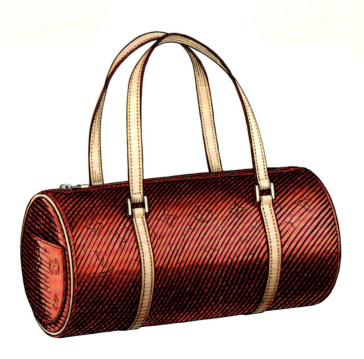

BEDFORD PAPILLON
In Pomme d'amour Monogram Vernis

Chapter I:

SPEEDY/PAPILLON

Pages 66–115

FROM TOP
TO BOTTOM

Overnight bag,
Hunting bag,
Square Mouth
travel bag

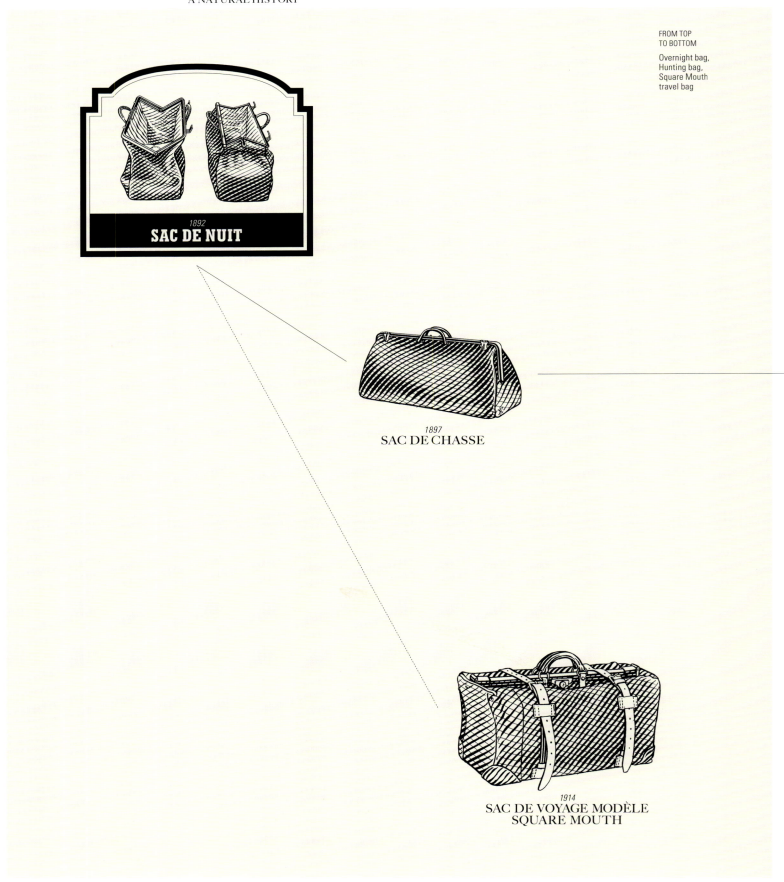

1892
SAC DE NUIT

1897
SAC DE CHASSE

1914
SAC DE VOYAGE MODÈLE
SQUARE MOUTH

Originally intended as accessories to the steamer trunk, bags such as the leather Overnight Bag,
with its characteristic wide, horizontal opening, became independent, lightweight pieces of
luggage in their own right. Spurred by Louis Vuitton's constant research into flexible materials,
this same evolutionary line gave rise to the emblematic Keepall canvas baggage, from around 1930.

GENEALOGY: SPEEDY AND PAPILLON

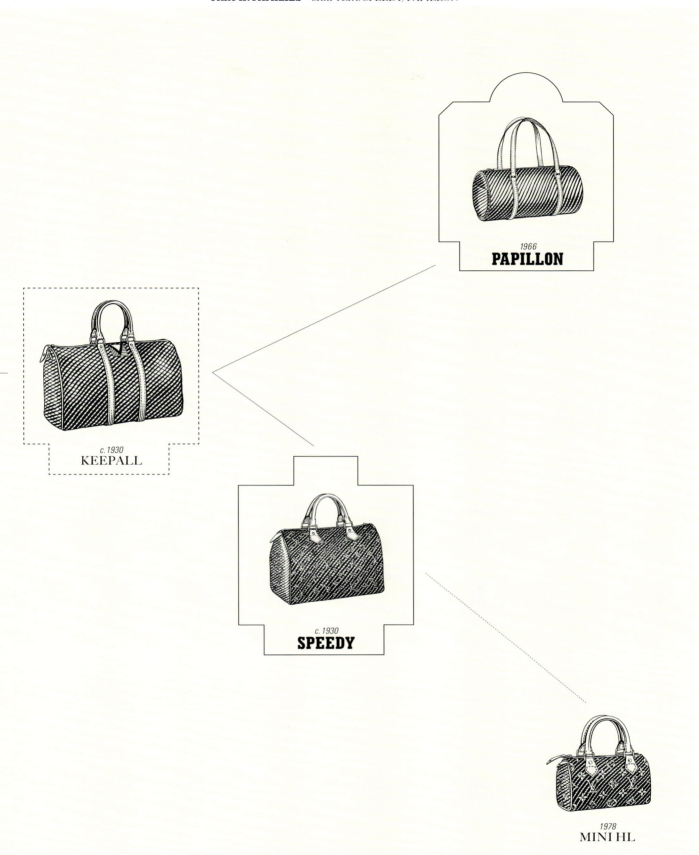

1966
PAPILLON

c. 1930
KEEPALL

c. 1930
SPEEDY

1978
MINI HL

The model was soon adjusted to become a hold-all city bag under the name Speedy, an icon that,
thirty years later, would share the characteristics of practicality and adaptability with the Papillon, its
equally famous relation. The most recent addition to the family, the Mini HL, perfects the lineage and is
an extreme adaptation to contemporary life. P. 66 and above drawings by Martin Mörck, 2013

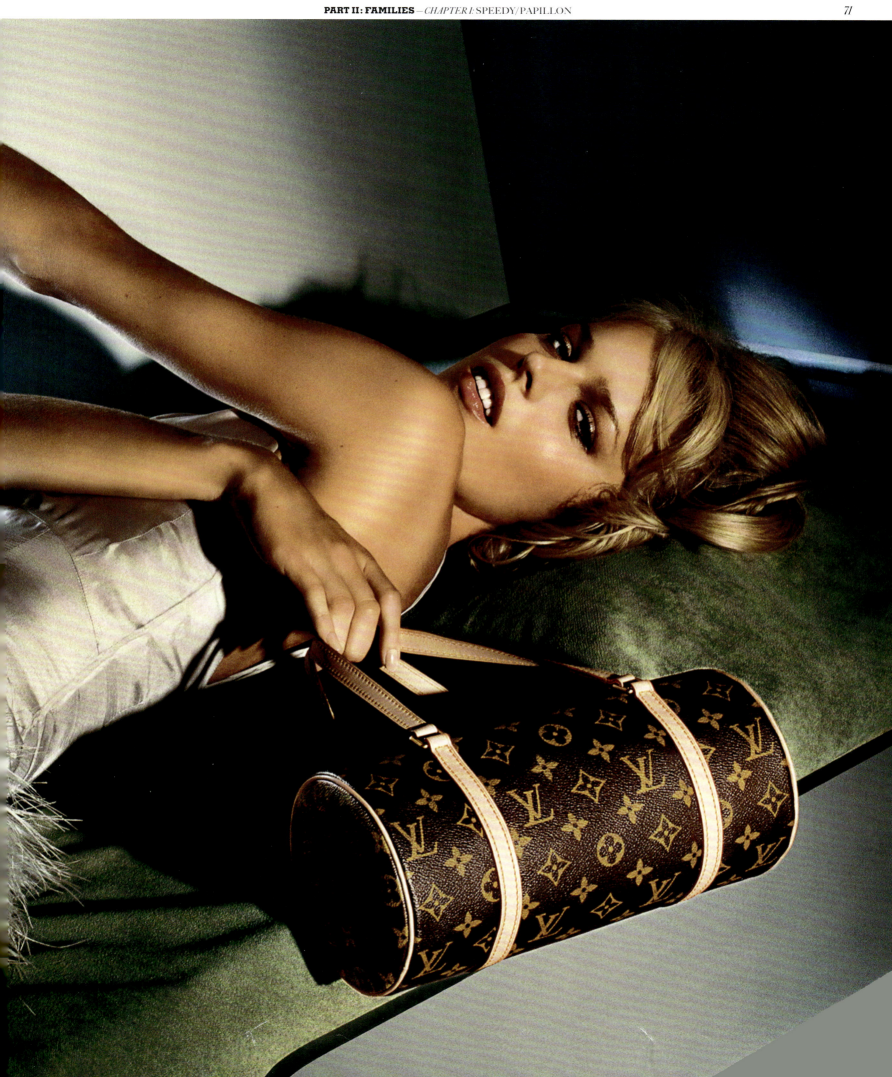

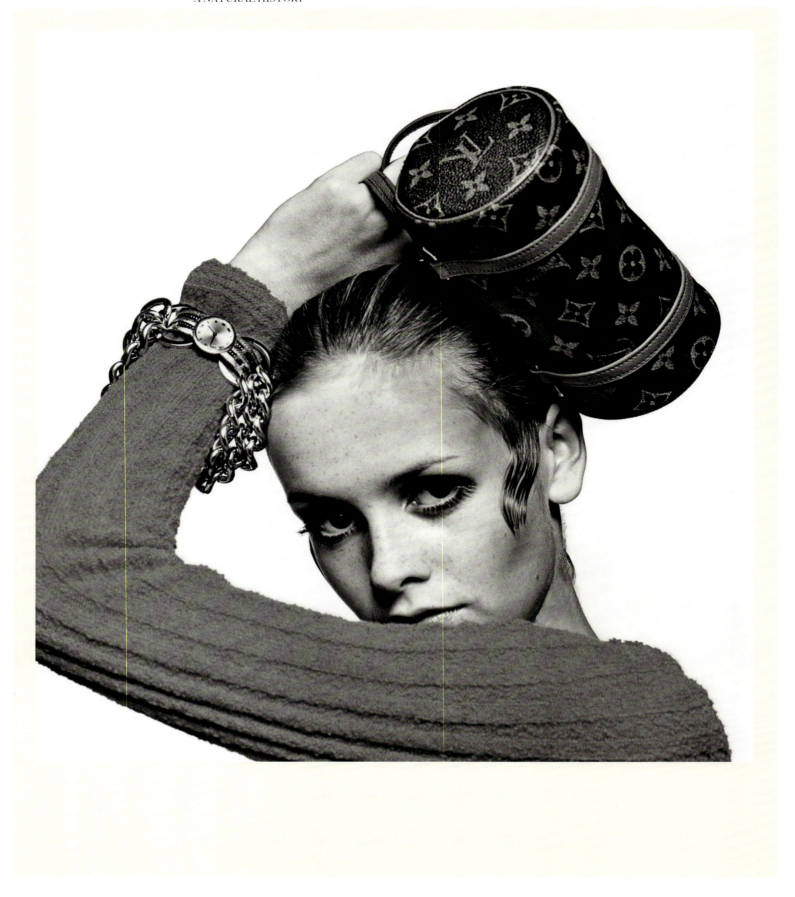

Twiggy carries a small Papillon in Monogram canvas. Photograph by Bert Stern, *Vogue UK*, 1967

SPEEDY/PAPILLON
COLOMBE PRINGLE

Both, in their way, belong in the hold-all family. While their common history goes all the way back to the end of the 19th century through their distant ancestors the Overnight Bag (1892) and the Hunting Bag (1897), they are the direct descendants of the Keepall, the occasional bag launched in 1924 whose name describes its purpose. It was originally produced in cotton canvas and intended for folding into the bottom of a suitcase, before being offered in Monogram canvas and becoming a multi-purpose bag. In a way, it foreshadowed the weekend bag. But let's not get ahead of ourselves.

In 1930, in the wake of the Keepall's global success, Louis Vuitton decided to create a smaller version, which it baptized the Express. Destined to become a handbag, its name recalls the passion for fast-paced living illustrated by the streamlined cars of the period and the first American appliances imported by the Allies after World War I. It would take the name Speedy, winning the world over to this high-speed lifestyle. First created in plain canvas, it appeared the following year in Monogram canvas, giving it a more urban look without losing sight of its practical purpose. The trend for hold-alls that would seduce the women of today had been launched. "Pliable and built like the Keepall, the Speedy was, for a long time, a pure travel accessory designed for personal effects that the traveller wanted to keep to hand in their immediate vicinity. It's also equipped with a padlock, like all the travel items," explains Xavier Dixsaut, Director of Innovation. "Then, from an accessory product, it became a handbag in its own right, retaining its Toron handles in natural cowhide leather and its riveted chapes for solidity."

With the era of the weekend "countryside rush," second homes became the new nirvana. People discovered the joys of decorating, fixing up a home, barbecuing. Televisions, washing machines and vacuum cleaners made their entrée into domestic life, and a society of leisure was established. The baby boom was in full swing, and mothers, too, were in a hurry. The Speedy, then available

PRECEDING DOUBLE PAGE SPREAD

"Le Feu sous la glace" ("Fire Under Ice"), Autumn-Winter 2002–2003 advertising campaign. In a train compartment, Eva Herzigova carries a large Papillon in Monogram canvas Photograph by Mert Alas and Marcus Piggott, 2002

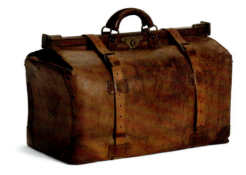

in three sizes (40, 35 and 30), became the indispensable ally of a new life divided between the home and the office. The stars also found it hard to resist: in 1965, Audrey Hepburn placed an order with Henry-Louis Vuitton for a smaller, lighter (but no less practical) model, the Speedy 25, for her Roman holidays. Thus, the family grew, and the Speedy's little brother was born.

Twiggy was the face of the year in 1966. This wisp of a woman with a boyish haircut and sweeping eyelashes became the new idol, and the number-one top model on the international stage. Youth was in fashion, and fashion was fixated upon youth. In the *grands magasins*, this trend heralded the death of the ladies' department. Mademoiselle Chanel disappeared, Cardin launched his unisex lines, and a space age Courrèges invaded the planet while Mary Quant reigned over the King's Road. There were miniskirts, white tights, baby doll dresses, heavy fringes and false eyelashes by the kilo; the baby boomers were exactly twenty years old: the age of metamorphosis. So the story goes, it was in this year, during a walk along the Champs-Élysées, that Henry-Louis Vuitton had a vision. Returning to his office, he sat down at his desk and designed a bag with delicate curves, held by two thin shoulder straps in grained leather, like delicate wings, from which it would derive its name: Papillon, meaning "butterfly." A year later, her hair slicked back and her eyes dark with eyeliner, Twiggy would be photographed with the bag in Monogram canvas for *Vogue UK*. But she was not the only one to succumb to its charms: the exquisite Jane Birkin also adopted it. The face of Swinging London, she had just been seen in *Blow Up*, the film by Michelangelo Antonioni that took the Palme d'Or at the 1967 Cannes Film Festival. Since then, the Papillon has been seen in every color, and has been equipped with a pochette, a small side pocket and a shoulder strap. In 2002, it had a makeover, flying to new heights in satin with handles in natural cowhide leather as the Little Papillon evening bag. In 2003, it was covered in flowers and made ultra-feminine by Takashi Murakami with his Cherry Blossom motif. The following year, it was seen by day and by night in monogrammed mink. It even lent itself to the conceptual musings of the architect Shigeru Ban—a master in the art of transforming paper, as demonstrated by his famous church in Kobe—who would dress cardboard tubes with the iconic Monogram canvas cylinder. And in 2012, it would take flight again with Marc Jacobs' Néo Papillon in Monogram Révélation, who ensured that it continued to flutter upon beautiful arms.

Of equally iconic status, the Speedy would also enjoy the same privileges of reinterpretation as the seasons and fashions progressed. A best-seller in all categories, it would be one of the first to adopt the Epi leather and then the Damier pattern canvas before being customized by Stephen Sprouse, Takashi Murakami, Sofia Coppola and Richard Prince—stars of the art world whose contributions to its story help inscribe the bag into the history of our time with versions that are altogether different, and yet, somehow, still the same.

FROM TOP TO BOTTOM

Square Mouth travel bag in grained leather, c. 1914, 75 × 43 × 43 cm, 10.6 kg
Louis Vuitton Collection

Overnight bag in grained leather, c. 1910, 51.5 × 39 × 27.5 cm, 5.2 kg
Louis Vuitton Collection

Canvas Keepall, folded and unfolded, c. 1933
Louis Vuitton Archives

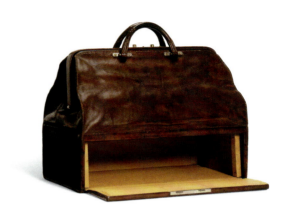

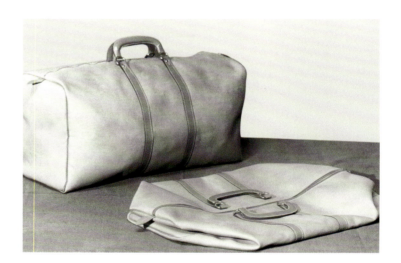

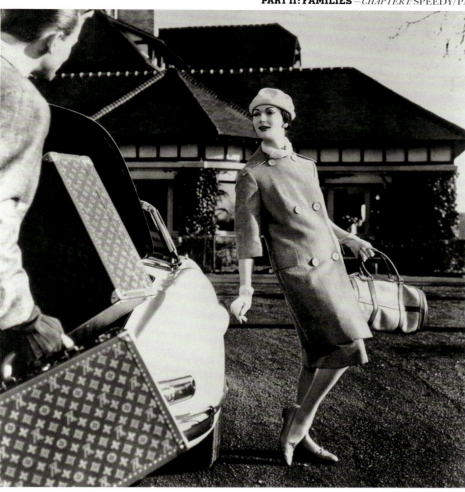

 LA PARISIENNE A UN CHIC
TOUT SPÉCIAL *pour* VOYAGER

Elle a des raffinements inattendus ; aussi bien

dans ses bagages que dans son costume,

elle cherche a obtenir un ensemble harmonieux

FROM TOP TO BOTTOM,
LEFT TO RIGHT

A woman carries a Round
bag in canvas; rigid
luggage in Monogram
canvas is shown in the
foreground, 1960s
Louis Vuitton Archives

"Parisian women travels
with special chic."
Advertising insert
presenting a woman with
her dog in a
train compartment,
surrounded by luggage:
a suitcase on the seat,
a toiletry kit on the
table and an overnight
bag on the floor
Drawing by M. Simon,
Vogue Paris, 1922

"Very Saks Fifth Avenue."
Illustration for
advertising insert. A
woman carries the
small and medium
Papillon in Monogram
canvas, *New York Times*,
September 8 1968
Louis Vuitton Archives

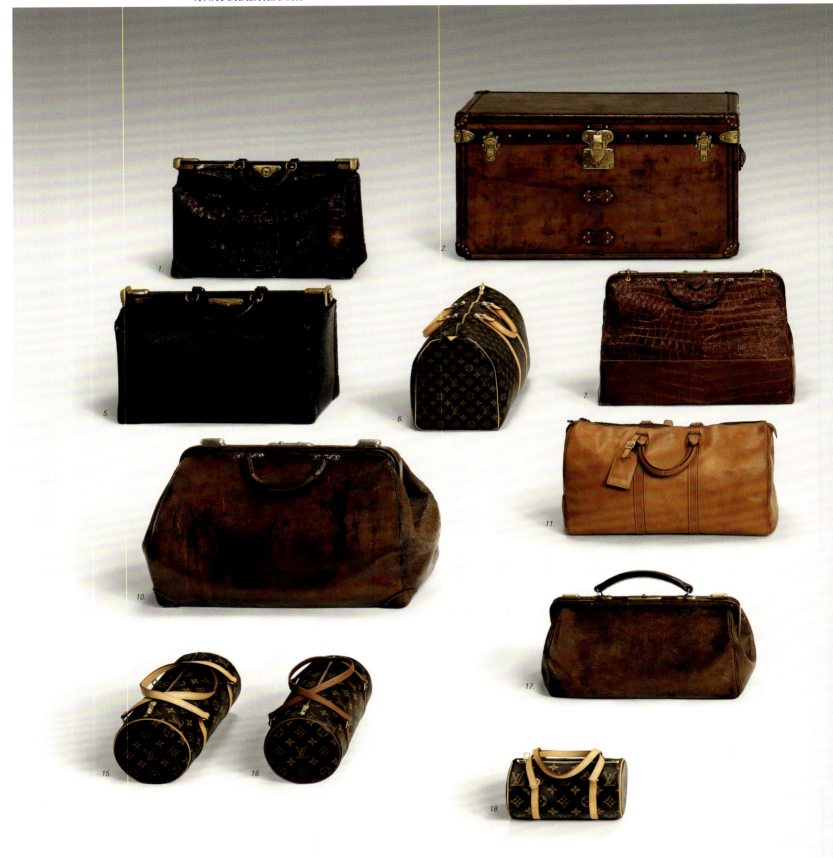

The iconic bags are pictured in the foreground; their "ancestors" are in the background. 1. Square Mouth travel bag in crocodile leather, 1931, 63 × 40 × 34 cm, 8.5 kg. Louis Vuitton Collection — 2. Mail trunk in natural cowhide leather, 1900, 97 × 54 × 51 cm, 25.3 kg. Louis Vuitton Collection — 3. Overnight bag in leather, 1890, 71 × 47 × 32 cm, 4.9 kg. Louis Vuitton Collection — 4. Square Mouth travel bag in grained leather, c. 1914, 75 × 43 × 43 cm, 10.6 kg. Louis Vuitton Collection — 5. Square Mouth travel bag in walrus leather, c. 1930, 56 × 44 × 31 cm, 7 kg. Louis Vuitton Collection — 6. Keepall 50 in Monogram canvas, 1983, 50 × 29 × 22 cm, 1.7 kg. Louis Vuitton Collection — 7. Isidore travel bag in crocodile leather, 1918, 59 × 41 × 35 cm, 5 kg. Louis Vuitton Collection — 8. Square Mouth travel bag in leather, c. 1914, 41 × 37 × 25 cm, 3.5 kg. Louis Vuitton Collection — 9. Overnight bag in grained leather, c. 1910, 51.5 × 39 × 27.5 cm, 5.2 kg. Louis Vuitton Collection — 10. Overnight bag in leather, c. 1910, 55 × 36 × 31 cm, 5.1 kg. Louis Vuitton Collection —

FAMILY PORTRAIT

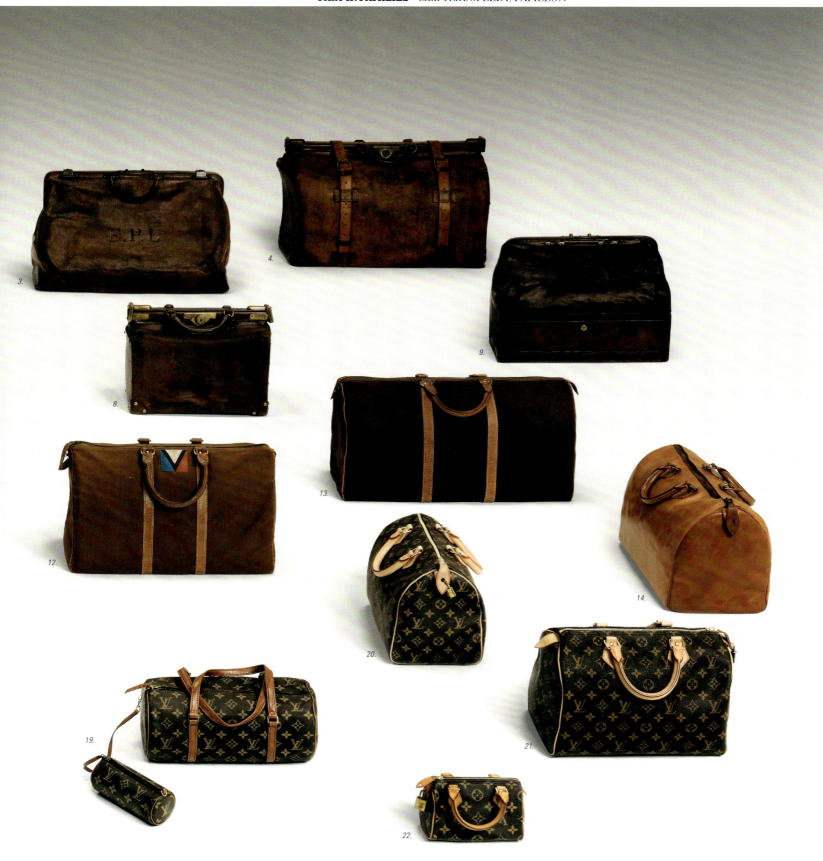

11. Keepall 50 in natural cowhide leather, c. 1980, 50 × 29 × 22 cm, 1.7 kg. Louis Vuitton Collection — 12. Keepall in cotton canvas, 1930, 50 × 28 × 23 cm, 1.2 kg. Louis Vuitton Collection — 13. Keepall in cotton canvas, c. 1930, 59 × 31 × 27 cm, 1.6 kg. Louis Vuitton Collection — 14. Speedy 40 in natural cowhide leather, c. 1980, 40 × 25 × 19 cm. Louis Vuitton Collection — 15. Large Papillon in Monogram canvas, 2002, 30 × 15 × 15 cm. Louis Vuitton Collection — 16. Medium Papillon in Monogram canvas, 1984, 26 × 14 × 14 cm. Louis Vuitton Collection — 17. Travel bag in grained leather, c. 1910, 44 × 23 × 19 cm, 0.9 kg. Louis Vuitton Collection — 18. Small Papillon in Monogram canvas, 2003, 19 × 10.5 × 10.5 cm. Louis Vuitton Collection — 19. Large Papillon and matching accessory case in Monogram canvas, 1967, 30 × 15 × 15 cm. Louis Vuitton Collection — 20. Speedy 30 in Monogram canvas, 1983, 30 × 21 × 17 cm. Louis Vuitton Collection — 21. Speedy 30 in Monogram canvas, 1983, 30 × 21 × 17 cm. Louis Vuitton Collection — 22. Mini HL in Monogram canvas, 1991, 15 × 10 × 7 cm. Louis Vuitton Collection. Photograph by Patrick Gries, 2013

SPEEDY

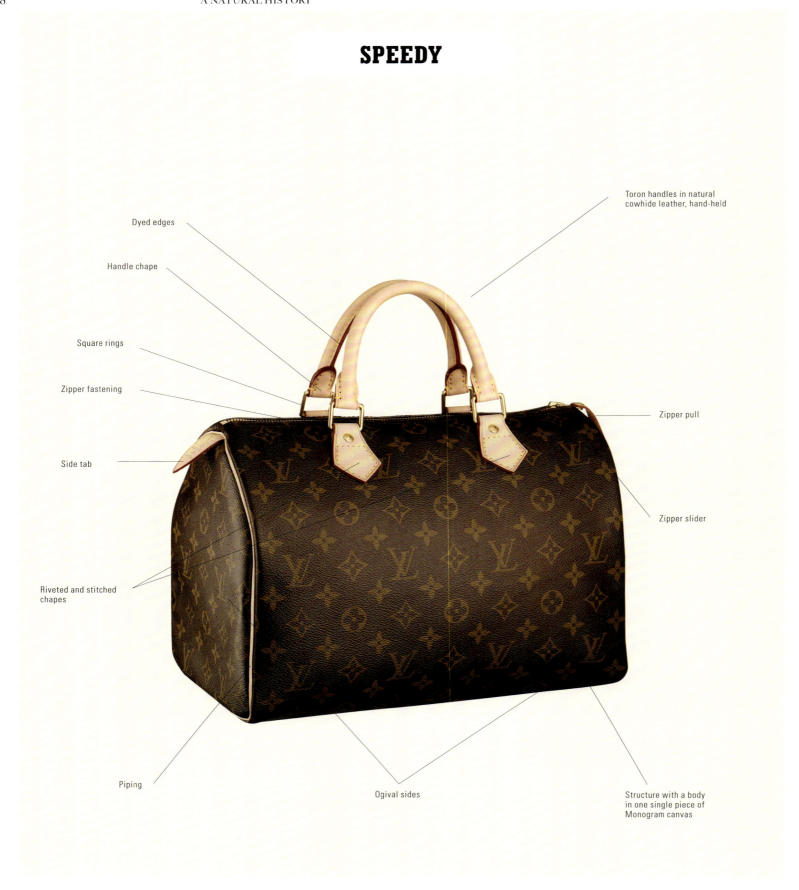

Toron handles in natural
cowhide leather, hand-held

Dyed edges

Handle chape

Square rings

Zipper fastening

Zipper pull

Side tab

Zipper slider

Riveted and stitched
chapes

Piping

Ogival sides

Structure with a body
in one single piece of
Monogram canvas

Speedy 30 in Monogram canvas, 30 × 21 × 17 cm — Large Papillon in Monogram canvas, 30 × 15 × 15 cm.
The Speedy and the Papillon, as well as the Mini HL (see p. 100), have a tubular, horizontal form. Their composition is
simple, consisting of three assembled pieces of Monogram canvas. The Speedy's structure is supple, whilst
that of the Papillon is more rigid. Originally, they had no interior compartments, but to make them more convenient,
they were equipped with a pocket for the Speedy and an independent pochette for the Papillon.

COMPARATIVE ANATOMY

PAPILLON

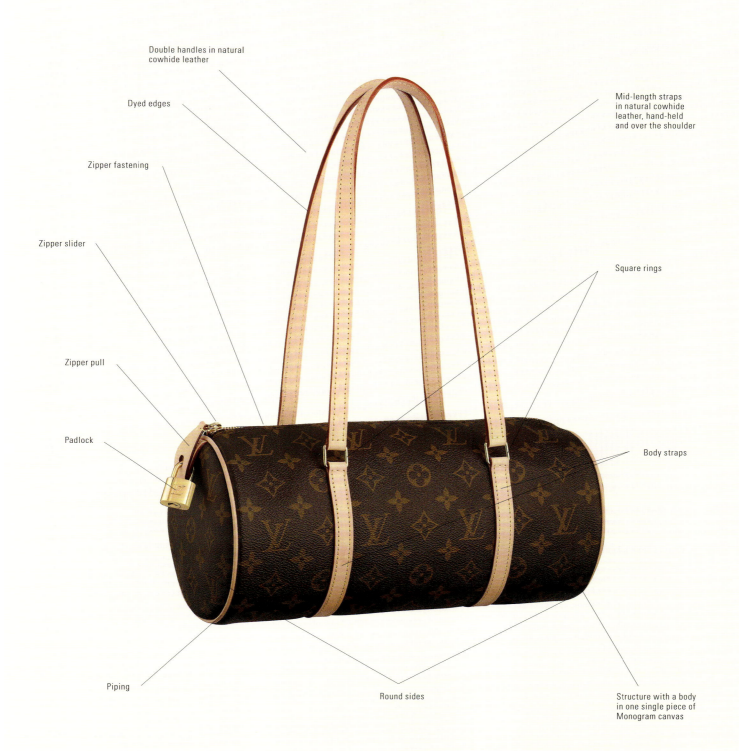

Double handles in natural cowhide leather

Dyed edges

Zipper fastening

Zipper slider

Zipper pull

Padlock

Piping

Mid-length straps in natural cowhide leather, hand-held and over the shoulder

Square rings

Body straps

Round sides

Structure with a body in one single piece of Monogram canvas

SPEEDY

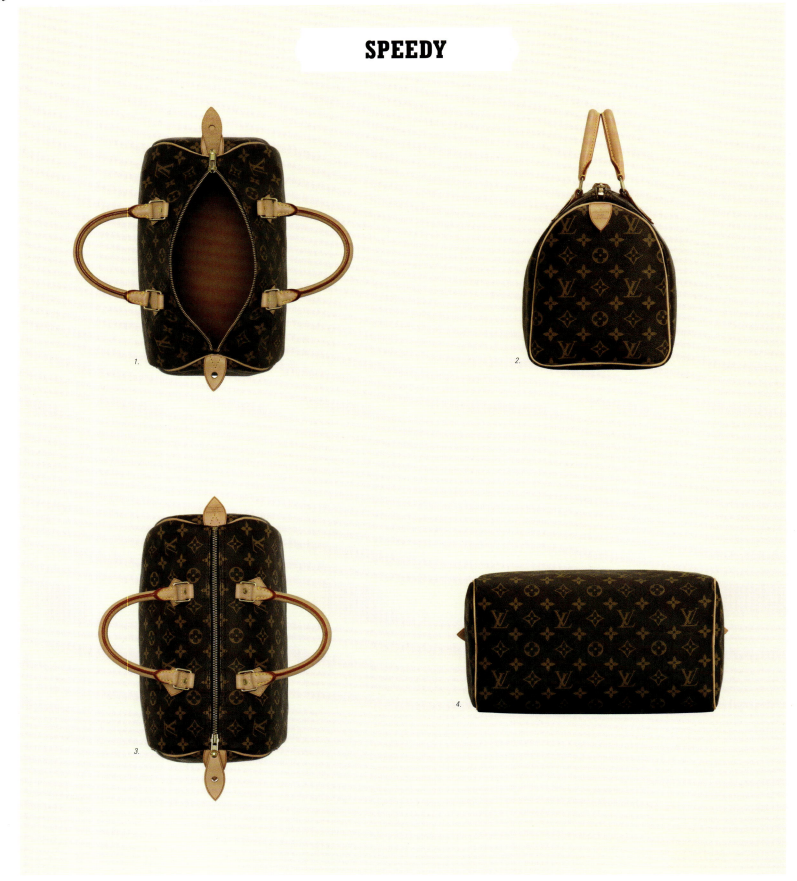

Speedy 30 in Monogram canvas, 30 × 21 × 17 cm: 1. Open, seen from above — 2. Profile view — 3. Closed,
seen from above — 4. View from below

Opposite: Detail of the interior D-ring and its attachment in natural cowhide leather, the zipper and the
handle chape with dyed edges. Photograph by Patrick Gries, 2013

MORPHOLOGY

PAPILLON

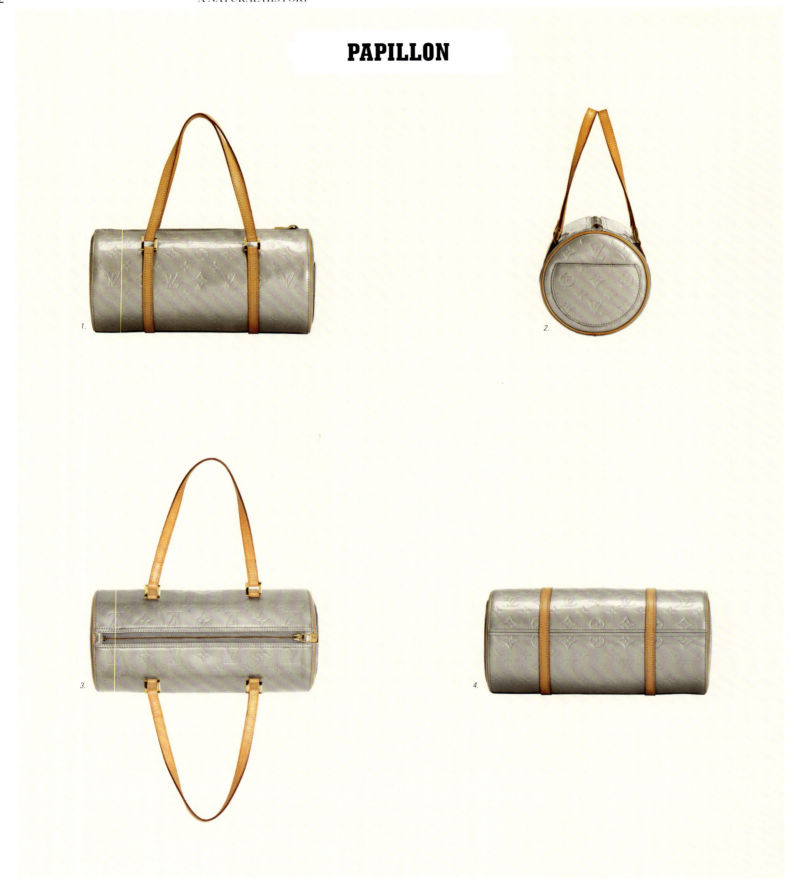

Bedford Papillon in gray Monogram Vernis, 30 × 15 × 15 cm : 1. Front view — 2. Profile view — 3. Closed,
seen from above — 4. Seen from below

Opposite: Detail of side pocket. Photograph by Patrick Gries, 2013

MORPHOLOGY

SPEEDY

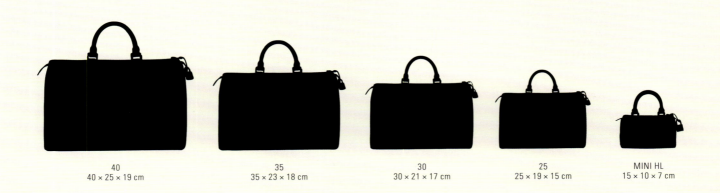

40
40 × 25 × 19 cm

35
35 × 23 × 18 cm

30
30 × 21 × 17 cm

25
25 × 19 × 15 cm

MINI HL
15 × 10 × 7 cm

PAPILLON

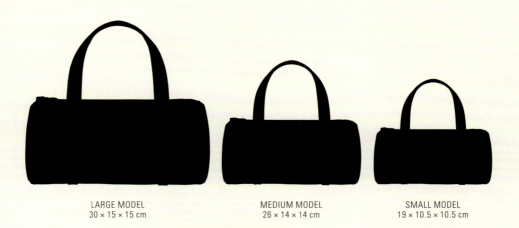

LARGE MODEL
30 × 15 × 15 cm

MEDIUM MODEL
26 × 14 × 14 cm

SMALL MODEL
19 × 10.5 × 10.5 cm

The Speedy and the Papillon have been produced in five and three sizes, respectively.
The Speedy 40, 35, 30 and 25 have been joined by the Mini HL, a diminutive version of the iconic model 30.
The Papillon has been produced in large, medium and small models.

DIMENSIONS

MONOGRAM EMPREINTE

MONOGRAM VERNIS

The Monogram Empreinte line is distinguished by its range of colors for the Speedy 25 and 30: 1. Aube —
2. Aurore — 3. Jaipur — 4. Orient — 5. Céleste — 6. Infini — 7. Terre — 8. Neige

The Monogram Vernis line offers a large variety of colors for the Bedford Papillon: 1. Bronze —
2. Noisette — 3. Marshmallow — 4. Perle — 5. Indigo blue — 6. Bleu ciel — 7. Lavande — 8. Gray —
9. Amaranth — 10. Pomme d'amour — 11. Fuchsia — 12. Framboise — 13. Red

COLOR SCHEMES

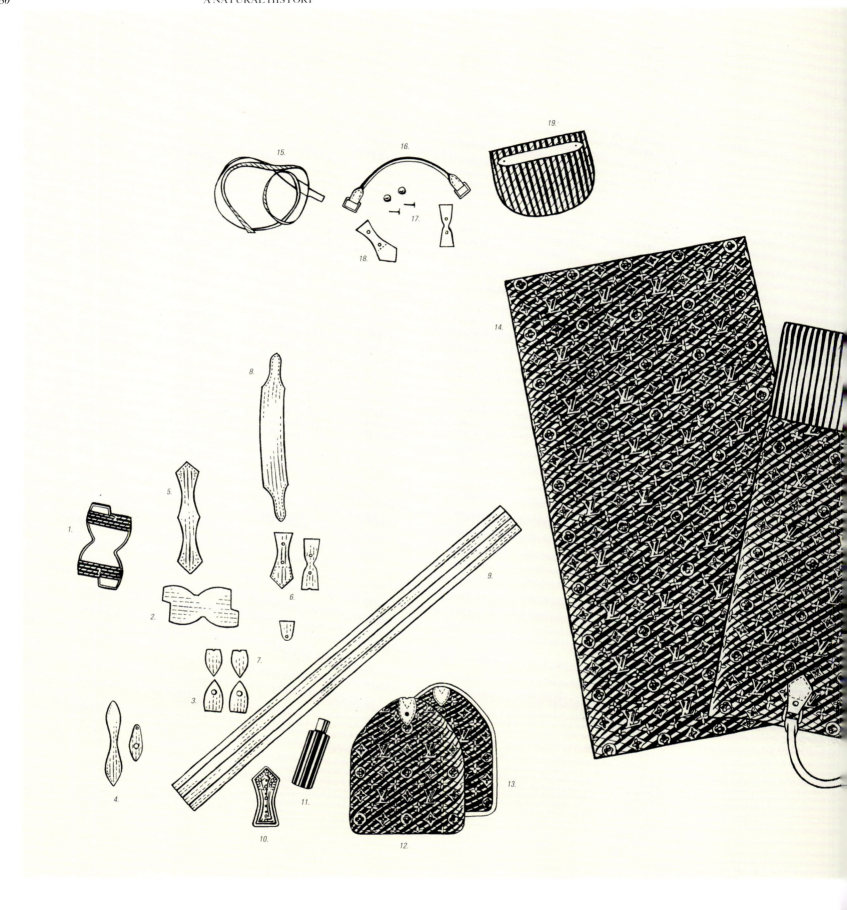

The construction of the Speedy requires sixty different preparation steps, twenty-two assembly stitchings and twenty-eight finishing steps,
for a total of one hundred and ten steps. 1. Punch for side tabs — 2. Leather cut for side tabs — 3. Four side tabs, two perforated — 4. Leather cut for a zipper puller and a perforated
zipper puller — 5. Leather cut for chapes — 6. Two chapes — 7. Chape reinforcement — 8. Leather cut for handle — 9. Piece of natural cowhide leather for piping — 10. Stamp
for marking stitching lines — 11. Bottle of red dye for Toron handle edges — 12. Ogival side in Monogram canvas with perforated side tab, without piping —

SPEEDY DECONSTRUCTED

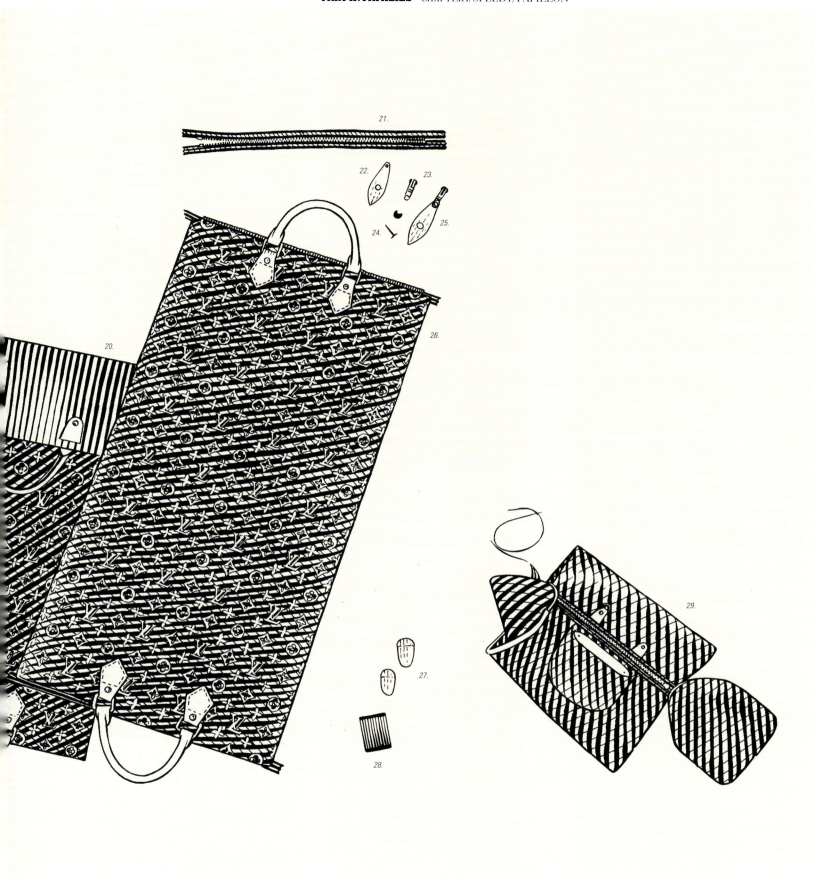

13. Ogival side in Monogram canvas with side tab and piping — 14. Body in one single piece of Monogram canvas — 15. Trimming — 16. Toron handle in natural cowhide leather with square rings — 17. Rivets — 18. Chapes — 19. Flat pocket in canvas — 20. Body in one single piece of Monogram canvas with Toron handles in natural cowhide leather, chapes, reinforced canvas lining and D-ring — 21. Zipper — 22. Zipper puller in natural cowhide leather — 23. Metal slider — 24. Rivet — 25. Slider and zipper puller — 26. Body with zipper attached — 27. Threads — 28. Set of needles — 29. Body of the Speedy inside out for assembling the sides. Drawing by Martin Mörck, 2013

Speedy 30 in Monogram canvas, 30 × 21 × 17 cm: 1. Folded, with handles and zipper puller turned down — 2. Folded,
with handles and zipper puller lifted up — 3. Only the ogival edges are unfolded, with the handles and zipper puller lifted up. The
Speedy's suppleness makes it easy to fold, allowing it to be carried inside other luggage without taking up too much space.

UNFOLDING THE SPEEDY

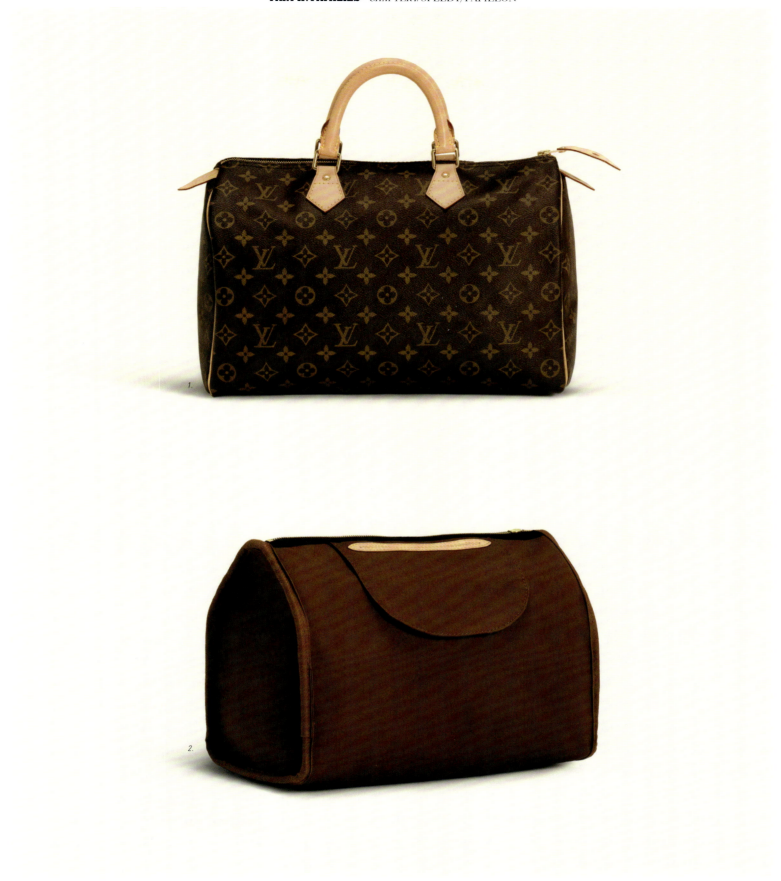

Speedy 30 in Monogram canvas, 30 × 21 × 17 cm: 1. Unfolded, right side out — 2. Unfolded, inside out.
The brown lining fabric and the inside pocket are shown.

SPEEDY INSIDE OUT

Louis Vuitton surprend depuis 1854.

 Sac Speedy
en cuir Epi bleu.

*Les bagages et accessoires Louis Vuitton ne sont en vente que dans les magasins
exclusifs Louis Vuitton : Paris • Nice • Cannes • Deauville • Strasbourg •
Toulouse • Lyon • Bordeaux • Marseille • Lille • Monte-Carlo • Genève • Lausanne •
Crans-sur-Sierre • Bruxelles • Luxembourg.
Pour de plus amples informations, veuillez appeler le (1) 45 62 47 00.*

Louis Vuitton
L'âme du voyage

"The Imaginary Voyages of Louis Vuitton." Advertising insert
from the series "The Spirit of Travel" presenting a Speedy in toledo blue Epi leather, 1995.
Photograph by Jean Larivière, 1995

Opposite: The model holds a Speedy in Mon Monogram canvas by its zipper puller and handles.
Photograph by Martin Lidell, *L'Officiel Netherlands*, October 2009

CARRIED AWAY

Among the House's notable clients are Muhammad Ali and his wife Veronica Porsche. She carries a Papillon in Monogram canvas
at the Baths of Caracalla, Rome, March 1979

Opposite: On the right, Catherine Deneuve carries a Speedy in Monogram canvas on the Croisette, Cannes, 1973

Following double page spread: A woman leaving a concert carries a Speedy 30 in Monogram canvas.
Photograph by Andrea Spotorno, *Self Service*, Spring-Summer 2007 – In front of a stand of counterfeit bags, a woman carries a Bedford
Papillon in perle Monogram Vernis. Photograph by Steve Hiett, *Vogue Italia*, November 1998

SIGHTINGS

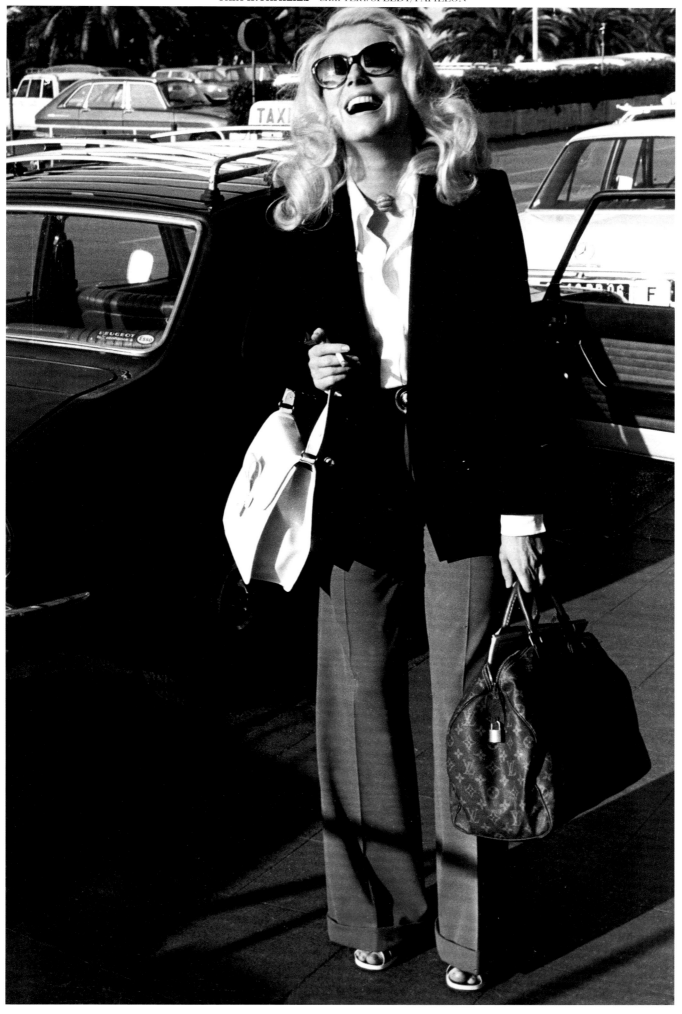

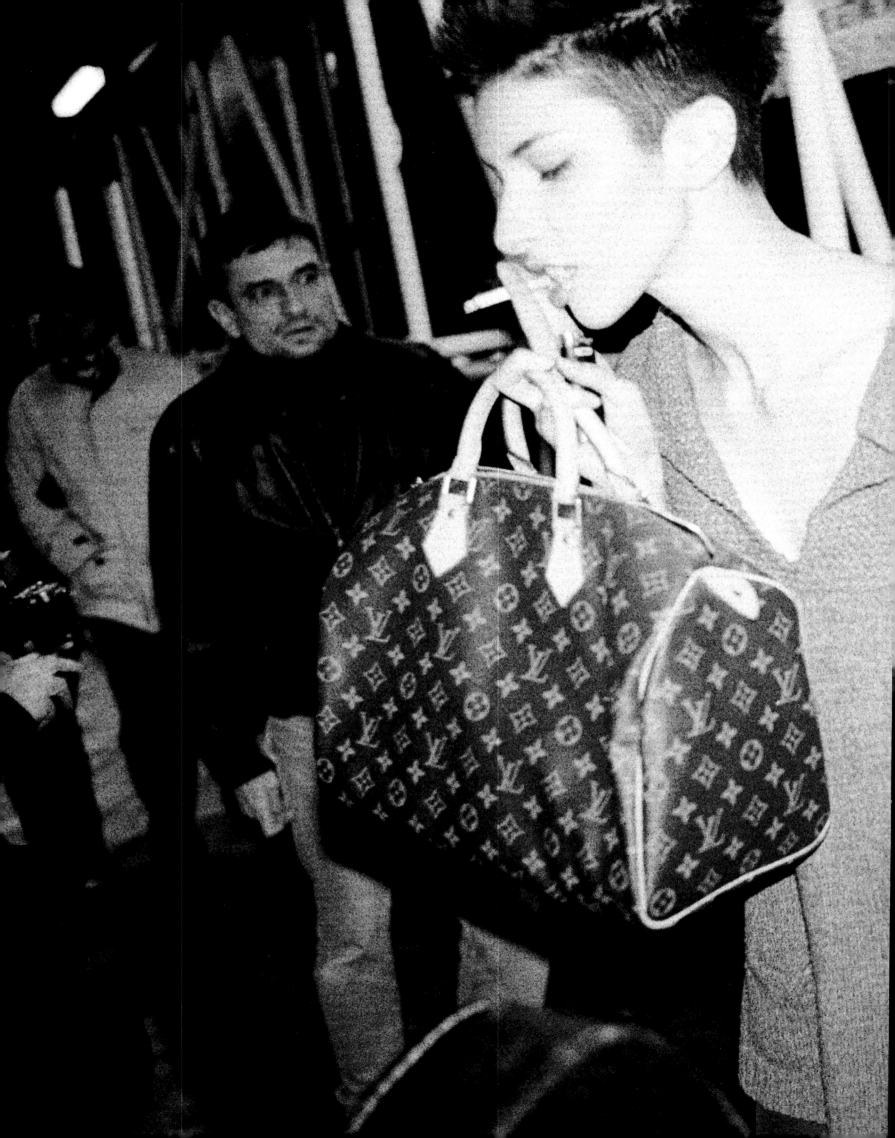

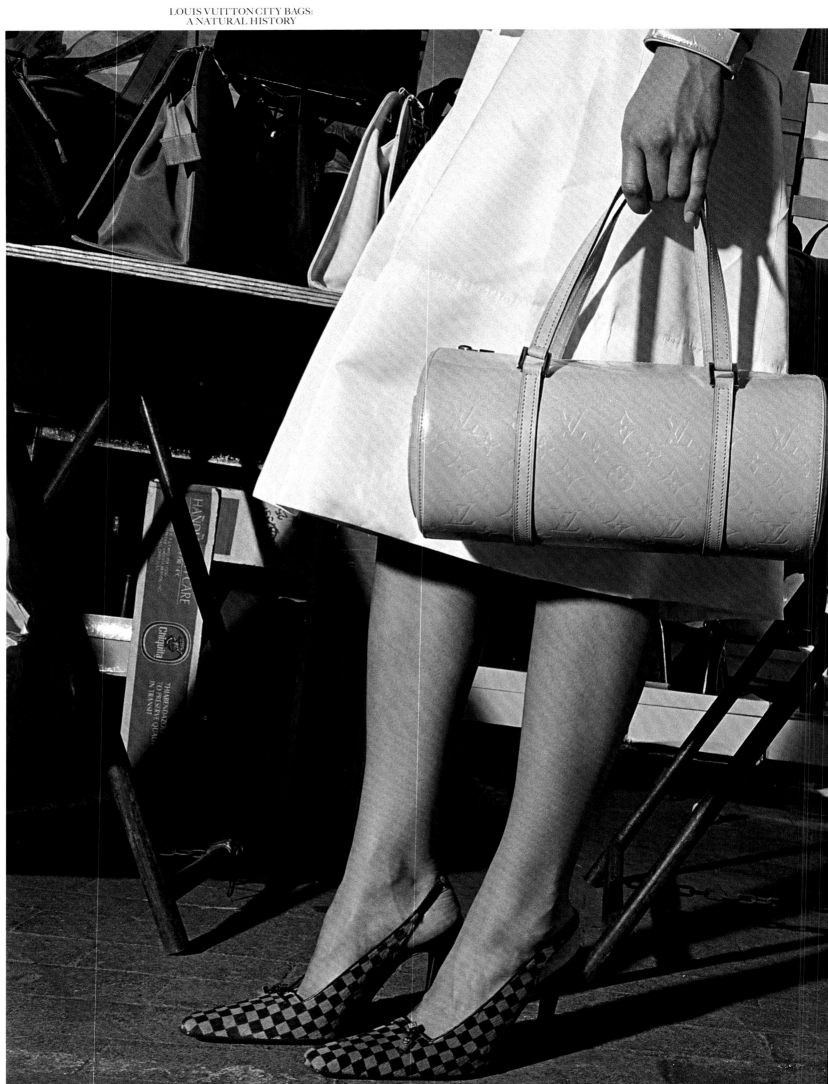

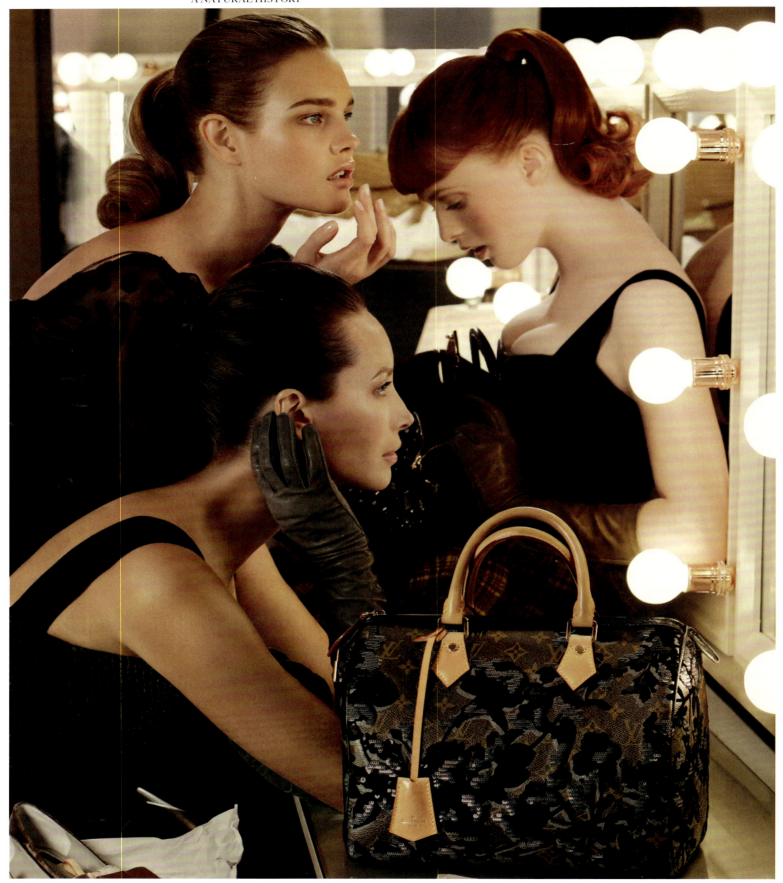

Autumn-Winter 2010–2011 advertising campaign with Natalia Vodianova, Christy Turlington and Karen Elson.
In the foreground, a Speedy in Monogram Fleur de Jais and in the background, the Carrousel bag in black Damier Virtuose.
Photograph by Steven Meisel, 2010

Opposite: Spring-Summer 2013 advertising campaign. On the right, two Speedy Cube bags in green Damier Cubic;
on the left, two Speedy East West bags in yellow Damier Cubic. The fashion show, advertising campaign and window designs
for this collection were created in collaboration with the French artist Daniel Buren. Photograph by Steven Meisel, 2013

SEASONAL COLLECTIONS

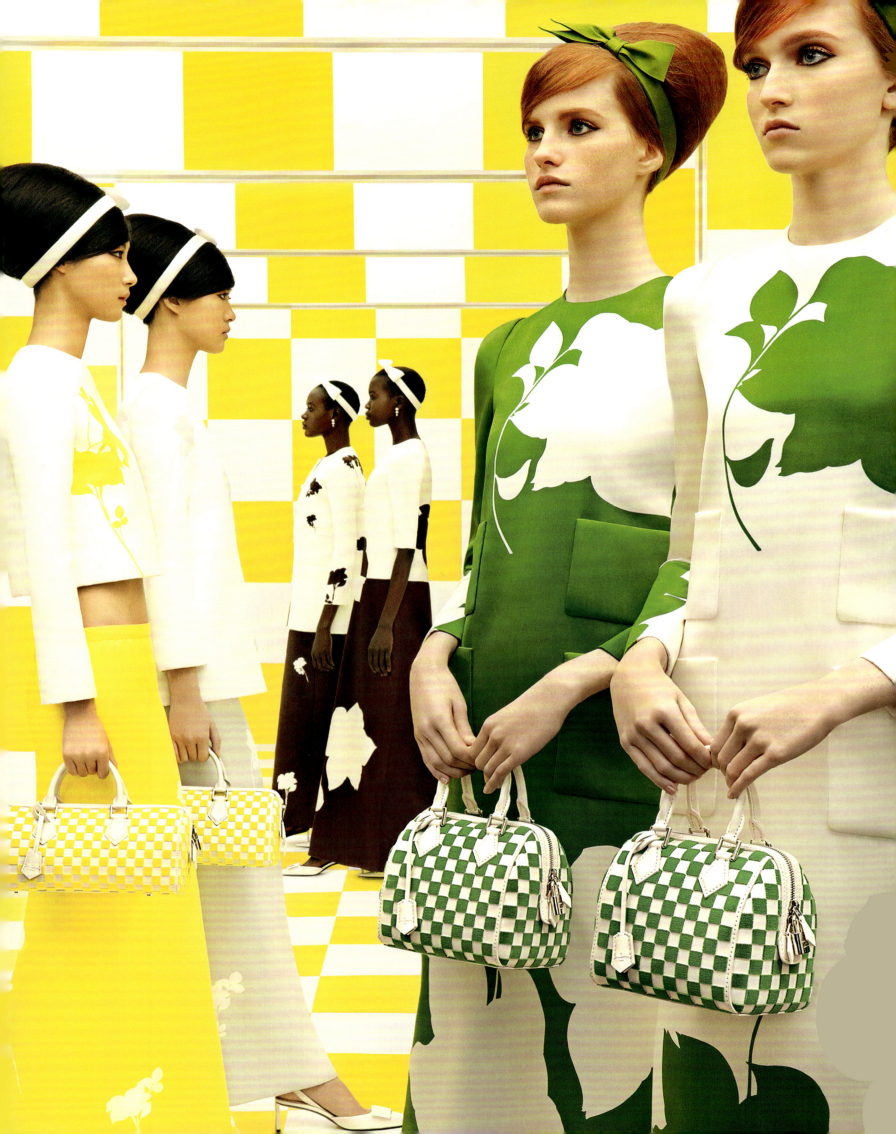

MINI HL

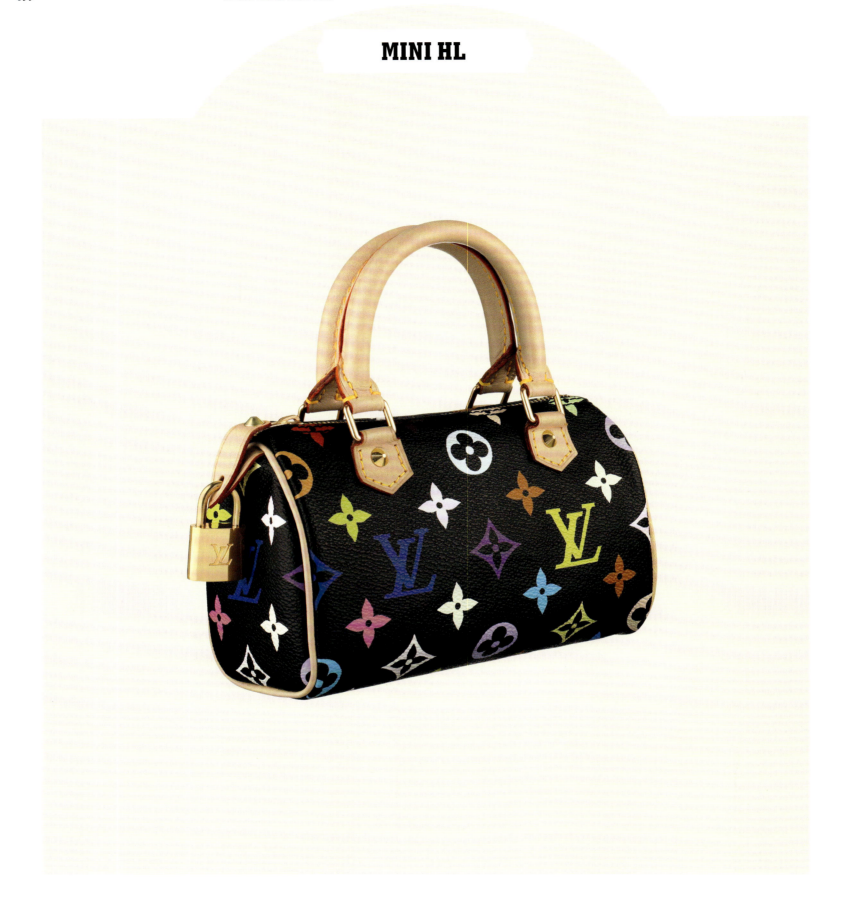

Mini HL in black Monogram Multicolore, 2003, 15 × 10 × 7 cm. The Mini HL was created by Henry-Louis Vuitton
in 1978 in Monogram canvas, and is a diminutive version of the Speedy 30. Monogram Multicolore (2002) is a creation by
Takashi Murakami for Louis Vuitton. © Takashi Murakami / Kaikai Kiki Co., Ltd. All rights reserved.

Opposite: In front of the Ladurée boutique on 16 Rue Royale, Karlie Kloss carries a Mini HL in Monogram canvas, women's
shoe catalogue Spring-Summer 2012. Photograph by Mark Segal, 2012

DIVERSIFICATION

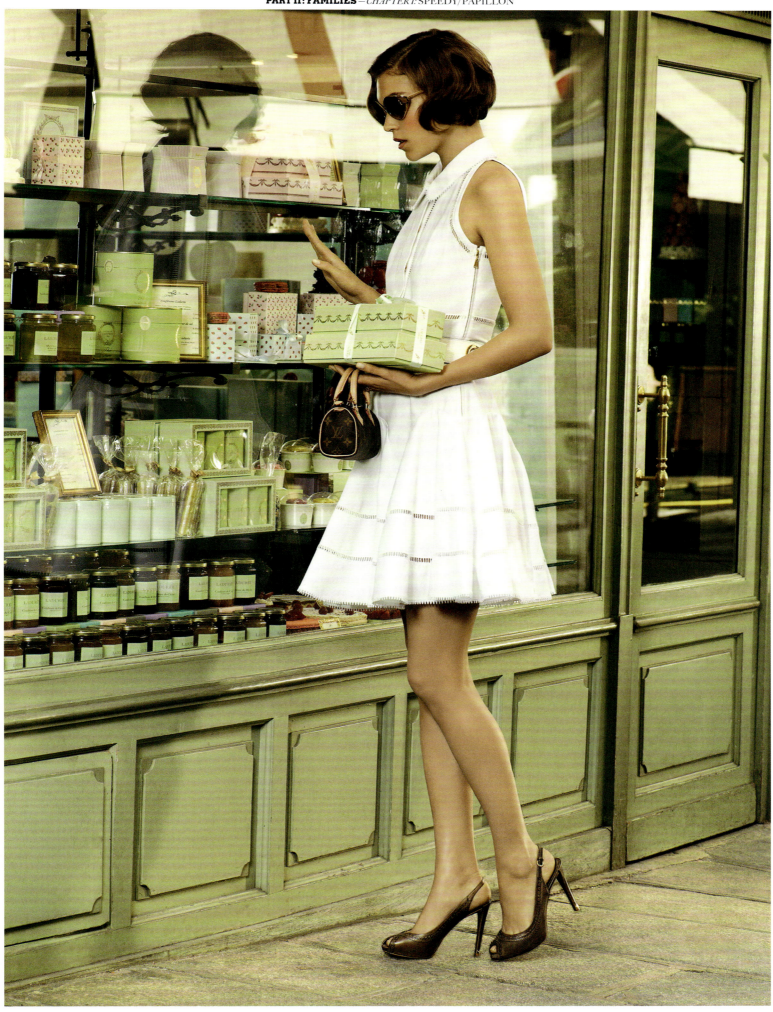

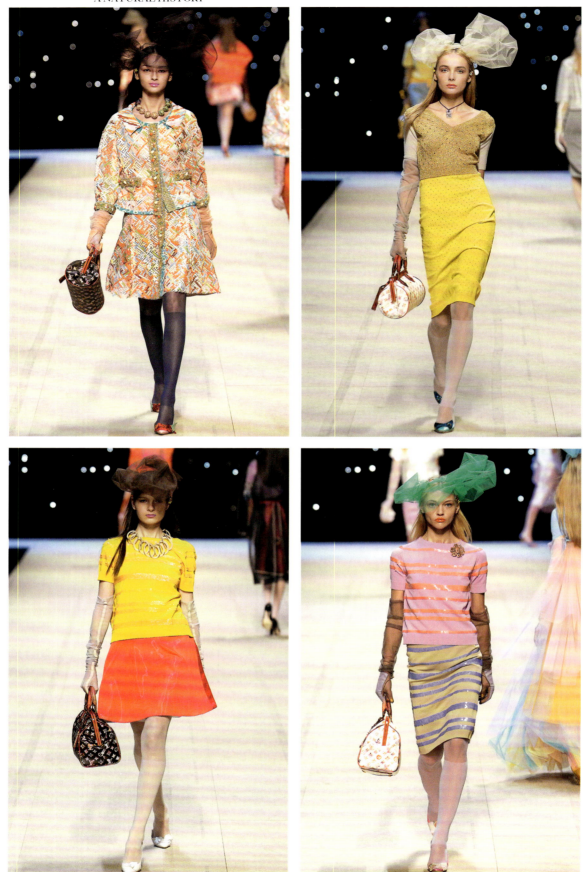

From left to right, top to bottom: Spring-Summer 2008 runway show, look 41, the model carries a Papillon Frame in brown Monogram Watercolor — Spring-Summer 2008 runway show, look 17, the model carries a Papillon Frame in white Monogram Watercolor — Spring-Summer 2008 runway show, look 33, the model carries a Speedy Frame in brown Monogram Watercolor — Spring-Summer 2008 runway show, look 25, the model carries a Speedy Frame in white Monogram Watercolor. The Monogram Watercolor line was the result of a collaboration with the American artist Richard Prince in 2008 (see pp. 310–311). Photographs by Chris Moore, 2007

Opposite: Autumn-Winter 2006–2007 runway show, look 12, the model carries a Papillon in gold Monogram Miroir. The gold and silver Monogram Miroir line was inspired by the work of art *Vuitton Bag*, a scupture of the Keepall in chromed bronze and silver created in an edition of eight by the French artist Sylvie Fleury in 2000, 78.7 × 45.7 × 20.3 cm. Photograph by Chris Moore, 2006

ARTISTIC VARIATIONS

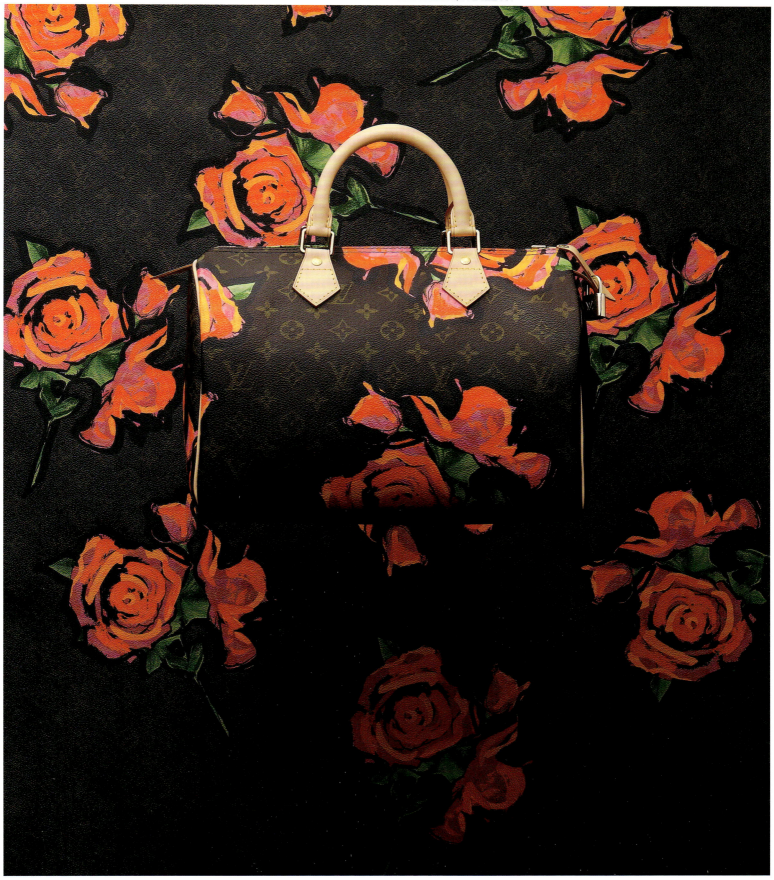

Speedy 30 in Monogram Roses. The line was the result of a collaboration with the American artist and designer
Stephen Sprouse in 2000. The artist had designed a rose motif that remained unused by the House
until 2009, when it was released in celebration of the collaboration's tenth anniversary. The Spring-Summer 2009
collection paid homage to this emblematic figure of 1990s New York pop culture.

Opposite: Large Papillon in red Monogram Vernis Dots Infinity. The Monogram Vernis Dots Infinity line was the result
of a collaboration with the Japanese artist Yayoi Kusama in 2012 (see p. 321). Photograph by Vincent Gapaillard, 2012

ARTISTIC VARIATIONS

SPEEDY: TAKASHI MURAKAMI

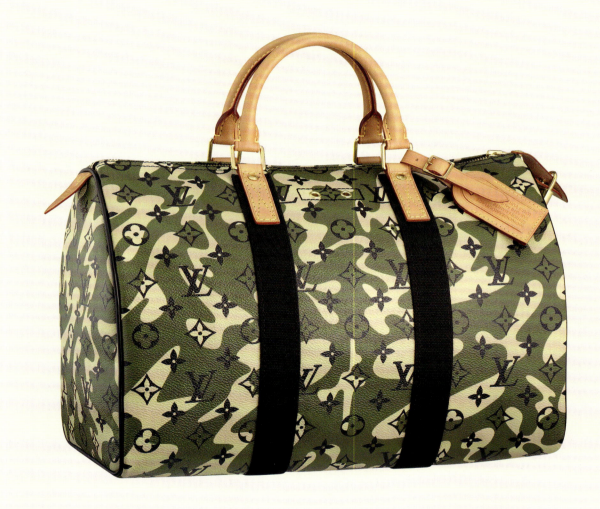

Speedy 35 in Monogramouflage, 2007, 35 × 23 × 18 cm. The Monogramouflage line was the result of a
collaboration with the Japanese artist Takashi Murakami in 2007 (see p. 327). Monogramouflage (2007) is a design
by Takashi Murakami for Louis Vuitton. © Takashi Murakami / Kaikai Kiki Co., Ltd. All rights reserved.

Opposite: Autumn-Winter 2008–2009 advertising campaign. Eva Herzigova carries a Jasmine bag in
Monogramouflage Denim in front of the Unisphère, a sculpture erected for the 1964 World's Fair in Queens,
New York. Photograph by Mert Alas and Marcus Piggott, 2008

ARTISTIC VARIATIONS

Interpreting the Papillon Bag, Shigeru Ban, 2006. The Japanese architect appropriated the terrace of the
Espace Culturel Louis Vuitton, on the top floor of the Champs-Élysées store in Paris, during the exhibition
"Icons" (September 15 to December 31, 2006), which presented reinterpretations of the House's iconic
bags by contemporary artists and designers. The poles and the ceiling of the tent are constructed of Papillon
bags in Monogram canvas. Photographs by Mazen Saggar, 2006

INSTALLATIONS

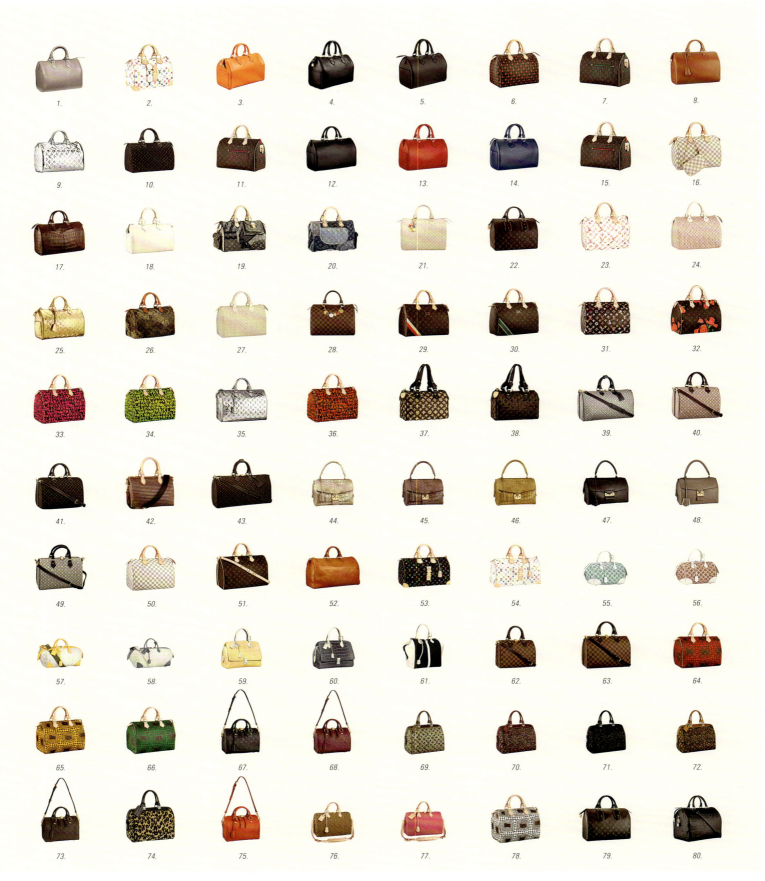

BIODIVERSITY: THE SPEEDY

1. Speedy 25 in Epi leather, 2000 — 2. Speedy 30 in Monogram Multicolore, 2003 — 3. Speedy 30 in Epi leather, 2004 — 4. Speedy 25 in Epi leather, 2003 — 5. Speedy 25 in Epi leather, 2003 — 6. Speedy 25 in Monogram Cerises, 2005 — 7. Speedy 30 in Monogram Perforé, 2006 — 8. Speedy 30 in Nomade leather, 2010 — 9. Speedy 30 in Monogram Miroir, 2006 — 10. Speedy 30 in Monogram Mini Lin, 2006 — 11. Speedy 30 in Monogram Perforé, 2006 — 12. Speedy 30 in Epi leather, 2003 — 13. Speedy 30 in Epi leather, 2004 — 14. Speedy 25 in Epi leather, 2004 — 15. Speedy 30 in Monogram Perforé, 2006 — 16. Speedy 30 and Mini Pochette Accessoires in Damier canvas, 2006 — 17. Speedy 30 in alligator leather, 2006 — 18. Speedy 25 in Epi leather, 2007 — 19. Speedy 30 in Monogram Denim Patchwork, 2007 — 20. Speedy 30 in Monogram Denim Patchwork, 2007 — 21. Speedy 30 in Monogram Mini Lin with Fleurs keyring, 2007 — 22. Speedy 30 in Monogram Mirage, 2007 — 23. Speedy 30 in Monogram Watercolor, 2008 — 24. Speedy 30 in Monogram Mini Lin Croisette, 2007 — 25. Speedy 30 in Monogram Miroir, 2006 — 26. Speedy 30 in Monogram Dentelle, 2007 — 27. Speedy 30 in Monogram Mini Lin, 2007 — 28. Speedy 30 in Damier canvas with Trunks&Bags chain, 2007 — 29. Speedy 30 in Mon Monogram canvas, 2007 — 30. Speedy 30 in Mon Monogram canvas, 2009 — 31. Speedy 30 in Monogram Watercolor, 2008 — 32. Speedy 30 in Monogram Roses, 2009 — 33. Speedy 30 in Monogram Graffiti, 2001 — 34. Speedy 30 in Monogram Graffiti, 2001 — 35. Speedy 30 in Monogram Miroir, 2006 — 36. Speedy 30 in Monogram Graffiti, 2001 — 37. Speedy 30 in Monogram Éclipse, 2009 — 38. Speedy 30 in Monogram Éclipse, 2009 — 39. Speedy Voyage 45 in Monogram Idylle, 2010 — 40. Speedy 30 in Monogram Idylle, 2010 — 41. Speedy 30 in Monogram Idylle, 2010 — 42. Speedy in Monogram Eden, 2010 — 43. Speedy Voyage 45 in Monogram Idylle, 2010 — 44. Small model Speedy Couture in alligator leather, 2010 — 45. Small model Speedy Couture in alligator leather, 2010 — 46. Small model Speedy Couture in alligator leather, 2010 — 47. Large model Speedy Couture in Orfèvre calfskin leather, 2010 — 48. Small model Speedy Couture in Orfèvre calfskin leather, 2010 — 49. Speedy 30 in Monogram Idylle, 2010 — 50. Speedy 30 in Damier canvas, 2006 — 51. Speedy 35 in Monogram canvas, 2011 — 52. Speedy 40 in cowhide leather, c. 1980 — 53. Speedy 40 in Monogram Multicolore, 2011 — 54. Speedy 40 in Monogram Multicolore, 2011 — 55. Speedy 30 in Monogram Sorbetto, 2012 — 56. Speedy Round in Monogram Denim, 2012 — 57. Speedy Round in Monogram Denim, 2012 — 58. Speedy Round in Monogram Denim, 2012 — 59. Speedy Air Dandy in alligator leather, 2012 — 60. Speedy Air Dandy in alligator leather, 2012 — 61. Speedy North South in Gourmand calfskin leather, 2012 — 62. Speedy 25 in Damier canvas, 2012 — 63. Speedy 30 in Damier canvas, 2012 — 64. Speedy 30 in Monogram Town, 2012 — 65. Speedy 30 in Monogram Town, 2012 — 66. Speedy 30 in Monogram Town, 2012 — 67. Speedy 25 in Monogram Empreinte, 2013 — 68. Speedy 25 in aurore Monogram Empreinte, 2013 — 69. Speedy 30 in khaki Monogram Sunshine Express, 2012 — 70. Speedy 30 in bordeaux Monogram Sunshine Express, 2012 — 71. Speedy 30 in black Monogram Sunshine Express, 2012 — 72. Speedy 30 in Monogram Sunshine Express, 2012 — 73. Speedy 25 in Monogram Empreinte, 2013 — 74. Speedy 30 in Monogram Léopard, 2006 — 75. Speedy 25 in Monogram Empreinte, 2013 — 76. Speedy 35 in Monogram Stone, 2013 — 77. Speedy 35 in Monogram Stone, 2013 — 78. Speedy 30 in Monogram Town, 2012 — 79. Speedy 30 in Monogram Mirage, 2007 — 80. Speedy Cube in "Louis Vuitton Paris Speedy" calfskin leather, 2008

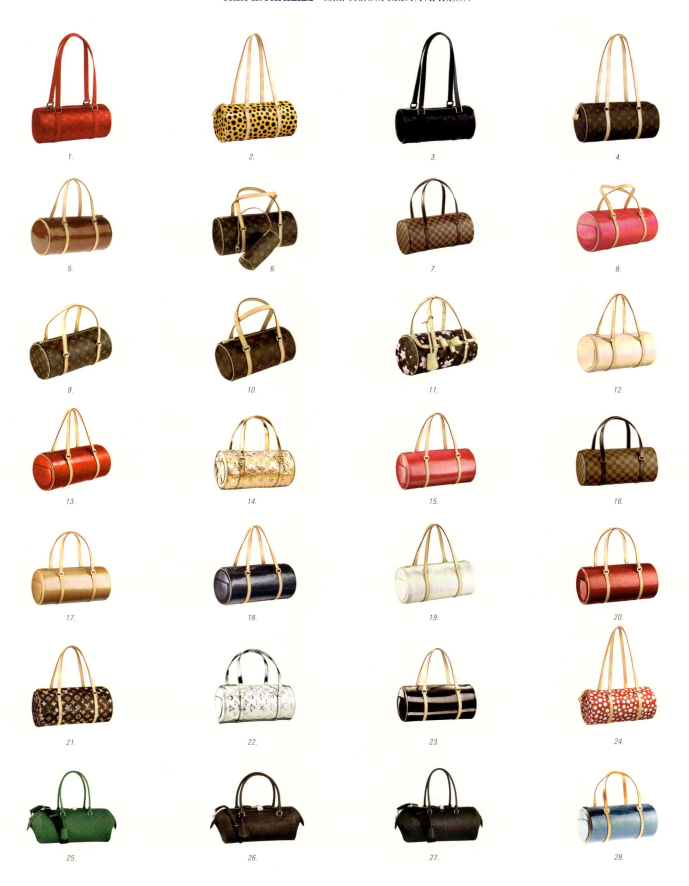

1. Little Papillon in red Monogram Satin, 2002 — 2. Large Papillon in yellow Monogram Vernis Dots Infinity, 2012 — 3. Little Papillon in black Monogram Satin, 2002 — 4. Large Papillon in Monogram canvas, 2012 — 5. Bedford Papillon in bronze Monogram Vernis, 2001 — 6. Large Papillon in Monogram canvas and matching accessory case, 2002 — 7. Large Papillon in Damier Ébène canvas, 2006 — 8. Bedford Papillon in fuchsia Monogram Vernis, 2003 — 9. Medium Papillon in Monogram canvas, 2002 — 10. Small Papillon in Monogram canvas, 2002 — 11. Papillon in brown Monogram Cherry Blossom, 2003 — 12. Bedford Papillon in marshmallow Monogram Vernis, 2004 — 13. Bedford Papillon in red Monogram Vernis, 2004 — 14. Papillon in gold Monogram Miroir, 2006 — 15. Bedford Papillon in framboise Monogram Vernis, 2005 — 16. Medium Papillon in Damier Ébène canvas, 2002 — 17. Bedford Papillon in noisette Monogram Vernis, 2005 — 18. Papillon Bedford in indigo blue Monogram Vernis, 2005 — 19. Bedford Papillon in perle Monogram Vernis, 2005 — 20. Bedford Papillon in pomme d'amour Monogram Vernis, 2005 — 21. Large Papillon in brown Monogram Watercolor, 2008 — 22. Papillon in silver Monogram Miroir, 2006 — 23. Bedford Papillon in amaranth Monogram Vernis, 2007 — 24. Large Papillon in red Monogram Vernis Dots Infinity, 2012 — 25. Large Néo Papillon in green Monogram Révélation, 2012 — 26. Small Néo Papillon in brown Monogram Révélation, 2012 — 27. Large Néo Papillon in black Monogram Révélation, 2012 — 28. Bedford Papillon in bleu ciel Monogram Vernis, 1998

BIODIVERSITY: THE PAPILLON

SHERWOOD: GENEALOGY

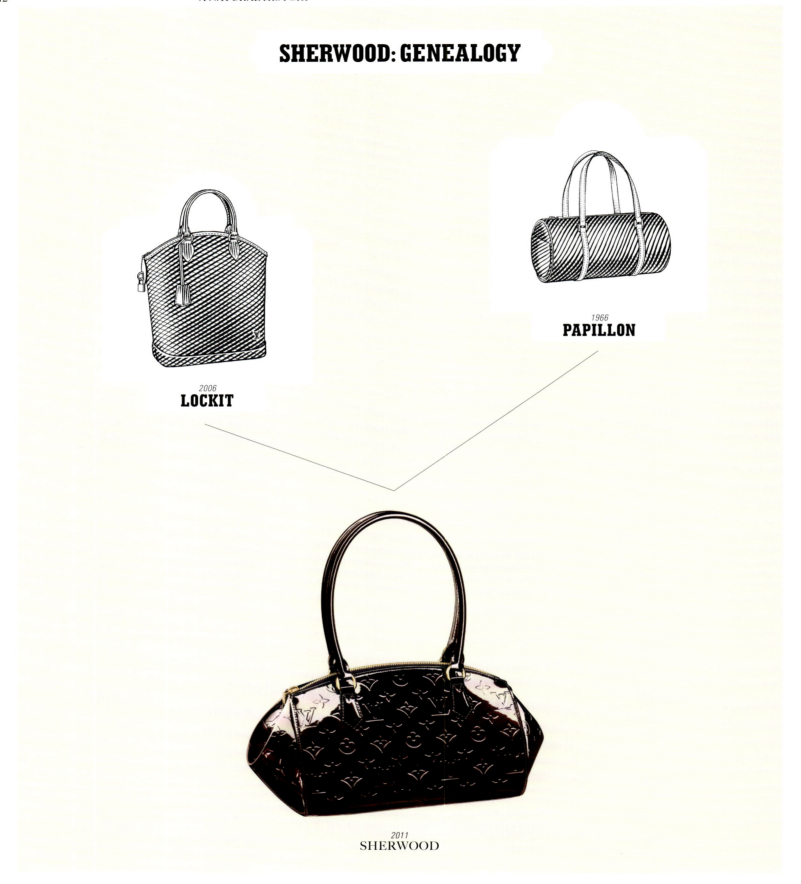

2006
LOCKIT

1966
PAPILLON

2011
SHERWOOD

Large Sherwood in amaranth Monogram Vernis, 2011, 40.5 × 21 × 17 cm. The Sherwood, a cross between
the iconic Papillon and Lockit bags, was born in 2011. From the former, it inherited its elongated silhouette and its
long, rounded handles. It gets its robust constitution and its identity as a day bag from the latter, as well as the
marriage of contrasts between its large capacity and its slender handles. Drawings by Martin Mörck, 2013

HYBRIDIZATION

SHERWOOD: SIDE PROFILE

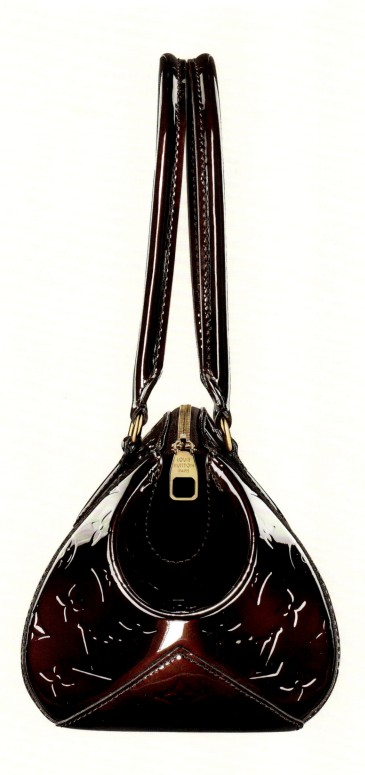

Large Sherwood in amaranth Monogram Vernis, 2011, 40.5 × 21 × 17 cm

Following double page spread: Autumn-Winter 2012-2013 advertising campaign. The models carry: a Speedy 30 Léopard (foreground, left), a North South Léopard bag (foreground, right) and a Baby Léopard bag (middle), whose lines are reminiscent of the Speedy and the Papillon. Photograph by Steven Meisel, 2012

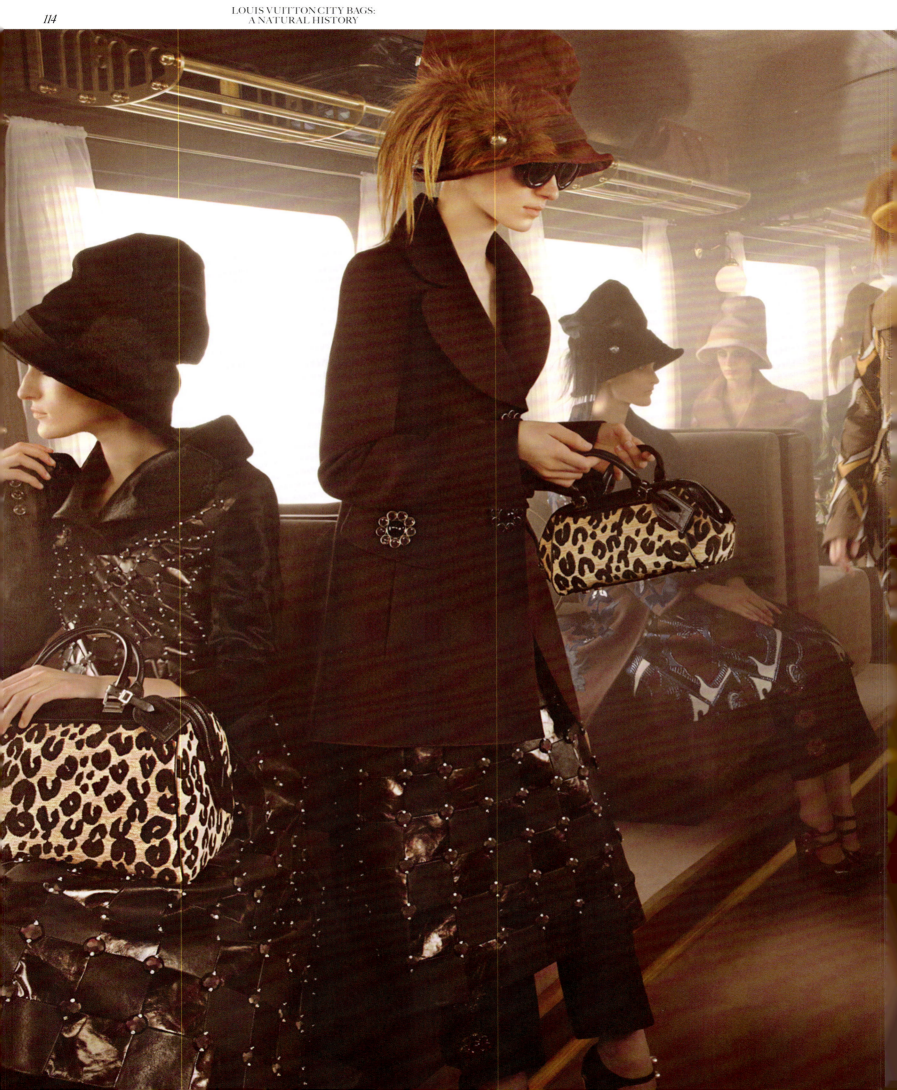

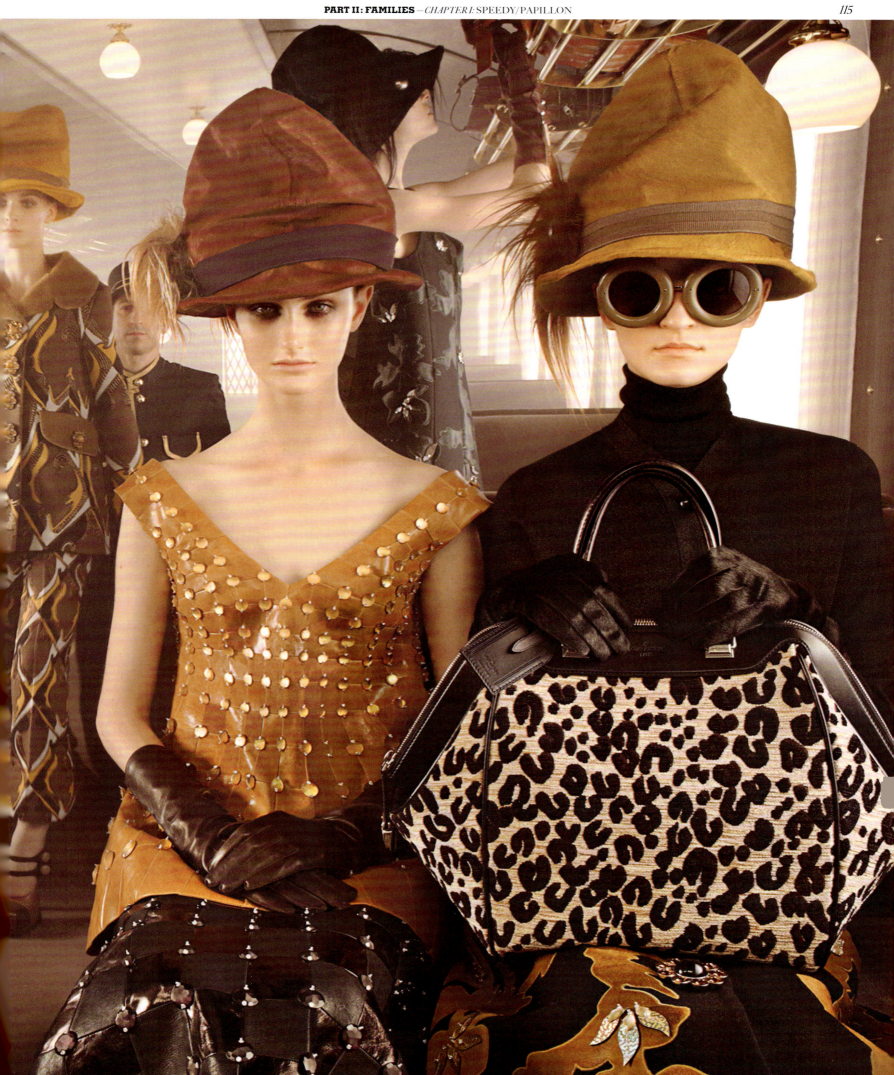

MEDIUM ALMA
In Black Epi leather

LOCKIT
In Caramel Nomade leather

Chapter II:

ALMA/LOCKIT

Pages 116–161

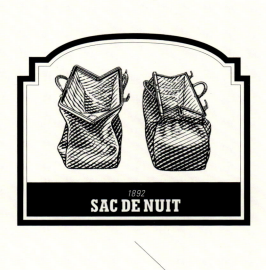

1892
SAC DE NUIT

1901
STEAMER BAG

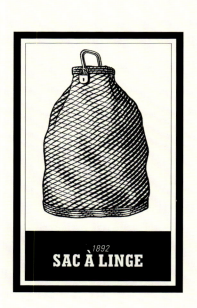

1892
SAC À LINGE

The Laundry bag, an accessory to the trunk, and the Overnight bag, a structured leather bag,
were both sources of inspiration for the 1901 Steamer Bag. Its pure lines, which flirt with the square and
the triangle, would be found from then on throughout all the lines of descent to the Alma and the Lockit.
The Squire bag and the canvas Champs-Élysées bag inherited its triangular contours, which would

GENEALOGY: ALMA AND LOCKIT

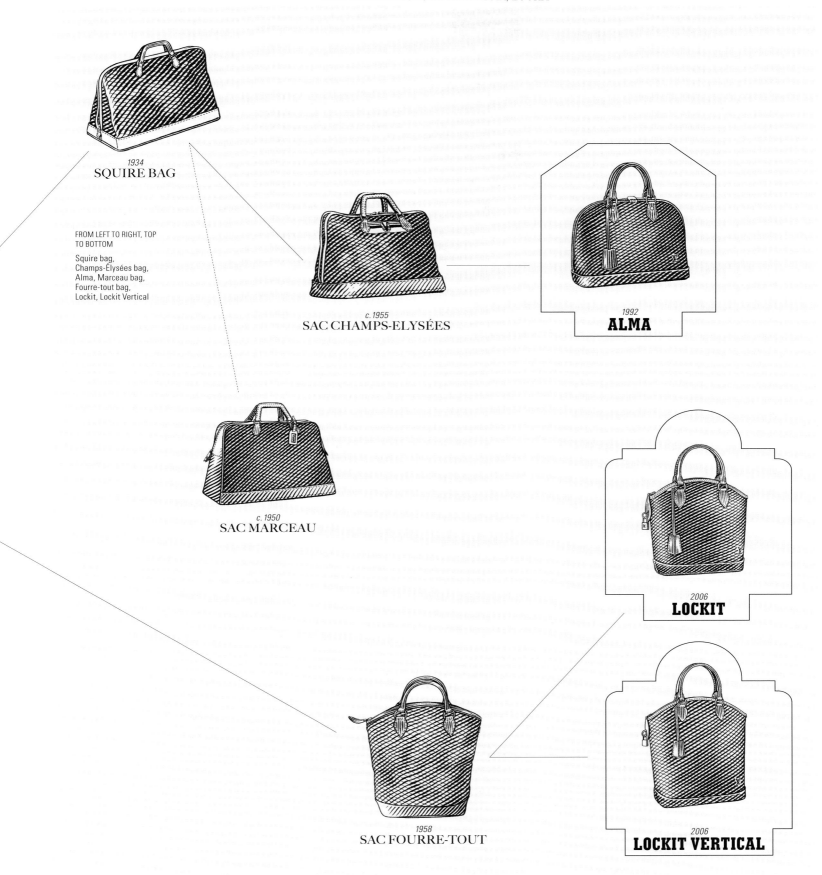

1934
SQUIRE BAG

FROM LEFT TO RIGHT, TOP
TO BOTTOM

Squire bag,
Champs-Élysées bag,
Alma, Marceau bag,
Fourre-tout bag,
Lockit, Lockit Vertical

c. 1955
SAC CHAMPS-ELYSÉES

1992
ALMA

c. 1950
SAC MARCEAU

2006
LOCKIT

1958
SAC FOURRE-TOUT

2006
LOCKIT VERTICAL

crystallize in 1992 with the Alma in Epi leather, a marriage of rigidity and sophistication
perfect for professional use. The squarer lines can be seen in the Fourre-tout bag from 1958, the predecessor
of the contemporary Lockit, a city bag as secure as its "inviolable" ancestor, the Steamer Bag.
P. 116 and above drawings by Martin Mörck, 2013

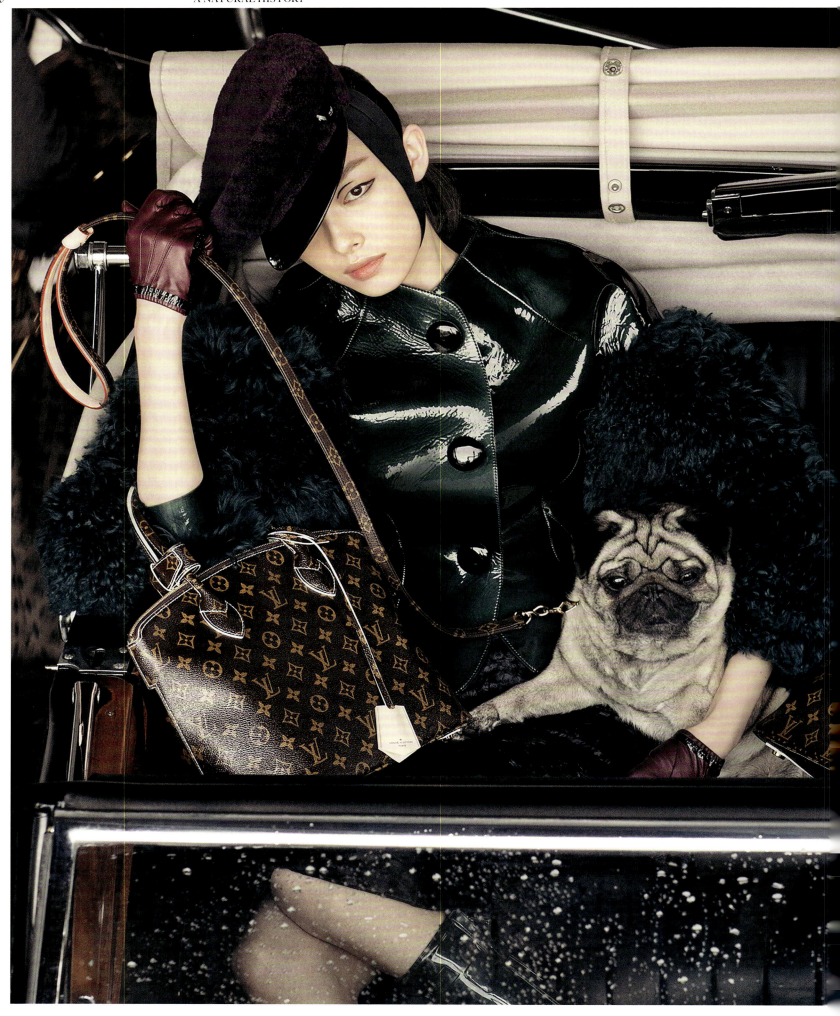

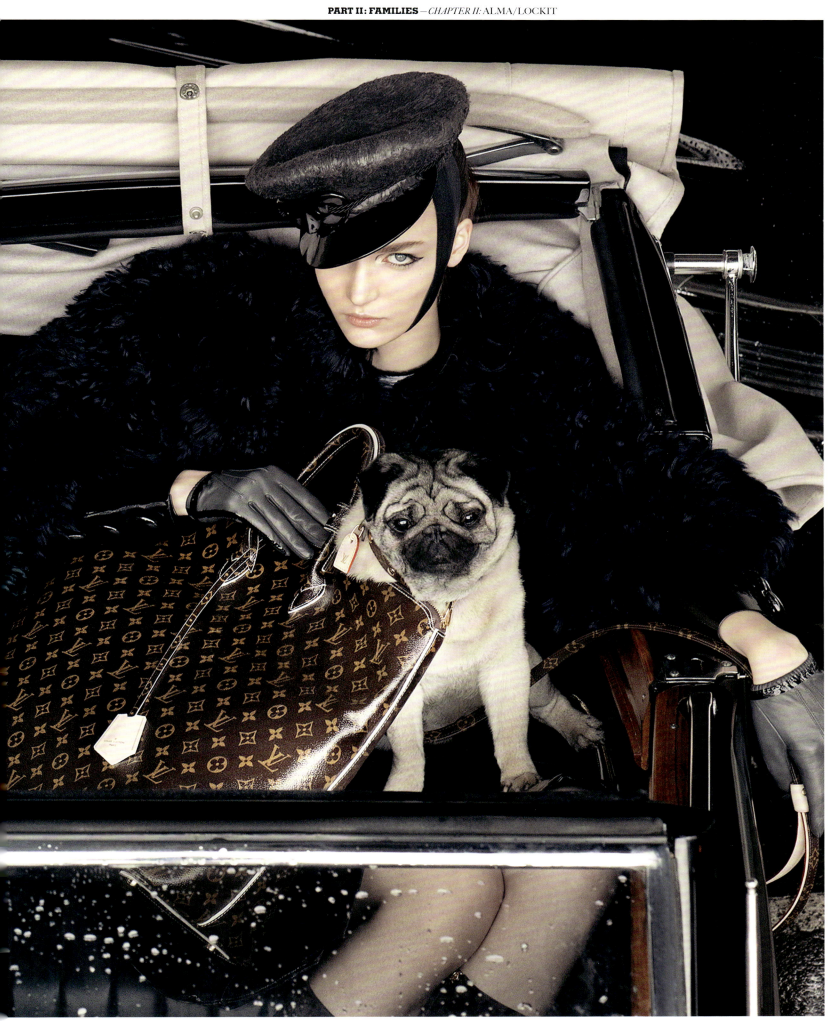

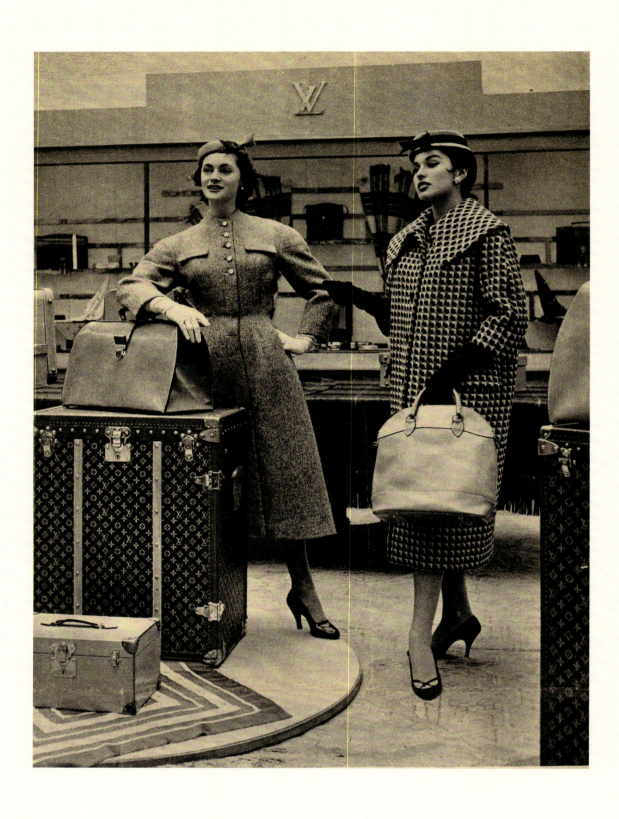

"Pastel tones for spring." Photograph for a press article showing two women in the Louis Vuitton store
on Avenue Marceau in Paris. To the left, in the foreground: a leather vanity case, a wardrobe trunk in
Monogram canvas and a travel bag in Moroccan leather. To the right, the model carries a canvas Fourre-tout bag.
Photograph by Seeberger, *Noir et Blanc*, March 8, 1954. Louis Vuitton Archives

ALMA/LOCKIT
COLOMBE PRINGLE

Both are equipped with a zip closure, a sign of their predisposition towards keeping safe the possessions entrusted to them. Both are available in several sizes, proof that they originate from the luggage family. In fact, both are fitted with a padlock, proof that they are traveling bags.

In this *pas de deux* that would lead them to fame, both would achieve the status of Louis Vuitton icon. This word confirms the starring role played by these city bags, which appeared in their current version in 1992 for the Alma, and in 2006 for the Lockit. Since then, with the changing fashions, collections and seasons, they have been adorned in Monogram canvas (notably in its Vernis and Miroir versions), in Epi leather, in Damier checked canvas, in exotic leathers, in sheepskin, in bright colors and in whimsical motifs by Takashi Murakami. The Lockit even dared to go transparent for a summer. But the two bags share more than a glorious present. Descendants, by marriage, of the supple or semi-supple travel bags such as the Laundry Bag and the Overnight Bag, the Alma and the Lockit have a common ancestor: the famous Steamer Bag.

Its name is directly inspired by the luxurious steam-powered trans-Atlantic ocean liners, which were equipped with all the latest innovations (the youngest ship in the Cunard Line fleet had helix turbines and elevator access to the first-class dining room). Travel by steamship was a new and fashionable leisure activity that enchanted high society and sparked a competitive desire amongst passengers to be the most elegant lady on the wharf or on deck at teatime.

PRECEDING DOUBLE PAGE SPREAD

Autumn-Winter 2011–2012 advertising campaign. The models are carrying a Lockit (left) and a Lockit Voyage (right), both in Monogram Fetish. Photograph by Steven Meisel, 2011

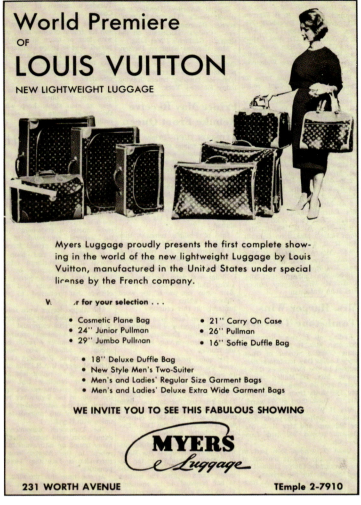

FROM TOP TO BOTTOM

"World Premiere of Louis
Vuitton New
Lightweight Luggage."
Advertising insert for
Myers, a Louis Vuitton
reseller in Palm
Beach, presenting an
ensemble of soft and
rigid luggage
Palm Beach Daily News,
April 4, 1962
Louis Vuitton Archives

The canvas Fourre-tout
bag, created in the
1950s, was the inspira-
tion for the Lockit,
launched in 2006, *Arts
ménagers*, June 1958
Louis Vuitton Archives

Introduced in 1901 under the name of "Inviolable," in reference to its closure system comprising straps held together by a padlock attachment, this occasional bag in leather or extra-strong canvas was specifically conceived for keeping dirty laundry separate from clean clothes during a long journey. It eliminated "that moral torture inflicted upon the traveller when customs officials at the border empty one's trunk, taking out the dirty laundry and showing it off to passers-by," according to an advertising flyer from 1910 that proclaimed its merits and its functionality. Designed to fold like an accordion onto its base so it wouldn't take up space in the luggage, the Steamer Bag could be hung up by its handle on the cabin door. There, it remained within easy reach for storing one's belongings without encroaching on the cabin space, which was limited even in first class. Very quickly, it became a symbol of refinement, and was often used on dry land as an elegant hold-all for automobile travel, carrying blankets, pillows, or even hunting game. It would also be used in the early days of air travel, safely stowed in the luggage hold thanks to its padlock. In 1909, Louis Blériot crossed the Channel by air; Roland Garros later flew over the Mediterranean in 7 hours and 53 minutes! Lindbergh would finally traverse the Atlantic by plane in 1927, and crossings by ocean liner would lose their luxurious aura with the conquest of the skies. Between the two wars aviation took off, going from military to commercial applications and influencing the design of travel goods.

And so it was that in 1934, Gaston-Louis Vuitton, the grandson of the House's founder, designed a triangular-shaped bag that he baptized the Squire. Legend has it that he was inspired by an order placed by a famous fashion designer in 1925. It was a bag entirely made of canvas, 45 cm long with a similar bottom to the Steamer Bag, upon which the interlaced double Cs appeared. This travel product was found in the House's archives and reworked to create the Alma by including the brand's signature elements—assembly style, yellow overstitching, the form of the chapes—and the LV signature. The Alma has a rectangular base similar to that of the Noé. It is fitted with the round handles that are also found on the Speedy. But in contrast to the latter, which is extremely supple and takes on the form of its contents, the Alma is a more rigid alternative: a more structured bag, its form remains constant. To ease its transition from travel accessory to city bag, the leather used on the handles and trimmings was modified and the interior was lined. Produced in four sizes, of which the largest is suitable for a travel bag, all that remained was to find a Parisian-sounding name for it that would resonate with international audiences. The Place d'Alma, from which the Avenue Montaigne—a luxury address and symbol of Parisian elegance—stretches towards the Champs-Élysées, provided the obvious solution. In 2010, twenty years after its creation, a smaller-sized Alma was launched to appeal to the daughters of the women who first adopted the bag. The baby-sized BB is equipped with a shoulder strap that leaves the hands free and gives it a youthful air.

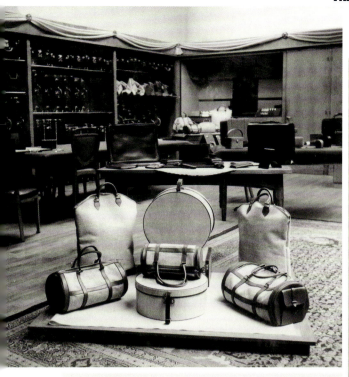

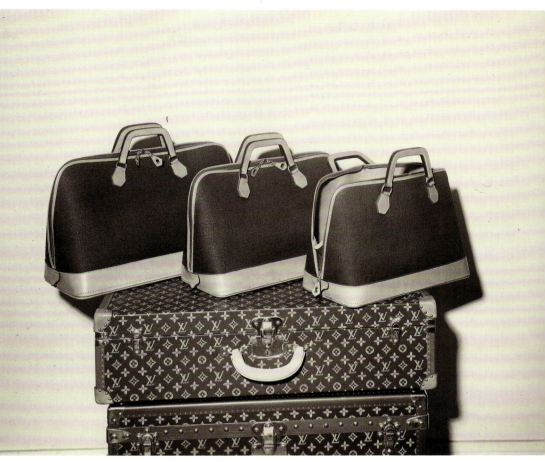

FROM TOP TO BOTTOM,
LEFT TO RIGHT

An ensemble of soft and
rigid luggage presented
in the Louis Vuitton store
on avenue Marceau in
Paris: in the foreground,
three versions of the
canvas Round bag; in the
center, two leather
hatboxes and on either
side, a canvas
Fourre-tout bag, 1950s.
Louis Vuitton Archives

The Marceau bag
in leather and cotton
canvas, 1955.
The Alma, launched in
1992, was inspired
by the Squire Bag created
in 1934 by Gaston-Louis
Vuitton. In the 1950s,
this form was reworked
and the results were
baptized the Marceau
and the Champs-Élysées
bags. Photograph taken
September 15,1955
Louis Vuitton Archives

Three versions of the
Champs-Élysées bag in
cotton canvas, created
in 1955, presented on a
trunk in Monogram
canvas, 1950s.
Louis Vuitton Archives

But what about the Lockit, which appeared in the 2006 catalogue? Its lines, splaying from top to bottom and softened by a rounded zipper that terminates with a security lock, give it a very feminine air. Originally, it was created in Monogram canvas or Nomade, a dyed, natural cowhide leather, specially treated so that the leather would develop a patina with time. Its orientation is north–south—with an emphasis on height—while the Alma's is more east–west. Its predecessor is suppos-edly the Fourre-tout bag presented in 1958 in the Knick-Knack series of soft luggage, much like the Steamer Bag and the Keepall, which appeared on the big screen car-ried by Audrey Hepburn in *Two for the Road*. The Lockit was a very feminine reinterpretation of this heritage with Toron handles, continuous sides and yellow over-stitching. Its base is slightly upturned and it closes with a zipper equipped with a padlock at the end—from which it derives its name—that suggests its affiliation with the travel bag family. Thus, it is logical that Lockit is avail-able in several sizes—a hallmark of the brand—as well as being the object of custom orders in the most precious leathers of the Haute Maroquinerie line. Nevertheless, both the Lockit and the Alma still maintain their original vocation as city bags, making them worthy of reinter-pretation by artists and top designers, from Azzedine Alaïa to Stephen Sprouse (the Alma), from Ugo Rondinone to Yayoi Kusama (the Lockit).

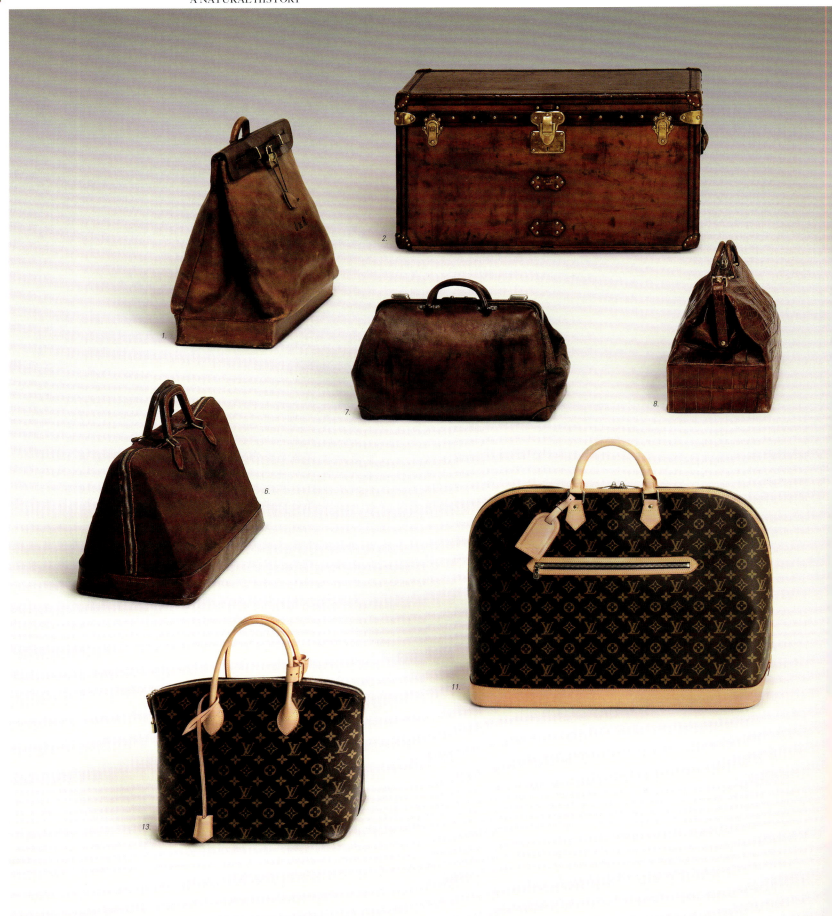

The iconic bags are pictured in the foreground; their "ancestors" are in the background. 1. Steamer Bag in leather, 1938, 66 × 66 × 28 cm, 5.5 kg. Louis Vuitton Collection — 2. Mail trunk in natural cowhide leather, 1900, 97 × 54 × 51 cm, 25.3 kg. Louis Vuitton Collection — 3. Steamer Bag in canvas, 1910, 51 × 60 × 23 cm, 2.7 kg. Louis Vuitton Collection — 4. Fourre-tout bag in canvas, c. 1958, 58 × 70 cm — 5. Overnight bag in leather, 1890, 71 × 47 × 32 cm, 4.9 kg. Louis Vuitton Collection — 6. Squire Bag in canvas, c. 1930, 51 × 40 × 25 cm, 2.2 kg. Louis Vuitton Collection — 7. Overnight bag in leather, c. 1910, 55 × 36 × 31 cm, 5 kg. Louis Vuitton Collection — 8. Isidore travel bag in crocodile leather, 1918, 59 × 41 × 35 cm, 5 kg.

FAMILY PORTRAIT

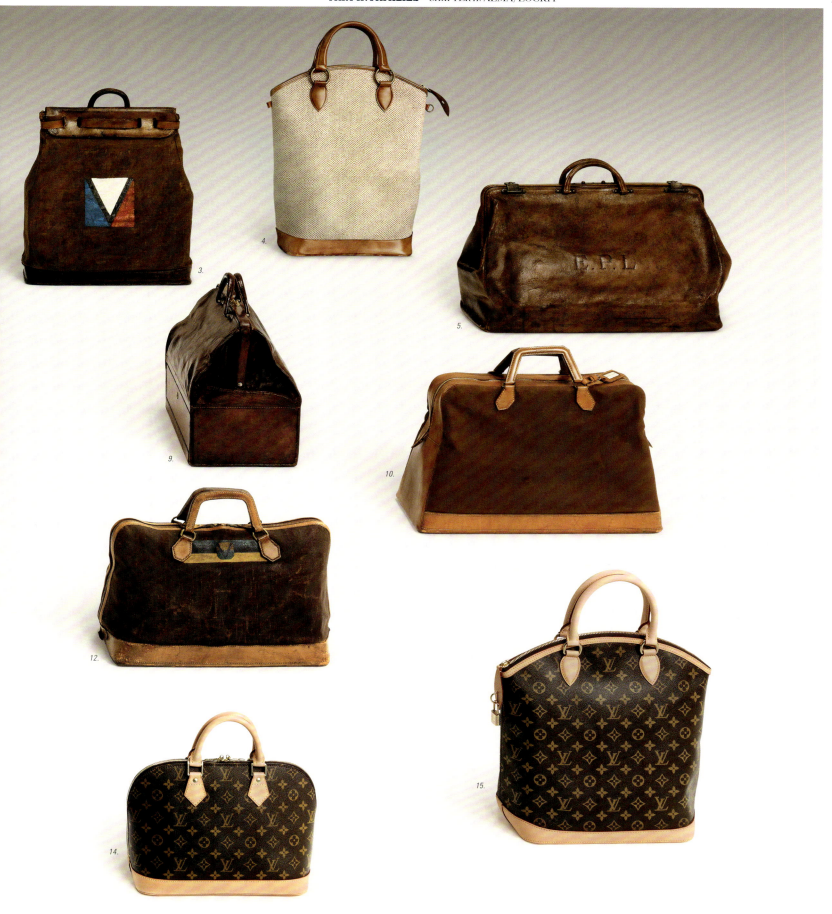

Louis Vuitton Collection — 9. Overnight bag in grained leather, c. 1910, 51.5 × 39 × 27.5 cm, 5.2 kg. Louis Vuitton Collection — 10. Marceau bag in canvas, c. 1950, 56.5 × 35.5 × 27 cm,
2.1 kg. Louis Vuitton Collection — 11. Large Alma Voyage in Monogram canvas, 2004, 50 × 34 × 22 cm, 2.2 kg. Louis Vuitton Collection — 12. Champs-Élysées bag in canvas, c. 1950,
50 × 39 × 23 cm, 1.8 kg. Louis Vuitton Collection — 13. Medium Lockit in Monogram canvas, 2011, 38 × 31 × 17 cm — 14. Small Alma in Monogram canvas, 1992, 32.6 × 24 × 15.3 cm.
Louis Vuitton Collection — 15. Lockit Vertical in Monogram canvas, 2007, 36 × 37 × 15 cm. Photograph by Patrick Gries, 2013

ALMA

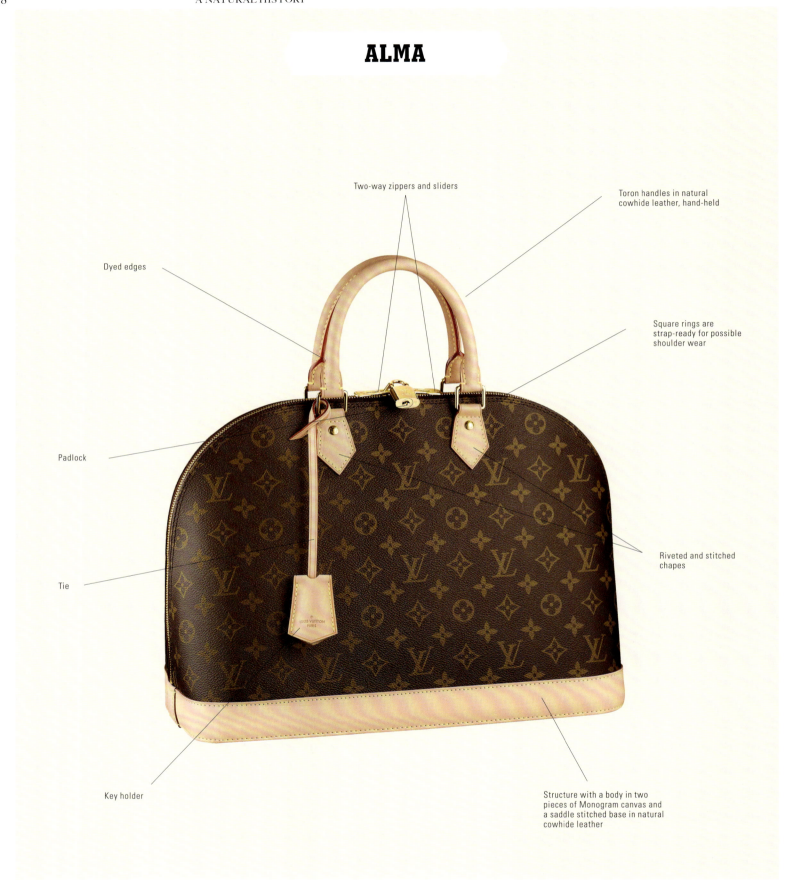

Two-way zippers and sliders

Toron handles in natural
cowhide leather, hand-held

Dyed edges

Square rings are
strap-ready for possible
shoulder wear

Padlock

Riveted and stitched
chapes

Tie

Key holder

Structure with a body in two
pieces of Monogram canvas and
a saddle stitched base in natural
cowhide leather

Small Alma in Monogram canvas, 32.6 × 24 × 15.3 cm — Lockit Vertical in Monogram canvas, 36 × 37 × 15 cm. The Alma and the
Lockit are prisms with a triangular base. They are made of three main components: two sides and a base designed to be placed
on the ground. The sides of the Lockit are square, whereas those of the Alma and the Lockit Vertical are rectangular. Both belong to
the range of semi-rigid bags. Originally designed to be hand-held, they can also be carried by a shoulder strap.

COMPARATIVE ANATOMY

LOCKIT VERTICAL

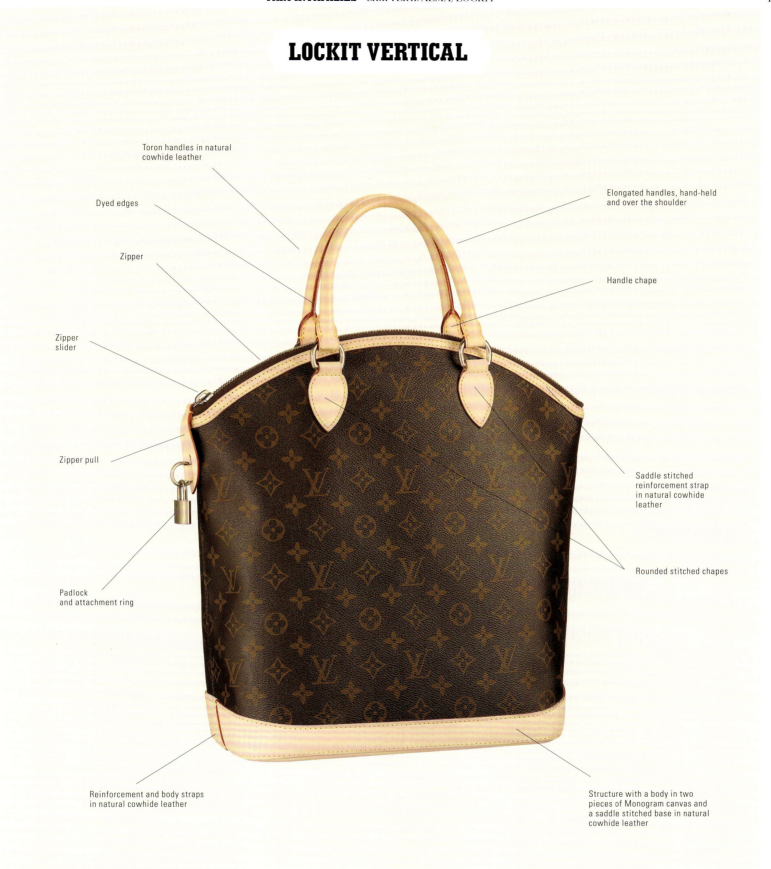

Toron handles in natural cowhide leather

Dyed edges

Zipper

Zipper slider

Zipper pull

Padlock and attachment ring

Elongated handles, hand-held and over the shoulder

Handle chape

Saddle stitched reinforcement strap in natural cowhide leather

Rounded stitched chapes

Reinforcement and body straps in natural cowhide leather

Structure with a body in two pieces of Monogram canvas and a saddle stitched base in natural cowhide leather

ALMA

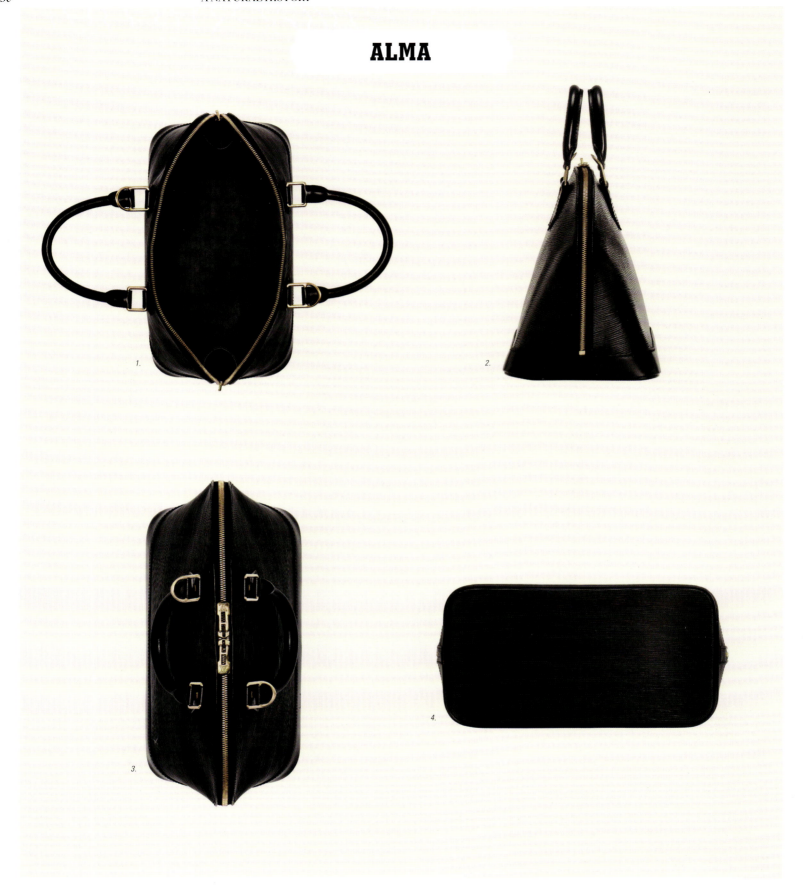

Small Alma in black Epi leather, 32.6 × 24 × 15.3 cm: 1. Open, seen from above — 2. Profile view —
3. Closed, seen from above — 4. Seen from below

Opposite: Detail of the open two-way zipper slider. Photograph by Patrick Gries, 2013

MORPHOLOGY

LOCKIT

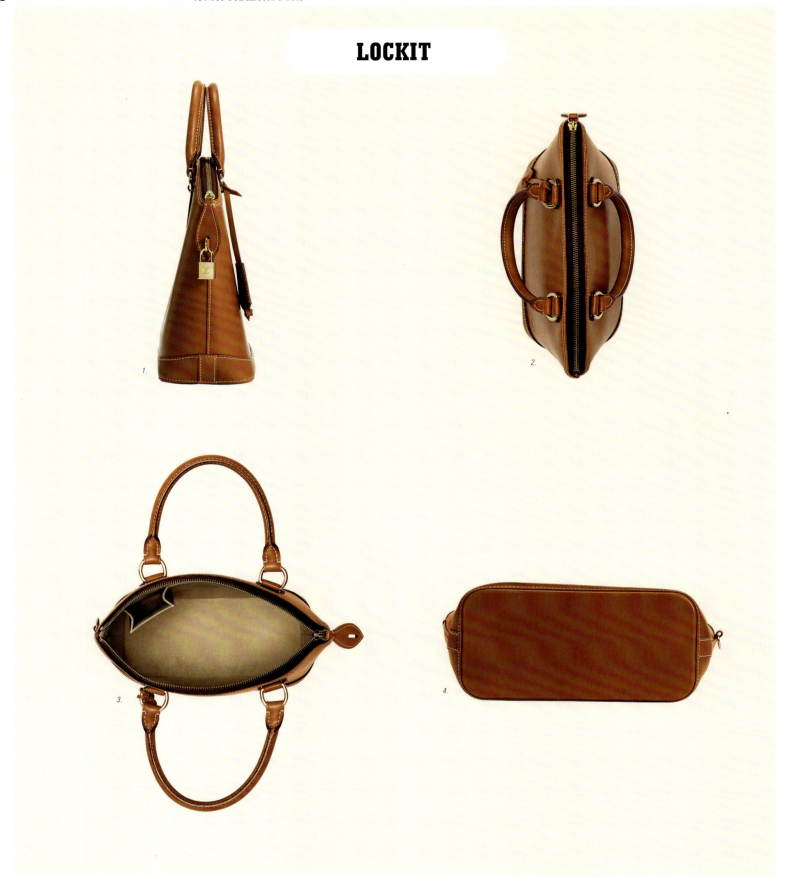

Lockit in caramel Nomade leather, 29 × 28 × 12 cm: 1. Profile view — 2. Closed, seen from above —
3. Open, seen from above — 4. Seen from below

Opposite: Detail of the zipper pull and the attachment ring for padlock. Photograph by Patrick Gries, 2013

MORPHOLOGY

ALMA

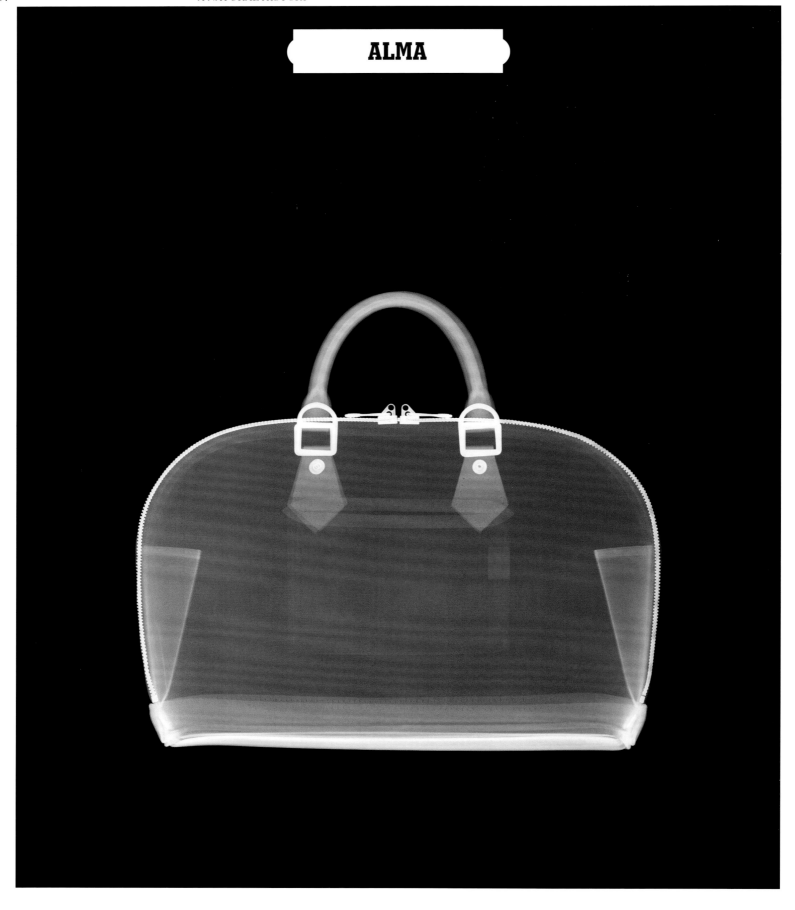

Small Alma in Epi leather, 32.6 × 24 × 15.3 cm. The x-ray shows the rigid structure and the rectangular form
of the bag, as well as its metallic components, including the zipper with its two sliders, the square handle rings and the
rivets. Inside, the side gussets and the central pocket are also visible. Photograph by Nick Veasey, 2013

X-RAYS

LOCKIT

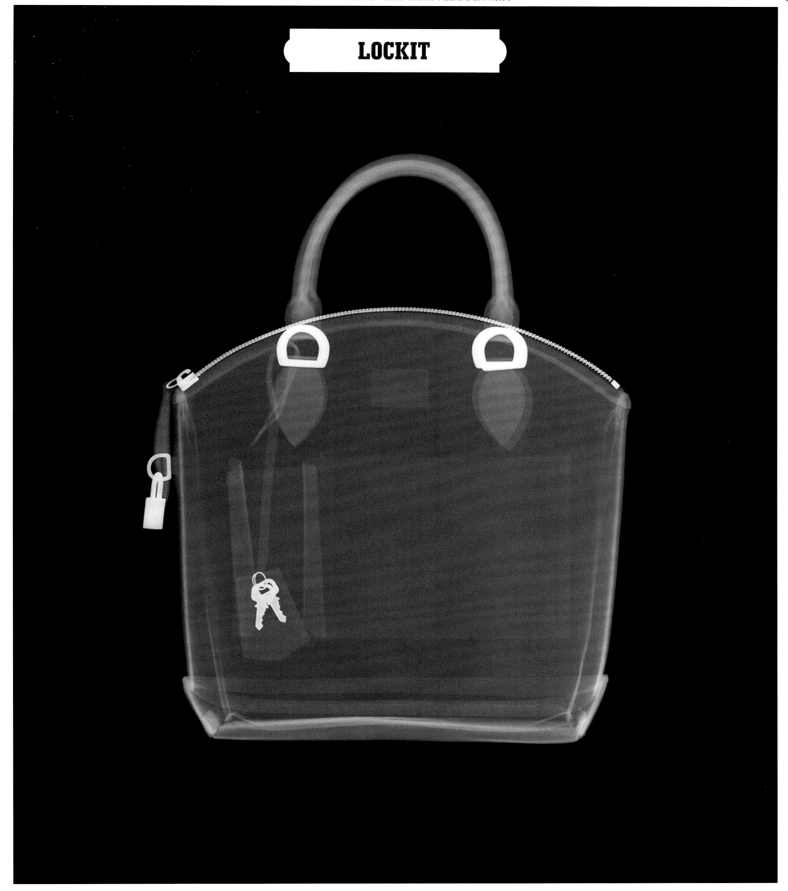

Lockit in Nomade leather, 29 × 28 × 12 cm. The x-ray shows the rigid structure and the square form of the bag,
as well as its hardware, including the zipper, the handle rings, the attachment ring and the padlock. The keys hidden
inside the key cloche are also visible. Photograph by Nick Veasey, 2013

ALMA

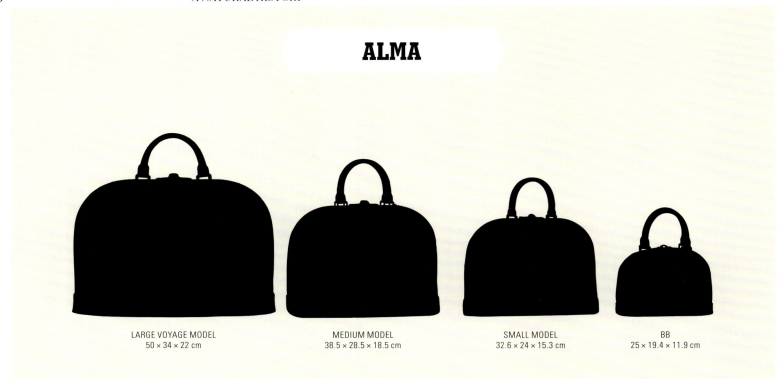

LARGE VOYAGE MODEL
50 × 34 × 22 cm

MEDIUM MODEL
38.5 × 28.5 × 18.5 cm

SMALL MODEL
32.6 × 24 × 15.3 cm

BB
25 × 19.4 × 11.9 cm

LOCKIT

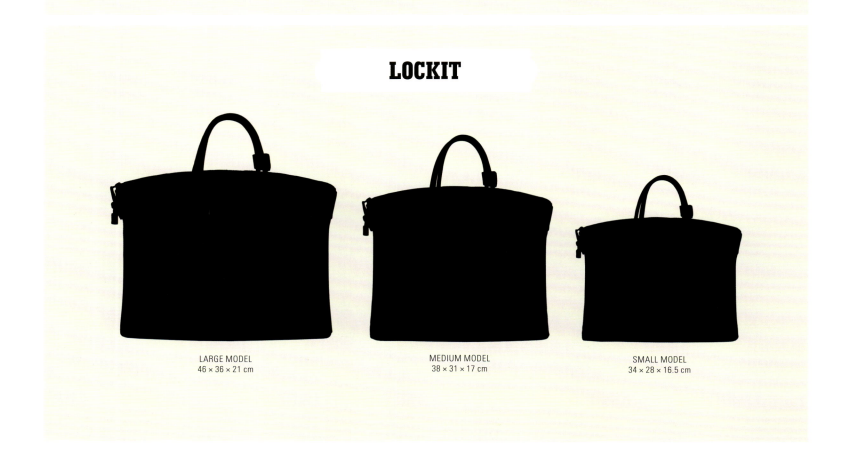

LARGE MODEL
46 × 36 × 21 cm

MEDIUM MODEL
38 × 31 × 17 cm

SMALL MODEL
34 × 28 × 16.5 cm

The Alma is available in three main sizes: medium, small and BB. It also exists in a large model, ideal for traveling. The
Lockit, which has benefited from a number of modifications since its creation, is also available in three sizes for the
2012 version: large, medium and small. In addition, it has been produced in horizontal and vertical versions.

DIMENSIONS

EPI LEATHER

ÉCORCE CALFSKIN LEATHER

The Epi leather line is distinguished by its vast array of colors for the Alma: 1. Red — 2. Fuchsia — 3. Figue — 4. Cassis — 5. Blue — 6. Indigo — 7. Myrtille —
8. Prune electric — 9. Bleu electric — 10. Cyan — 11. Menthe — 12. Green — 13. Citron — 14. Vanille — 15. Ivory — 16. Amande electric — 17. Sable —
18. Jaune tassili — 19. Mandarine — 20. Piment — 21. Cannelle — 22. Cacao — 23. Rubis — 24. Carmine — 25. Moka — 26. Black — 27. Noir electric — 28. Grès

Écorce calfskin leather, from the Haute Maroquinerie line, is available in a large variety of colors for the Lockit: 1. Red — 2. Cassis — 3. Aubergine —
4. Black — 5. Bleu canard — 6. Bleu océan — 7. Purple — 8. Navy — 9. White — 10. Blanc cassé — 11. Brown — 12. Taupe — 13. Vert forêt — 14. Tabac —
15. Mandarine — 16. Caramel — 17. Pomme — 18. Pistache

COLOR SCHEMES

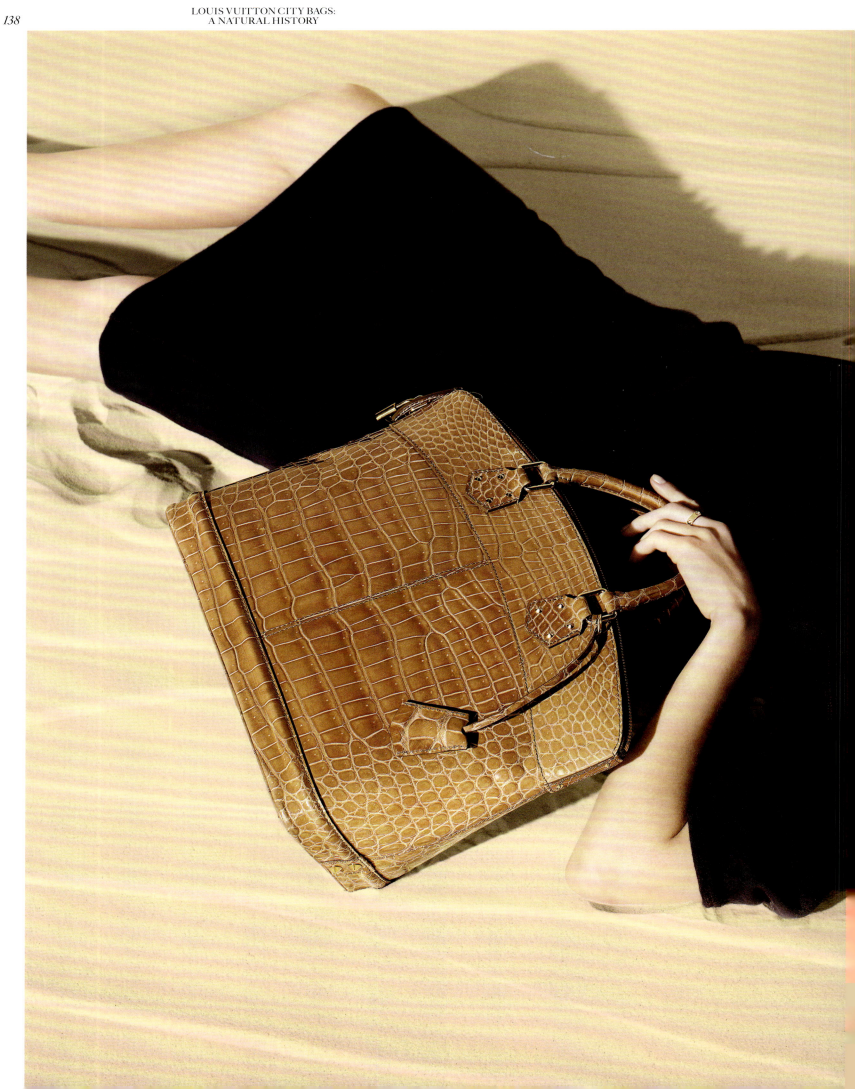

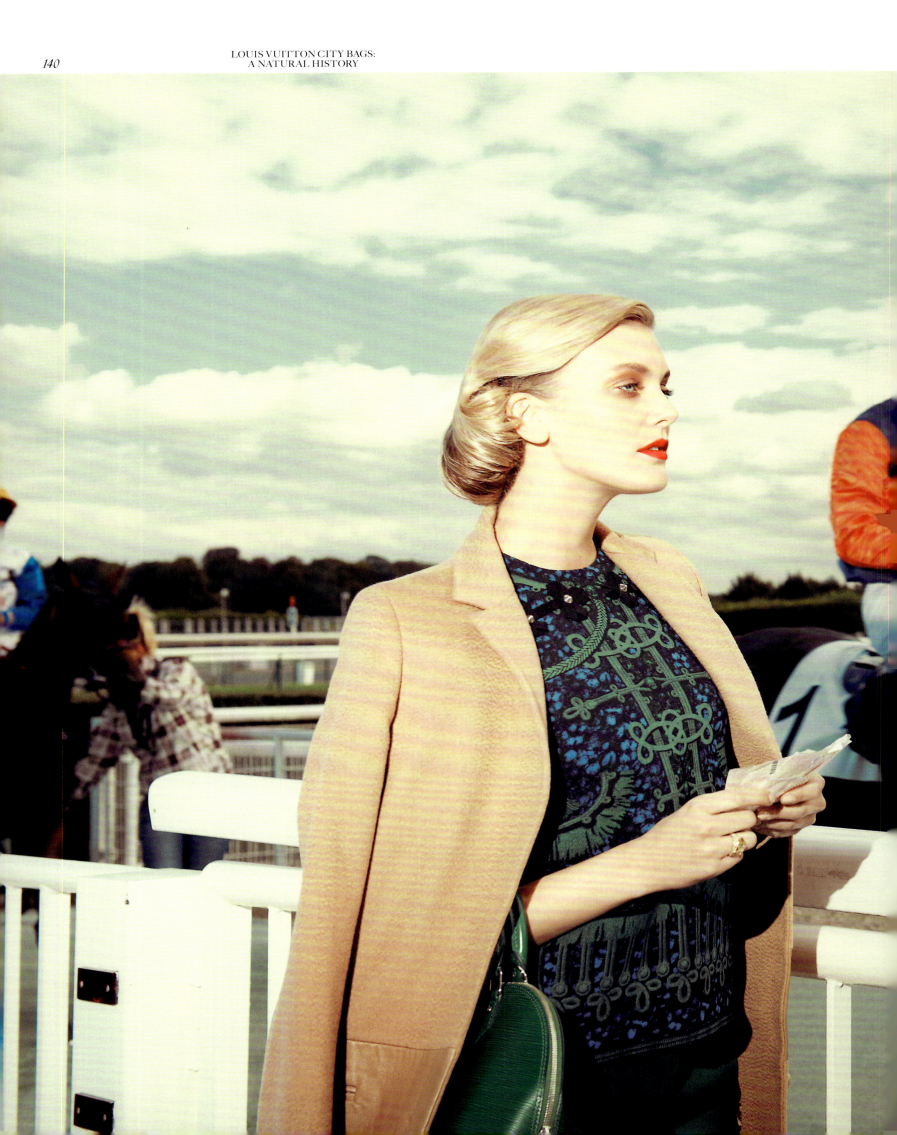

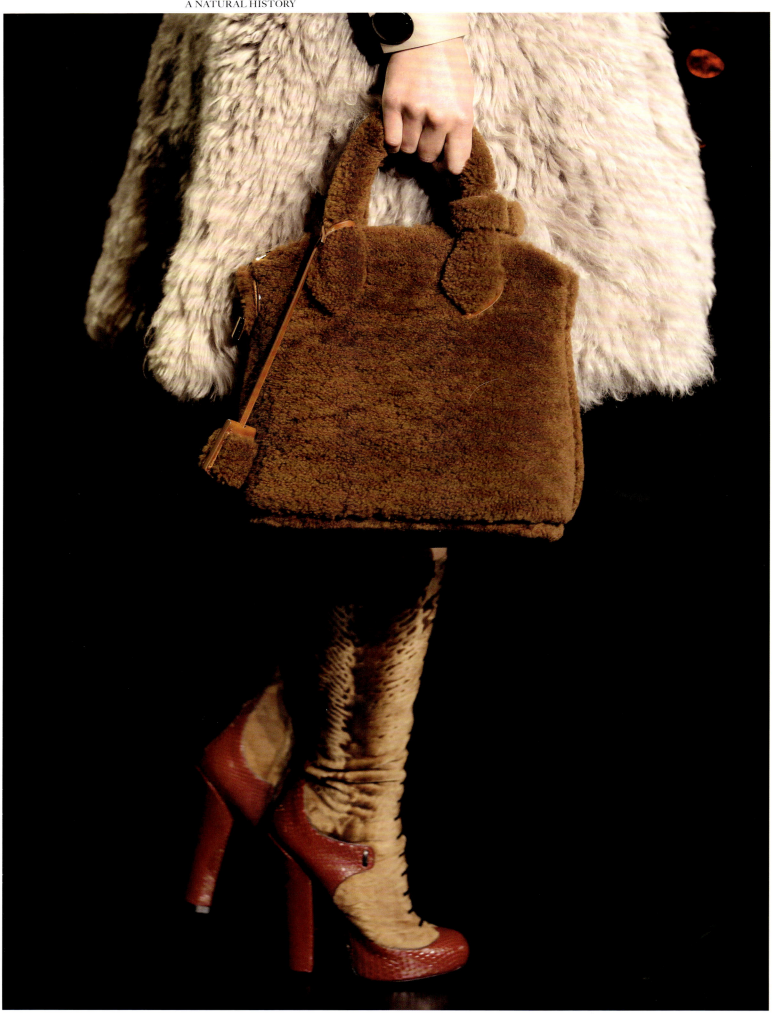

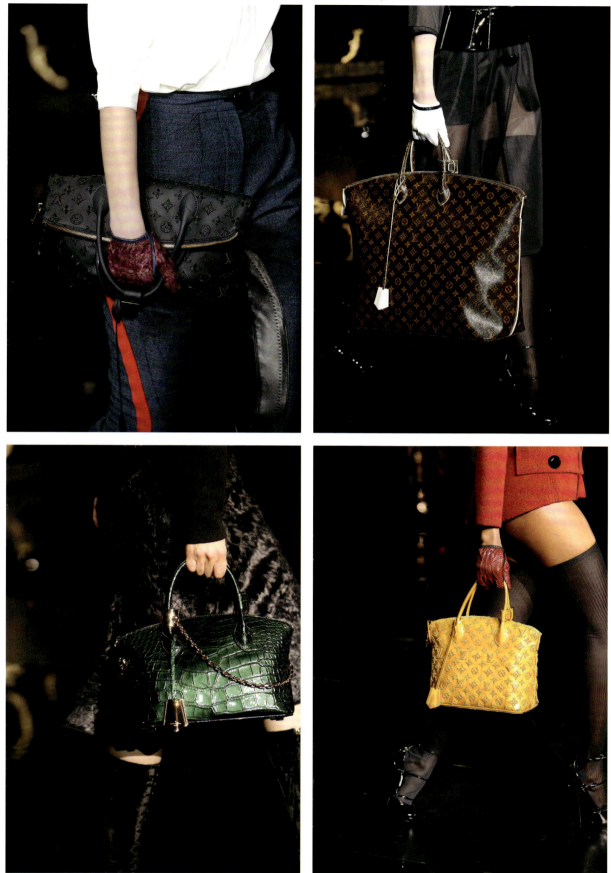

From left to right, top to bottom: Autumn-Winter 2011–2012 runway show, look 07, the model carries a medium Lockit Vertical in black Monogram Desire — Autumn-Winter 2011–2012 runway show, look 02, the model carries a Lockit Voyage in Monogram Fetish — Autumn-Winter 2011–2012 runway show, look 26, the model carries a Lockit Devotion in green alligator leather — Autumn-Winter 2011–2012 runway show, look 08, the model carries a Lockit in moutarde Monogram Fascination. Photographs by Ludwig Bonnet, 2011

Opposite: Autumn-Winter 2011–2012 runway show, look 33, the model carries a Lockit Pulsion in caramel wool. Photograph by Ludwig Bonnet, 2011

Preceding double page spreads: Pages 138–139: The model carries a medium Lockit in beige cappuccino crocodile leather, Louis Vuitton maroquinerie catalogue, 2008, pp. 6–7. Photograph by Sofia Sanchez and Mauro Mongiello, 2008

Pages 140–141: A woman at a racetrack carries an Alma in menthe Epi leather. Photograph by Kourtney Roy, *Diva*, January 2013

SEASONAL COLLECTIONS

ALMA: STEPHEN SPROUSE

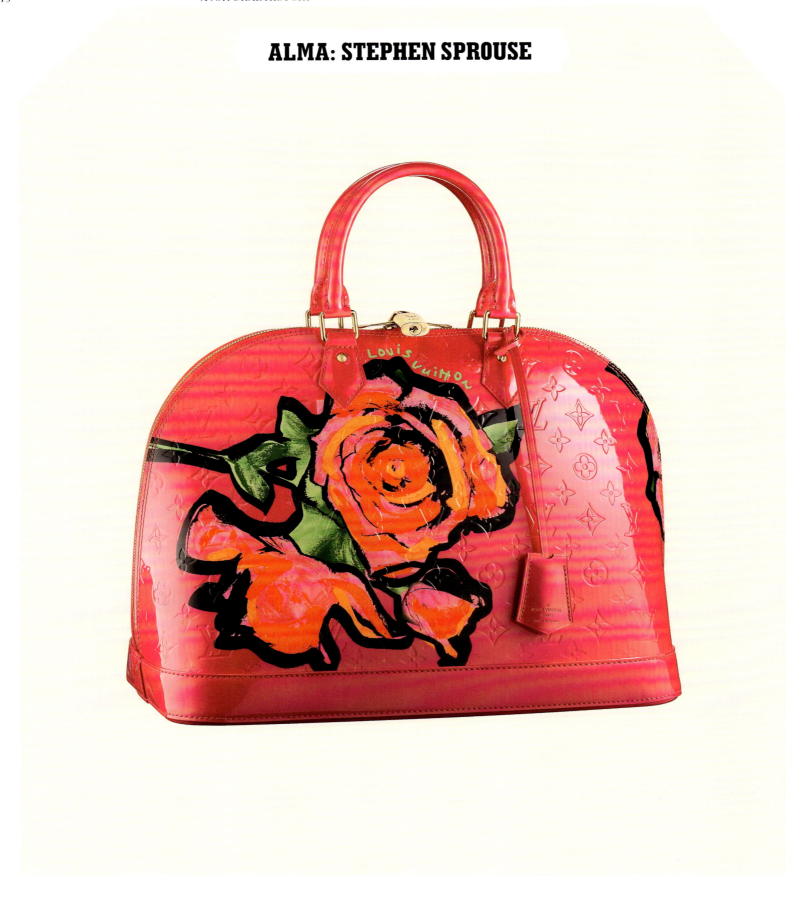

Stephen Sprouse (1953–2004) is the first designer with whom Marc Jacobs chose to collaborate in 2000. The American artist and designer
designed two new motifs that reinterpret the Monogram, Monogram Graffiti and Monogram Roses. The last would be used in leather goods only,
in 2009 to celebrate the anniversary of the first artistic collaboration, and exists in Monogram canvas and in Monogram Vernis.

Rose pop Medium Alma in Monogram Vernis Roses, 2009, 38.5 × 28.5 × 18.5 cm

Opposite: Spring-Summer 2001 advertising campaign. In Miami, Ana Cláudia Michels carries a small horizontal Alma in black Graffiti.
Photograph by Patrick Demarchelier, 2001

Preceding double page spread: Raquel Zimmerman carries a large Alma in gold Monogram Miroir. The Monogram Miroir line was inspired by the sculpture Vuitton Bag (2000) by the French artist Sylvie Fleury. Photograph by Mert Alas and Marcus Piggott, *W Magazine*, August 2006

ARTISTIC VARIATIONS

ALMA: TAKASHI MURAKAMI

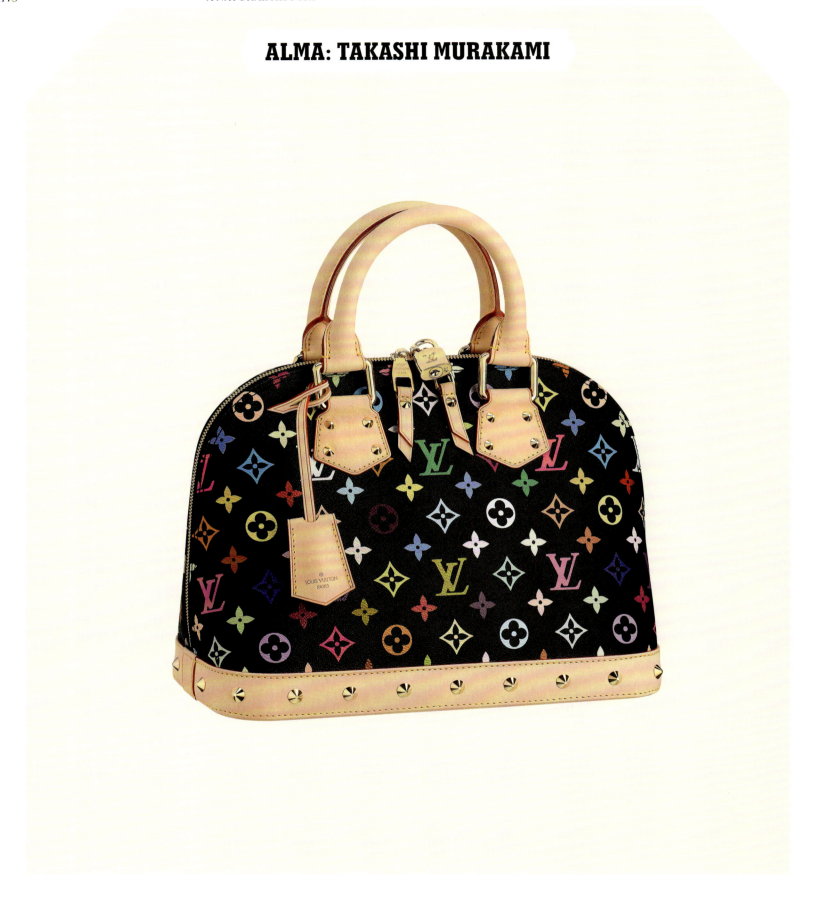

Small Alma in black Monogram Multicolore, 2003, 32.6 × 24 × 15.3 cm. Studs incrust the base band in natural cowhide leather, adding a dynamic element to the bag's traditional silhouette. The Monogram Multicolore line is the result of a collaboration with the Japanese artist Takashi Murakami in 2007 (see p. 327). Monogram Multicolore (2002) is a creation by Takashi Murakami for Louis Vuitton. © Takashi Murakami / Kaikai Kiki Co., Ltd. All rights reserved.

Opposite: Spring-Summer 2003 runway show, look 06, the model carries an Alma in white Monogram Multicolore.
Photograph by Dan Lecca, 2002

ARTISTIC VARIATIONS

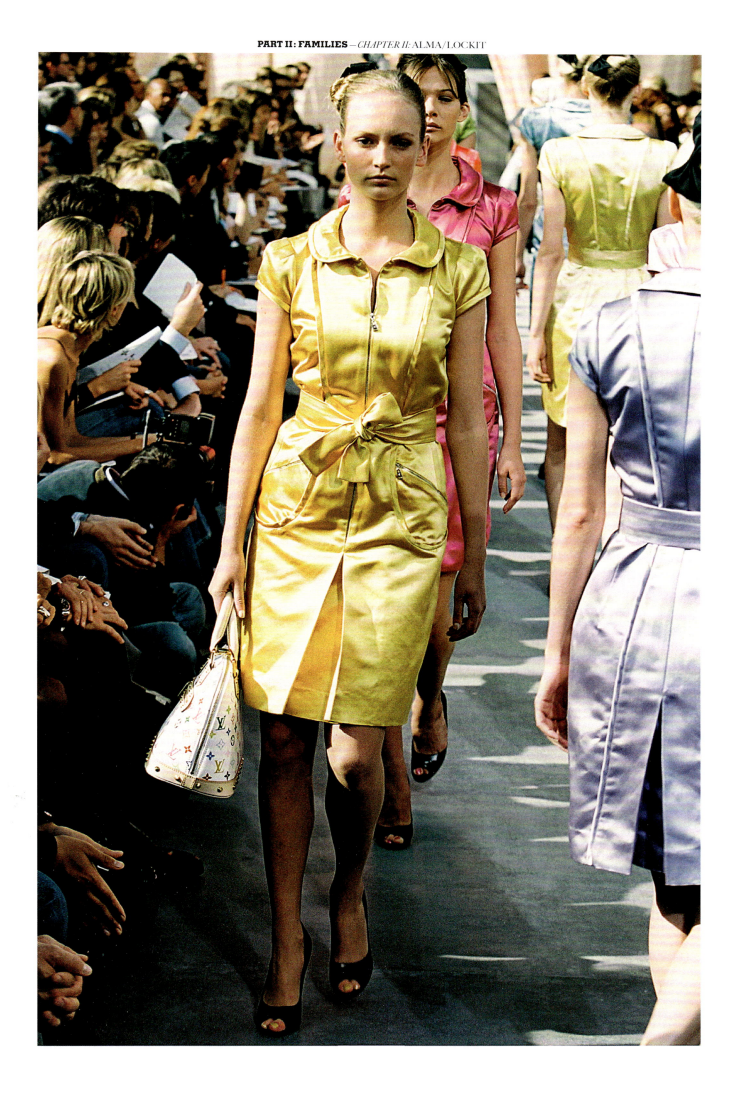

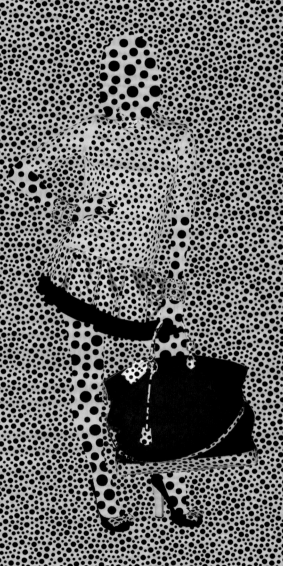

LOCKIT: YAYOI KUSAMA

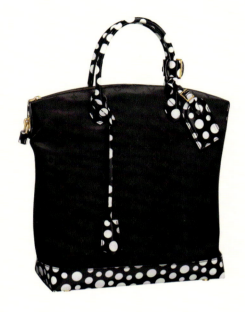

MEDIUM LOCKIT
In Black Monogram Nylon Dots Infinity

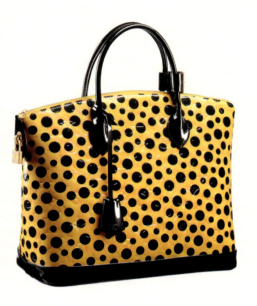

MEDIUM LOCKIT
In Yellow Monogram Vernis Dots Infinity

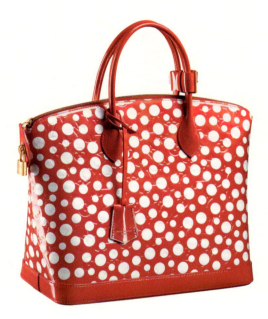

MEDIUM LOCKIT
In Red Monogram Vernis Dots Infinity

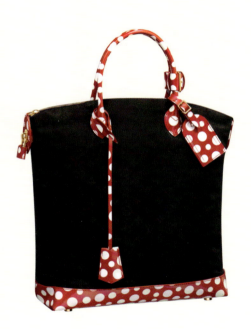

MEDIUM LOCKIT
In Red Monogram Nylon Dots Infinity

From left to right, top to bottom: Medium Lockit in black Monogram Nylon Dots Infinity, 2012, 39 × 30.5 × 18 cm — Medium Lockit in yellow Monogram Vernis Dots Infinity, 2012, 38 × 31 × 17 cm — Medium Lockit in red Monogram Vernis Dots Infinity, 2012, 38 × 31 × 17 cm — Medium Lockit in red Monogram Nylon Dots Infinity, 2012, 39 × 30.5 × 18 cm. The Dots Infinity line is the result of a collaboration with the Japanese artist Yayoi Kusama in 2012 (see p. 321).

Opposite: The model carries a large Lockit in yellow Monogram Nylon Dots Infinity, *Louis Vuitton Yayoi Kusama Catalogue*, 2012. Illustration by Theseus Chan/WORK/ASHU, 2012

ARTISTIC VARIATIONS

INSTALLATIONS

Lux-Flux — Interpreting the Alma Bag, Tim White-Sobieski, 2006

Opposite: Detail of *Interpreting the Lockit Bag*, Ugo Rondinone, 2006, Louis Vuitton Collection. These two installations by the American artist Tim White-Sobieski and the Swiss artist Ugo Rondinone were presented at the Espace Culturel Louis Vuitton, on the top floor of the Champs-Élysées store in Paris, during the exhibition "Icons" (September 15 through December 31, 2006), which featured representations of the House's iconic bags by contemporary artists and designers.

INSTALLATIONS

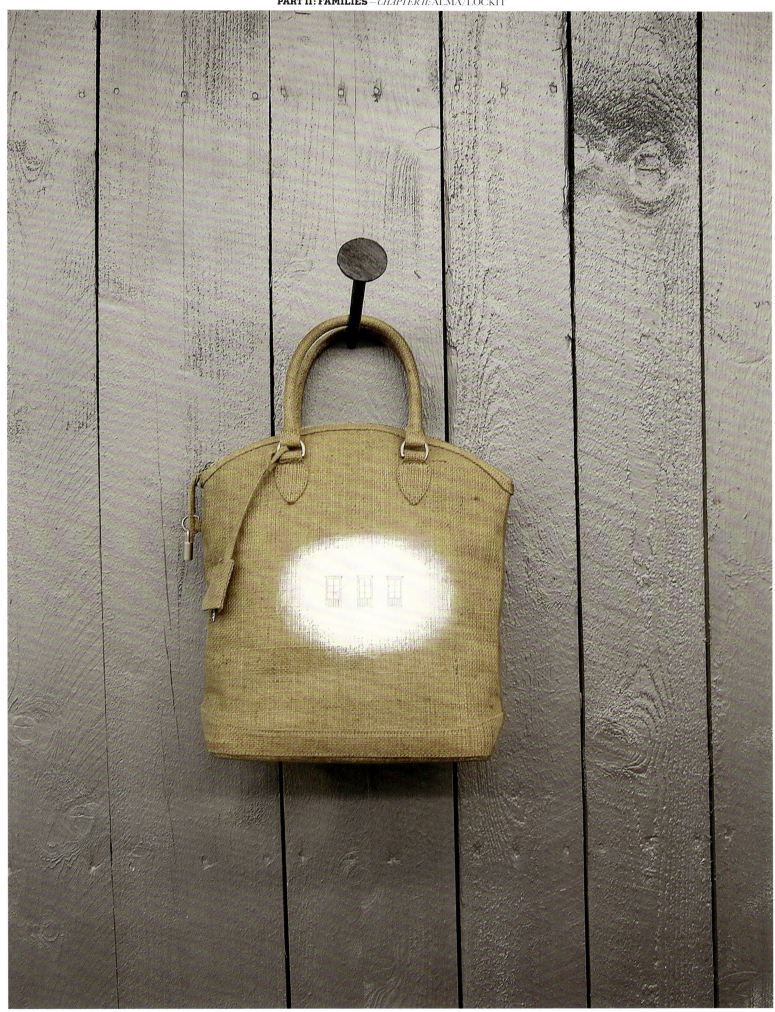

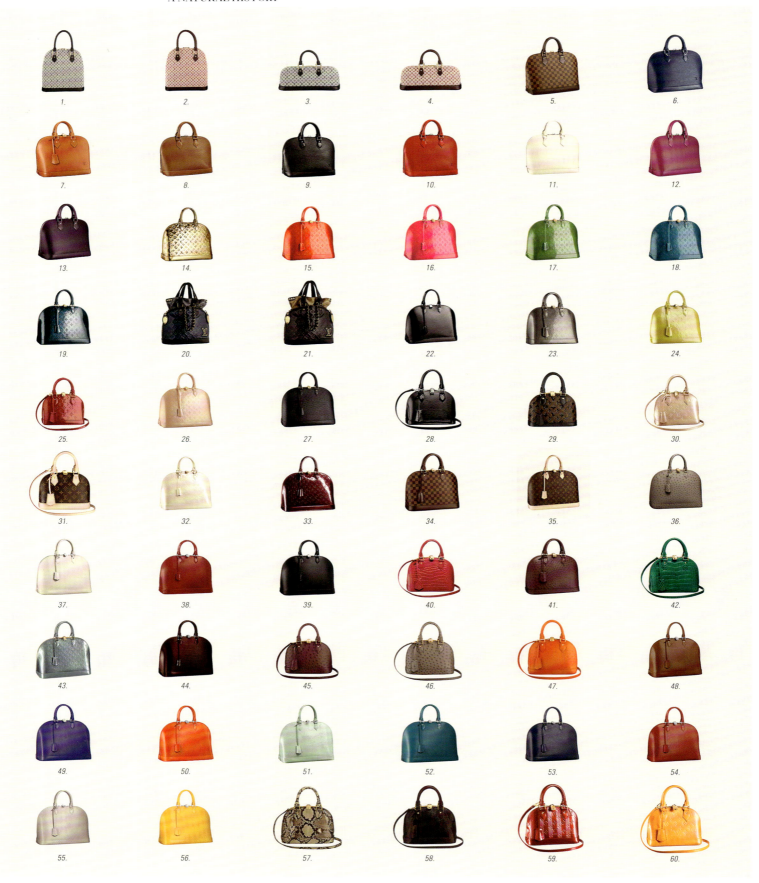

1. Tall Alma in khaki Monogram Mini, 2001 — 2. Tall Alma in cerise Monogram Mini, 2001 — 3. Long Alma in blue Monogram Mini, 2001 — 4. Long Alma in cerise Monogram Mini, 2001 — 5. Small Alma in Damier Ébène canvas, 2004 — 6. Small Alma in myrtille Epi leather, 2004 — 7. Small Alma in caramel Nomade leather, 2006 — 8. Small Alma in cannelle Epi leather, 2006 — 9. Small Alma in black Epi leather, 2005 — 10. Small Alma in red Epi leather, 2005 — 11. Small Alma in ivory Epi leather, 2007 — 12. Small Alma in grenade Epi leather, 2008 — 13. Small Alma in cassis Epi leather, 2008 — 14. Medium Alma in gold Monogram Miroir, 2008 — 15. Medium Alma in orange sunset Monogram Vernis, 2008 — 16. Medium Alma in rose pop Monogram Vernis, 2008 — 17. Medium Alma in vert tonic Monogram Vernis, 2008 — 18. Medium Alma in bleu galactic Monogram Vernis, 2008 — 19. Medium Alma in bleu nuit Monogram Vernis, 2010 — 20. Néo Alma in blue Monogram Double Jeu, 2009 — 21. Néo Alma in black Monogram Double Jeu, 2009 — 22. Medium Alma in noir electric Epi leather, 2010 — 23. Small Alma in gris art déco Monogram Vernis, 2010 — 24. Small Alma in vert impression Monogram Vernis, 2010 — 25. Alma BB in pomme d'amour Monogram Vernis, 2010 — 26. Medium Alma in rose florentin Monogram Vernis, 2010 — 27. Medium Alma in black ostrich leather, 2010 — 28. Alma BB in noir electric Epi leather, 2011 — 29. Alma BB in black Monogram Éclipse, 2011 — 30. Alma BB in rose florentin Monogram Vernis, 2009 — 31. Alma BB in Monogram canvas, 2010 — 32. Medium Alma in blanc corail Monogram Vernis, 2011 — 33. Medium Alma in rouge fauviste Monogram Vernis, 2010 — 34. Small Alma in Damier Ébène canvas, 2010 — 35. Medium Alma in Monogram canvas, 2010 — 36. Large Alma in tourterelle ostrich leather, 2010 — 37. Medium Alma in ivory Epi leather, 2010 — 38. Medium Alma in rubis Epi leather, 2010 — 39. Medium Alma in black Epi leather, 2010 — 40. Alma BB in fuchsia brilliant alligator leather, 2010 — 41. Small Alma in prune ostrich leather, 2010 — 42. Alma BB in émeraude brilliant alligator leather, 2013 — 43. Small Alma in givre Monogram Vernis, 2011 — 44. Medium Alma in prune electric Epi leather, 2012 — 45. Alma BB in prune ostrich leather, 2013 — 46. Alma BB in tourterelle ostrich leather, 2013 — 47. Alma BB in piment ostrich leather, 2013 — 48. Medium Alma in cacao Epi leather, 2011 — 49. Medium Alma in piment Epi leather, 2011 — 50. Medium Alma in figue Epi leather, 2011 — 50. Medium Alma in amande electric Epi leather, 2011 — 52. Medium Alma in cyan Epi leather, 2011 — 53. Medium Alma in indigo Epi leather, 2011 — 54. Medium Alma in carmine Epi leather, 2011 — 55. Medium Alma in grès Epi leather, 2011 — 56. Medium Alma in citron Epi leather, 2011 — 57. Alma BB in natural python skin, 2013 — 58. Alma BB in prune python skin, 2013 — 59. Alma BB in pomme d'amour Monogram Vernis Rayures, 2012 — 60. Alma BB in jaune passion Monogram Vernis, 2012

BIODIVERSITY: THE ALMA

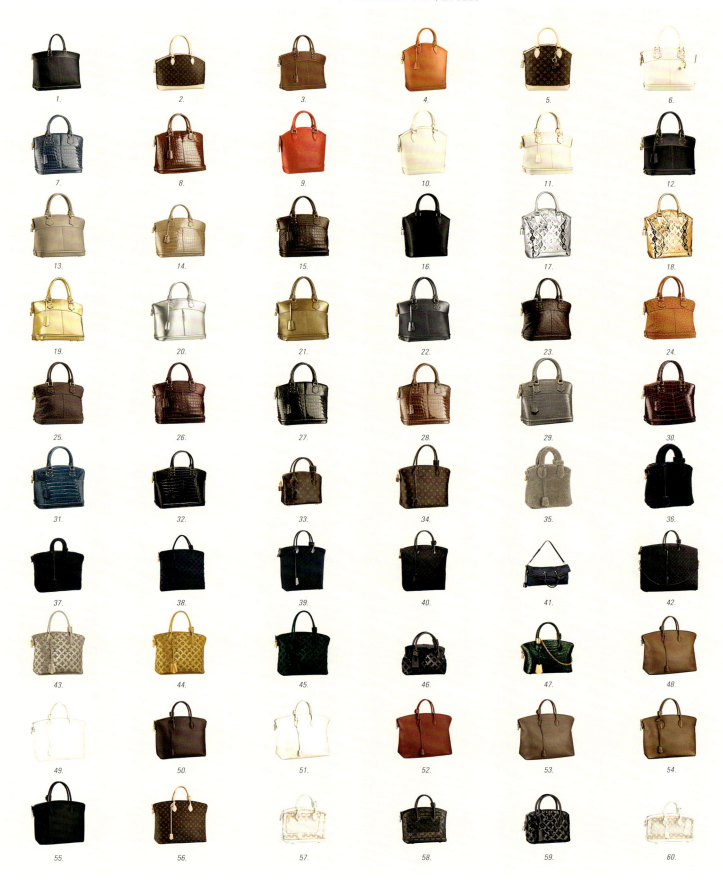

1. Lockit Travel in black Suhali goatskin leather, 2006 — 2. Lockit Horizontal in Monogram canvas, 2007 — 3. Medium Lockit in sienne Suhali goatskin leather, 2006 — 4. Lockit Vertical in caramel Nomade leather, 2007 — 5. Lockit in Monogram canvas with Jack&Lucie key ring, 2006 — 6. Medium Lockit in white Suhali goatskin leather with Hollywood key ring, 2006 — 7. Small Lockit in blue brilliant alligator leather, 2006 — 8. Medium Lockit in brown alligator leather, 2006 — 9. Lockit in red Epi leather, 2007 — 10. Lockit in ivory Epi leather, 2007 — 11. Small Lockit in white Suhali goatskin leather, 2007 — 12. Small Lockit in black Suhali goatskin leather, 2010 — 13. Small Lockit in vérone Suhali goatskin leather, 2007 — 14. Medium Lockit in beige cappuccino brilliant alligator leather, 2006 — 15. Small Lockit in brown matte alligator leather, 2006 — 16. Lockit in black Epi leather, 2007 — 17. Lockit in silver Monogram Miroir, 2007 — 18. Lockit in gold Monogram Miroir, 2007 — 19. Small Lockit in gold Suhali goatskin leather, 2007 — 20. Small Lockit in silver Suhali goatskin leather, 2007 — 21. Small Lockit in bronze Suhali goatskin leather, 2007 — 22. Small Lockit in chrome Suhali goatskin leather, 2007 — 23. Small Lockit in moka ostrich leather, 2009 — 24. Small Lockit in cognac ostrich leather, 2009 — 25. Small Lockit in raisin ostrich leather, 2009 — 26. Small Lockit in prune matte alligator leather, 2007 — 27. Small Lockit in black brilliant alligator leather, 2007 — 28. Small Lockit in brown brilliant alligator leather, 2007 — 29. Small Lockit in gray brilliant crocodile leather, 2007 — 30. Small Lockit in bourgogne brilliant crocodile leather, 2010 — 31. Small Lockit in bleu glacial brilliant alligator leather, 2010 — 32. Medium Lockit in black brilliant alligator leather, 2010 — 33. Lockit BB in Monogram Fetish, 2011 — 34. Lockit in Monogram Fetish, 2011 — 35. Lockit Pulsion in gray wool, 2011 — 36. Lockit Pulsion in navy wool, 2011 — 37. Lockit Voyage Pulsion in navy wool, 2011 — 38. Medium Lockit Vertical in navy Monogram Addiction, 2011 — 39. Medium Lockit Vertical in navy Monogram Desire, 2011 — 40. Medium Lockit Vertical in black Monogram Desire, 2011 — 41. Large Lockit Vertical in blue Monogram Desire, 2011 — 42. Large Lockit Vertical in black Monogram Desire, 2011 — 43. Lockit in gray Monogram Fascination, 2011 — 44. Lockit in moutarde Monogram Fascination, 2011 — 45. Lockit in green Monogram Fascination, 2011 — 46. Lockit BB Frame in black Monogram Fascination, 2011 — 47. Lockit Devotion in green brilliant alligator leather, 2011 — 48. Large Lockit in tabac Écorce calfskin leather, 2012 — 49. Medium Lockit in white Soie calfskin leather, 2012 — 50. Small Lockit in iris noir Frisson goatskin leather, 2012 — 51. Large Lockit in white Écorce calfskin leather, 2012 — 52. Large Lockit in red Soie calfskin leather, 2012 — 53. Large Lockit in taupe Écorce calfskin leather, 2012 — 54. Medium Lockit in tabac Écorce calfskin leather, 2012 — 55. Small Lockit in black Soie calfskin leather, 2012 — 56. Medium Lockit in Monogram canvas, 2011 — 57. Lockit in white Monogram Transparence, 2012 — 58. Lockit in black Monogram Transparence, 2012 — 59. Lockit BB in black Monogram Bouclette, 2013 — 60. Lockit East West in white Monogram Transparence, 2012

BIODIVERSITY: THE LOCKIT

DÉESSE: GENEALOGY

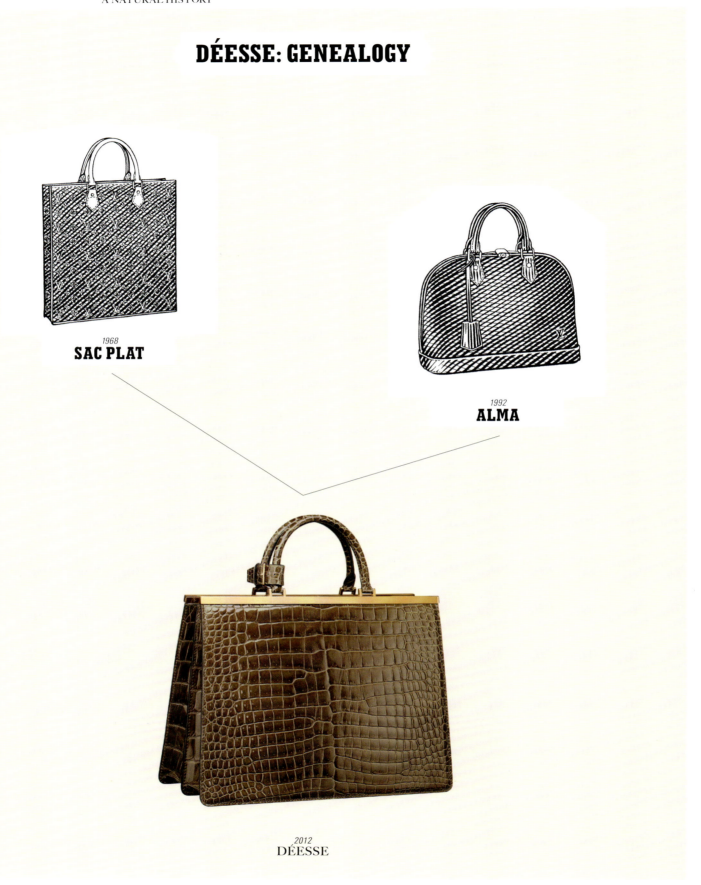

1968
SAC PLAT

1992
ALMA

2012
DÉESSE

Large Déesse in gris éléphant brilliant crocodile leather, 2012, 33 × 26 × 14.5 cm. The Déesse, which could be a cross
between the iconic Alma and Sac Plat bags, was born in 2012. From the former, it inherited its simplicity of form and
strong graphic impact, as well as its feminine, sophisticated look. It gets its rectilinear silhouette and gusseted
structure from the latter. With its classic lines and its precious clasp, it recalls the first ladies' handbags created
by the House between 1900 and 1920. Drawings by Martin Mörck, 2013

HYBRIDIZATION

DÉESSE: OPEN

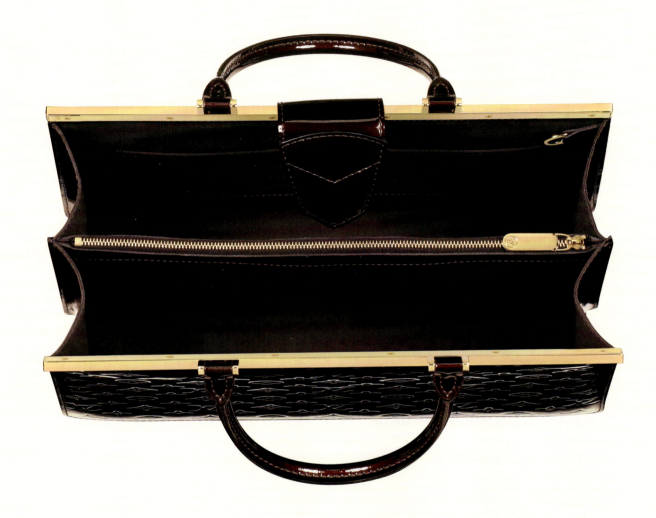

Large Déesse in amaranth Monogram Vernis, 2012, 33 × 26 × 14.5 cm, open, seen from above. Thanks to
its two compartments, its central zipped pocket and its side gussets, the Déesse offers organized women the advantage
of variable capacity for professional or personal use.

BIKER

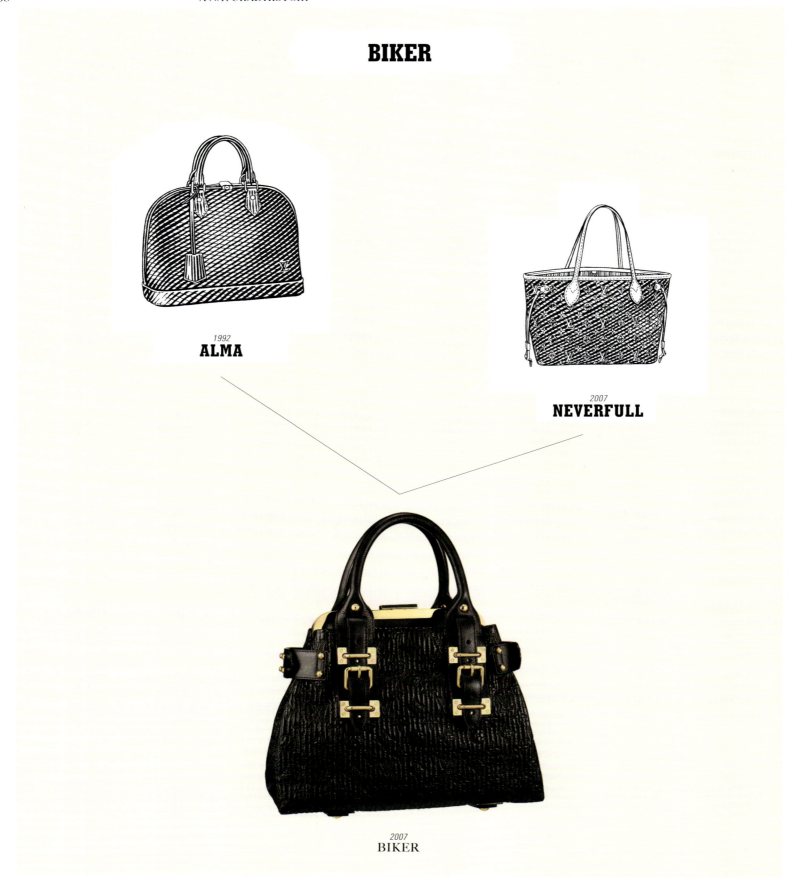

1992
ALMA

2007
NEVERFULL

2007
BIKER

Biker in black Monogram Motard, 2007, 36 × 25 × 14 cm. The Biker, which could be a cross between the
iconic Alma and Neverfull bags, was born in 2007. From the former, it inherited its strong, defined silhouette, as
well as its secure clasp, which makes it well suited for professional use. It gets its large capacity and adaptability
for more personal use from the latter. Drawings by Martin Mörck, 2013

HYBRIDIZATION

The model carries a Biker in black Monogram Motard. Photograph by Luciana Val and Franco Musso,
Numéro, September 2007

Following double page spread: Spring-Summer 2012 advertising campaign. On the left, the model carries
a Lockit in white Monogram Transparence; on the right, the model carries an East West Lockit in white
Monogram Transparence. Photograph by Steven Meisel, 2011

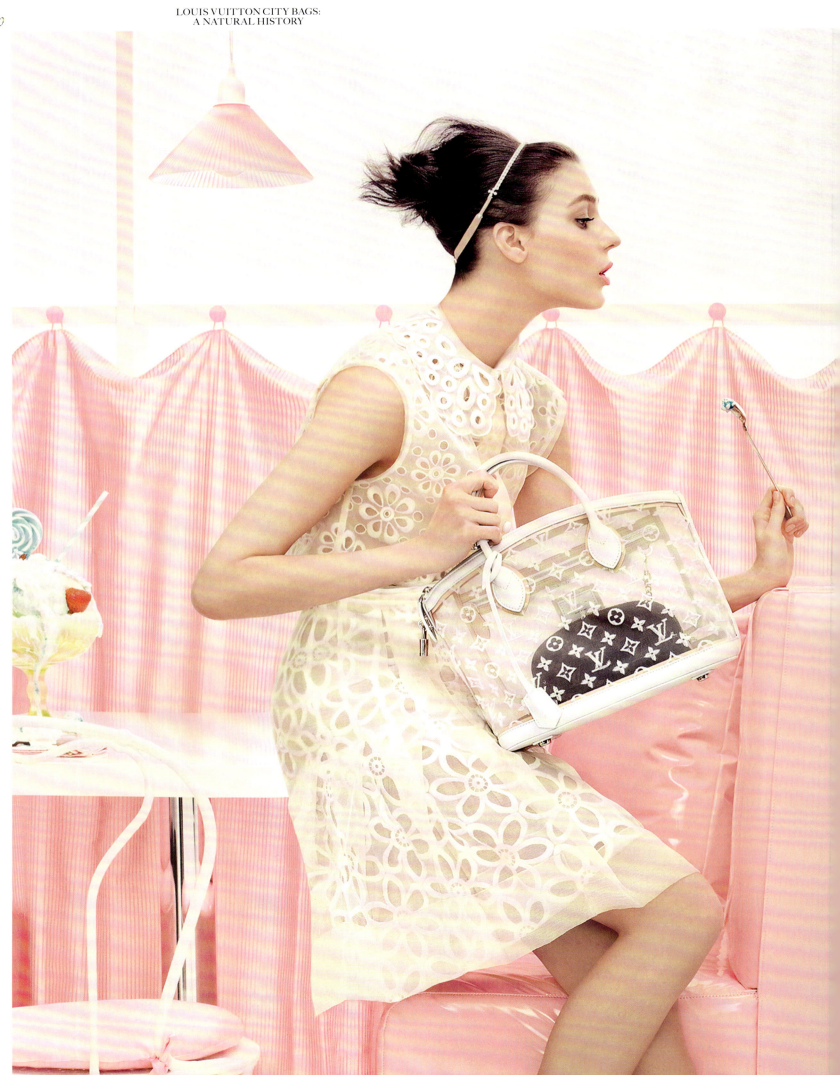

NOÉ
In Bleu toledo Epi leather

BUCKET
In Monogram canvas

Chapter III:
NOÉ/BUCKET
Pages 162–201

FROM TOP TO BOTTOM,
LEFT TO RIGHT

Laundry bag, Navy bag,
Bucket bag, First Noé.

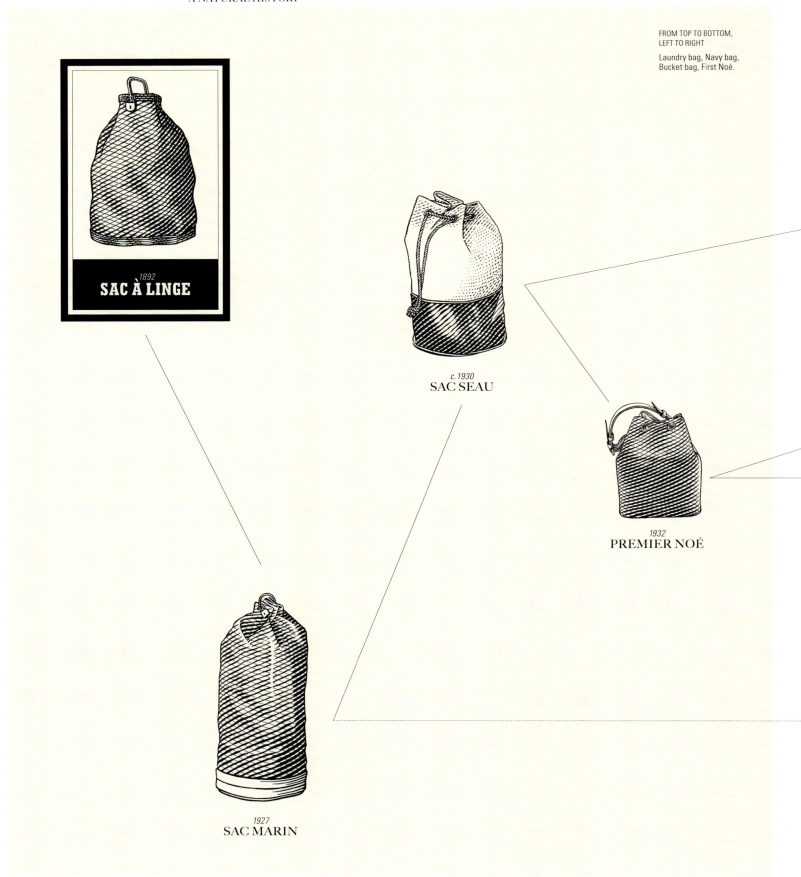

1892
SAC À LINGE

c.1930
SAC SEAU

1932
PREMIER NOÉ

1927
SAC MARIN

Extremely supple and cylindrical in form, the Laundry bag, originally used as an accessory to the
steamer trunk, was transformed in 1927 to become an independent piece of luggage designed for travel by
ocean liner: the Navy bag. The line descending from the two models continued to evolve
in the direction of practicality, towards products that were easy to handle and are multipurpose.

GENEALOGY: NOÉ AND BUCKET

FROM TOP TO BOTTOM,
LEFT TO RIGHT

Bucket Purse, Petit Noé,
Large Noé, Bucket, Noé,
Randonnée

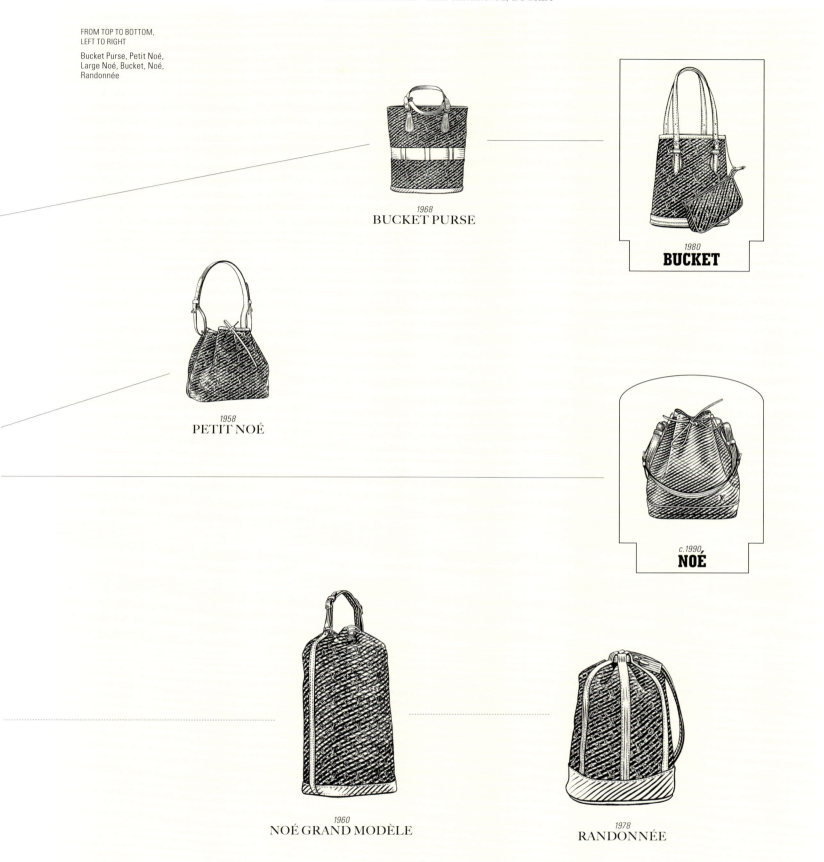

1968
BUCKET PURSE

1980
BUCKET

1958
PETIT NOÉ

c.1990
NOÉ

1960
NOÉ GRAND MODÈLE

1978
RANDONNÉE

and sometimes still closely linked to travel, such as the 1978 Randonnée. The Noé from 1932
and its contemporary versions, as well as the Buckets from 1968 and 1980, share the characteristics
of a highly accessible hold-all ideal for leisure use, but are also well adapted for daily use in the
modern city. P. 162 and above drawings by Martin Mörck, 2013

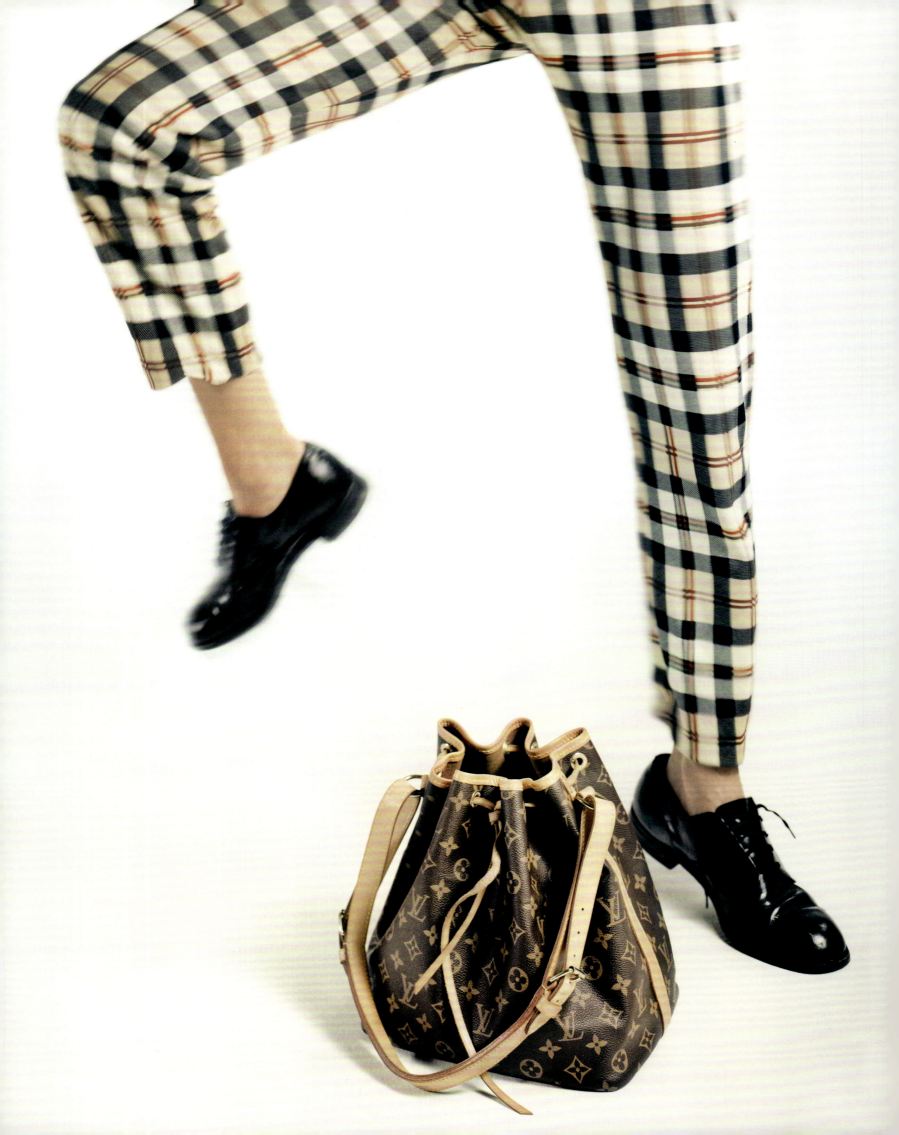

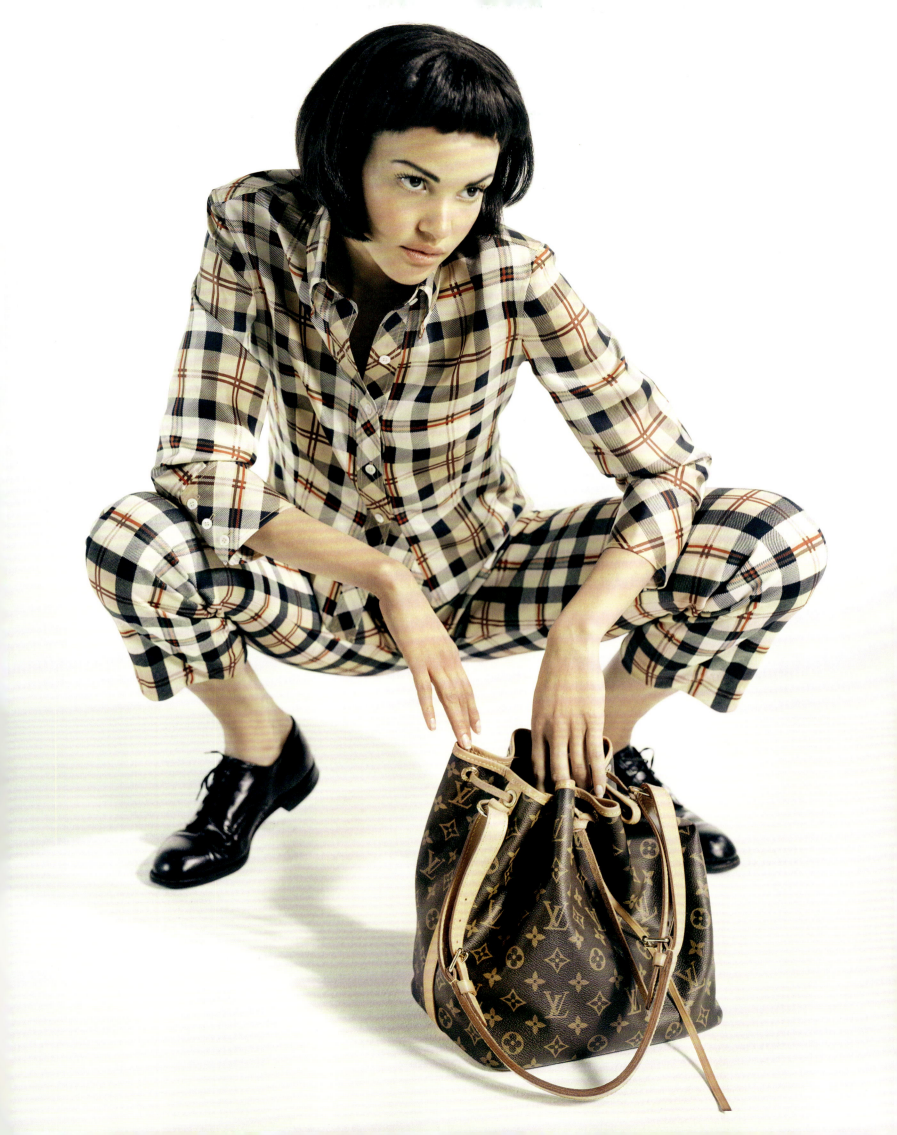

A woman at the beach with a Noé in Monogram canvas, 1960s. Louis Vuitton Archives

NOÉ/BUCKET
COLOMBE PRINGLE

It inherited its name from Noah, the famous hero of the ark. If it was necessary, one could bring an entire world of objects with them in the Noé, and it would survive the changing winds and currents of the fashion seasons. The late 1960s would see the birth of one of the Noé's descendants, the Bucket, taking its name from "a cylindrical container equipped with a handle," which, as the dictionary continues, was originally "designed to carry liquids"—a true family resemblance, as we'll soon see…

We won't need to go all the way back in time to the Great Flood, but we will start our story with Noé's genesis in 1932. A winemaker adept at the subtle art of making champagne had approached Gaston-Louis Vuitton, who was renowned in his own right for the art of helping people carry their dreams. So what was the dream of this winemaker? A chic bag, of course, but with unrivalled solidity, for transporting his bottles of "divine" nectar. His ideal? It should be as light as the bubbles in his champagne, as elegant as his *meilleur cru*, and able to contain five bottles—four with their corks upright, and one upside down—as a gift to the enlightened wine enthusiasts that were his clients. Picnic lunches, automobile excursions, exquisite banquets… This fine vintage had to have a place in the trunk of a cabriolet without risking breakage or damage to the picnic basket, silverwear, crystal glasses or precious dishes squeezed in beside the bottles.

Gaston-Louis Vuitton knew his classics. He remembered that, upon reaching land, the biblical patriarch planted grapevines on Mount Ararat and became a great lover of wine. Noé, therefore, was an obvious choice of name. But it was also a nod to the past. Gaston-Louis Vuitton had not forgotten his own family legend: he hauled out the famous accompaniment to the rigid trunks, the Laundry bag, the basic ancestor of the hold-all created at the end of the 19th century. Cut from a simple cotton canvas,

PRECEDING DOUBLE
PAGE SPREAD

"Louis Vuitton celebrates
Monogram canvas."
Advertising campaign for
the centenary of
Monogram canvas in
1996. In the foreground,
a Petit Noé in Monogram
canvas. Photograph by
Guzman, 1996

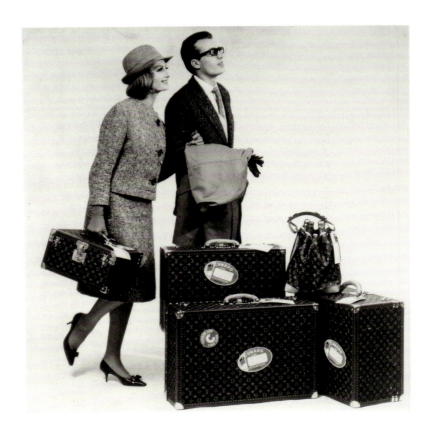

this softly curved cylinder appeared for the first time in the trunk-maker's 1892 catalogue. In the 1920s, bolstered by the fashion for sport and seaside vacations, this canvas bag adopted a more sophisticated look under the name Navy bag. All that remained was to adapt it for its new mission by marrying strength with flexibility. Thus, its creator had the idea to use a natural vegetable tanned cowhide leather that would resist the weight of this precious beverage and stand up to long-term use. For a closure, Gaston-Louis Vuitton replaced the original handle with a simple leather lace that delicately tightened to hold the bottles in place. Then he fitted it with an adjustable shoulder strap for comfortable carrying. But the Noé didn't limit its uses to champagne; almost immediately, it was made available in three sizes—small, medium and large—the last of which would serve its users, once again, as a laundry bag. You can't escape your destiny!

Twenty years later, the Noé still had more tricks up its sleeve. In 1959, it joined the growing family of city bags, clothed in the Monogram canvas that would bear witness to its noble blood. Preceded by its reputation for excellence—its functionality, its elegance, its efficiency— it became the modern woman's best ally. This active woman could stuff it full of magazines, throw in her diary, her makeup case and her work files, or slip her precious papers in the inside pocket. The Noé continually proves its impressive ability to adapt while maintaining its sensual softness. Even full to the brim, it resists the strain thanks to its solid leather base in natural cowhide leather, finished with a refined saddle stitch. These virtues have made it a long-lasting success, with a host of converts amongst celebrities from Juliette Gréco to

FROM LEFT TO RIGHT,
TOP TO BOTTOM

A couple is surrounded by luggage in Monogram canvas: three suitcases, a Vanity case and a Noé containing bottles of champagne.1960s
Louis Vuitton Archives

Navy bag in Monogram canvas, 1990,
36 × 60 × 36 cm, 2.2 kg
Louis Vuitton Collection

Two Noé in leather, one of which contains a bottle of champagne. The Noé was originally designed for transporting five bottles, upon the request of a champagne maker. Photograph taken October 1, 1954
Louis Vuitton Archives

Large Noé in Monogram canvas, c. 1960,
38 × 67 × 19 cm
Louis Vuitton Collection

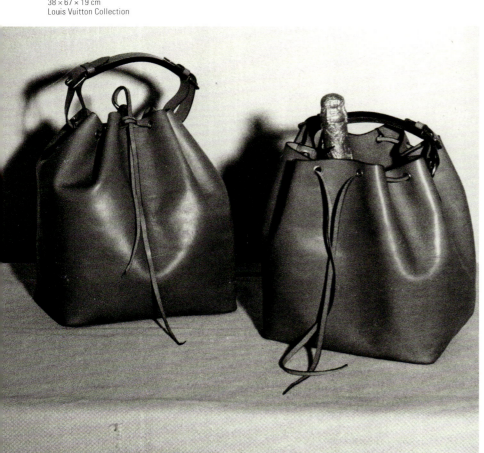

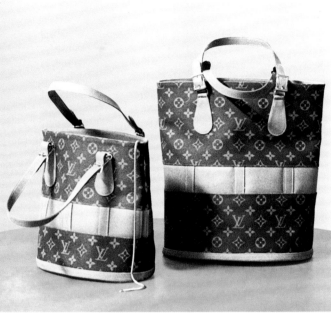

FROM LEFT TO RIGHT,
TOP TO BOTTOM

Ladies' handbag, 1950s
Photograph taken
September 15,1955
Louis Vuitton Archives

Small and large Bucket
Purse in Monogram
canvas Photograph
taken March 28, 1968
Louis Vuitton Archives

"Live in Monogram." A
woman carries a Noé in
Monogram canvas
Photograph by Pascal
Louis, Louis Vuitton
product catalogue, 1996
Louis Vuitton Archives

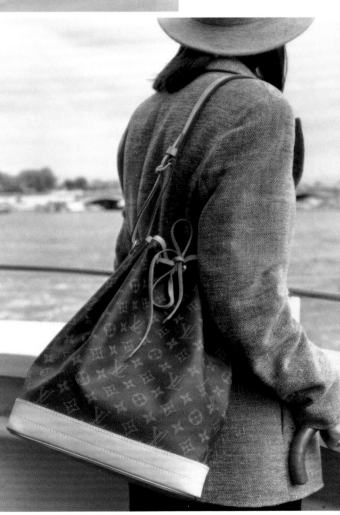

Lauren Bacall, and earning popularity particularly among the Japanese, who favor the small model—a fashionable, modern version of their traditional kimono bag. This worldwide recognition elevated the bag to the rank of bestseller in 1986, 1990, 1991 and 1992. Over the years, the Noé has been adorned in Epi leather, sported Takashi Murakami motifs and appeared in daringly bright colors—and even sequins, for the Cruise collection, when it became a rococo evening purse—evolving from mythical to iconic status.

And the Bucket? No, it's not just for bringing to the beach. But it does owe its name to the form and stability it derives from the "dome that reinforces its bottom." It began its journey on Fifth Avenue, Madison Avenue and Rodeo Drive. The simplicity of its lines, the efficacy of its adjustable double strap, its capacity and—an important detail—its additional pochette for keeping essential items to hand made it *the* shopping bag for American women as of 1968, accompanying them from the office to the supermarket, and in their travels and weekend jaunts to Long Island. Then, after a detour via the Land of the Rising Sun in 1982, when the Japanese fell for its simplicity and its canvas emblazoned with the emblematic LV, it made its entrance onto the world stage in 1992. It has been there ever since. So much so that Marc Jacobs invited his artist friends—Takashi Murakami chief amongst them—to mark it with their own creative seal. A fine destiny for a bucket.

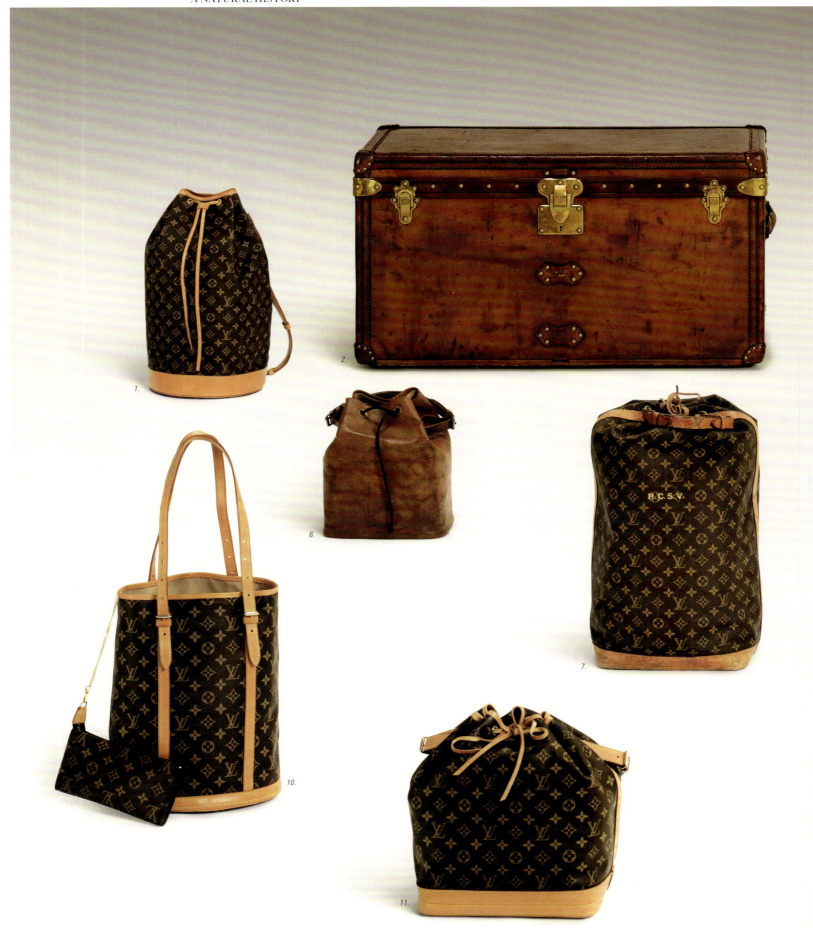

The iconic bags are pictured in the foreground; their "ancestors" are in the background. 1. Navy bag in Monogram canvas, 1986, 27 × 50 × 30 cm, 1 kg. Louis Vuitton Collection — 2. Mail trunk in natural cowhide leather, 1900, 97 × 54 × 51 cm, 25.3 kg. Louis Vuitton Collection — 3. Navy bag in canvas, 1929, 41 × 103 × 41 cm — 4. Large Randonnée in Monogram canvas, c. 1990, 33 × 48 × 18 cm — 5. Navy bag in Monogram canvas, 1990, 36 × 60 × 36 cm, 2.2 kg. Louis Vuitton Collection — 6. Noé in grained leather, c. 1930, 27 × 33 × 21 cm. Louis Vuitton Collection — 7. Large Noé in Monogram canvas, c. 1960, 38 × 67 × 19 cm. Louis Vuitton Collection —

FAMILY PORTRAIT

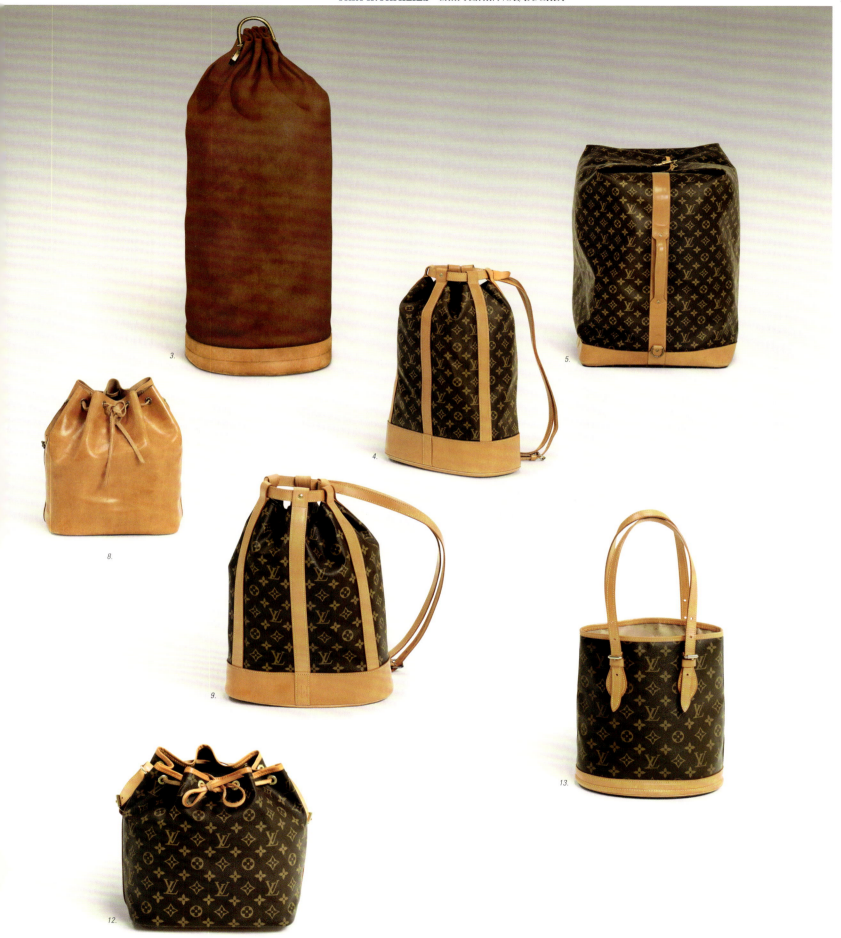

8. Noé in leather, c. 1980, 30 × 33 × 20 cm. Louis Vuitton Collection — 9. Randonnée Noé/Monogram canvas, 1978, 29 × 40 × 15.5 cm.
Louis Vuitton Collection — 10. Large Bucket in Monogram canvas, 1992, 27 × 36 × 20 cm. Louis Vuitton Collection — 11. Noé in
Monogram canvas, 1983, 26 × 34 × 20 cm. Louis Vuitton Collection — 12. Petit Noé in Monogram canvas, 1983, 25 × 27 × 20 cm. Louis Vuitton
Collection — 13. Small Bucket in Monogram canvas, 1980, 23 × 26 × 16 cm. Photograph by Patrick Gries, 2013

NOÉ

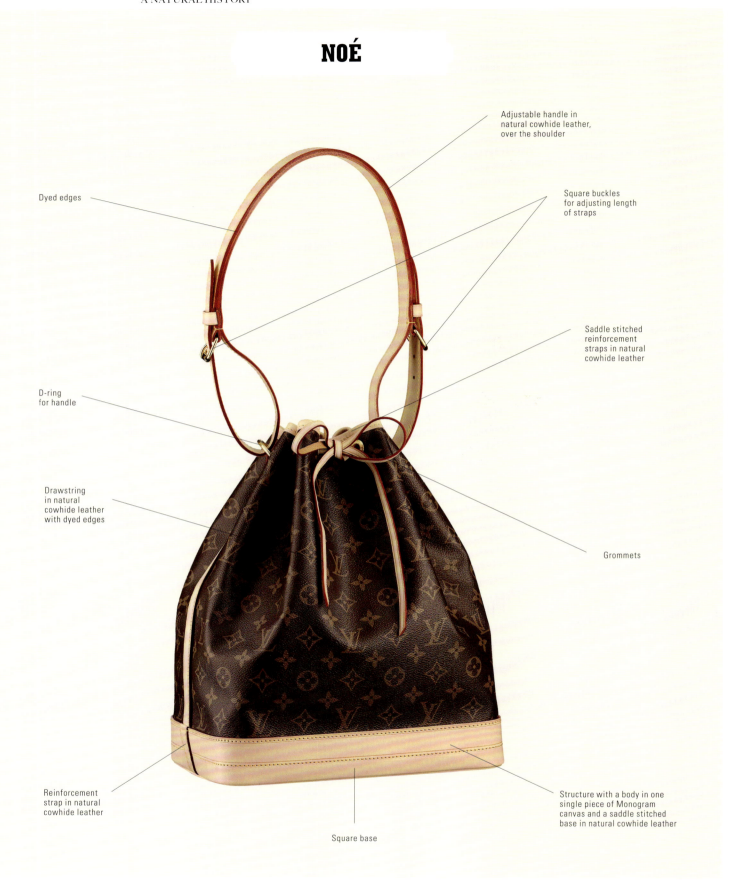

Adjustable handle in
natural cowhide leather,
over the shoulder

Square buckles
for adjusting length
of straps

Dyed edges

Saddle stitched
reinforcement
straps in natural
cowhide leather

D-ring
for handle

Drawstring
in natural
cowhide leather
with dyed edges

Grommets

Reinforcement
strap in natural
cowhide leather

Structure with a body in one
single piece of Monogram
canvas and a saddle stitched
base in natural cowhide leather

Square base

Noé in Monogram canvas, 26 × 34 × 20 cm — Small Bucket in Monogram canvas, 23 × 26 × 16 cm. Both
characterized by their rounded lines, the Noé and the Bucket are constructed upon a rectangular and an oval base
respectively. Each comprises three main elements: two sides, in leather or in canvas, and a reinforced base in natural
cowhide leather or canvas. While the Noé's suppleness comes from the soft material of its sides, the Bucket has a
semi-rigid structure. Both belong to the range of bucket bags that Louis Vuitton began producing in the early 1930s.

COMPARATIVE ANATOMY

BUCKET

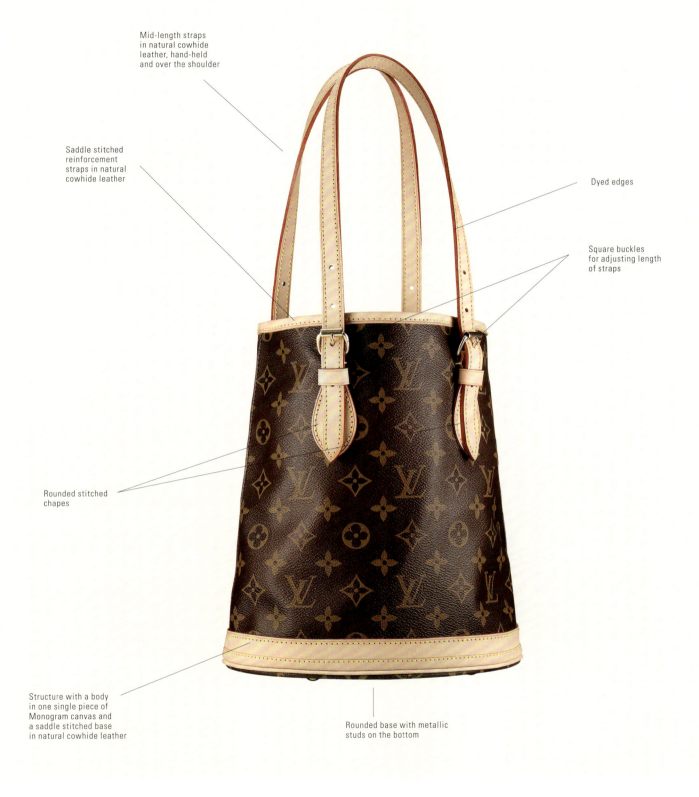

Mid-length straps in natural cowhide leather, hand-held and over the shoulder

Saddle stitched reinforcement straps in natural cowhide leather

Dyed edges

Square buckles for adjusting length of straps

Rounded stitched chapes

Structure with a body in one single piece of Monogram canvas and a saddle stitched base in natural cowhide leather

Rounded base with metallic studs on the bottom

NOÉ

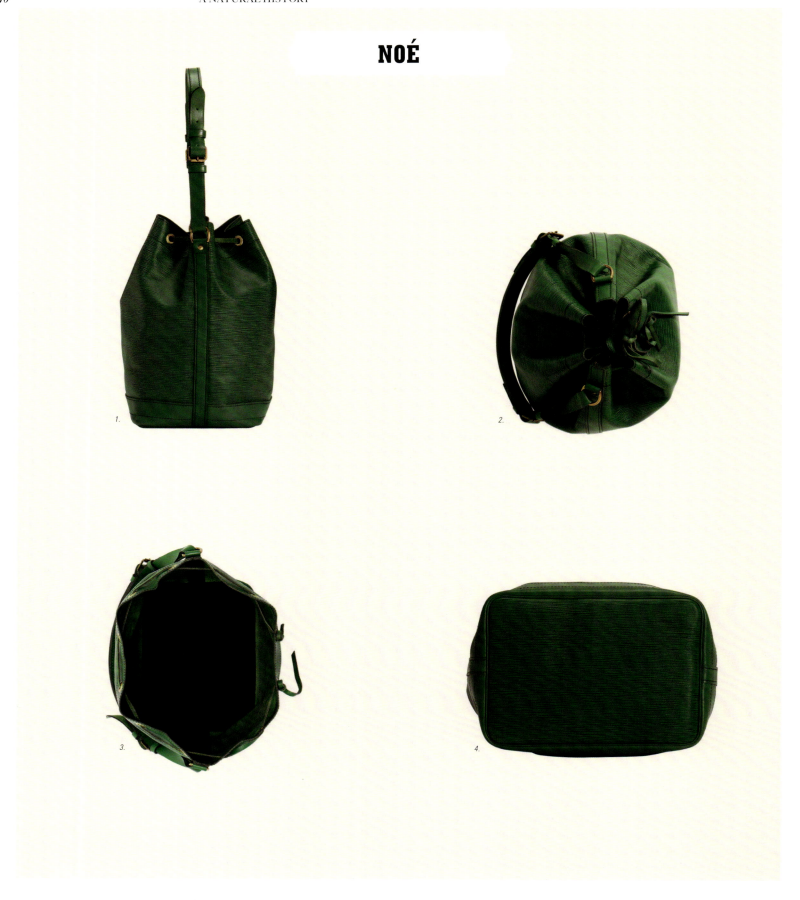

Noé in vert bornéo Epi leather, 26 × 34 × 20 cm: 1. Profile view — 2. Closed, seen from above —
3. Open, seen from above — 4. Seen from below

Opposite: Detail of two grommets and the tightening thread. Photograph by Patrick Gries, 2013

MORPHOLOGY

BUCKET

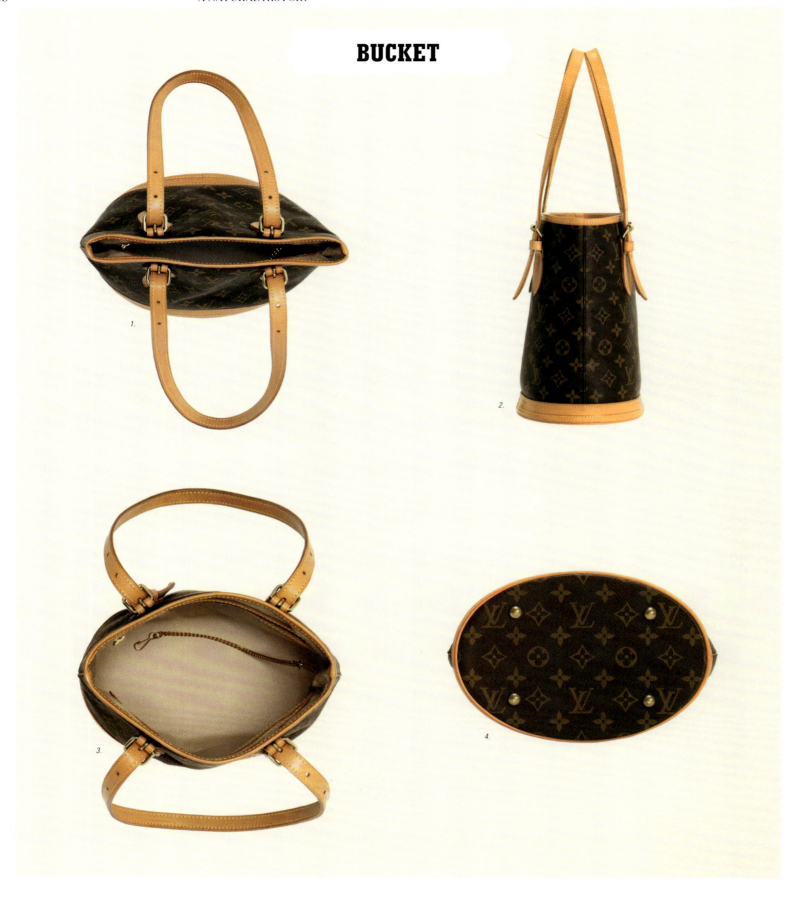

Small Bucket in Monogram canvas, 23 × 26 × 16 cm: 1. Closed, seen from above — 2. Profile view —
3. Open, seen from above — 4. Seen from below

Opposite: Detail of the base and two metallic bottom studs. Photograph by Patrick Gries, 2013

MORPHOLOGY

NOÉ

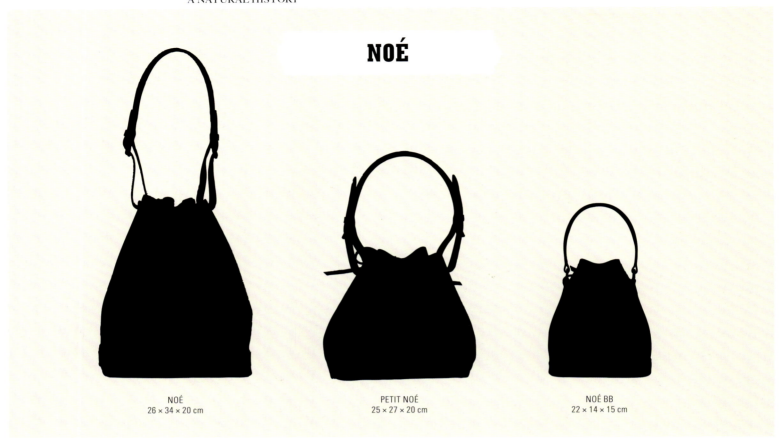

NOÉ
26 × 34 × 20 cm

PETIT NOÉ
25 × 27 × 20 cm

NOÉ BB
22 × 14 × 15 cm

BUCKET

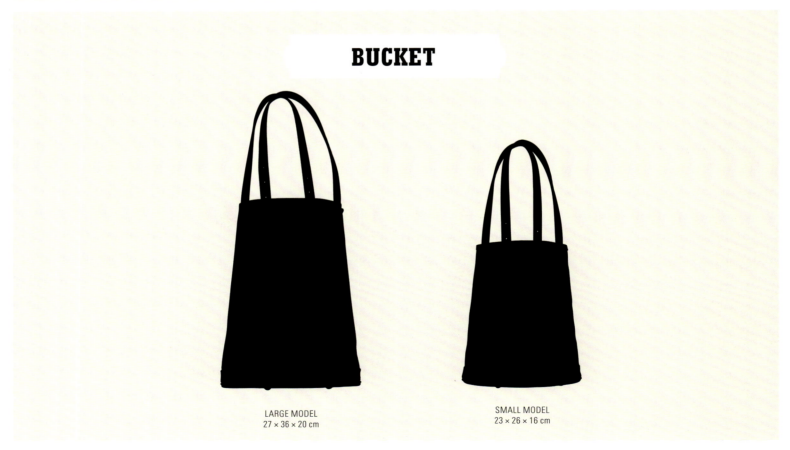

LARGE MODEL
27 × 36 × 20 cm

SMALL MODEL
23 × 26 × 16 cm

The Noé is available in three main sizes: standard, petit and BB. The Bucket exists in large and small models.

DIMENSIONS

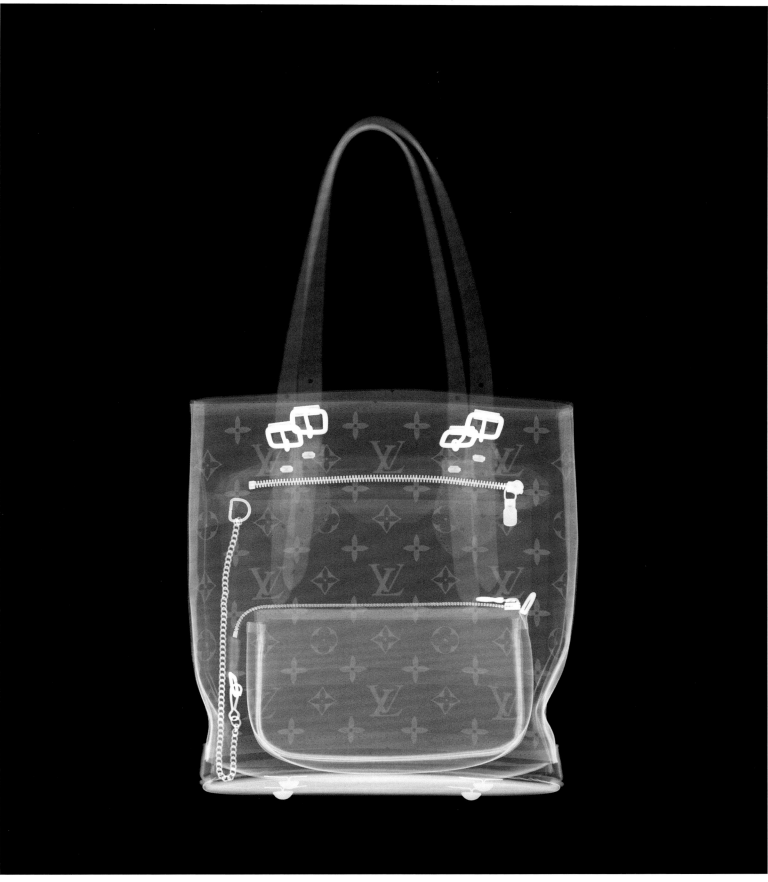

Small Bucket in Monogram canvas with Mini Pochette Accessoires, 23 × 26 × 16 cm. The x-ray shows the semi-rigid structure and the cylindrical form of the bag, as well as its metallic elements: the inside pocket's zipper and slider, the buckles on the handles and the studs on the bottom of the bag, the metallic chain and its attachment ring and the zipper and slider of the Mini Pochette Accessoires inside. The reinforced base and the Monogram motif are also visible. Photograph by Nick Veasey, 2013

X-RAY

Louis Vuitton surprend depuis 1854.

Les bagages et accessoires Louis Vuitton ne sont en vente que dans les magasins
exclusifs Louis Vuitton : Paris • Nice • Cannes • Deauville • Strasbourg •
Toulouse • Lyon • Bordeaux • Marseille • Lille • Monte-Carlo • Genève • Lausanne •
Crans-sur-Sierre • Bruxelles • Luxembourg.
Pour de plus amples informations, veuillez appeler le (1) 45 62 47 00.

L'âme du voyage

"The Imaginary Voyages of Louis Vuitton." Advertising insert from the series "The Spirit of Travel" presenting a Noé in
Monogram canvas, 1995. Photograph by Jean Larivière, 1995.

Opposite: Isabeli Fontana carries a Bucket in Monogram canvas. Photograph by David Sims, *Vogue Paris*, November 2009

CARRIED AWAY

Scene from the American television series *Bewitched*, which aired from 1964 to 1972.
The actress Elizabeth Montgomery, who plays Samantha, carries a large Bucket Purse in Monogram canvas.
Photograph from ABC Photo Archives

Opposite: Anne and Kirk Douglas, 1960. Anne Douglas carries a large Bucket Purse in Monogram canvas.
Photograph by Michel Jeanneau, *L'Illustration*, late 1960s

SIGHTINGS

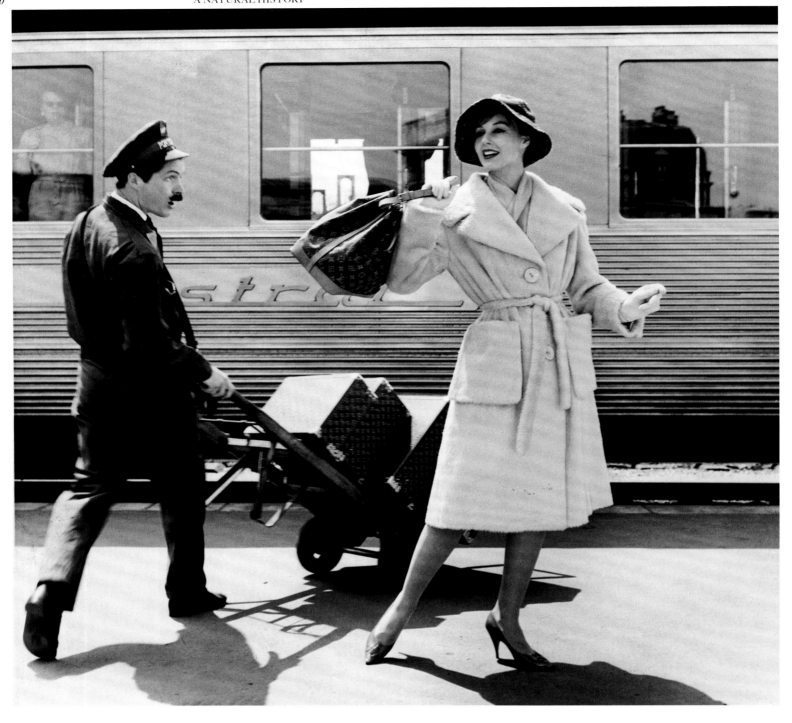

On the train platform, in front of the *Mistral* that connects Paris to the Côte d'Azur, the model carries a Noé in
Monogram canvas; on the luggage cart are Cotteville, Bessac and Bisten suitcases in Monogram canvas, *Vogue Paris*, 1960s

Opposite: "Bon voyage." Press article featuring a Noé in Monogram canvas. Photograph by Seeberger, *Collections*,
Autumn-Winter 1961. Louis Vuitton Archives

TRAVEL

BON VOYAGE

JEAN LUCE

Jan Luce. « Frileuse ». Trois-quarts en jersey gris avec col châle recouvert de tricot à grosses côtes. Chapeau Jean Barthet. Bagages Louis Vuitton.

Blonco. « 425 ». Manteau en lainage à carreaux fondus bruns, turquoise et tabac de L.S.P. Louis Schmoll. Col rabattu, ampleur discrète, une martingale retient les plis du dos. Chapeau Jean Barthet. Chaussures C. Jourdan.

BLONCO

SEEBERGER

From left to right, top to bottom: Autumn-Winter 2009–2010 runway show, look 48, the model carries a Néo Noé in cranberry Monogram
Double Jeu — Autumn-Winter 2009–2010 runway show, look 60, the model carries a Néo Noé in ambre Monogram
Éclipse — Autumn-Winter 2009–2010 runway show, look 14, the model carries a Néo Noé in blue Monogram Double Jeu — Autumn-Winter
2009–2010 runway show, look 54, the model carries a Néo Noé in black Monogram Éclipse. Photographs by Chris Moore, 2009

Opposite: Autumn-Winter 2009–2010 advertising campaign. Madonna carries a Néo Noé in cranberry Monogram Double Jeu.
Photograph by Steven Meisel, 2009

SEASONAL COLLECTIONS

RANDONNÉE 1978

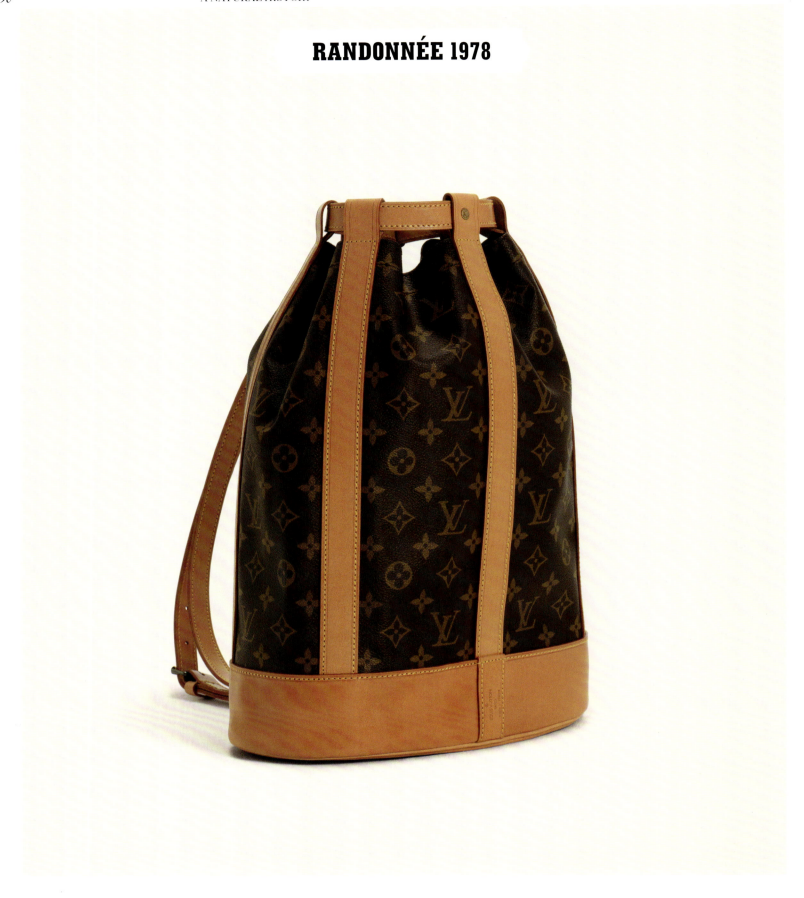

Randonnée in Monogram canvas, 1978, 29 × 40 × 15.5 cm. Louis Vuitton Collection. The Randonnée in Monogram canvas was launched in 1978 as an accessory for hikers and day-trippers. It inherited its form from the Navy bag and belongs to the range of bucket bags. Like the Noé and the Bucket, this bag with rounded lines has a leather-reinforced base and a structure in canvas or leather (in its 1986 Epi version). However, its body is still made from one single piece, supported by vertical leather straps. It can be carried around the body, by hand or over the shoulder thanks to its adjustable handles. Though it has no inner compartments, like the Noé and the Bucket it contains a Pochette Accessoires for storing precious personal items.

DIVERSIFICATION

RANDONNÉE C. 1990

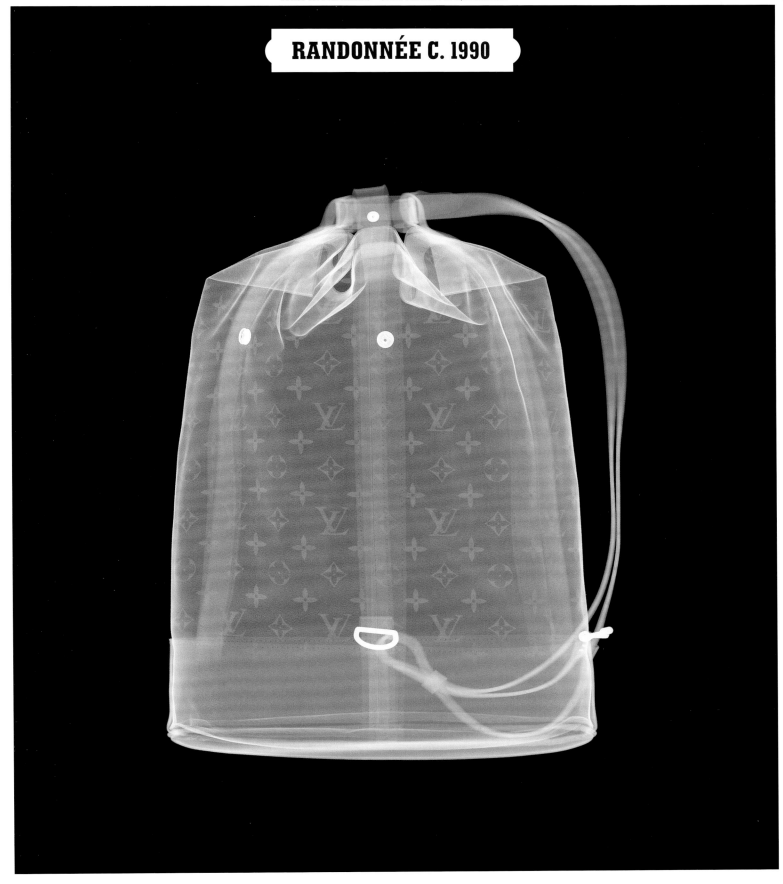

X-ray of the large Randonnée in Monogram canvas, c. 1990, 33 × 48 × 18 cm. The x-ray shows the bag's semi-rigid structure, cylindrical form, leather reinforcement straps and cinched closure, as well as its metallic elements, including the rivets, the strap buckle and the half-round D-ring strap attachment. The reinforced base and the Monogram motif are also visible. Photograph by Nick Veasey, 2013

X-RAY

NOÉ: TAKASHI MURAKAMI

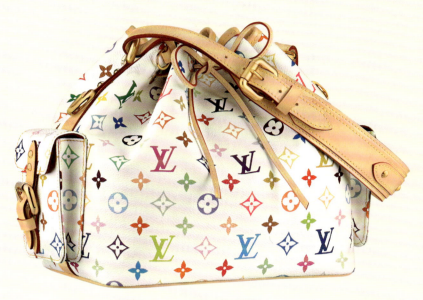

PETIT NOÉ
In white Monogram Multicolore

PETIT NOÉ
In black Monogram Multicolore

Two Petit Noé in white Monogram Multicolore (above) and black Monogram Multicolore (below), 2005, 25 × 27 × 18 cm. Two
side pockets were added to make the bag's traditional silhouette more dynamic. The Monogram Multicolore line is
the result of a collaboration with the Japanese artist Takashi Murakami in 2007 (see p. 327). Monogram Multicolore (2002)
is a creation by Takashi Murakami for Louis Vuitton. © Takashi Murakami / Kaikai Kiki Co., Ltd. All rights reserved.

ARTISTIC VARIATIONS

BUCKET: TAKASHI MURAKAMI

Bucket in Monogram Cerises, 2004, 23 × 26 × 16 cm. The Monogram Cerises line is the result of a collaboration with
the Japanese artist Takashi Murakami in 2004 (see p. 327 and pp. 370–371). Monogram Cerises (2004) is a creation by Takashi
Murakami for Louis Vuitton. © Takashi Murakami / Kaikai Kiki Co., Ltd. All rights reserved.

all Black space

all white space

2 IS 1

"ICON BAG"

2006

Preparatory sketch for the installation *Interpreting the Noé Bag*, Robert Wilson, 2006. This video installation
by the American director was presented at the Espace Culturel Louis Vuitton on the top floor of the
Champs-Élysées store in Paris, during the exhibition "Icons" (September 15 to December 31, 2006), which featured
representations of the House's iconic bags by contemporary artists and designers.

Opposite: *Interpreting the Noé Bag*, Robert Wilson, 2006

INSTALLATIONS

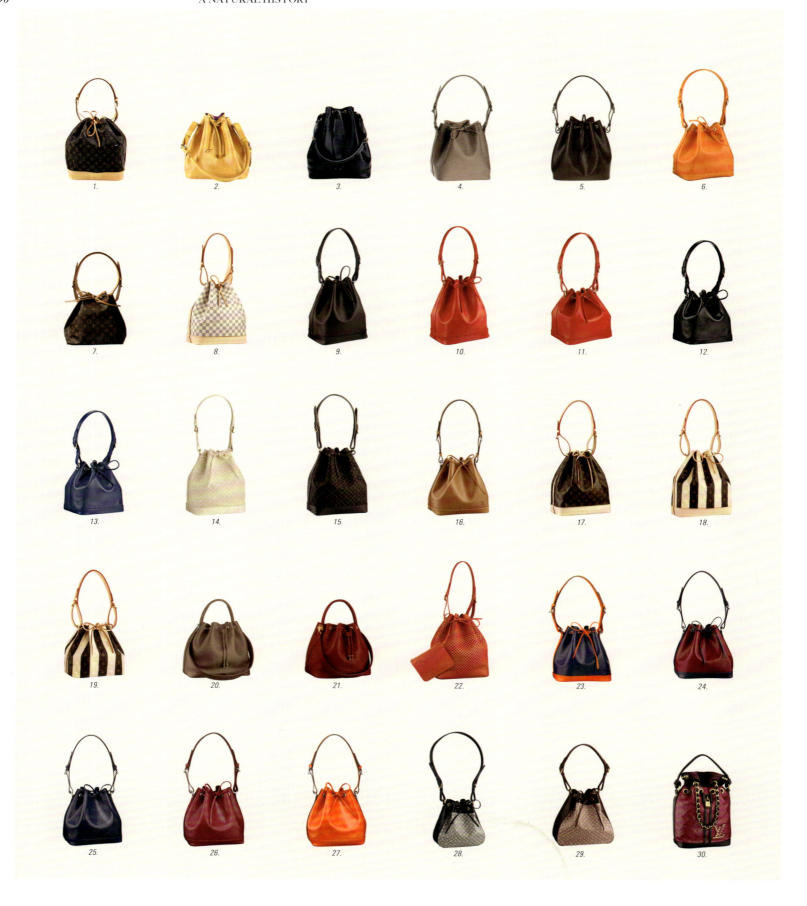

1. Noé in Monogram canvas, 1995 — 2. Petit Noé in jaune tassili Epi leather, 1996 — 3. Noé in noir kouril Epi leather, 1999 — 4. Petit Noé in lilas Epi leather, 2002 — 5. Petit Noé in moka Epi leather, 2000 — 6. Petit Noé in mandarine Epi leather, 2003 — 7. Petit Noé in Monogram canvas, 1999 — 8. Noé in Damier Azur canvas, 2006 — 9. Noé in moka Epi leather, 2003 — 10. Noé in red Epi leather, 2003 — 11. Petit Noé in red Epi leather, 2003 — 12. Petit Noé in black Epi leather, 2013 — 13. Petit Noé in myrtille Epi leather, 2004 — 14. Noé in dune Monogram Mini Lin, 2007 — 15. Noé in ébène Monogram Mini Lin, 2007 — 16. Petit Noé in cannelle Epi leather, 2007 — 17. Noé in Monogram canvas, 1999 — 18. Noé in Monogram Rayures canvas, 2012 — 19. Petit Noé in Monogram Rayures canvas, 2012 — 20. Large Noé in taupe Bougie calfskin leather, 2012 — 21. Small Noé in red Écorce calfskin leather, 2012 — 22. Noé in perforated corail Flore calfskin leather and matching pochette, 2012 — 23. Petit Noé in indigo, menthe and piment Epi leather, 2012 — 24. Petit Noé in figue fuchsia and indigo Epi leather, 2012 — 25. Petit Noé in indigo Epi leather, 2013 — 26. Petit Noé in fuchsia Epi leather, 2013 — 27. Petit Noé in piment Epi leather, 2013 — 28. Small Noé in encre Monogram Idylle, 2012 — 29. Small Noé in sépia Monogram Idylle, 2012 — 30. Néo Noé in cranberry Monogram Double Jeu, 2009

BIODIVERSITY: THE NOÉ

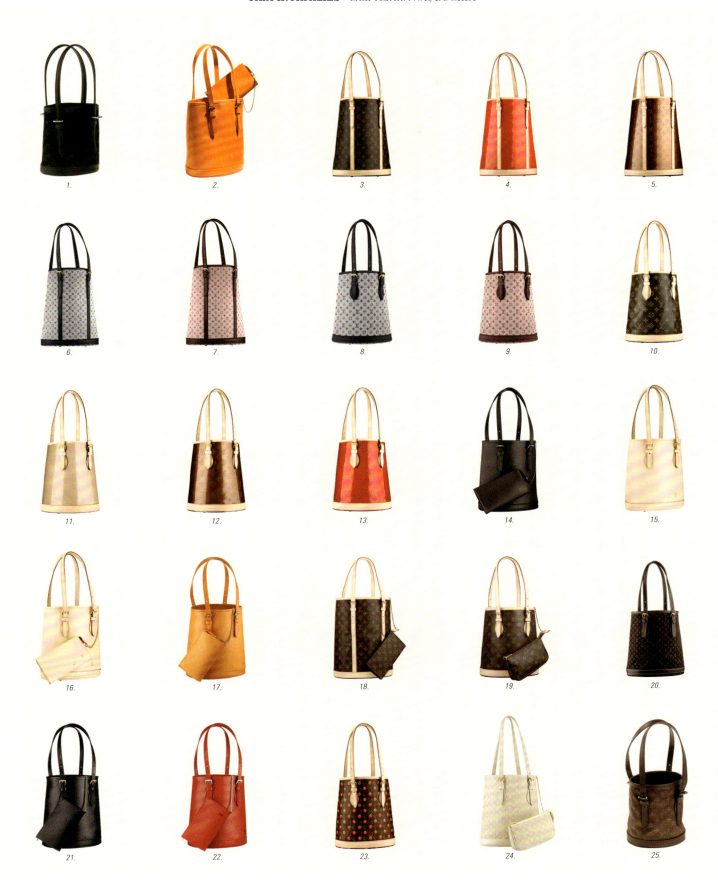

1. Little Bucket in black Monogram Satin, 2001 — 2. Large Bucket in mandarine Epi leather and matching pochette, 2003 — 3. Large Bucket in Monogram canvas, 1999 — 4. Large Bucket in red Monogram Vernis, 2003 — 5. Large Bucket in bronze Monogram Vernis, 2003 — 6. Large Bucket in blue Monogram Mini, 2003 — 7. Large Bucket in cerise Monogram Mini, 2003 — 8. Small Bucket in blue Monogram Mini, 2003 — 9. Small Bucket in cerise Monogram Mini, 2003 — 10. Small Bucket in Monogram canvas, 1999 — 11. Small Bucket in beige Monogram Vernis, 2003 — 12. Small Bucket in bronze Monogram Vernis, 2003 — 13. Small Bucket in red Monogram Vernis, 2003 — 14. Small Bucket in moka Epi leather and matching pochette, 2003 — 15. Small Bucket in natural cowhide leather, 2003 — 16. Small Bucket in natural cowhide leather and matching pochette, 2003 — 17. Small Bucket in mandarine Epi leather and matching pochette, 2003 — 18. Large Bucket in Monogram canvas and matching pochette, 1999 — 19. Small Bucket in Monogram canvas and matching pochette, 1999 — 20. Small Bucket in ébène Monogram Mini Lin, 2006 — 21. Small Bucket in black Epi leather and matching pochette, 2003 — 22. Small Bucket in red Epi leather and matching pochette, 2003 — 23. Small Bucket in Monogram Cerises, 2004 — 24. Small Bucket in dune Monogram Mini Lin and matching pochette, 2007 — 25. Little Bucket in taupe Monogram Satin, 2001

BIODIVERSITY: THE BUCKET



ARTSY

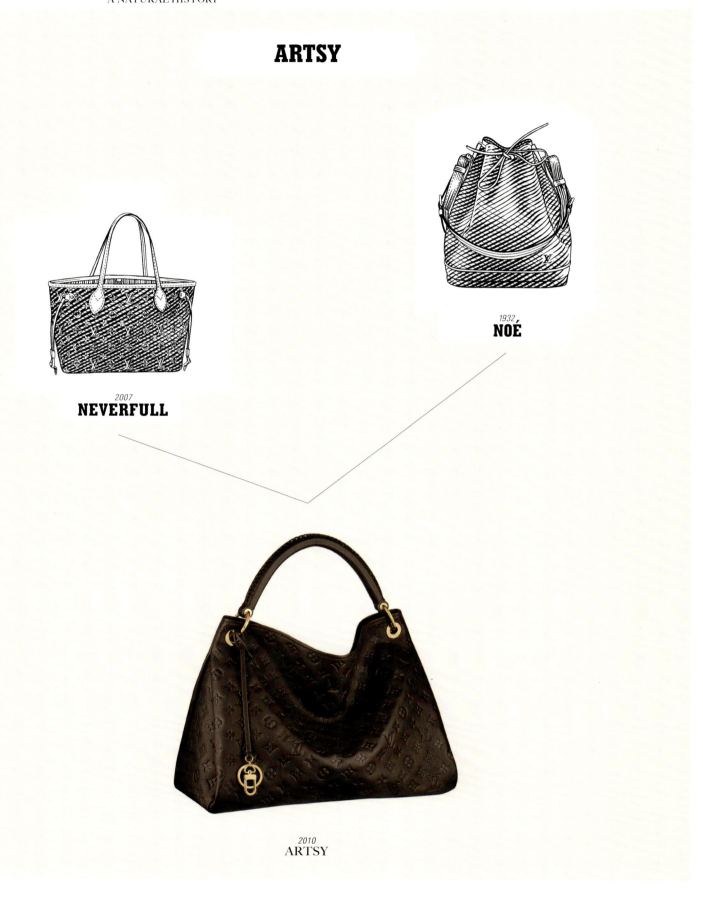

2007
NEVERFULL

1932
NOÉ

2010
ARTSY

Medium Artsy in ombre Monogram Empreinte, 2010, 24 × 32 × 46 cm. The Artsy, which could be a cross between
the iconic Noé and Neverfull bags, was born in 2010. From the former, it could have inherited its elegant simplicity and its
single handle. It probably gets its suppleness and large capacity from the latter. Drawings by Martin Mörck, 2013

Opposite: Spring-Summer 2010 advertising campaign. Beside Lara Stone is a large Artsy in Monogram canvas.
Photograph by Steven Meisel, 2010

Following double page: The model carries an Aviator bag in bordeaux Monogram Aviator, whose lines are reminiscent of
the Noé's. Photograph by Sølve Sundsbø, *Vogue Italia*, September 2011

HYBRIDIZATION

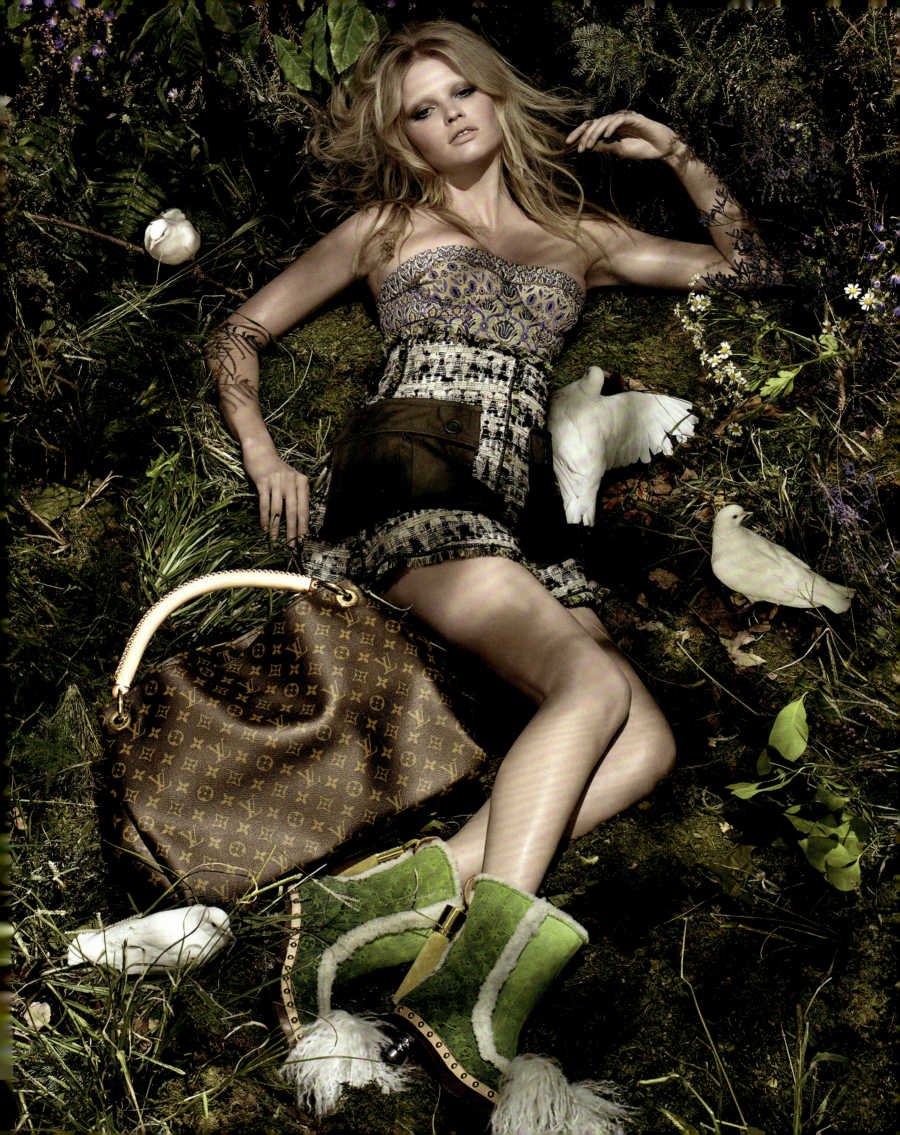

SAC PLAT
In Damier Ébène canvas

NEVERFULL, MEDIUM MODEL
In Damier Azur canvas

Chapter IV:
SAC PLAT/NEVERFULL
Pages 202–245

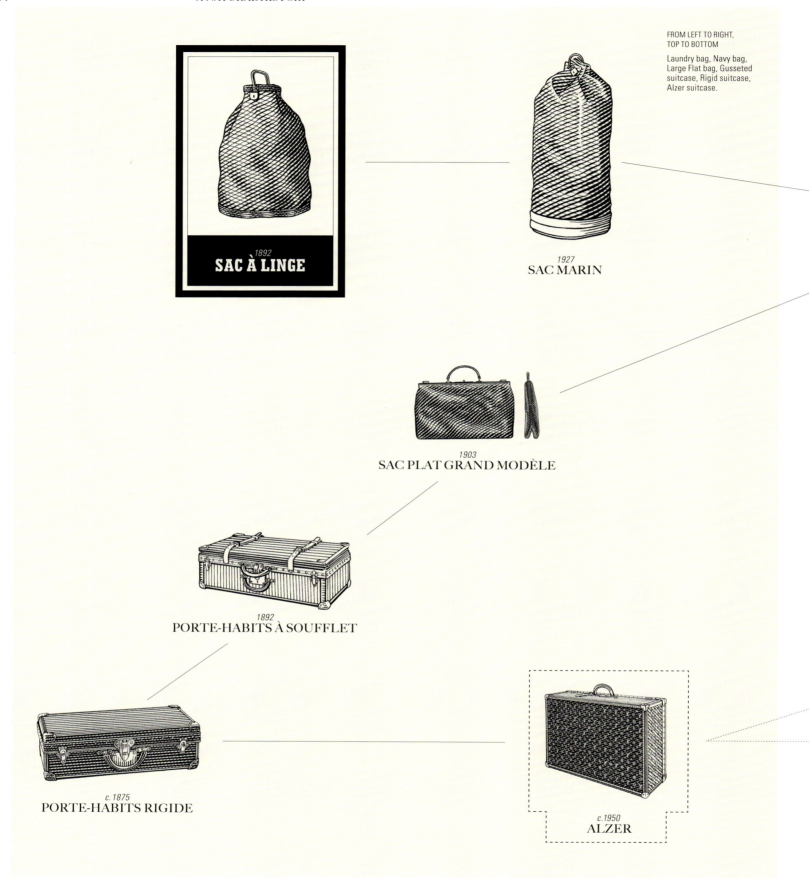

FROM LEFT TO RIGHT,
TOP TO BOTTOM

Laundry bag, Navy bag,
Large Flat bag, Gusseted
suitcase, Rigid suitcase,
Alzer suitcase.

1892
SAC À LINGE

1927
SAC MARIN

1903
SAC PLAT GRAND MODÈLE

1892
PORTE-HABITS À SOUFFLET

c.1875
PORTE-HABITS RIGIDE

c.1950
ALZER

Descendants of the wardrobe trunk and the steamer trunk, lighter hand luggage—from the Alzer suitcase
to the gusseted suitcase, and occasional bags such as the Laundry bag and Navy bag—developed in the late 19th
century. These two lineages crossed, resulting in a new generation of bags with a basic rectangular form:
a supple rectangle in the case of the Neverfull, the legacy of the Navy bag, and a more rigid rectangle for the

GENEALOGY: NEVERFULL AND SAC PLAT

FROM LEFT TO RIGHT,
TOP TO BOTTOM

Beach bag, Week-End
bag, Neverfull, Sac Plat,
Président Classeur,
Porte-documents Voyage,
Cotteville suitcase

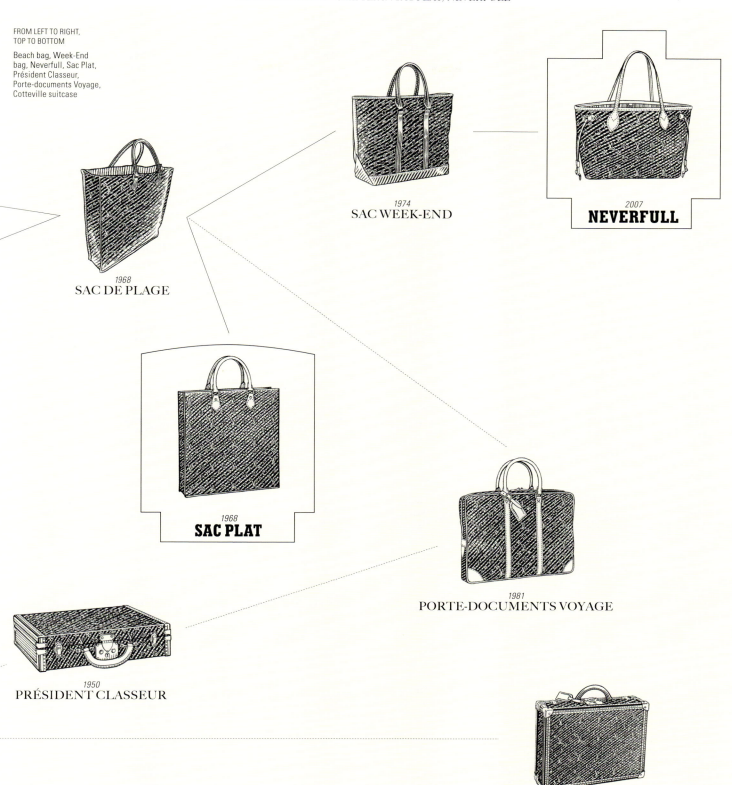

1974
SAC WEEK-END

2007
NEVERFULL

1968
SAC DE PLAGE

1968
SAC PLAT

1981
PORTE-DOCUMENTS VOYAGE

1950
PRÉSIDENT CLASSEUR

1999
VALISE COTTEVILLE

Sac Plat, which inherited the gusset from its ancestor, the suitcase. Functionally, they take after their
predecessors: the Neverfull is at its best in a relaxed, maritime setting, while the Sac Plat is well
suited to an urban, professional context. The former also shares common traits with the Bucket, while
the latter is closer to the Porte-documents Voyage. P. 202 and above drawings by Martin Mörck, 2013

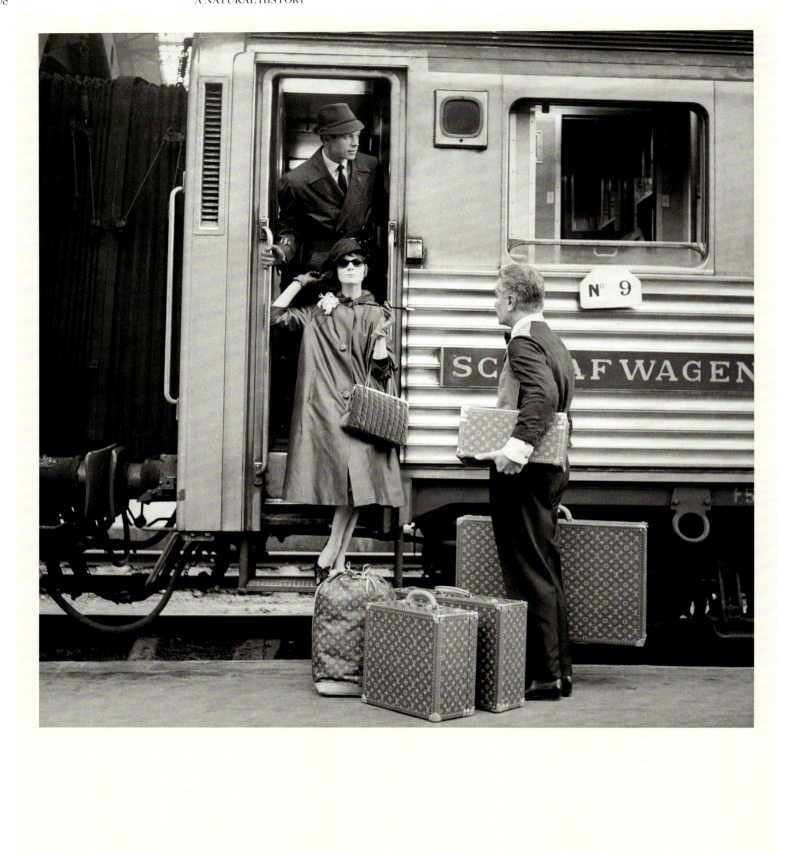

An elegant woman steps off a train with her luggage: Alzer and Cotteville suitcases, a Navy bag and a Vanity Case in Monogram canvas.
She carries a cloth ladies' handbag. 1960s. Louis Vuitton Archives

SAC PLAT/NEVERFULL
COLOMBE PRINGLE

The Sac Plat and the Neverfull: two brothers of well established character. They are neither entirely the same, nor entirely different; they share many common features—no closure, a simple structure, two handles— but they cultivate their differences. Each has chosen its own path: one is the more masculine and professional, while the other is more epicurean and sporty. Both have inherited a sense of duty from their ancestors, yet they each affirm their own preferences.

The Sac Plat has retained much from its progenitor, the suitcase. A more compact, lighter version of the rigid trunk, it elegantly accompanied larger luggage and replaced it for short stays, carrying the essential items for the traveller's appearance and comfort: "toiletries case, sleepwear and a change of clothes for the next day."

The Neverfull has visible connections to the famous Navy bag, which could be flattened down to almost nothing at the bottom of a cabin trunk only to open up again at the opportune moment, and its parent, the Laundry Bag (1892). These ancestors—indispensable for any self-respecting globe-trotter—left their legacy in its cylindrical form, its small leather handles and the soft canvas that would bend to the desires of its master, making it the ideal companion for long journeys.

At the crossroads of history, they would each exhibit their qualities and evolve in their own right.

PRECEDING DOUBLE PAGE SPREAD

"Louis Vuitton. Damier." 1998 advertising campaign. Maggie Rizer carries a Sac Plat Venice in Damier Ébène canvas Photograph by Inez van Lamsweerde and Vinoodh Matadin, 1998

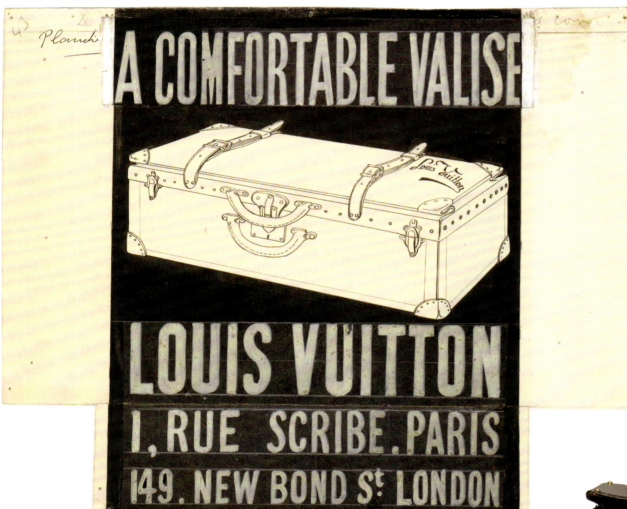

A COMFORTABLE VALISE

LOUIS VUITTON

1, RUE SCRIBE. PARIS

149. NEW BOND St LONDON

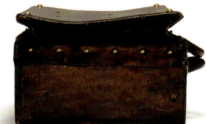

MALLE VACHE
à ½ Soufflet

Longueur : 55, 60, 65, 70 et 75 cent.

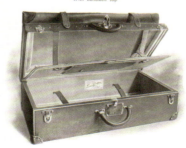

THE COWHIDE VALISE
With bellowed top

Length : 22, 24, 26, 28 & 30 inches

The Sac Plat had its own revolution. May 1968 called for "power to the imagination!" The word "design" had just been added to the French dictionary. French women were daring to wear trousers in the city, but in the office, only 7% "wore the pants." The Sac Plat also turned away from its past, becoming a multi-purpose hold-all. It was used for shopping, in boutiques or at the market. It was better still for carrying working women's files. Thus, it became the ally of women who claimed equality and liberty for themselves. Rectangular, with Toron handles, available in two sizes and fitted with a generous gusset, it made its first appearance in Monogram canvas. Appreciated for its allure as much as for its elegant sobriety, it has been produced over the seasons and the years in Epi leather and in Damier checked canvas, as well as being embellished with cherries by Takashi Murakami. Since its early days, it has been an obvious choice for women with an eye for style—and a sense for good investments. Thirty years later, there was a new call for equality: men would claim the right to their own version of this cult tote bag—a new star in the galaxy of Louis Vuitton icons.

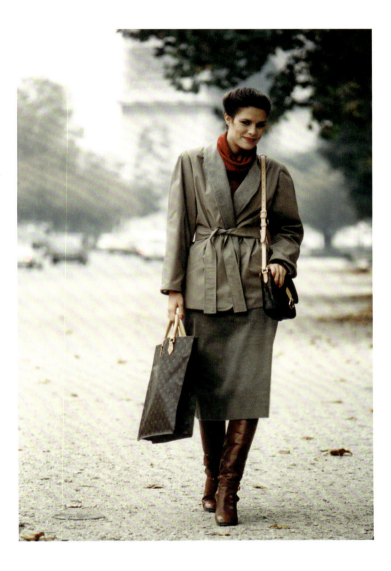

The last born of its line, the Neverfull has inherited all of its ancestors' qualities—not least of which its capacity, affirmed by its name. This is a bag that will never be overwhelmed by its contents, or by its success. The Neverfull came into existence in 2007. Its interior pays homage to its lineage with a striped lining that recalls the canvas in the trunks of times past (though the stripes have been updated with a flower motif); however, the lining isn't only there "to tell a story, but also to be functional," says Nicholas Knightly, Director of Leather Goods Design since 2004. Graced with slender handles in natural cowhide leather and "reinforced with double stitching and thick overstitched chapes," each is able to support more than a hundred kilos in weight. Beneath its apparent lightness, there's a resistance that can withstand any challenge. It stands at the ready to fulfill the daily needs – from the pragmatic to the whimsical—of its users: "We didn't have a bag for going to the beach, working, shopping, carrying baby equipment… The Neverfull is all of that combined." It is intelligently designed down to the smallest detail to accomplish its mission, boasting: "exactly the right length from the shoulder to be comfortable and give a sensation of intimacy and closeness to the body; two small cords on the sides for changing its form and therefore its look, by transitioning from sportswear to sophisticated; a lightness due to the voluntary absence of metal." And, like the Sac Plat, it can also be flattened to slip tidily into a suitcase, bending just as easily to the desires of those who make it the servant of their predilections. To each her trophy, from Saint-Tropez to Palm Beach, from Porto Cervo to Kitzbühel. The destinies and the destinations for the Neverfull are infinite, for not only is it never too full, but it is always to hand! A member of the House's very select club of icons, it will undoubtedly be a receptacle for the fondest memories of generations to come. And that is how history is made.

The model carries a Sac Plat in her hand and a Saint-Cloud bag over her shoulder, both in Monogram canvas
Photograph taken in 1979
Louis Vuitton Archives

Week-End bag in Monogram canvas, 1991, 46.5 × 30.5 × 13 cm, 1.1 kg
Louis Vuitton Collection

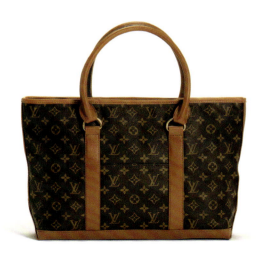

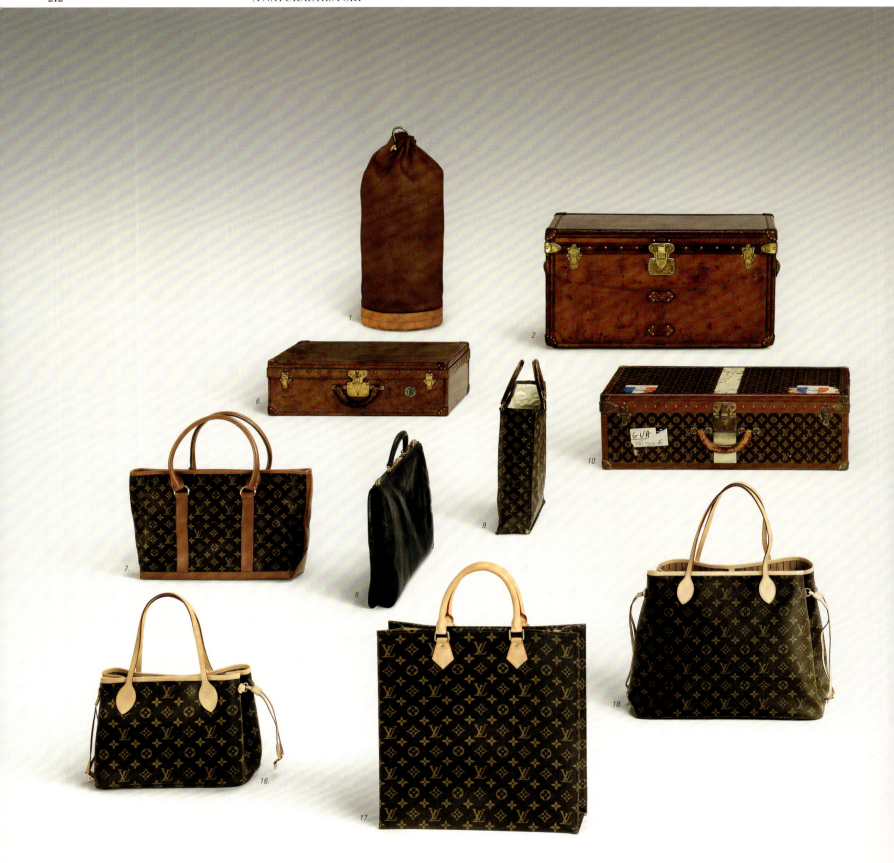

The iconic bags are pictured in the foreground; their "ancestors" are in the background. 1. Navy bag in canvas, 1929, 41 × 103 × 41 cm — 2. Mail trunk in natural cowhide leather, 1900, 97 × 54 × 51 cm, 25.3 kg. Louis Vuitton Collection — 3. Gusseted suitcase in leather, 1891, 71 × 22 × 36 cm, 7.2 kg. Louis Vuitton Collection — 4. Wardrobe trunk in Monogram canvas, c. 1905, 57 × 129 × 59 cm, 43.8 kg. Louis Vuitton Collection — 5. Navy bag in Monogram canvas, 1986, 27 × 50 × 30 cm, 1 kg. Louis Vuitton Collection — 6. Suitcase in natural cowhide leather, 1912, 65 × 21 × 42 cm, 5.7 kg. Louis Vuitton Collection — 7. Week-End bag in Monogram canvas, 1991, 46.5 × 30.5 × 13 cm, 1.1 kg. Louis Vuitton Collection — 8. Large flat bag in leather, c. 1910, 55 × 42 × 13 cm, 1.9 kg. Louis Vuitton Collection — 9. Beach Bag in Monogram canvas, 1968, 38 × 36.5 × 12 cm. Louis Vuitton Collection — 10. Alzer suitcase in Monogram canvas, 1956, 82 × 27 × 54 cm, 9.4 kg. Louis Vuitton Collection —

FAMILY PORTRAIT

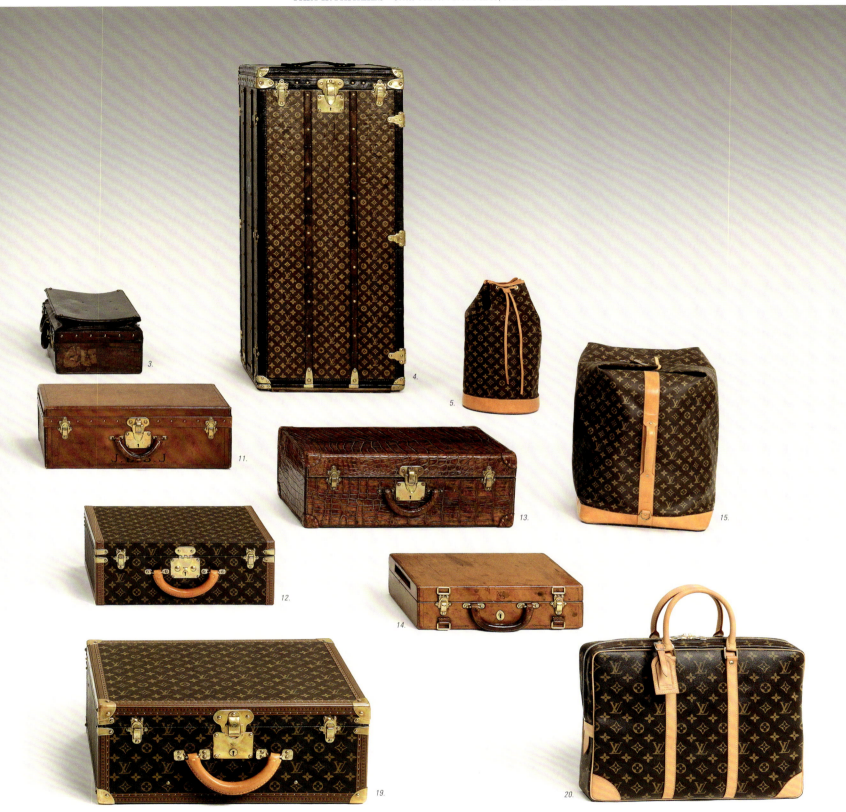

11. Leather suitcase, 1904, 61.5 × 22 × 42 cm, 6.9 kg. Louis Vuitton Collection — 12. Super Président Classeur attaché case in Monogram canvas, 1983, 45 × 18 × 37 cm, 3.2 kg. Louis Vuitton Collection — 13. Suitcase in crocodile leather, 1903, 62 × 24 × 42 cm, 6.7 kg. Louis Vuitton Collection — 14. Despatch box in natural cowhide leather, 1921, 41 × 12 × 34 cm, 2.8 kg. Louis Vuitton Collection — 15. Navy bag in Monogram canvas, 1990, 36 × 60 × 36 cm, 2.2 kg. Louis Vuitton Collection — 16. Small Neverfull in Monogram canvas, 2007, 29 × 22 × 13 cm. Louis Vuitton Collection — 17. Sac Plat in Monogram canvas, 1968, 38 × 36.5 × 9 cm — 18. Large Neverfull in Monogram canvas, 2007, 40 × 33 × 20 cm — 19. Cotteville suitcase in Monogram canvas, 1999, 51.5 × 21 × 40 cm, 4.7 kg. Louis Vuitton Collection — 20. Porte-documents Voyage in Monogram canvas, 1984, 16.5 × 13 × 3.5 cm. Louis Vuitton Collection. Photograph by Patrick Gries, 2013

NEVERFULL

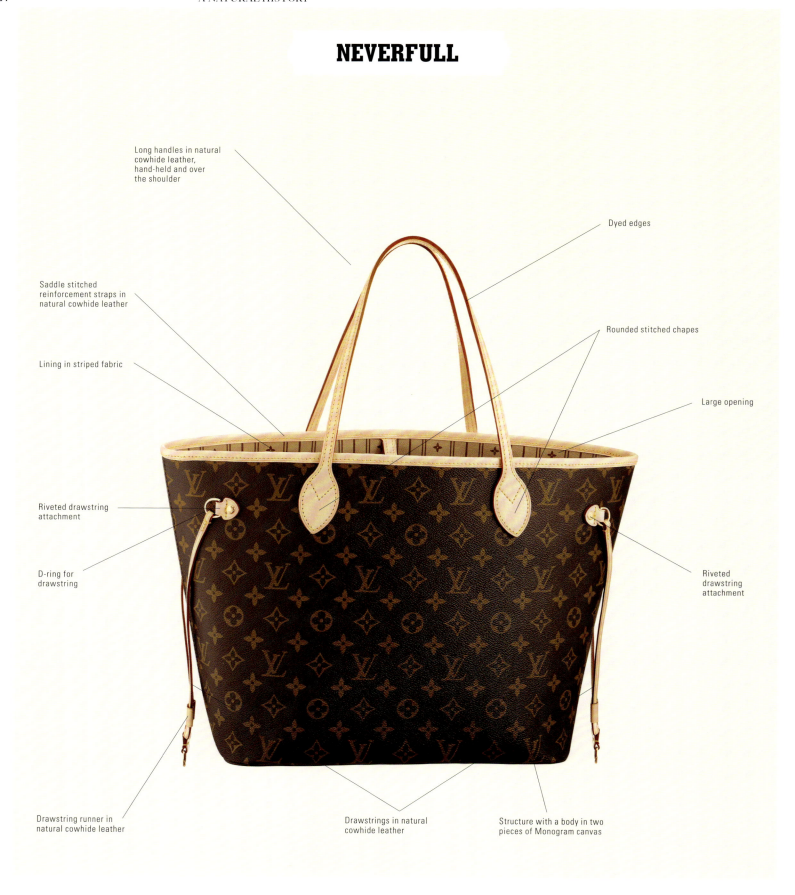

Long handles in natural
cowhide leather,
hand-held and over
the shoulder

Dyed edges

Saddle stitched
reinforcement straps in
natural cowhide leather

Rounded stitched chapes

Lining in striped fabric

Large opening

Riveted drawstring
attachment

Riveted
drawstring
attachment

D-ring for
drawstring

Drawstring runner in
natural cowhide leather

Drawstrings in natural
cowhide leather

Structure with a body in two
pieces of Monogram canvas

Medium Neverfull in Monogram canvas, 32 × 29 × 17 cm — Sac Plat in Monogram canvas,
38 × 36.5 × 9 cm. The Neverfull and the Sac Plat take the form of rectangular prisms that are open at
the top and have identical opposite sides. Five pieces are required for their construction.
They each have two handles, favoring over the arm or over the shoulder wear in the case of the Neverfull;

COMPARATIVE ANATOMY

SAC PLAT

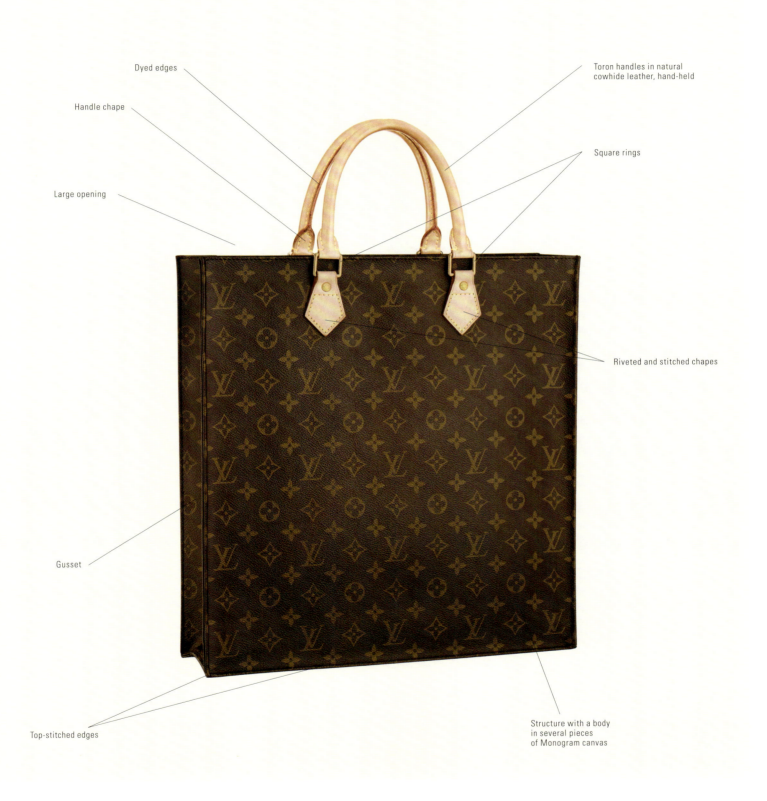

Dyed edges

Handle chape

Large opening

Gusset

Top-stitched edges

Toron handles in natural
cowhide leather, hand-held

Square rings

Riveted and stitched chapes

Structure with a body
in several pieces
of Monogram canvas

the Sac Plat is only carried by hand. The Neverfull inherited its soft structure from
occasional bags such as the Navy bag and the Overnight Bag, and can therefore be
considered as closely related to the Keepall and the Speedy as to the Bucket and the Noé. The Sac Plat,
however, has a more rigid structure that it shares with its ancestors the suitcases.

NEVERFULL

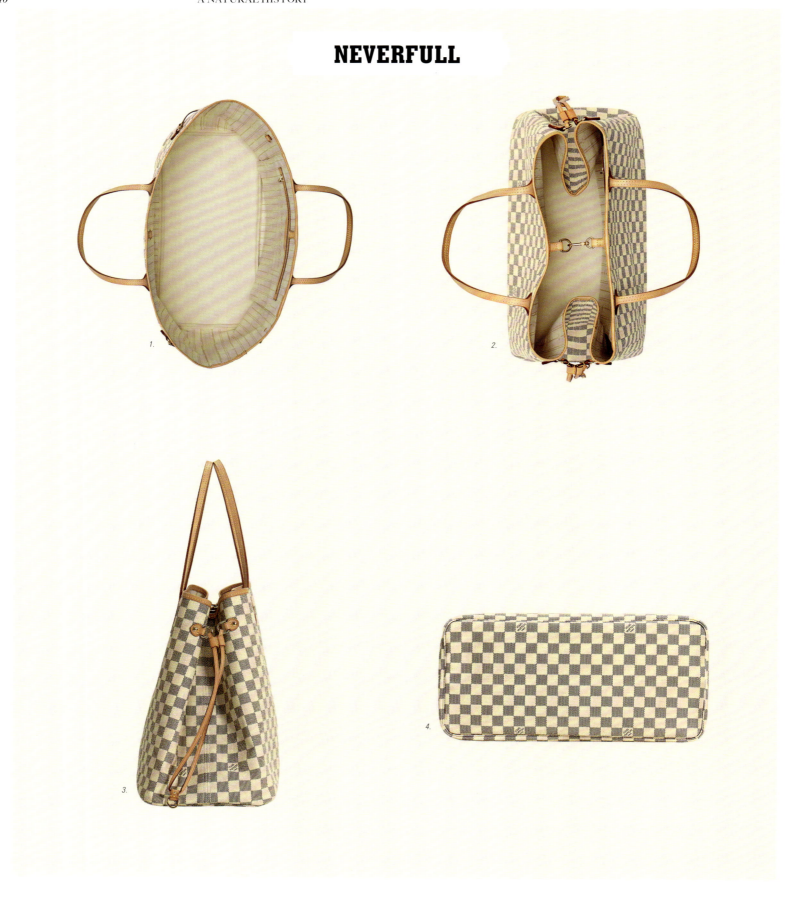

Large Neverfull in Damier Azur canvas, 40 × 33 × 20 cm: 1. Open, seen from above — 2. Closed, seen from above —
3. Profile view — 4. Seen from below

Opposite: Detail of the riveted drawstring attachment, the half-round D-ring and the drawstring.
Photograph by Patrick Gries, 2013

MORPHOLOGY

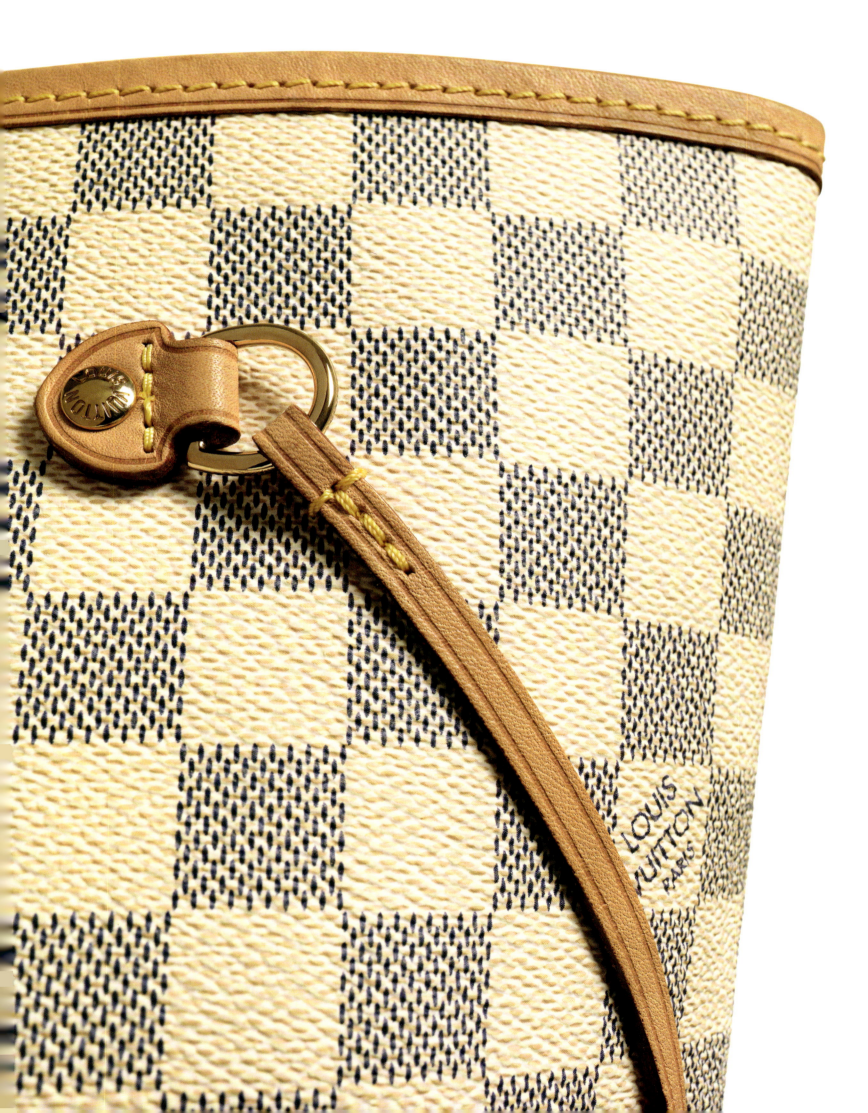

LOUIS
VUITTON
PARIS

SAC PLAT

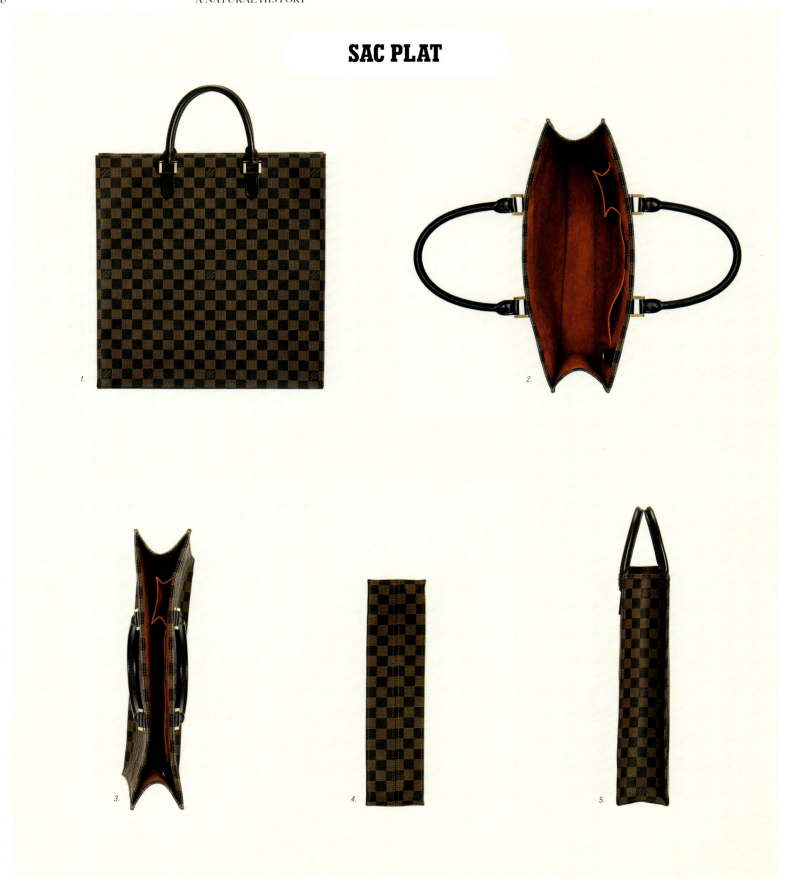

Sac Plat in Damier Ébène canvas, 36.5 × 38 × 9 cm: 1. Front view — 2. Open, seen from above —
3. Closed, seen from above — 4. Seen from below — 5. Profile view

Opposite: Detail of the interior and the inside pocket. Photograph by Patrick Gries, 2013

MORPHOLOGY

INSIDE POCKET

HANDLES

Parts for the construction of the interior pocket and the handles of the Neverfull: 1. Cotton lining fabric — 2. Tab and D-ring holder —
3. Zipper — 4. Leather pieces — 5. Overcut pieces — 6. Stitched leather — 7. Edging dye

NEVERFULL DECONSTRUCTED

SIDE DRAWSTRINGS

BODY

Parts for the construction of the side drawstrings and the body of the Neverfull: 8. Leather drawstrings — 9. Leather piece, half-round D-ring
and completed drawstring attachment with rivets — 10. Leather piece, half-round D-ring and rivet for the D-ring attachment tab on the
drawstrings — 11. Leather drawstrings — 12. Leather pieces, half-round D-ring and rivet for inside D-ring attachment tab — 13. Damier Ébène
canvas lined with red striped fabric — 14. Base in Damier Ébène canvas for the exterior and red textile for the interior — 15. Finishing strips
Drawings by Martin Mörck, 2013

NEVERFULL

SMALL MODEL
29 × 22 × 13 cm

MEDIUM MODEL
32 × 29 × 17 cm

LARGE MODEL
40 × 33 × 20 cm

XL
51 × 38 × 21 cm

The Neverfull is available in four sizes: XL, large, medium and small

DIMENSIONS

SAC PLAT

Sac Plat in Damier Ébène canvas, 36.5 × 38 × 9 cm. The x-ray shows the semi-rigid structure and the rectangular form of
the bag, as well as its metallic elements: the half-round D-ring on the left and the square rings that attach the handles. The folds
in the side gussets and base and the Damier motif are also visible. Photograph by Nick Veasey, 2013

X-RAY

Large Neverfull in Damier Azur canvas, 40 × 33 × 20 cm: 1. Folded in three — 2. Folded in two — 3. Unfolded, empty — 4. Unfolded, full.
The Neverfull is easily folded and unfolded, allowing it to be carried inside other luggage without taking up too much space.

UNFOLDING THE NEVERFULL

3.

4.

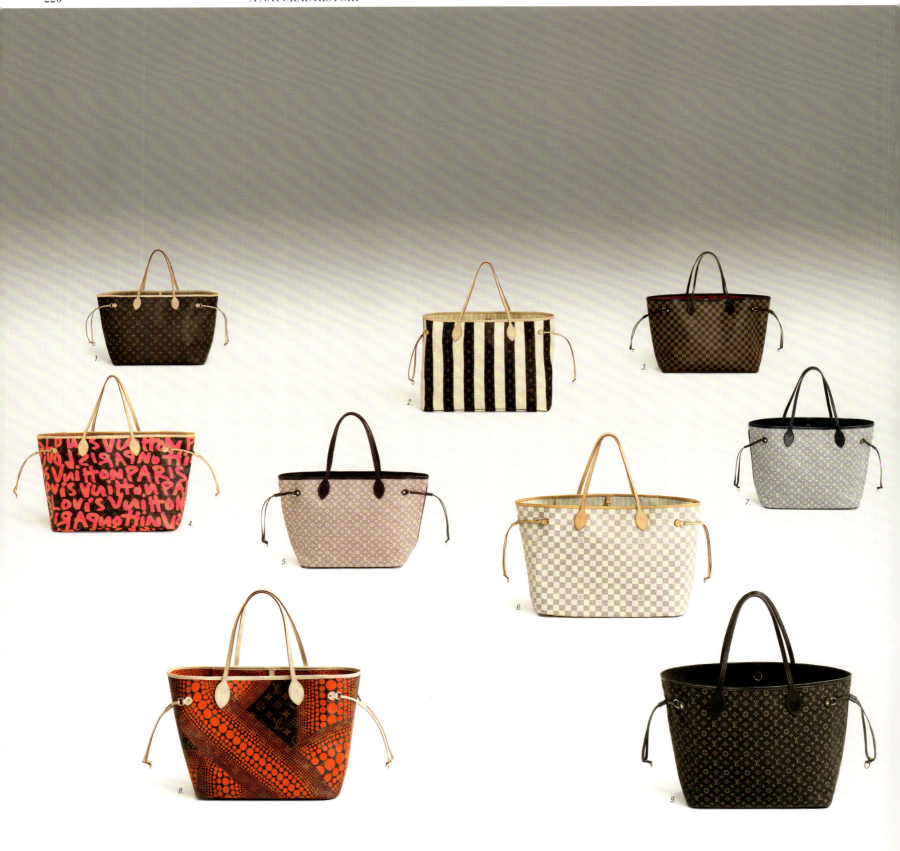

1. and 10. Large Neverfull in Monogram canvas and beige striped lining fabric — 2. and 11. Neverfull XL in Monogram
Rayures and lining fabric with contrasting beige stripes — 3. and 12. Large Neverfull in Damier canvas and red
striped lining fabric — 4. and 13. Large Neverfull in fuchsia Monogram Graffiti and fuchsia Graffiti lining fabric, designed in
collaboration with Stephen Sprouse — 5. and 14. Medium Neverfull in sepia Monogram Idylle and bordeaux striped

NEVERFULL INSIDE OUT

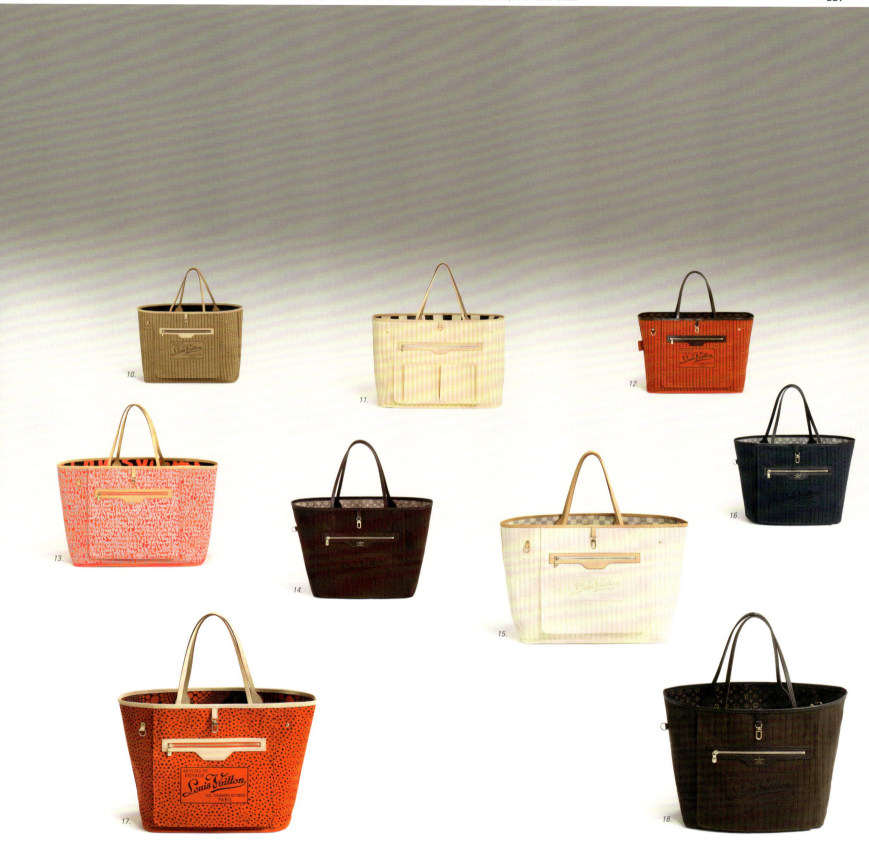

lining fabric — 6. and 15. Large Neverfull in Damier Azur canvas and cream striped lining fabric — 7. and 16. Medium
Neverfull in encre Monogram Idylle and navy striped lining fabric — 8. and 17. Medium Neverfull in red Monogram
Waves and red lining fabric with black polka dot motif, designed in collaboration with Yayoi Kusama — 9. and 18. Neverfull
in fusain Monogram Idylle and khaki striped lining fabric. Photographs by Patrick Gries, 2013

The hotel labels are all from the personal collection of Gaston-Louis Vuitton: 1. Label from the Columbus Hotel in Bremen, Germany, c. 1937. Louis Vuitton Archives — 2. Label from the Fuji Hotel in Tokyo, Japan, c. 1960. Louis Vuitton Archives — 3. Label from the Nouvel Hôtel de France in Évian-les-Bains, France, c. 1920. Louis Vuitton Archives — 4. Large Neverfull in Monogram Deauville (France) — 5. Large Neverfull in Monogram Saint-Moritz (Switzerland) — 6. Label from the Atlantic Hotel in Hamburg, Germany, c. 1930. Louis Vuitton Archives — 7. Label from the Ruhl Hotel in Nice, France, c. 1920. Louis Vuitton Archives — 8. Label from the Royal Hôtel in Évian-les-Bains, France, c. 1912. Louis Vuitton Archives — 9. Large Neverfull in Monogram Saint-Tropez (France) — 10. Label from the La Léchère Hotel in La Léchère-les-Bains, France, c. 1925. Louis Vuitton Archives

11. Label from the Grand Hôtel Neues Stahlbad in Saint-Moritz, Switzerland, c. 1910. Louis Vuitton Archives — 12. Large Neverfull in Monogram Palm Beach (USA) — 13. Label from the Saint Catherine Hotel on Catalina Island, California, USA, c. 1920. Louis Vuitton Archives — 14. Large Neverfull in Monogram Portofino (Italy) — 15. Label from the Schwarzer Bock Hotel in Wiesbaden, Germany, c. 1927. Louis Vuitton Archives — 16. Label from the Fairmont Hotel in San Francisco, USA, c. 1910. Louis Vuitton Archives — 17. Label from the Royal Hôtel in Deauville, France, c. 1950. Louis Vuitton Archives — 18. Large Neverfull in Monogram Kampen (Germany) — 19. Large Neverfull in Monogram Saint Barth (French Caribbean) — 20. Label from the Tiefenbrunner Hotel in Kitzbühel, Austria, c. 1925. Louis Vuitton Archives — 21. Label from the Albergo Genovese Hotel in Varazze, Italy, c. 1938. Louis Vuitton Archives

Inside the great hall of Oscar Niemeyer's French Communist Party Headquarters in Paris, a model wears a fox
toque hat and a Françoise bag in Mini Bleu Monogram canvas. From Autumn-Winter 2001–2002 Louis Vuitton catalogue.
Photograph by Clayton Burkhart, 2011

Opposite: "Cruise," 2010 advertising campaign. Isabeli Fontana carries a large Neverfull in Damier Azur canvas. Photograph
by Patrick Demarchelier, 2010

CARRIED AWAY

A model carries a flat bag in black Epi leather. From Autumn-Winter 2001–2002 Louis Vuitton catalogue.
Photograph by Clayton Burkhart, 2011

Opposite: Raquel Zimmerman carries a Neverfull in Monogram canvas. Photograph by Steven Meisel,
Vogue Italia, November 2011

SIGHTINGS

From left to right, top to bottom: Spring-Summer 2008 runway show, look 07, the Nurse carries a Heartbreak bag in red Monogram Jokes. Photograph by Chris Moore, 2007 — Autumn-Winter 1999-2000 runway show, look 44, the model carries a large Reade bag in gold Monogram Vernis. Photograph by Dan Lecca, 1999 — Spring-Summer 2000 runway show, look 45, the model carries a Memphis portfolio bag in beige Monogram Vernis Fleurs. Photograph by Dan Lecca, 1999 — Autumn-Winter 2003-2004 runway show, look 20, the model carries a Verty bag in beige alligator leather. Photograph by Frédérique Dumoulin, 2003

Opposite: Spring-Summer 2007 runway show, look 34, the model carries a That's Love tote bag in beige cotton canvas. Photograph by Ludwig Bonnet, 2006

SEASONAL COLLECTIONS

SAC PLAT: ROBERT WILSON

MEDIUM READE
In Orange Monogram Vernis Fluo

SMALL READE
In Pink Monogram Vernis Fluo

Medium Reade bag in orange Monogram Vernis Fluo, 2002, 26 × 34 × 11.5 cm — Small Reade bag in pink Monogram Vernis Fluo, 2002, 18 × 22.5 × 10.5 cm. To celebrate Cristmas 2002, the famous American director Robert Wilson designed the window displays for Louis Vuitton stores around the world. A leader in avant-garde theatre in New York, he redesigned the LV Monogram in fluorescent orange, pink and green and applied these same bright colors to the Monogram Vernis used in the leather goods and accessories collection for Christmas 2002.

Opposite: The model carries a medium Neverfull in red Monogram Waves, Louis Vuitton Yayoi Kusama product catalogue, 2012. The Monogram Waves line is the result of a collaboration with the Japanese artist Yayoi Kusama in 2012 (see p. 321). Photograph by Angelo Pennetta, 2012

ARTISTIC VARIATIONS

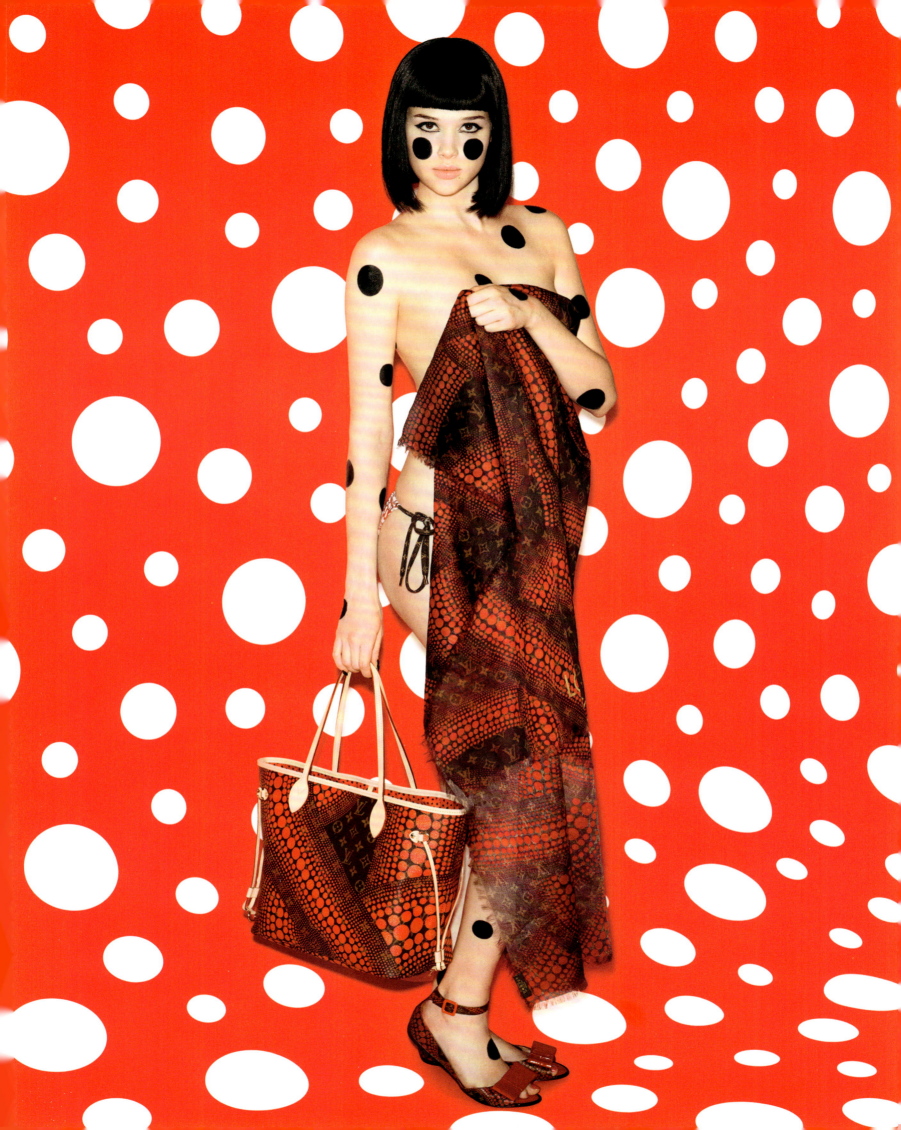

SAC PLAT: FABRIZIO PLESSI

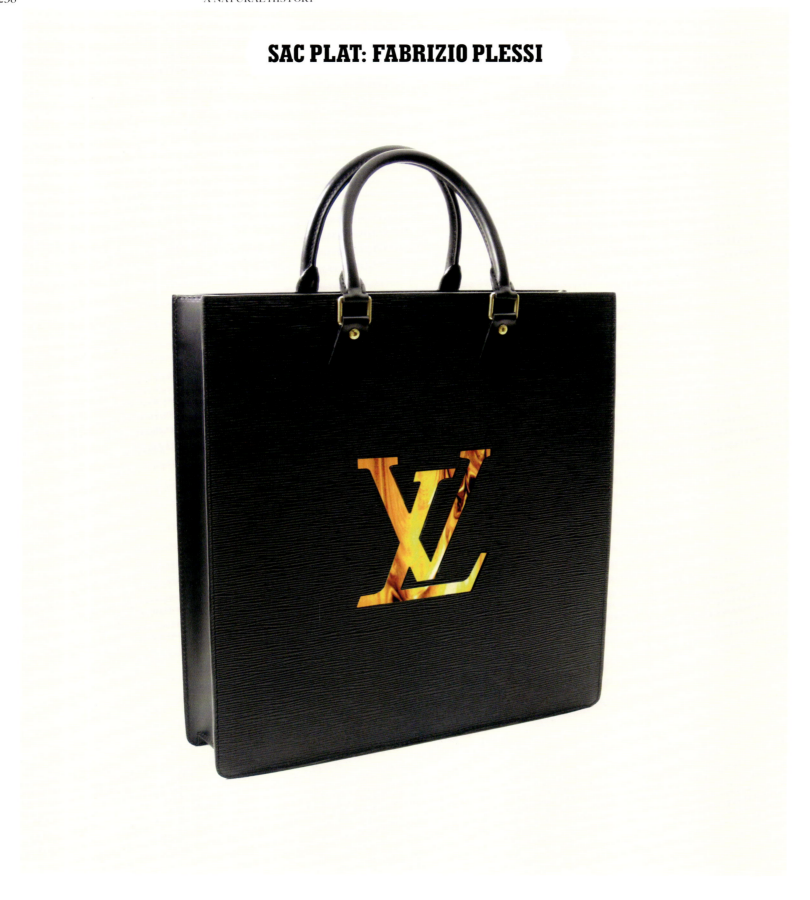

Sac Plat Fusion in black Epi leather, fitted with an ultra flat TFT-LCD screen, 2008, 36.5 × 38 × 9 cm. Louis Vuitton
Collection. Fabrizio Plessi is one of the best-known contemporary video artists in Europe. For the opening
of the Maison Louis Vuitton on Canton Road in Hong Kong on March 14, 2008, he created a portable work of
video art, the Sac Plat Fusion, which is equipped with a screen showing images of molten gold through a cutout of the
LV Monogram on the front. The handbag was made in a limited edition of 88, a lucky number in China.

Opposite: Preparatory sketch for the Sac Plat Fusion, Fabrizio Plessi, 2008. Louis Vuitton Archives

ARTISTIC VARIATIONS

SERIE DI BORSE A TIRATURA LIMITATA

BORSA IN PELLE RIGIDA NERA POCHI CENTIMETRI DI TECNOLOGIA

AL'INTERNO UN TELEVISORE ULTRAPIATTO CON PROGRAMMA DVD INCORPORATO + BATTERIA

ORO LIQUIDO CHE SCENDE DA UN ALTO VERSO IL BASSO CONTINUAMENTE

COLATA DI ORO LIQUIDO DIGITALE IN MOVIMENTO

UN PICCOLO TELEVISORE AL PLASMA FA VIVERE LA BORSA COME UN OGGETTO VIVO.

TV

DVD

PLESSI ©

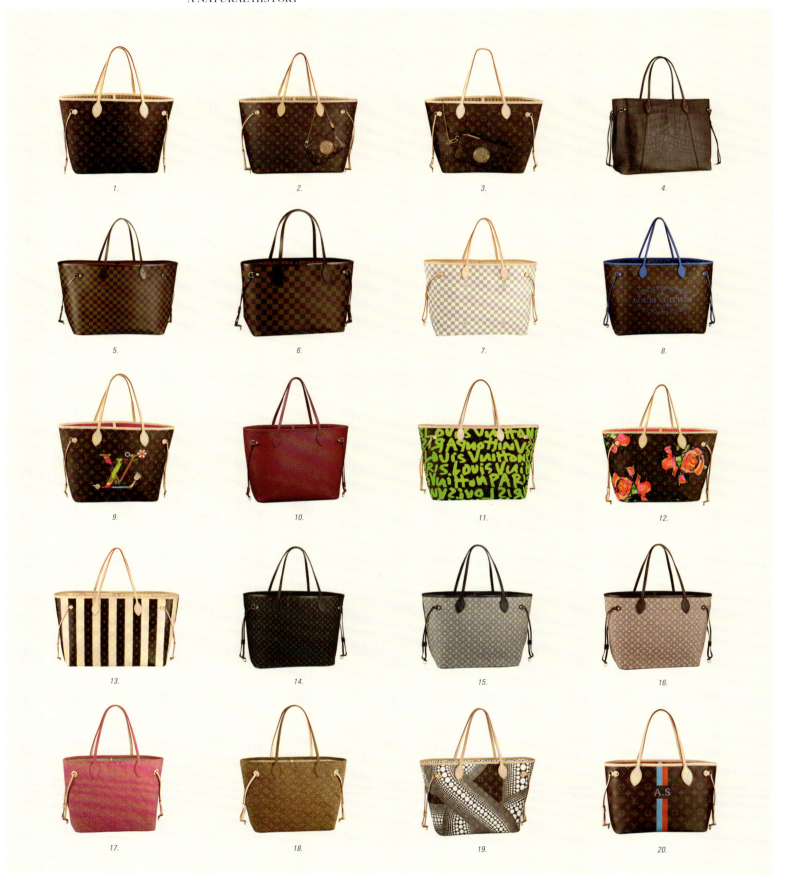

1. Medium Neverfull in Monogram canvas, 2007 — 2. Large Neverfull in Monogram canvas and matching Mini Pochette Accessoires Trunks&Bags, 2007 — 3. Medium Neverfull in
Monogram canvas and matching Complice wallet, 2007 — 4. Large Neverfull in chocolat matte crocodile leather, 2008 — 5. Large Neverfull in Damier Ébène canvas, 2008 —
6. Small Neverfull in Damier Ébène canvas, 2008 — 7. Large Neverfull in Damier Azur canvas, 2009 — 8. Large Neverfull in grand bleu ikat Monogram canvas, 2013 — 9. Medium
Neverfull in Monogram LV Hands, 2007 — 10. Medium Neverfull in fuchsia Epi leather, 2013 — 11. Large Neverfull in green Monogram Graffiti, 2009 — 12. Medium Neverfull in
Monogram Roses, 2009 — 13. Neverfull XL in Monogram Rayures, 2011 — 14. Medium Neverfull in fusain Monogram Idylle, 2012 — 15. Medium Neverfull in encre Monogram Idylle,
2012 — 16. Medium Neverfull in sepia Monogram Idylle, 2012 — 17. Medium Neverfull in pink Monogram Stone, 2013 — 18. Medium Neverfull in caramel Monogram Stone,
2013 — 19. Medium Neverfull in white Monogram Waves, 2012 — 20. Small Neverfull in Mon Monogram canvas, 2010

BIODIVERSITY: THE NEVERFULL

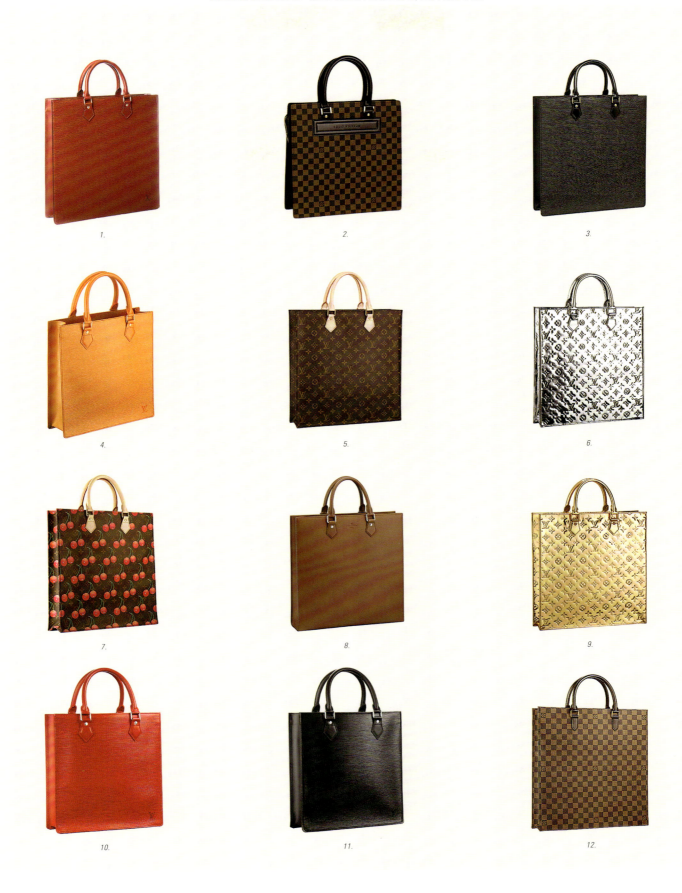

1. Sac Plat in fauve kenyan Epi leather, 1995 — 2. Large Sac Plat Venice in Damier Ébène canvas, 1999 — 3. Neverfull in noir kouril Epi leather, 1999 — 4. Small Sac Plat in mandarine Epi leather, 2004 — 5. Sac Plat in Monogram canvas, 1999 — 6. Sac Plat in silver Monogram Miroir, 2009 — 7. Sac Plat in Monogram Cerises, 2005 — 8. Sac Plat in tabac Nomade leather, 2012 — 9. Sac Plat in gold Monogram Miroir, 2009 — 10. Small Sac Plat in rouge castillan Epi leather, 2004 — 11. Small Sac Plat in moka Epi leather, 2004 — 12. Sac Plat in Damier Ébène canvas, 2003

BIODIVERSITY: SAC PLAT

MÉTIS: GENEALOGY

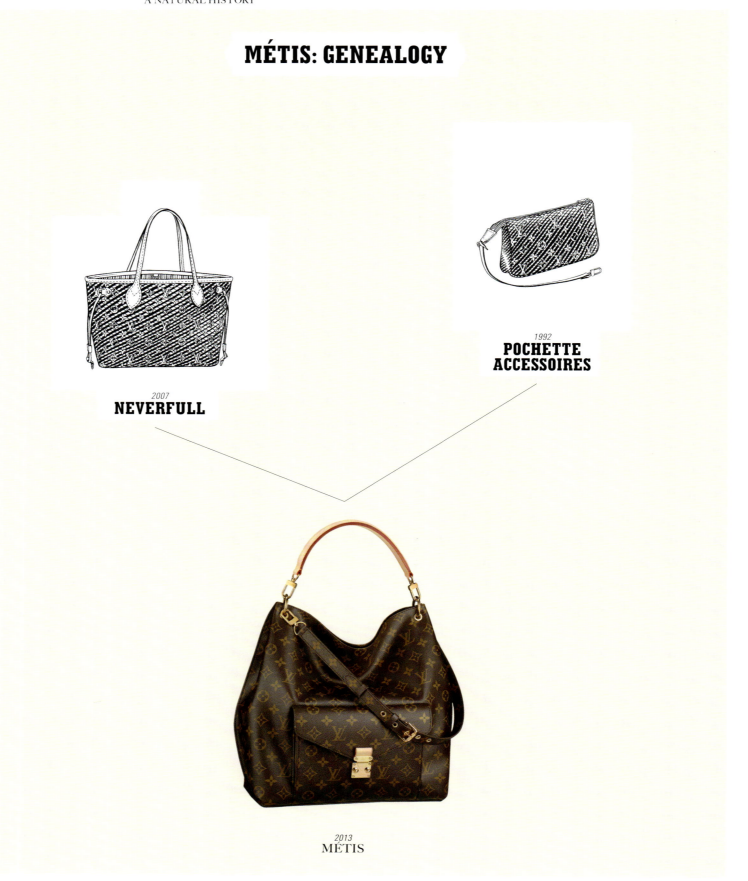

2007
NEVERFULL

1992
**POCHETTE
ACCESSOIRES**

2013
MÉTIS

Métis in Monogram canvas, 2013, 32 × 34 × 13 cm. The Métis, could be a cross between the iconic Neverfull and
Pochette Accessoires, was born in 2013. From the former, it could have inherited its suppleness and its large capacity,
as well as its over the shoulder design. The latter seems to be grafted onto the bag in the form of an external pocket
secured with an S-Lock clasp, making it ideal for storing personal belongings. Drawings by Martin Mörck, 2013

HYBRIDIZATION

FLAT SHOPPER: GENEALOGY

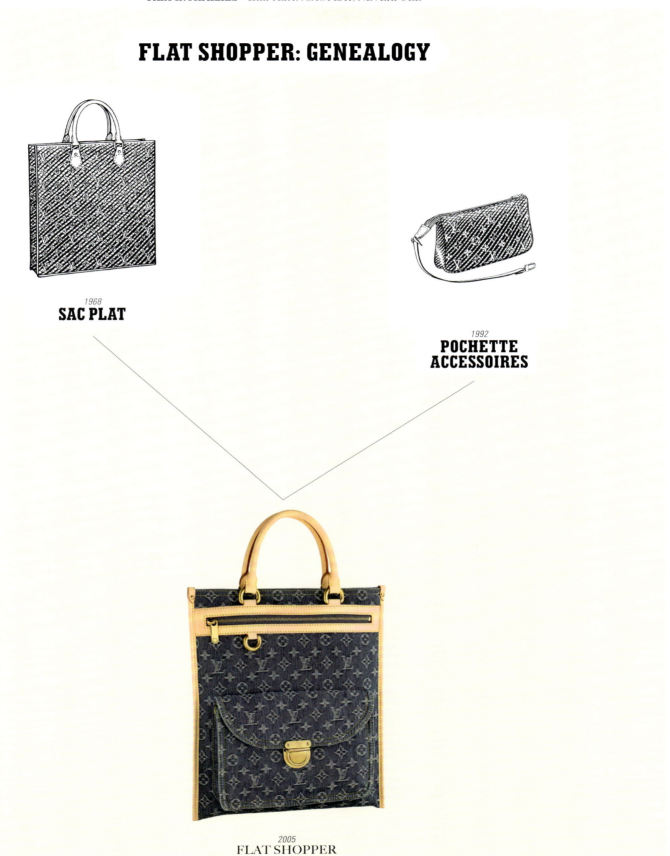

1968
SAC PLAT

1992
POCHETTE ACCESSOIRES

2005
FLAT SHOPPER

Flat Shopper in blue Monogram Denim, 2005, 33 × 36.5 cm. The Flat Shopper, a cross between the iconic Sac Plat and Pochette Accessoires, was born in 2005. From the former, it inherited its Toron handles, its slim form and its predisposition to daily use as a city bag. The latter is grafted onto the bag in the form of an external pocket secured with a Tuck clasp, making it ideal for storing personal belongings. Drawings by Martin Mörck, 2013

Following double page: On a pontoon, Caroline Ribeiro sports a Monogram Cruise tote bag in transparent vinyl. Photograph by Steve Hiett, *Numéro*, May 2000

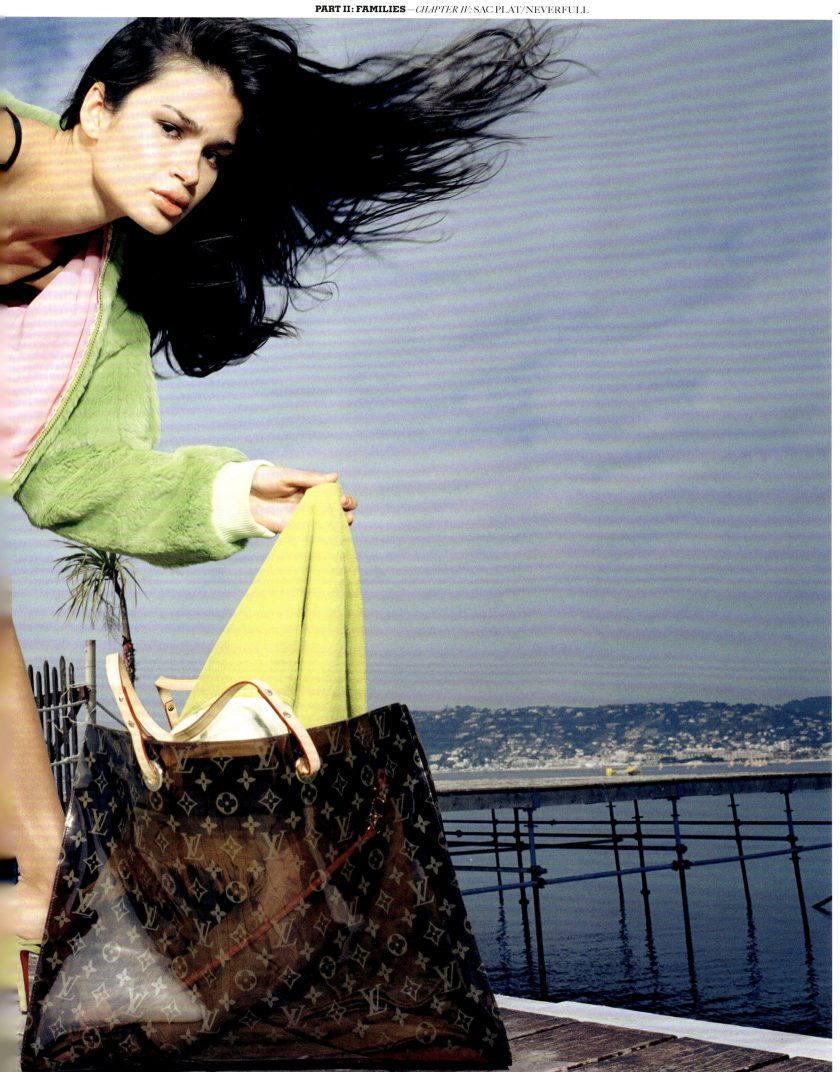

POCHETTE ACCESSOIRES
In Monogram canvas

MINAUDIÈRE BIJOU
In acetate and gold-plated brass

Chapter V:
POCHETTES/MINAUDIÈRES
Pages 246–279

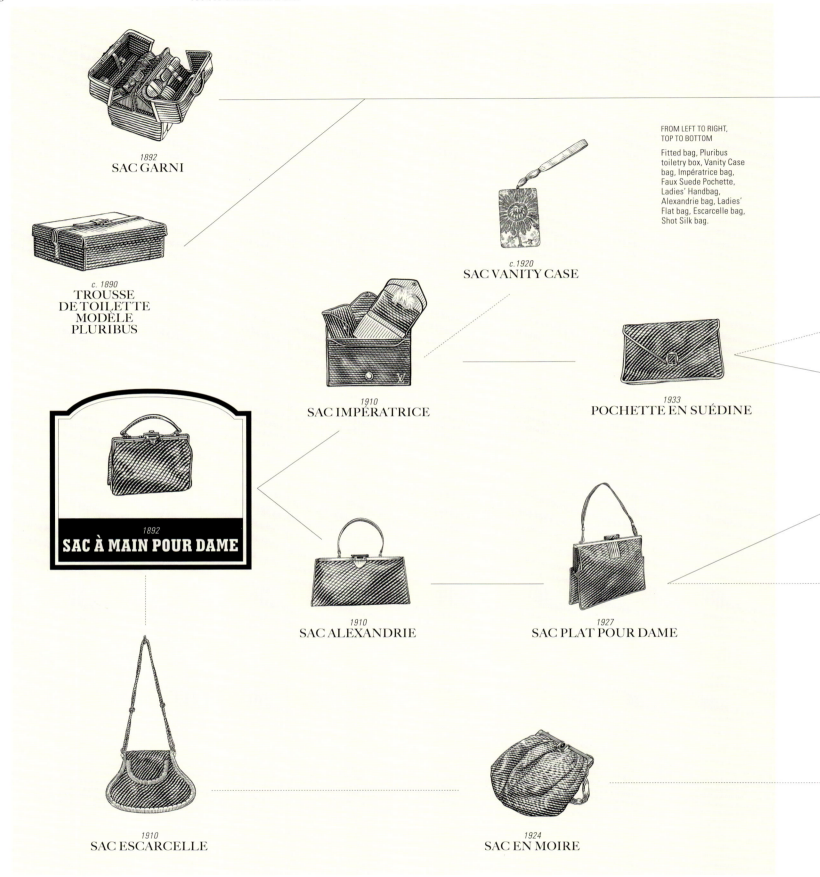

1892
SAC GARNI

c. 1890
TROUSSE
DE TOILETTE
MODÈLE
PLURIBUS

c. 1920
SAC VANITY CASE

FROM LEFT TO RIGHT,
TOP TO BOTTOM

Fitted bag, Pluribus
toiletry box, Vanity Case
bag, Impératrice bag,
Faux Suede Pochette,
Ladies' Handbag,
Alexandrie bag, Ladies'
Flat bag, Escarcelle bag,
Shot Silk bag.

1910
SAC IMPÉRATRICE

1933
POCHETTE EN SUÉDINE

1892
SAC À MAIN POUR DAME

1910
SAC ALEXANDRIE

1927
SAC PLAT POUR DAME

1910
SAC ESCARCELLE

1924
SAC EN MOIRE

Despite their appearance, the fitted travel bags and accessory bags for the steamer trunk can be considered the ancestors of the finest and most precious of these women's accessories. Through a reduction in size, minaudières would come to be a diminutive version of the toiletry kit. An indispensible article of hand baggage for elegant ladies during the first half of the 20th century, Louis Vuitton transformed it into a Vanity Case with a more rounded form and more supple materials as of the 1960s. Minaudières were used for the evening, their purpose being to carry only what was strictly necessary: a mirror, powder, lipstick... all organized in an object that completed an elegant and sophisticated ensemble. The minaudière shares this characteristic with the pochette, whose ascendance occured alongside the ladies' handbag. Accompanying the traveling woman as of the late 19th century, the latter developed at Louis Vuitton out

GENEALOGY: POCHETTE AND MINAUDIÈRE

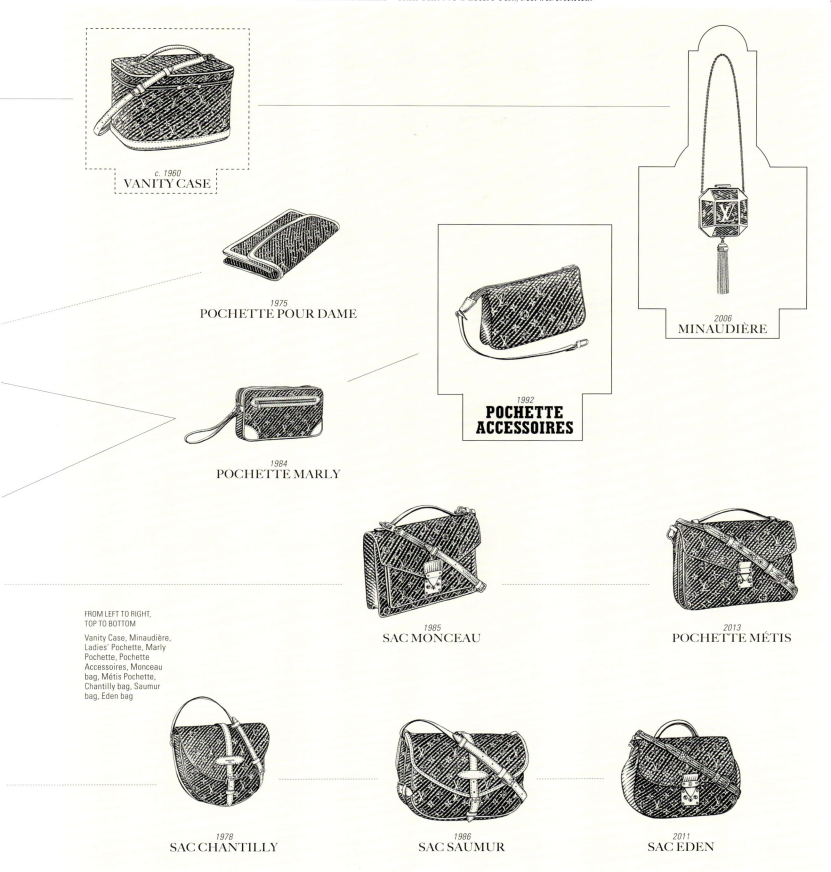

c. 1960
VANITY CASE

1975
POCHETTE POUR DAME

1984
POCHETTE MARLY

1992
POCHETTE ACCESSOIRES

2006
MINAUDIÈRE

1985
SAC MONCEAU

2013
POCHETTE MÉTIS

FROM LEFT TO RIGHT,
TOP TO BOTTOM

Vanity Case, Minaudière,
Ladies' Pochette, Marly
Pochette, Pochette
Accessoires, Monceau
bag, Métis Pochette,
Chantilly bag, Saumur
bag, Eden bag

1978
SAC CHANTILLY

1986
SAC SAUMUR

2011
SAC EDEN

of the smallest versions of the flat bag, which were adopted for daily use as a means to carry large and small items alike. With its multiple contours, the ladies' handbag never ceased to evolve, to adapt and to reduce in size, culminating in the modern-day handbag and especially the pochette. In its Accessoires version, it has even become to the bag what the bag was to the trunk. A family with a complex and porous genealogy, the pochettes and minaudières designation comprises three types of small format bags: simple and elegant envelopes, legacies of the Impératrice bag; gusseted bags, the more functional descendants of the Alexandrie bag; and more supple, rounded bags, the successors of the Escarcelle bag. P. 246 and above drawings by Martin Mörck, 2013

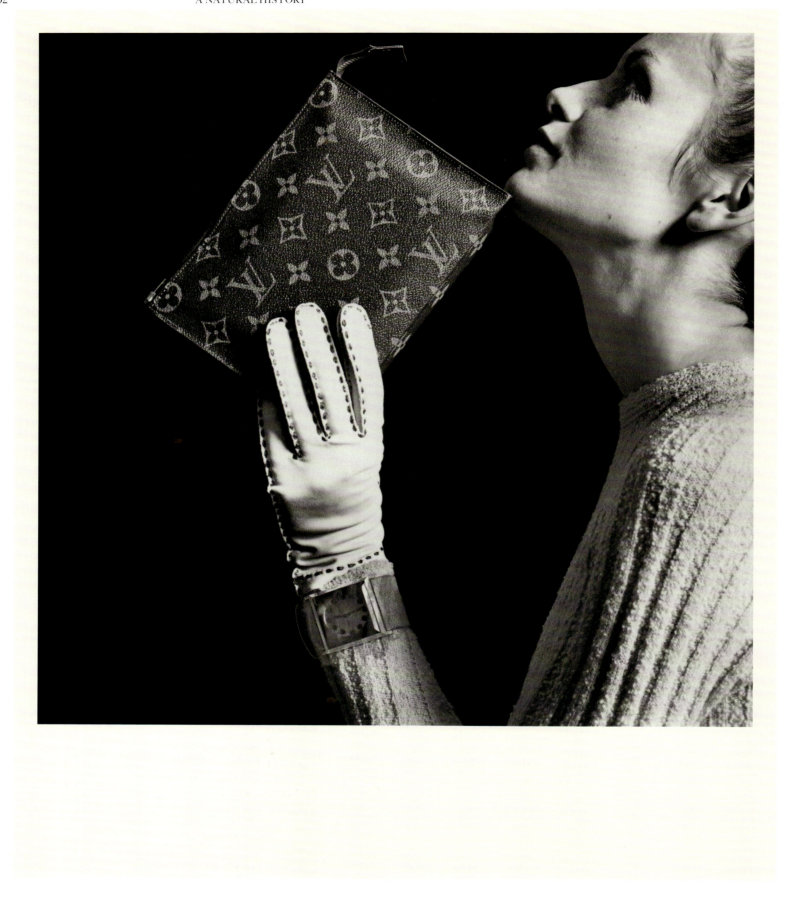

Twiggy carries a Toilette pochette in Monogram canvas. Photograph by Bert Stern, *Vogue UK*, 1967

POCHETTES/MINAUDIÈRES
COLOMBE PRINGLE

Once upon a time, at the turn of the last century, fashion engravings pictured models posing with parasols, feather fans or opera glasses as accessories—but never with a handbag. The reason why? Elegant ladies of the Belle Époque would keep their lace handkerchiefs, their small change, their salts and powders buried within the yards of linen and ruffled flounces that accentuated the hourglass figure, accessible through a slit in their skirts. In a pocket, in other words. But that was about to change.

In 1900, Paris inaugurated its Universal Exhibition. It was the beginning of the great shake-up of the industrial era. Visitors traveled by tram or horse-drawn carriage to the inauguration of the Grand Palais, with those from further afield arriving by railway at the capital's new stations, the Gare d'Orsay and the Gare de Lyon. The "electric fairy" (the light bulb) illuminated daily life. The French discovered the joys of sport and the bicycle with the first Tour de France. Innovations abounded, transforming people's way of life, and fashions changed along with the times. Goodbye poufs and crinolines! Slowly but surely, the silhouette lightened and relaxed: skirts clung to the hips; the *costume trotteur*, designed for walking, was gathered at the small of the back; narrow dresses were the preferred look. And with them, poof! The pockets disappeared. Fashion makes no concessions.

It was the beginning of a story with many twists and turns. The story of a great family which, a hundred years and three generations later, would give rise to a bestseller in all categories: the Pochette Accessoires. Originally tucked inside the Noé or the Bucket, it started out as just an appendix for keeping makeup, small papers, keys, money and the like. "At the end of the 1980s, during a trip to Japan," recalls Xavier Dixsaut, Director of Innovation, "I noticed that the women in kimonos who carried the large Papillon were leaving the small case, which was intended for inside, visibly attached to the exterior. It was charming and inspiring, but I thought that would be impossible in Europe. Then, in order to avoid an over-filled interior pocket ruining the form of the Noé, the Pochette Accessoires was added. An incalculable number of prototypes was necessary in order to obtain the correct finish, given that it has no lining and finished seams on the interior. Making something simple

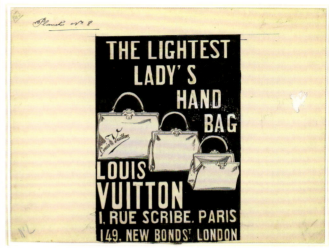

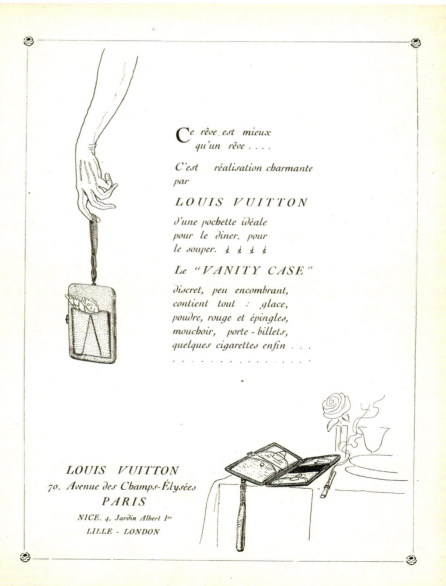

FROM LEFT TO RIGHT,
TOP TO BOTTOM

Page dedicated to ladies'
handbags featuring the
Alexandrie and Shopping
Bag models
Louis Vuitton product
catalogue, c. 1910
Louis Vuitton Archives

"The Lightest Lady's Hand
Bag." Mock up for
advertising insert,
drawing in India ink and
watercolor, c. 1910
Louis Vuitton Archives

"The Vanity Case. This
dream is better than a
dream, it's Louis
Vuitton's charming
realization of the ideal
pochette for a dinner…"
Advertising insert, 1920s
Louis Vuitton Archives

is often complicated! It would take four years before women would take it out of their bag and carry it on their shoulder! It was in 1992 that the Pochette Accessoires became a product in its own right."

Made popular by its ability to be worn in the day or the evening, with jeans or a dress, at a brunch or a nightclub, it is equipped with a detachable strap for over the shoulder wear, or it can be carried by hand as a soft clutch. More recently, it has been embellished with a gold-plated chain under the appellation Favorite. Produced in Monogram canvas, and then in Damier checkerboard as of 2006 (even before Murakami got his hands on it), it is now lined with a fine canvas and its bottom is reinforced. Today, the Pochette Accessoires has earned its status as an icon, becoming women's best friend, irrespective of their generation. But let's return to its origins…

Once upon a time in 1910, there was the Escarcelle. The first pochette in a long lineage, one of its ancestors, extra flat and in gusseted leather, notably appeared in the arms of the English suffragettes and in the Louis Vuitton catalogue of 1892 under the name "Ladies' Hand Bag." Equally successful, it was considered a complement to late nineteenth-century baggage, in which the owner could store her most precious objects. A small bag, round and soft, in black velvet with gold-plated attachments and a long, thin cord that slipped over the shoulder, the Escarcelle was inspired by a pilgrim's purse spotted by Louis Vuitton in a tapestry at the Cluny Museum in Paris. "Thanks to Vuitton, the city bag will become one of the most graceful adornments of high society," predicted an expert in a 1910 edition of the journal *Fermes et châteaux,* "and the theater bag that they have just launched […] will be a revelation for every woman." The bag's name was not left to chance; the proof of this is found in the *Petit Larousse* dictionary, which defines the "escarcelle" as a "purse, wallet, etc., considered from the point of view of the money that it contains," and whose Italian origin, "*scarsella,*" meaning "stingy," might seem amusing. Because make no mistake, women were not at all frugal when it came to dreaming of the new products that would accompany them in their first steps towards emancipation.

Fifty years later, the question was still current. Women were making their voices heard, and their bodies were finally their own. Now they wanted power. Once the hippy skirts and the Chinese blue Mao jackets were gone, designers felt a shift in the air: blazers with shoulder pads expressed determination; marked waistlines expressed femininity; gestural silhouettes expressed self-affirmation. Fashion accompanied women in their ambitions. In 1978, Louis Vuitton responded to the Amazons of the city with the Chantilly. A descendant of the Escarcelle from which it took its round shape, its suppleness and its poise, this bag, fitted with a long strap and named after a racecourse, was inspired by the bags carried by ladies who spent their weekends riding. Shortly after, in an updated version, the Chantilly would stray from the racetrack and take to the streets of cities

FROM TOP TO BOTTOM

Fitted ladies' bag in pigskin leather, c. 1910, 32 × 26 × 15 cm Louis Vuitton Collection

Ladies' flat bag in crocodile leather, 1928, 26.5 × 19 × 6 cm Louis Vuitton Collection

Mock up for an advertising insert featuring three ladies' handbags, drawing in India ink, graphite and gouache, 1920s Louis Vuitton Archives

Detail of the clasp on the ladies' flat bag in Morocco leather, 1927, 26.5 × 19 × 3 cm Louis Vuitton Collection

FROM TOP TO BOTTOM

"Two traveling coats that combine elegance and comfort." Advertising insert featuring a large flat bag in black Morocco leather designed for traveling, and containing compartments for papers, passport and banknotes. *Vogue Paris*, July 1926

"An Elegant Stroll." Page dedicated to: the ladies' handbags Memphis, Spa and Ixelles, ideal for purchases; the Assouan, Nattier and Watteau bags, for complementing a ladies' skirt suit; the cloth Louis XVI, Empire, Baguette and Japonais bags with clasps, perfect for visits; and the silk Guirlandes, Croisillons, Rayures and Fleurs bags, for evenings spent at the theater or dancing. Louis Vuitton product catalogue, 1910, pp. 6–7 Louis Vuitton Archives

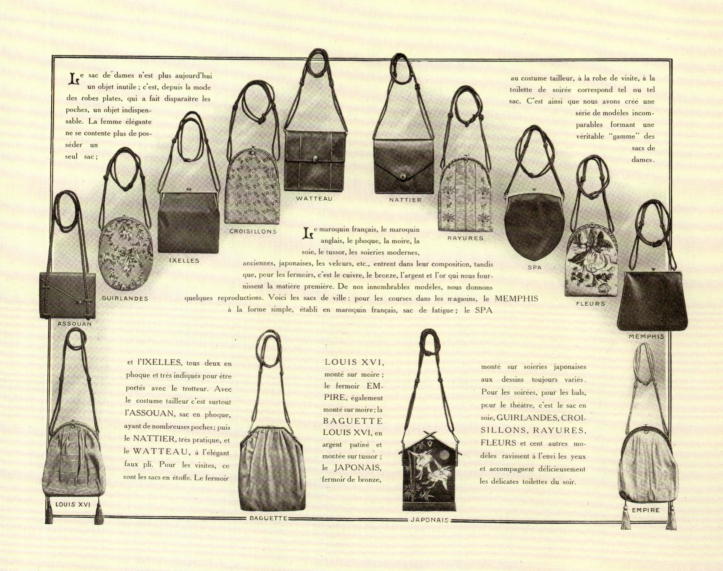

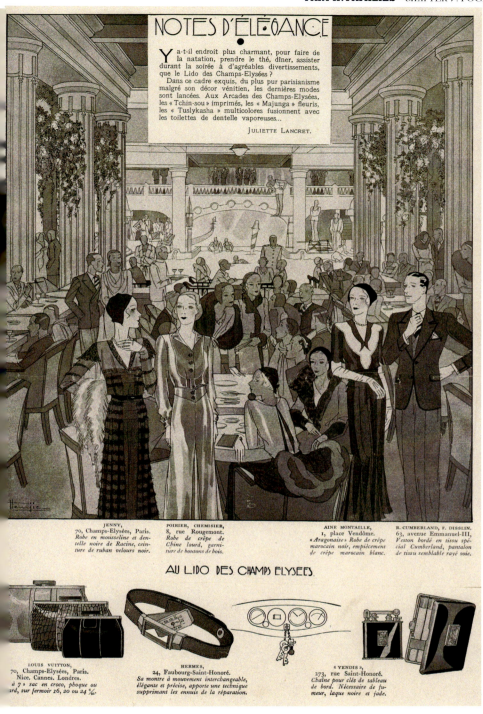

throughout the world in Monogram canvas. The vogue for shoulder bags was launched, seducing women who wanted to take their destiny in their hands. In 1986, the Saumur, whose name evokes the prestigious school of horse riding, would offer its own version. Inspired by the bags affixed to the hunter's saddle, it boasted a double compartment and adjustable side straps. Then, in 2011, came the Eden to crown the adventure. The youngest of this lineage, round and soft, is at once feminine and functional; its name alone tells of its ambition. But while it incarnates a certain idea of paradise, the story doesn't stop there. Instead, it starts again... but differently.

Once upon a time, also in 1910, there was the Impératrice. Was it just a coincidence that in London the double-decker bus, known in France as the *bus à impériale*, had been inaugurated that same year? The result of a

compromise between the city bag and the travel bag, this "hand-held pouch" was originally used for carrying maps, documents and other essential papers for automobile excursions. Extra flat, the Impératrice slid "between the cushion and the upholstered seat" in the front of a Panhard, the first valveless motorcar. With time, it became increasingly feminine until it was finally taken out as an evening bag in the 1920s. It would cede its place to the Vanity Case bag, in silk crepe and lurex yarn. The Vanity Case was "better than a dream [...], an ideal pochette for a dinner or a supper [...] [that] holds everything: mirror, powder, lipstick and pins, hand-kerchief, money, and a few cigarettes..." Oh yes! Women were smoking in public! With the drama of the First World War, women had learned how to manage on their own, keeping the country running while the men were off at the front. In this difficult time of adversity, they

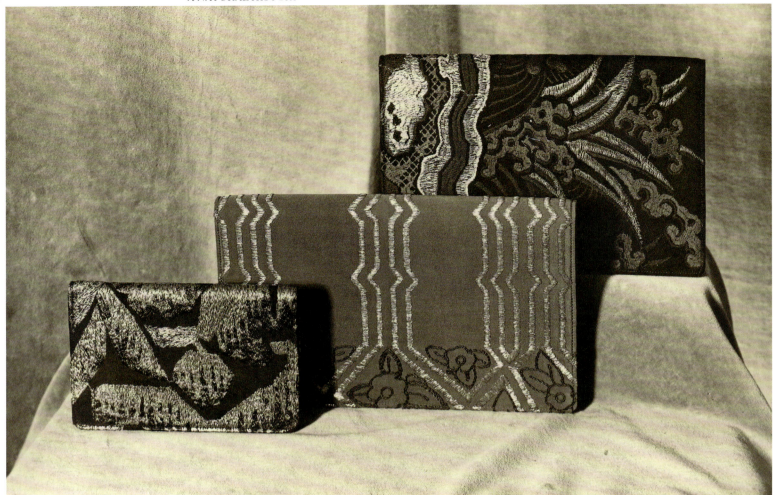

FROM TOP TO BOTTOM

Embroidered pochettes,
c. 1927
Louis Vuitton Archives

Design for a ladies'
pochette in black suede
with a clasp in matte gold,
drawing in graphite
pencil, India ink and
yellow and red
watercolor on tracing
paper, 1920s–1930s
Louis Vuitton Archives

had tasted independence and a certain kind of freedom.
Soon they would cut their hair, leave home without a
hat, shorten their skirts, abandon their corsets and lace
petticoats, and slip their legs into silk stockings to
dance the Charleston, mixing with the riffraff of Mont-
parnasse and giddy with the rhythms of the Jazz Age.
Coco Chanel led the dance; the reign of Paul Poiret was
over and the *garçonne* was born, laying claim to a new
lightheartedness—a symbol of loosening social mores as
well as appearances.

And finally, once upon a time in 1910, there was the
Alexandrie. This newly launched bag—extra flat and
square like its cousin the Impératrice, but with a gusset
like the Escarcelle—was "of an incomparable lightness,
but containing only a few items," according to the 1910
catalogue. And so, it was really more of a pochette: a
place for carrying the essentials. Available in the fashion-
able Morocco leather and sealskin of the time, it was
equipped with a small handle and a precious clasp with
Art Deco or Liberty motifs. Its simple but alluring lines
would be brought back into vogue by Marc Jacobs as
of 2006. In 2013, under the name of Vivienne, it exists in
a range of the most precious leathers and sports a pal-
ladium lock, encapsulating the elegance of the pochette
with the twist of a shoulder strap. Adopted by a new
generation for use by day or by night, for every occasion,
the great Pochette Accessoires will be the next to go
down in history.

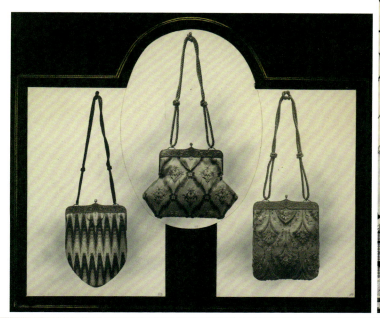

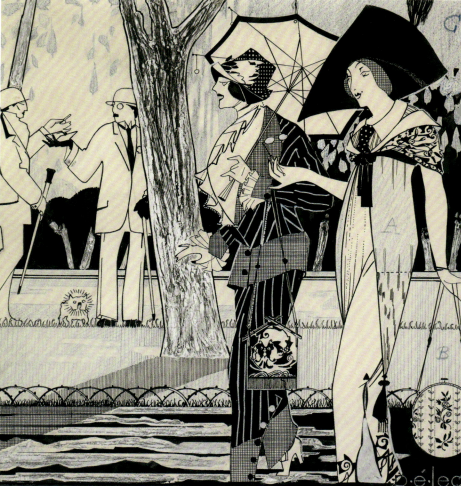

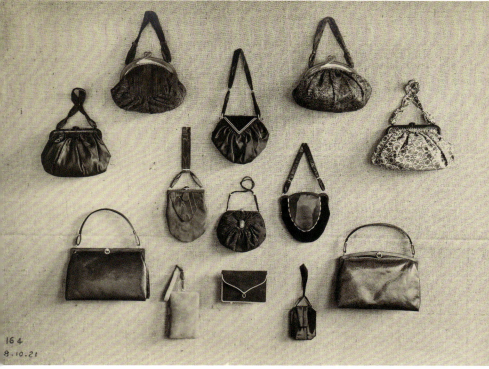

16 4
8·10·21

FROM LEFT TO RIGHT,
TOP TO BOTTOM

Ladies' cloth handbags
in various forms with
adjustable handles and
Viennese clasps, 1910s
Louis Vuitton Archives

"An Elegant Stroll." Title
page featuring elegant
ladies carrying a Japonais
bag with a bronze clasp
mounted on Japanese silk
and a floral silk bag.
Drawing by Pierre-Émile
Legrain, Louis Vuitton
product catalogue, 1910
Louis Vuitton Archives

Ladies handbags and
pochettes, including bags
with a tortoiseshell
clasp, the Cabochon bag,
the Le Bâté bag, tote bags
and the Vanity Case
bag. Photograph taken on
October 28, 1921
Louis Vuitton Archives

Design for a handbag
with two cabochons,
drawing in graphite pencil
on vellum paper
Drawing attributed to
Condere, undated
Louis Vuitton Archives

Ladies' handbag with
triangular clasp, 1920s.
Organizing accessories
are visible inside.
Photograph taken on
September 20, 1921
Louis Vuitton Archives

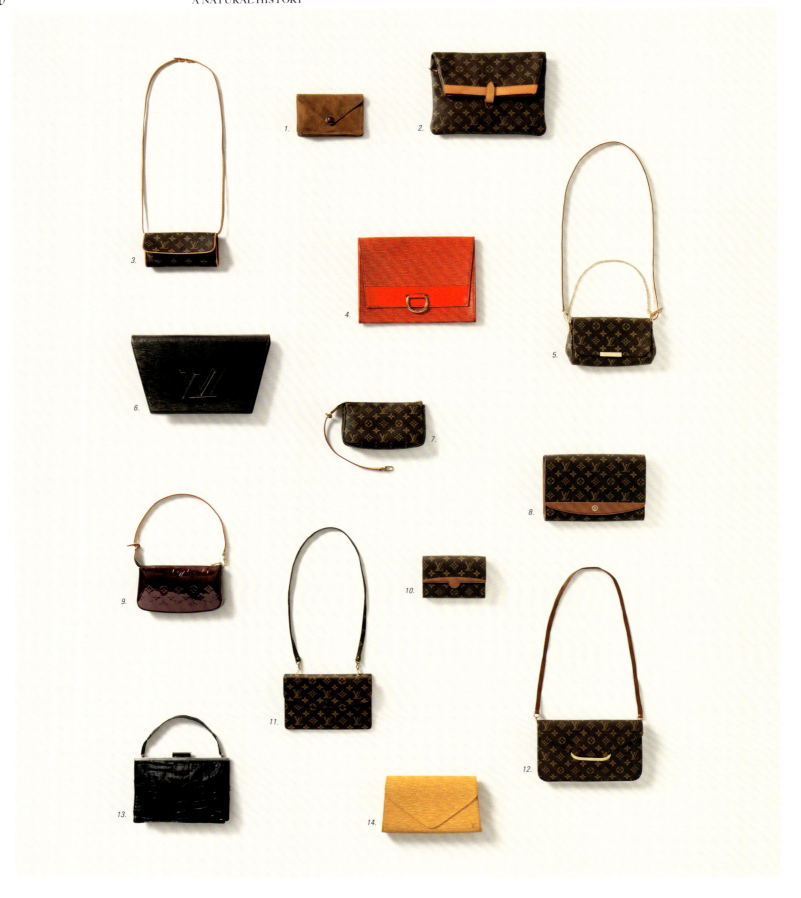

1. Pochette in havane faux suede, 1933, 19 × 13 × 2.5 cm. Louis Vuitton Collection — 2. Folding pochette in Monogram canvas, 1978, 31 × 22 × 6 cm. Louis Vuitton Collection — 3. Small Twin pochette in Monogram canvas, 1998, 19.4 × 10 × 4 cm. Louis Vuitton Collection — 4. Iéna pochette in rouge castillan Epi leather, 1986, 31 × 24 × 3 cm. Louis Vuitton Collection — 5. Small Favorite pochette in Monogram canvas, 2012, 24 × 14 × 4 cm. Louis Vuitton Collection — 6. Trapèze pochette in noir kouril Epi leather, 1988, 37 × 22 × 4.5 cm. Louis Vuitton Collection — 7. Pochette Bags Accessoires in Monogram canvas, 1998, 21 × 13 × 3 cm. Louis Vuitton Collection — 8. Bordeaux pochette in Monogram canvas, 1995, 27 × 18.5 × 4 cm. Louis Vuitton Collection — 9. Pochette Accessoires in amaranth Monogram Vernis, 1998, 21 × 13 × 3 cm. Louis Vuitton Collection — 10. Arche pochette for belt in Monogram canvas, 2007, 17 × 13 × 3.5 cm. Louis Vuitton Collection — 11. Pochette with double flap in Monogram canvas, 1979, 24 × 16 × 4.5 cm. Louis Vuitton Collection — 12. Houston bag in Monogram canvas, 1980, 28 × 17 × 5 cm. Louis Vuitton Collection — 13. Ladies' flat bag in black crocodile leather, 1928, 26.5 × 19 × 6 cm. Louis Vuitton Collection — 14. Arts Déco pochette in jaune tassili Epi leather, 1993, 26.7 × 16 × 4.5 cm. Louis Vuitton Collection. Photograph by Patrick Gries, 2013

FAMILY PORTRAIT: POCHETTES

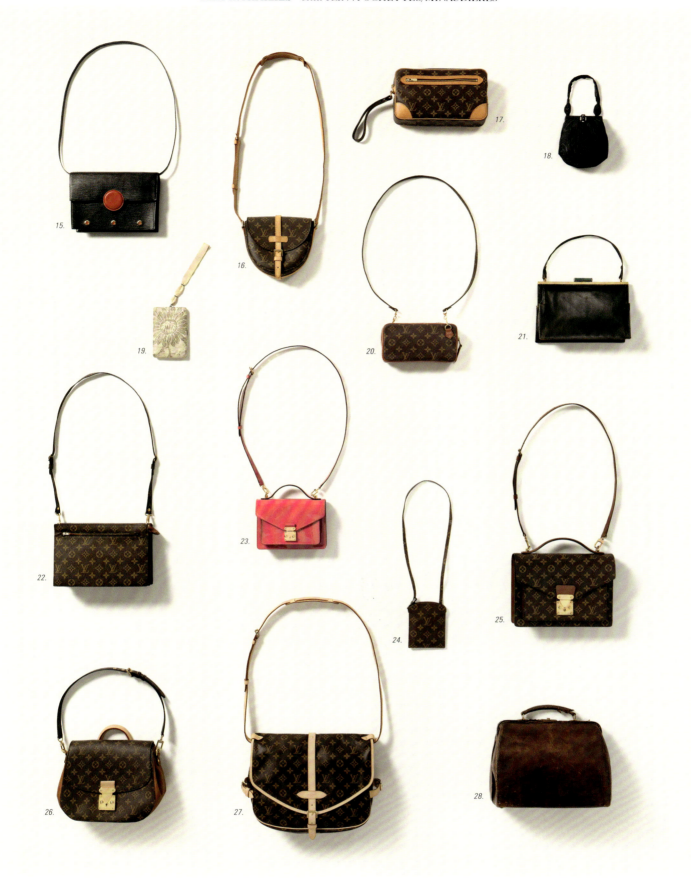

15. Hublots pochette in noir kouril Epi leather and rouge castillan clasp, 1990, 26 × 16.5 × 4.2 cm. Louis Vuitton Collection — 16. Chantilly bag in Monogram canvas, 1983, 19 × 18 × 5 cm — 17. Marly pochette in Monogram canvas, 2001, 26 × 16 × 5 cm. Louis Vuitton Collection — 18. Ladies' handbag in black shot silk, 1924, 14 × 17 × 3 cm. Louis Vuitton Collection — 19. Vanity Case bag in silk crêpe and Lurex thread, c. 1920, 10 × 15.5 × 1.5 cm. Louis Vuitton Collection — 20. Sport pochette in Monogram canvas, c. 1980, 21 × 11 × 4 cm. Louis Vuitton Collection — 21. Ladies' flat bag in black Morocco leather, 1927, 26.5 × 19 × 3 cm. Louis Vuitton Collection — 22. Enghien bag in Monogram canvas, 1982, 25 × 19 × 5 cm — 23. Monceau BB bag in patent Indian rose calfskin leather, 2013, 19.7 × 15 × 5.5 cm — 24. Secret pochette in Monogram canvas, 1981, 10.5 × 13.5 × 1.5 cm. Louis Vuitton Collection — 25. Monceau bag in Monogram canvas, c. 1985, 28 × 22 × 11 cm. Louis Vuitton Collection — 26. Medium Eden bag in Monogram canvas, 2011, 31 × 26 × 10 cm — 27. Large Saumur bag in Monogram canvas, 2012, 35 × 26 × 13 cm — 28. Ladies' fitted bag in pigskin leather, c. 1910, 32 × 26 × 15 cm. Louis Vuitton Collection. Photograph by Patrick Gries, 2013

POCHETTE ACCESSOIRES

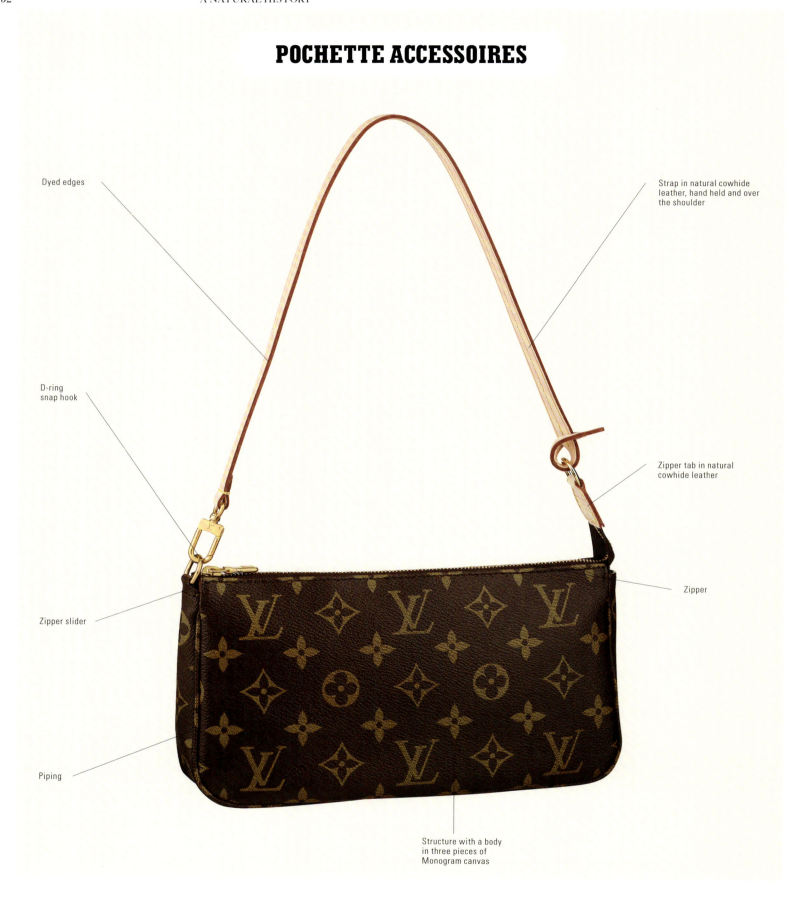

Dyed edges

Strap in natural cowhide leather, hand held and over the shoulder

D-ring snap hook

Zipper tab in natural cowhide leather

Zipper slider

Zipper

Piping

Structure with a body in three pieces of Monogram canvas

Pochette Accessoires in Monogram canvas, 21 × 13 × 3 cm. The Pochette Accessoires is a triangular prism in three pieces, equipped with a zipper closure. The detachable strap makes it highly versatile, allowing it to transform from a simple pochette into a small handbag or an interior pochette for the Bucket, the Noé or the Neverfull.

ANATOMY

POCHETTE ACCESSOIRES: VIEWS

Pochette Accessoires in Monogram canvas, 21 × 13 × 3 cm: 1. Seen from below — 2. Profile view —
3. Open, seen from above — 4. Closed, seen from above

MORPHOLOGY

VIVIENNE

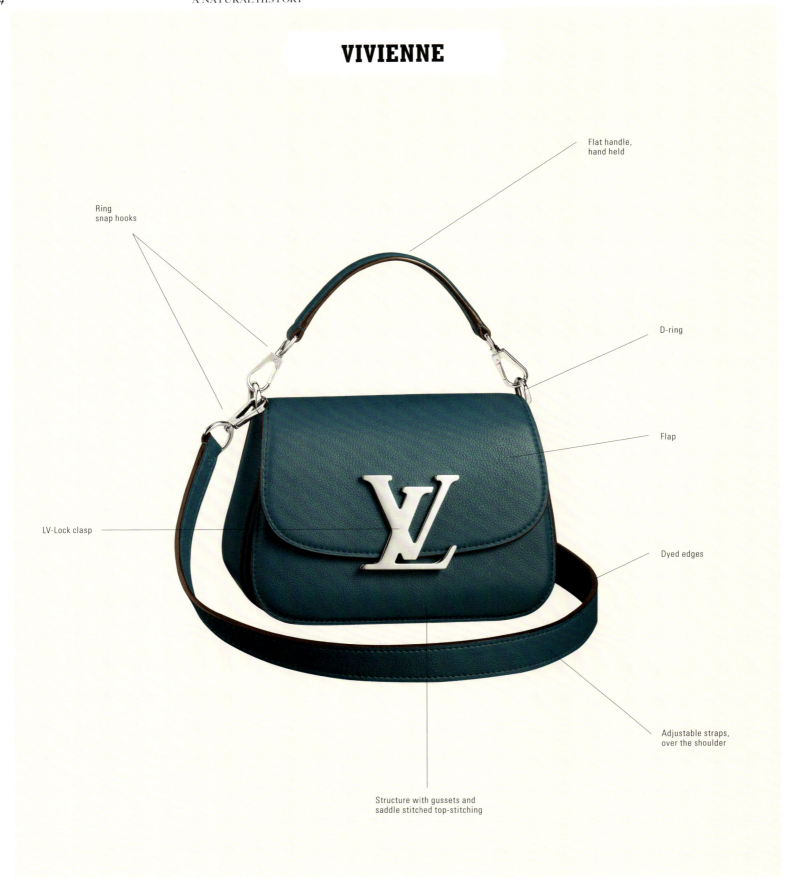

Flat handle,
hand held

Ring
snap hooks

D-ring

Flap

LV-Lock clasp

Dyed edges

Adjustable straps,
over the shoulder

Structure with gussets and
saddle stitched top-stitching

Vivienne in bleu canard Bougie calfskin leather, 22 × 17 × 9 cm — Monceau BB in patent Indian rose calfskin leather,
19.7 × 15 × 5.5 cm. The Vivienne and the Monceau are both rectangular prisms, though the Vivienne has a more rounded
form. Both have inherited clasps to secure their flap closures from their ancestors, and both have a handle and a shoulder
strap—which are detachable on the Vivienne—making them convenient for hand-carrying or over the shoulder wear.
Their compartmentalized interior makes them equally functional.

COMPARATIVE ANATOMY

MONCEAU BB

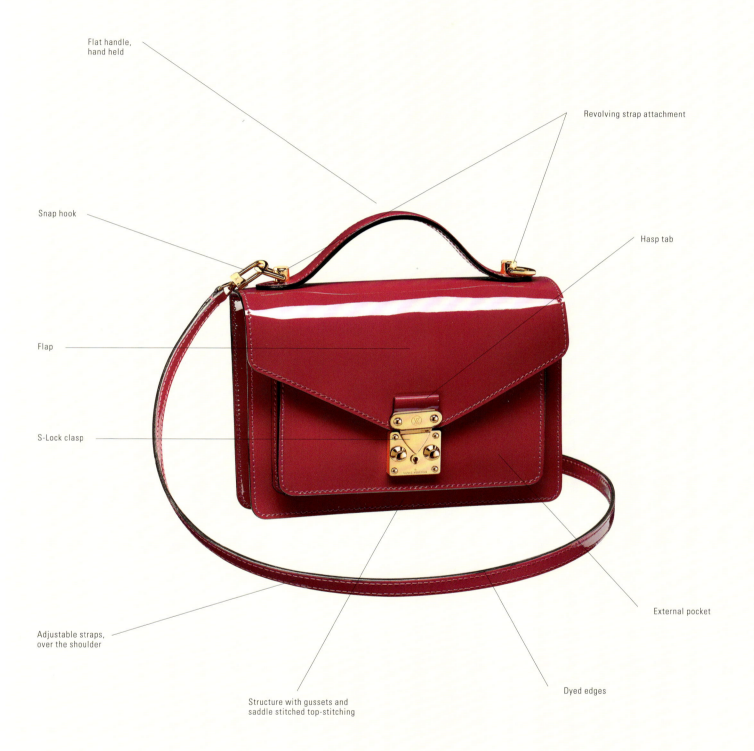

Flat handle, hand held

Revolving strap attachment

Snap hook

Hasp tab

Flap

S-Lock clasp

Adjustable straps, over the shoulder

External pocket

Dyed edges

Structure with gussets and saddle stitched top-stitching

POCHETTE IN NEVERFULL

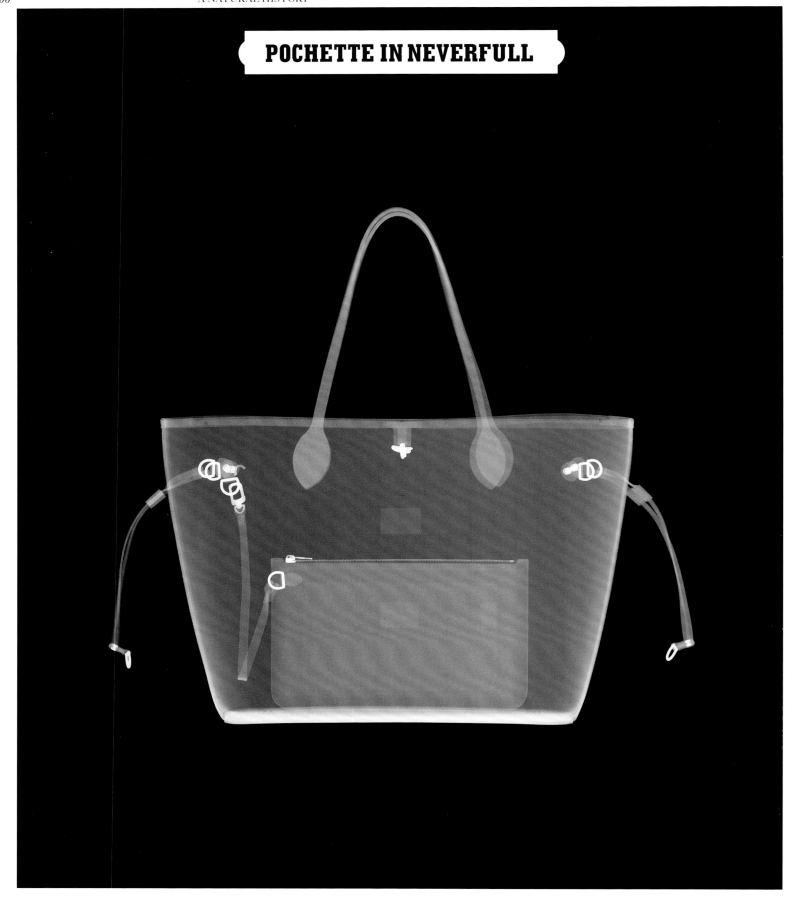

Medium Neverfull in Epi leather, 32 × 29 × 17 cm, containing its matching Pochette Accessoires. The x-ray
shows the Pochette attached by its strap to the inside of the Neverfull and the bags' metallic elements: the attachment
rings and the rivets of the bag, and the half-round D-ring and zipper of the Pochette. The Neverfull's reinforced
base is also visible. Photograph by Nick Veasey, 2013

X-RAYS

POCHETTE IN NOÉ

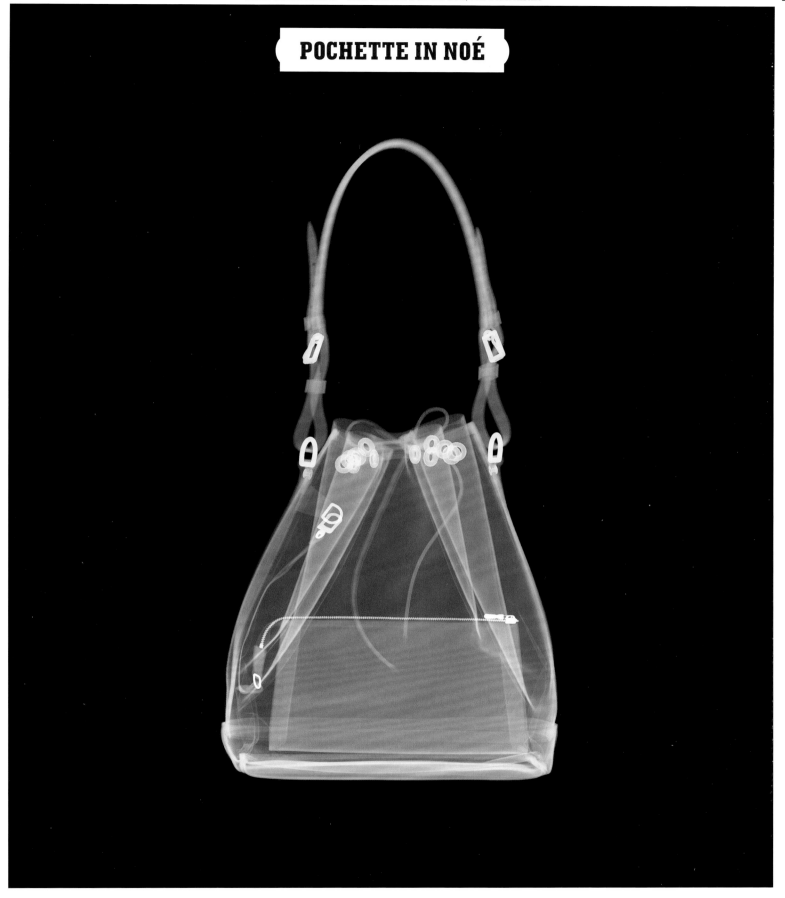

Noé in Epi leather, 26 × 34 × 20 cm, containing its matching Pochette Accessoires. The x-ray shows the Pochette
Accessoires attached by its strap to the inside of the Noé, and the bags' metallic components: the half-round D-rings,
the grommets and the buckles on the Noé; the snap-hook, the half-round D-ring and the zipper on the Pochette.
The folds at the drawstring closure on the Noé bear witness to the suppleness of its materials. The drawstring, as well
as the reinforced base, are also visible. Photograph by Nick Veasey, 2013

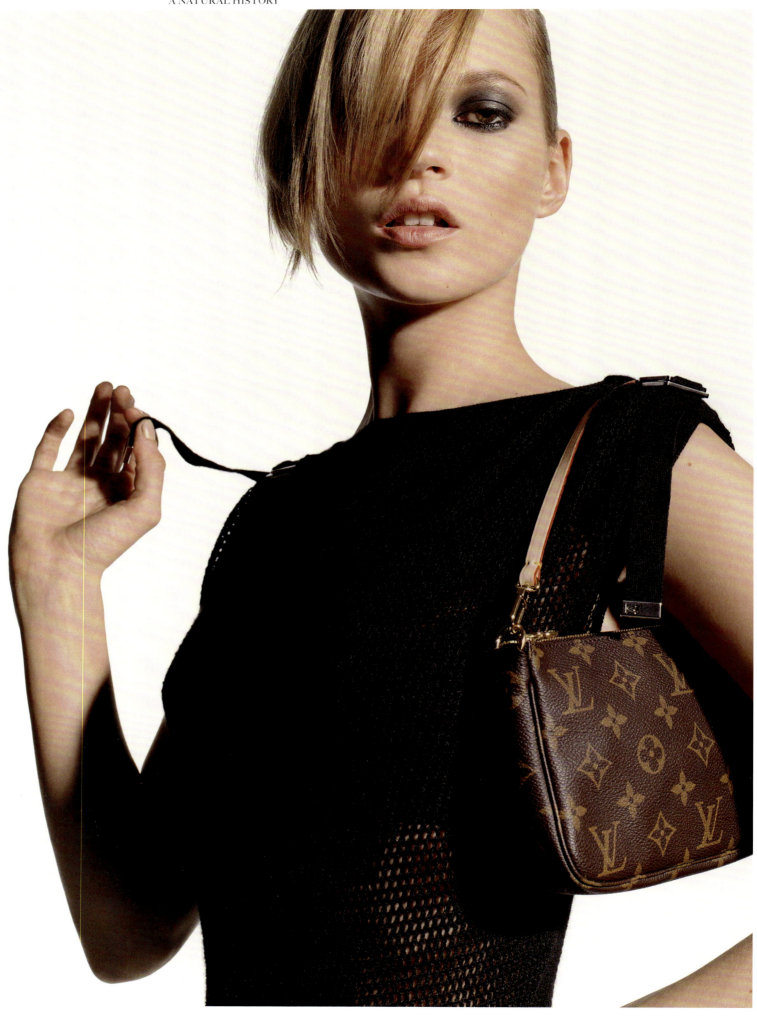

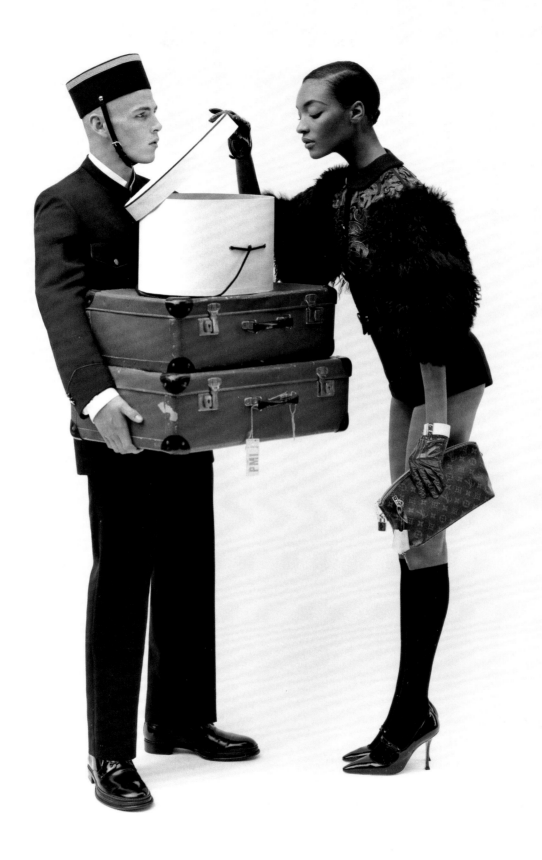

The model carries a medium Lockit Clutch in Monogram Fetish with removable chain and handcuff.
Photograph by Alasdair McLellan, *Vogue UK*, August 2011

Opposite: Autumn-Winter 2000–2001 advertising campaign. Kate Moss carries the Pochette Accessoires in Monogram
canvas. Photograph by Inez Van Lamsweerde and Vinoodh Matadin, 2000

Following double page spread: Spring-Summer 2008 advertising campaign. Claudia Schiffer carries a Pochette in
pink Monogram Bonbon. Photograph by Mert Alas and Marcus Piggott, 2008

SEASONAL COLLECTIONS

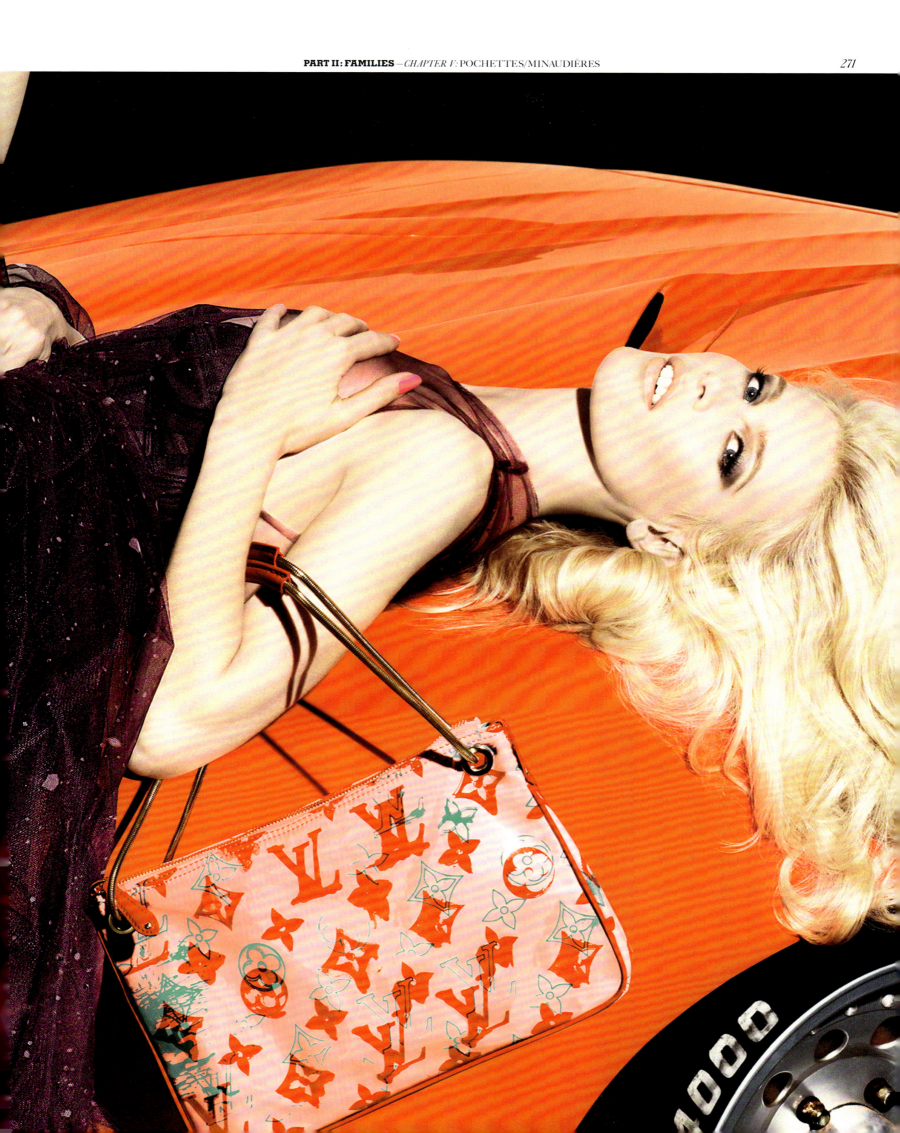

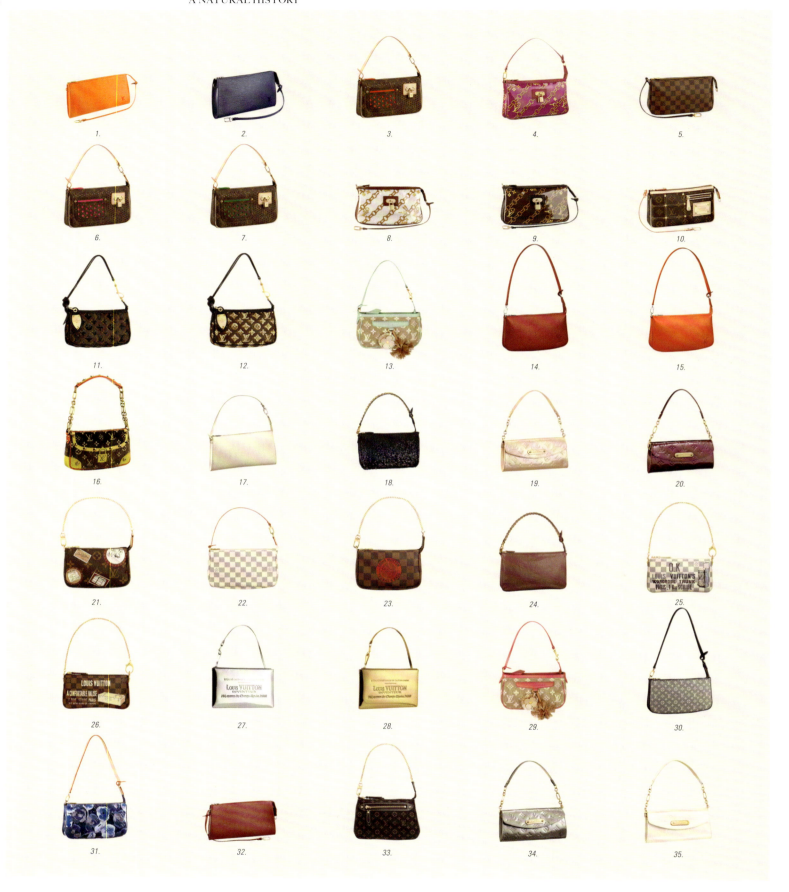

1. Pochette Accessoires in mandarine Epi leather, 2003 — 2. Pochette Accessoires in myrtille Epi leather, 2003 — 3. Pochette Accessoires in orange Monogram Perforé, 2006 — 4. Pochette Accessoires in fuchsia Monogram Charms, 2006 — 5. Pochette Accessoires in Damier canvas, 2009 — 6. Pochette Accessoires in fuchsia Monogram Perforé, 2006 — 7. Pochette Accessoires in green Monogram Perforé, 2006 — 8. Pochette Accessoires in white Monogram Charms, 2006 — 9. Pochette Accessoires in taupe Monogram Charms, 2006 — 10. Pochette Accessoires Riveting in Monogram canvas, 2007 — 11. Pochette Accessoires in black Monogram Éclipse, 2009 — 12. Pochette Accessoires in gold Monogram Éclipse, 2009 — 13. Pochette Accessoires in green Monogram Sabbia, 2011 — 14. Pochette Accessoires in carmin Epi leather, 2012 — 15. Pochette Accessoires in piment Epi leather, 2012 — 16. Pochette Accessoires in Monogram Trompe L'Œil, 2004 — 17. Pochette Accessoires in ivory Epi leather, 2010 — 18. Pochette Accessoires Rêverie in wool and polyester embroidered with marine sequins, 2013 — 19. Pochette Sunset Boulevard in rose florentin Monogram Vernis, 2010 — 20. Pochette Sunset Boulevard in rouge fauviste Monogram Vernis, 2010 — 21. Mini Pochette Accessoires in Monogram Patch, 2008 — 22. Pochette Accessoires in Damier Azur canvas, 2006 — 23. Mini Pochette Accessoires in Damier Trunks&Bags canvas, 2008 — 24. Medium Pochette Accessoires in pink Boudoir calfskin leather, 2013 — 25. Medium Pochette Milla in Damier Azur Trunk canvas, 2010 — 26. Medium Pochette Milla in Damier Valise canvas, 2010 — 27. Pochette Louis Vuitton Inventeur in silver Monogram Miroir, 2006 — 28. Pochette Louis Vuitton Inventeur in gold Monogram Miroir, 2006 — 29. Pochette Accessoires in pink Monogram Sabbia, 2011 — 30. Pochette Accessoires in encre Monogram Idylle, 2012 — 31. Pochette Accessoires in grand bleu Monogram Vernis Ikat, 2013 — 32. Pochette Accessoires in rubis Epi leather, 2009 — 33. Mini Pochette Accessoires in fusain Monogram Idylle, 2010 — 4. Pochette Sunset Boulevard in gris art déco Monogram Vernis, 2010 — 35. Pochette Sunset Boulevard in perle Monogram Vernis, 2007

BIODIVERSITY: POCHETTE ACCESSOIRES

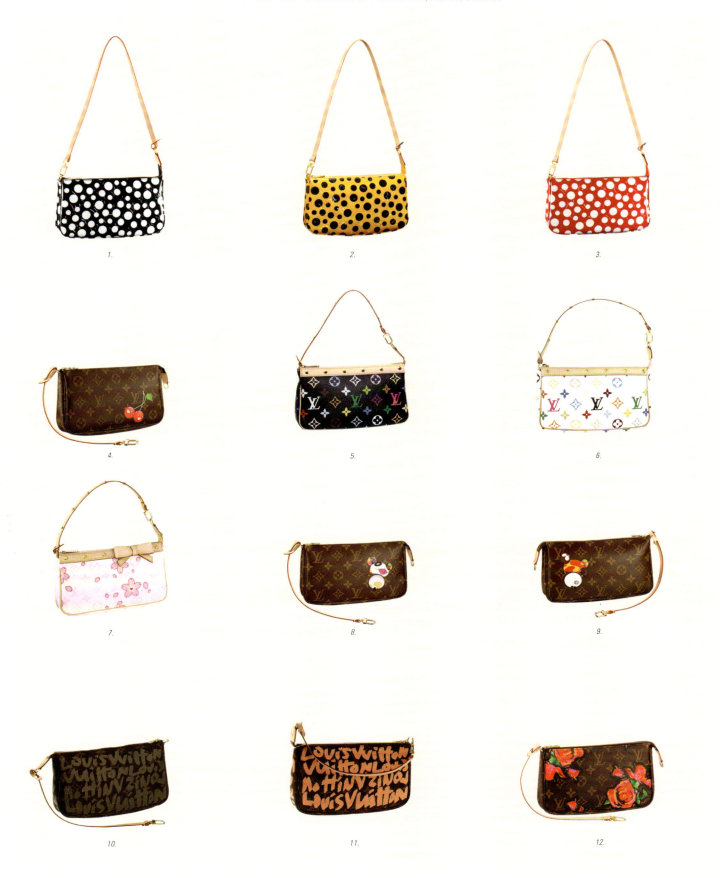

In collaboration with Yayoi Kusama: 1. Pochette Accessoires in black Monogram Vernis Dots Infinity, 2012 — 2. Pochette Accessoires in yellow Monogram Vernis Dots Infinity, 2012 — 3. Pochette Accessoires in red Monogram Vernis Dots Infinity, 2012. In collaboration with Takashi Murakami: 4. Pochette Accessoires in Monogram Cerises, 2005 — 5. Pochette Accessoires in black Monogram Multicolore, 2003 — 6. Pochette Accessoires in white Monogram Multicolore, 2003 — 7. Pochette Accessoires in pink Monogram Cherry Blossom, 2003 — 8. Pochette Accessoires in Monogram Panda, seen from the front, 2004 — 9. Pochette Accessoires in Monogram Panda, seen from the back, 2004. In collaboration with Stephen Sprouse: 10. Pochette Accessoires in khaki Monogram Graffiti, 2001 — 11. Pochette Accessoires in pêche Monogram Graffiti, 2001 — 12. Pochette Accessoires in Monogram Roses, 2008

ARTISTIC VARIATIONS: POCHETTE ACCESSOIRES

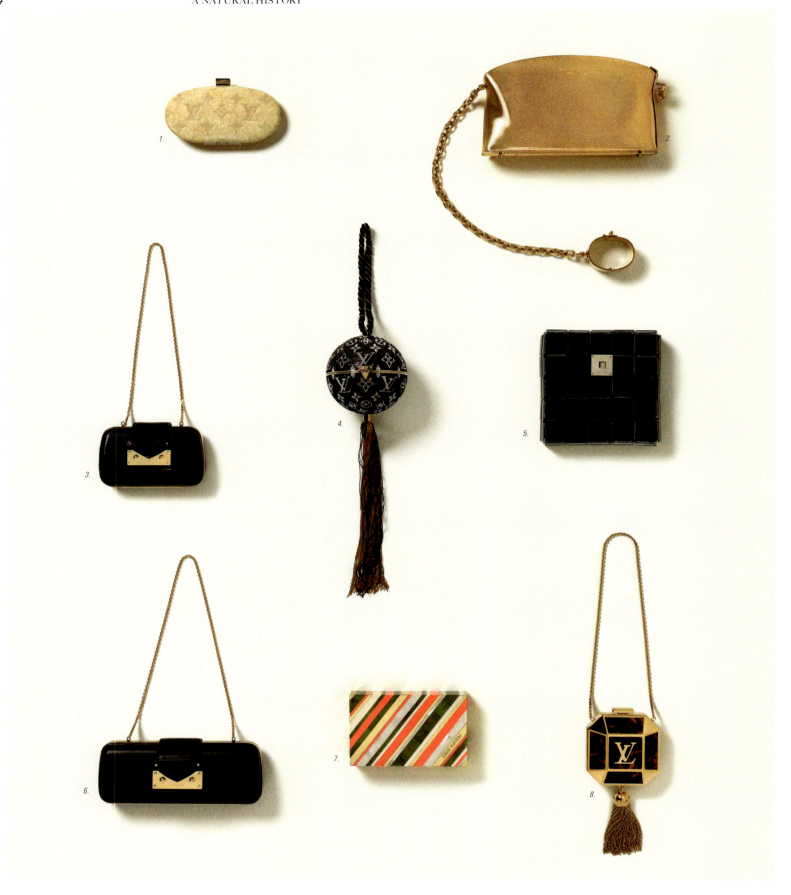

1. Minaudière Dragée in Monogram Dragée, made from pieces of eggshell, 2012, 16.5 × 10 × 3.5 cm. Louis Vuitton Collection — 2. Minaudière Lockit in guilloché
brass, 2011, 24.5 × 14.5 × 5.4 cm — 3. Minaudière Petit Trésor in black lizard skin, 2011, 13.5 × 8.5 × 5.5 cm. Louis Vuitton Collection — 4. Minaudière Sphère
in black Monogram Nova, made with more than 13,000 rhinestones, 2011, 13 × 63 cm — 5. Minaudière Prisme in black onyx, 2013, 16 × 16 × 3 cm — 6. Minaudière
Trésor in black calfskin leather, 2011, 22.5 × 9 × 5.5 cm — 7. Rose foncé Minaudière Berlingot in mother-of-pearl, metal and resin, 2011, 16.1 × 11 × 4 cm —
8. Minaudière Petit Bijou in acetate, 2011, 10 × 11 × 5.5 cm. Louis Vuitton Collection. Photograph by Patrick Gries, 2013

Opposite: Anja Rubik carries a Minaudière Sphère in black Monogram Nova. Photograph by Mikael Jansson, *Vogue Paris*, May 2011

FAMILY PORTRAIT: MINAUDIÈRES

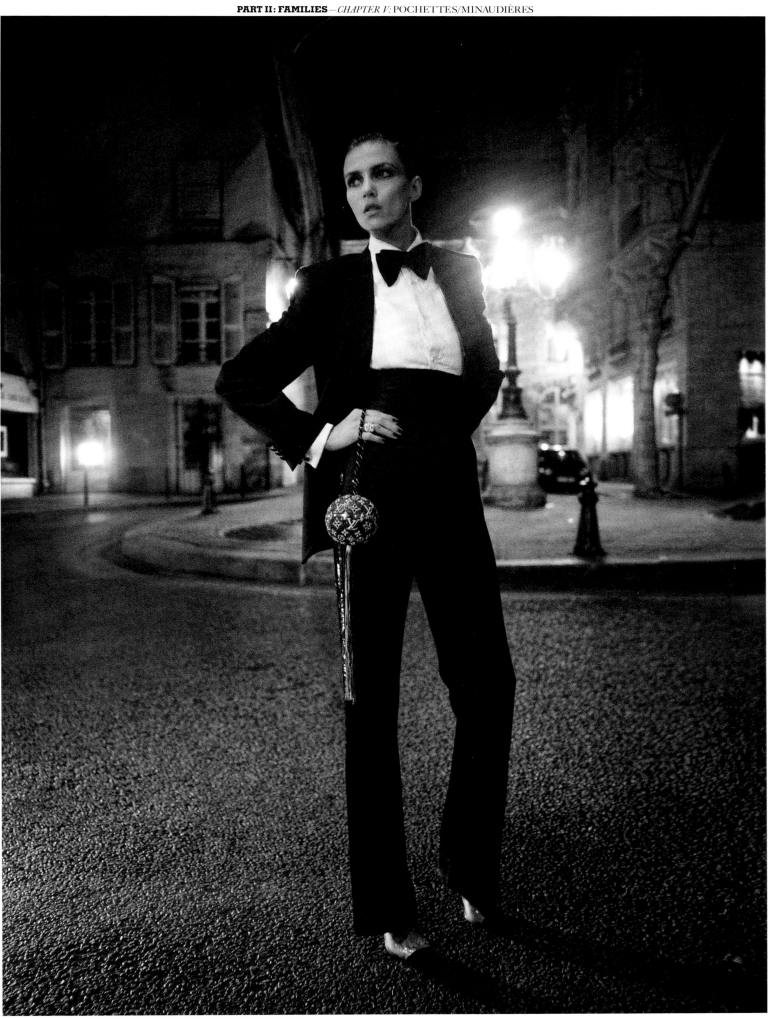

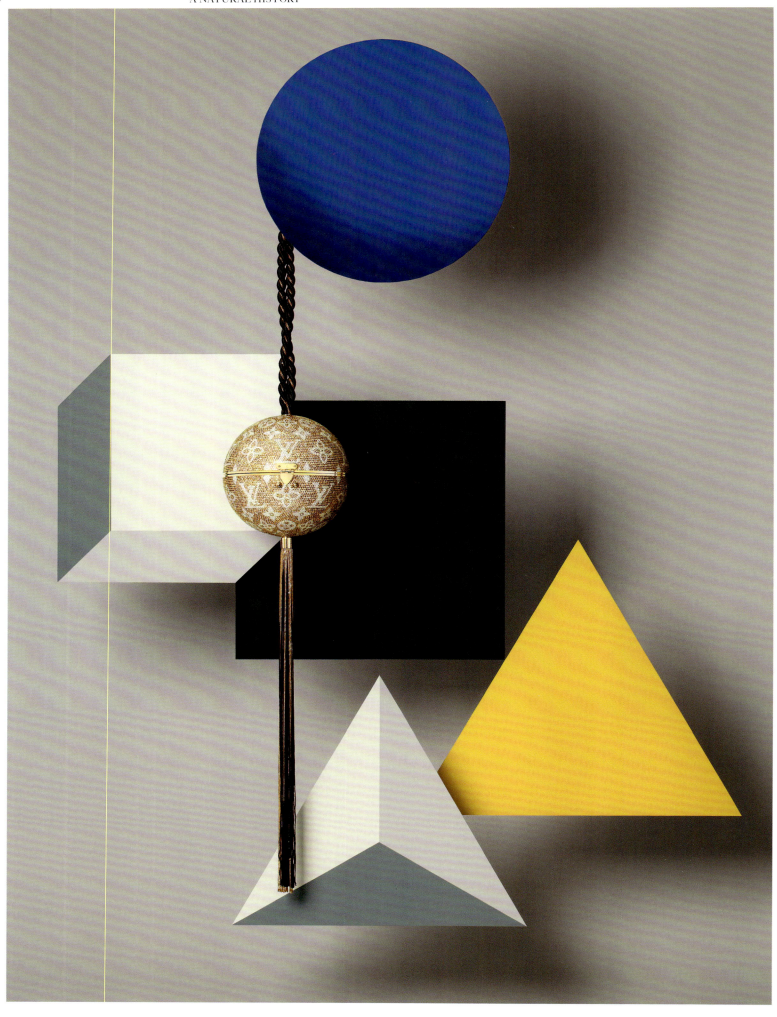

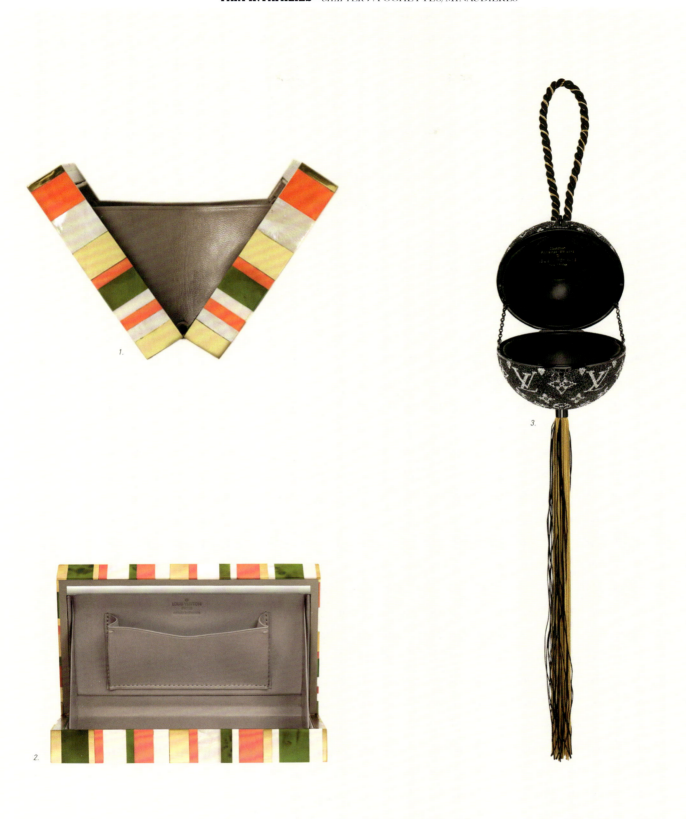

Rose foncé Minaudière Berlingot in mother-of-pearl, metal and resin, 16.1 × 11 × 4 cm: 1. Open, profile view — 2. Open, front view — Minaudière Sphère in black Monogram Nova, 13 × 63 cm: 3. Open, front view

Opposite: Minaudière Sphère in gold Monogram Nova. Photograph by Tania and Vincent, *Please*, Summer 2012

Following double page spread: Autumn-Winter 2007–2008 advertising campaign. The actress Scarlett Johansson carries a Clutch in silver Monogram Limelight. Photograph by Mert Alas and Marcus Piggott, 2007

MORPHOLOGY

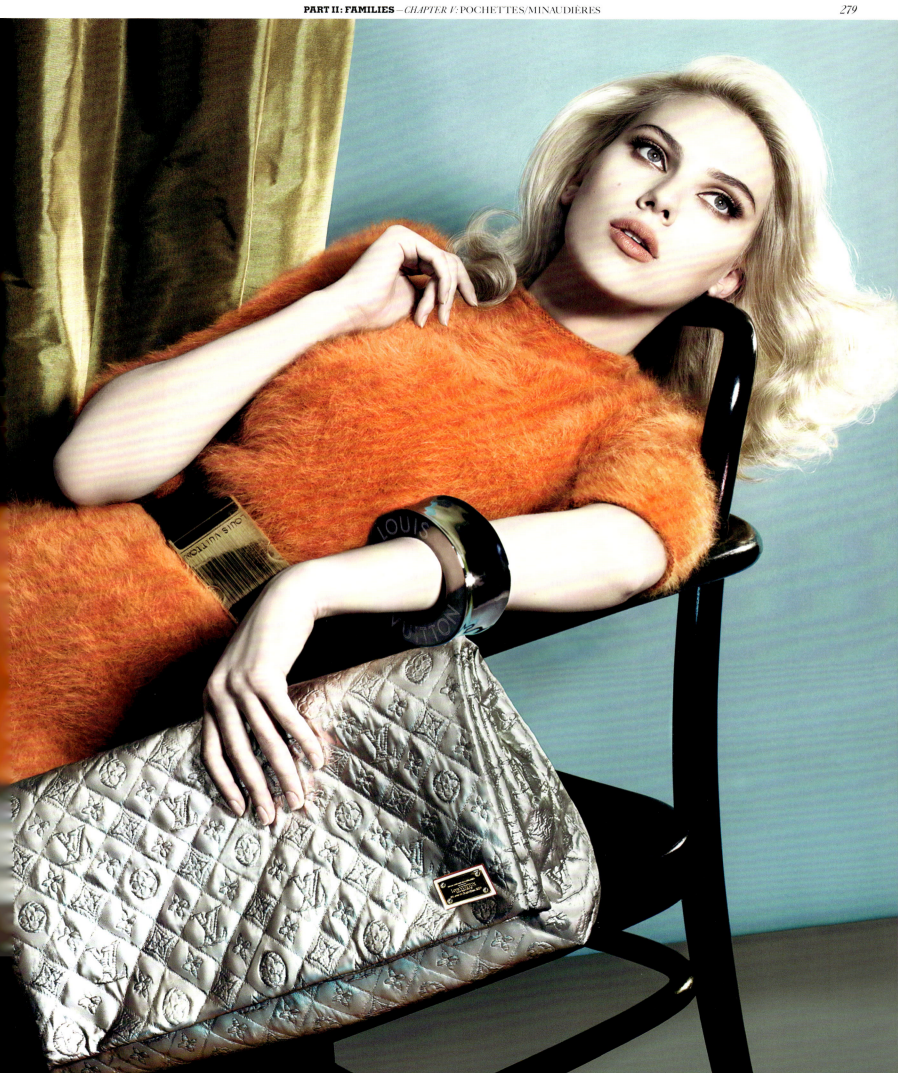

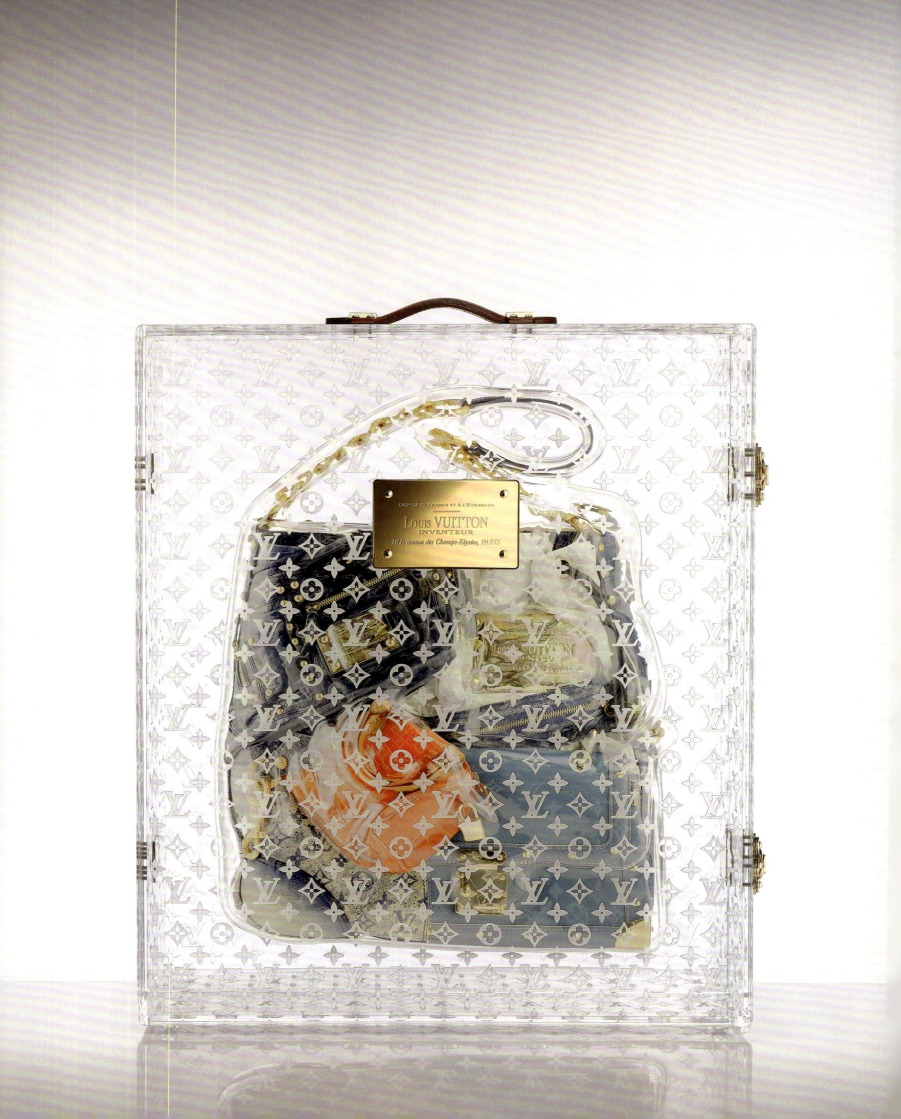

Chapter VI:
MUTATIONS
Pages 280–341

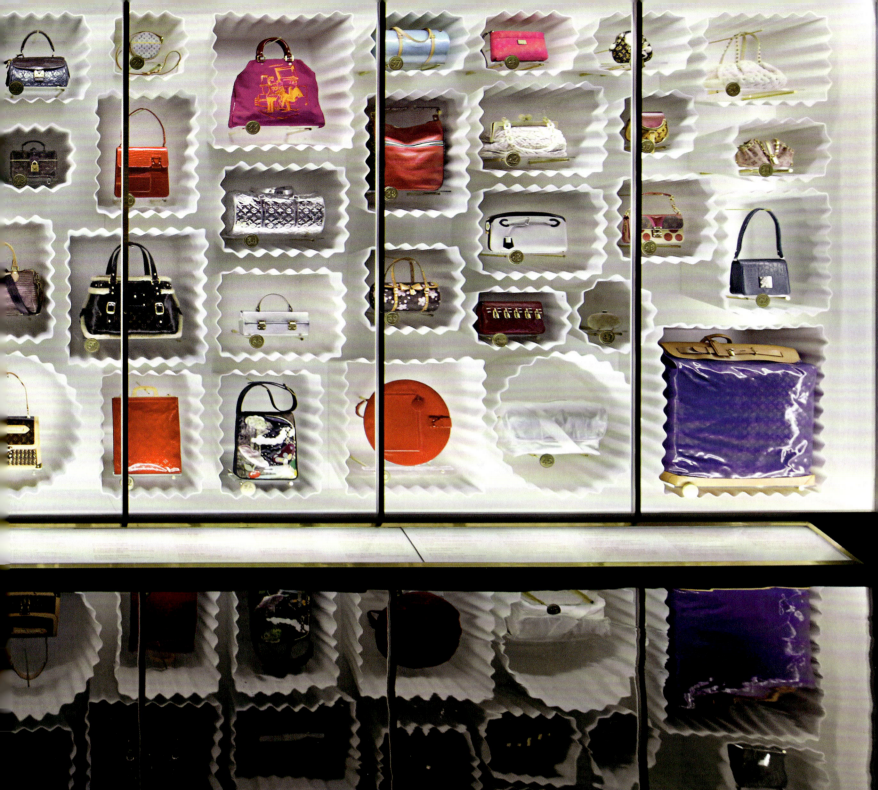

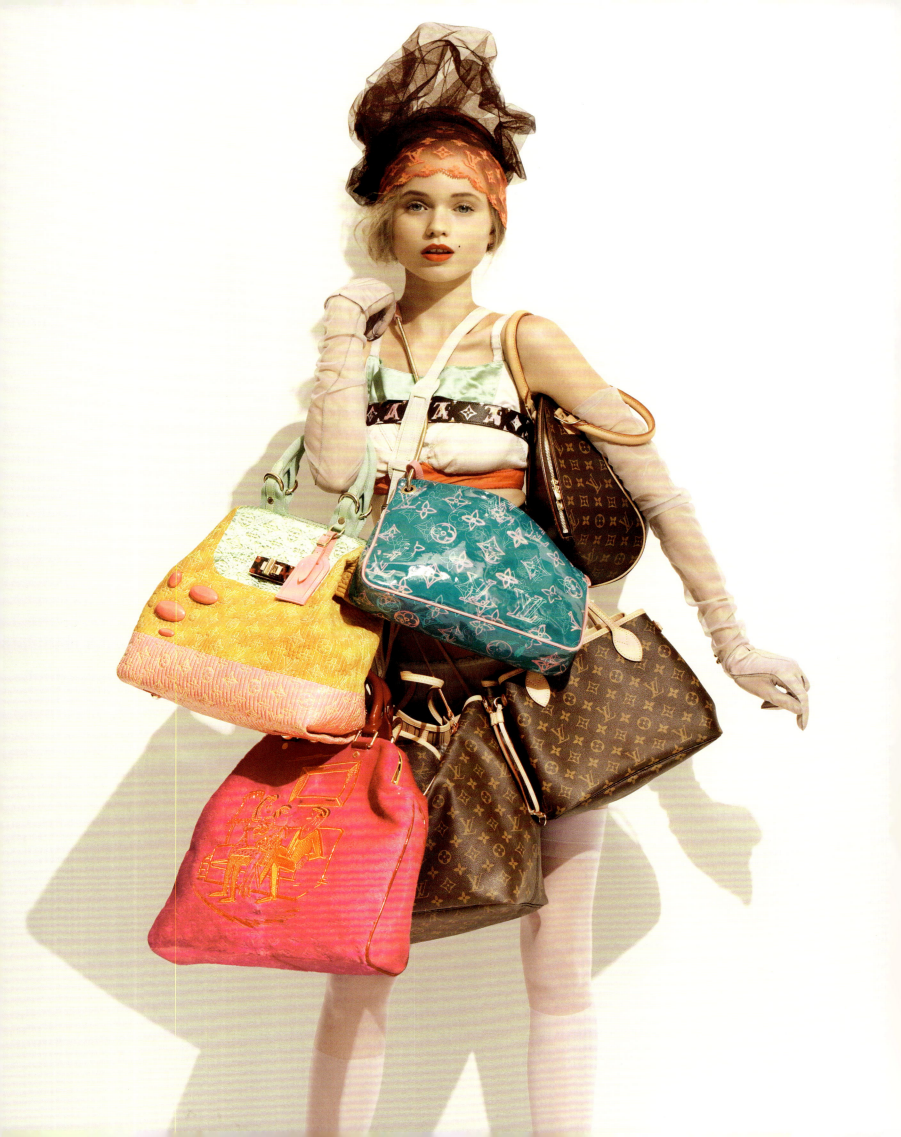

MUTAGENESIS
IAN LUNA

"I WAS BROUGHT HERE TO DO SOMETHING, TO MAKE THIS YOUNG AND COOL, CONTEMPORARY AND OF THE MOMENT. IN ORDER TO DO THAT, I HAVE TO HAVE A CERTAIN AMOUNT OF DISRESPECT FOR THE RULES. THE ONLY TIME ANYTHING EVER REALLY CHANGES IS WHEN YOU'RE RESPECTFUL AND DISRESPECTFUL AT THE SAME TIME."
—MARC JACOBS

FILTHY SEXY LUCRE

The upward trajectory of Louis Vuitton in the period between 1998 and the first decade of the 21st century occludes the reality that chance and risk still hold significant sway on even the best-laid plans. A few wizened *hommes d'affaires* can well engage in some revisionism, but revival was nowhere near a sure thing when LVMH chairman Bernard Arnault handed the reins of the *malletier* to Yves Carcelle in 1990—or indeed when both tapped Marc Jacobs to become artistic director *chez* Louis Vuitton in 1997. Arriving as it did at the crossroads of Messrs. Arnault, Carcelle and Jacobs' careers, which incidentally coincided with an ascendant, seemingly unstoppable Miuccia Prada and rumblings of a similar restoration at Gucci with Domenico de Sole and Tom Ford, the mid- to late 1990s seemed to many an unlikely time and place from whence Louis Vuitton could attempt to stage a comeback for the ages.

It must, and it did. Detractors, admirers and detached observers will long debate the causes and courses of this epic reversal, but this unique union of man, moment and internet would have made for very little had it not been for the flexibility afforded by a number of key structural changes at the company that the major players must have achieved through cycles of protracted conflict and negotiation.

Chief of these was the debut of a women's ready-to-wear collection (and tertiary menswear, jewelry and wristwatch lines), and it proved a boon to the handbags—formally called *sacs de ville* or City Bags—that still make up the majority of the company's sales, and represent the most profitable line of accessories in the history of modern fashion. Now firmly plugged into the ceaseless rhythms of Paris' many fashion weeks, these seasonal demands would now have to be integrated into how the company brought its goods to market, and necessitated change at a systemic level. The design bureaus in Paris responsible for the upkeep of its luggage and *haute maroquinerie* divisions were now susceptible to currents that they could afford to merely coast in decades past. With Louis Vuitton now accessorizing its own garments, bags would now have to be customized and even re-imagined in ways that would have been inconceivable at any point in the last century.

YEAR ZERO

The second half of the 20th century marked a crucial turning point for the design ateliers at Louis Vuitton, and one development in particular led to the proliferation of City Bags. For the first century of the House, monogrammed canvas, from its earliest form (Trianon Grey canvas, 1854) to its most recognizable iterations, proved near indestructible as a membrane to trunks and other forms of structured luggage like the Alzer suitcase. But it proved too brittle for many forms of soft-sided carryalls, and as evidenced by some of the more ancient examples of treated canvas bags in the company's archives in Asnières-sur-Seine, these items fared less well over time than contemporaneous all-cowhide or pigskin luggage. The determination of Henry-Louis Vuitton saw the development of a more flexible canvas in 1959, which improved on precedent as it spurred the development of canonical bag designs, such as the Speedy, Papillon and the Noé, which saw instant popularity in the 1960s.

Fast-forward to 1998 and much of the visual and plastic language of Louis Vuitton's accessories remained largely unchanged, and imprinted canvas City Bags in the ubiquitous 1896 Monogram, or the earlier 1888 Damier checkerboard still dominated the popular conception of the brand. For these bags to remain undisputed markers of luxury into the new millennium, their DNA would have to be rewritten, and their sturdy handles would have to bear the freight of even the talk of resurgence.

The model carries a Firebird bag in pink Monogram Cartoons, a Firebird bag in yellow, green and pink Monogram Motard and a Pochette Bonbon in turquoise Monogram Bonbon, all designed in collaboration with the American artist Richard Prince in 2008. She also carries an Ellipse bag and two Neverfull bags in Monogram canvas Photograph by KT Auleta, *V Magazine*, Spring 2008

PRECEDING DOUBLE PAGE SPREAD

"Chocolate Box." Installation presented at the exhibition "Louis Vuitton / Marc Jacobs" at the Musée des Arts Décoratifs in Paris, from March 9 to September 16, 2012.

P. 280
Tribute Patchwork Collector bag in a Plexiglas case screen-printed with the Louis Vuitton Monogram, 2007, 58 × 70 × 24 cm, 21.4 kg
Louis Vuitton Collection

Hedgehog, sculpture created in 2011 by the British artist Billie Achilleos using Louis Vuitton bags and accessories, and shown in the exhibition "Maroquinaris Zoologicae" at the Maison Deyrolle in Paris, October 3, 2011 Photograph by Mazen Saggar, 2011

Indeed, the first decade of Marc Jacobs' tenure as design director is a case study in how the manipulation of Louis Vuitton's codes spawned a material, formal and typological complexity that went a long way to establishing a true material culture (in every possible sense) and how forceful, directed challenges to established ways of seeing would surprise even the agitators. His inaugural ready-to-wear show for Louis Vuitton, held at the Grande Halle de la Villette in March 1998, was infamously bereft of bags save for a white leather tote. Echoing the prevailing fashion zeitgeist, this Minimalist stance was seen then as either quaint or too clever by half. But this provocation can now be understood (with the benefit of not a little hindsight) as Year Zero to a deliberate agenda. With *tabula rasa*, the inevitable demands for novelty set the stage for a violent release of creative energy—and what did come would nearly obliterate all that came before.

Jacobs's elite design collaborators—first in Louis Vuitton's bag department in the upper floors of 2 rue du Pont-Neuf, and later from very far afield—engaged this task at first with some referential delicacy but their hearts were always set to radical gestures. With Jacobs' tenure at LV now fully in its second decade, one would need the most extensive of Linnean cladograms to organize what exactly it is that he and his merry band had wrought. But that is entirely the point of attempting a taxonomy. This ongoing narrative of invention, adaptation, evolution, and crucially, mutation goes beyond a narrow mandate to explain a commercial phenomenon, even one of great

magnitude. More notably, it illustrates the indispensable role of variation (sometimes even to excess) in the service of design, and in so doing, limns a story whose implications to contemporary applied arts are only now being grasped. Fashion design, now empowered by its own rubric—and more importantly, its own historians— is fully emancipated from the critical evaluation of other disciplines, and can capably render judgment on the achievement of one of its own.

GMO

In biology, mutation, and its causal processes—mutagenesis[1]—is one of the driving forces of evolution. Linked inextricably to adaptation, mutagenesis is the process by which the DNA of an organism is altered, either through natural or induced agency, to produce a mutation. Adapting this notion of progress to make sense (in a cladistic way) of Louis Vuitton's City Bags in the Jacobean age, drama too resides in the mutability of a specific set of heritable traits. We have to reject a reductive conception of "family" that exists in mathematics in favor of a genealogy that makes allowances for accident and uncertainty. Aggressive tinkering in the LV laboratory has produced some fearsome, even furry chimeras, and while these strains always track back to common ancestors, the lines of ascent and descent aren't always clear—and are, at times, fudged on purpose.

Like so many snakes and lizards sloughing off their skins, these City Bags saw their familiar, speckled hides acquire unprecedented texture and color in this period. Marc Jacobs would improve on a capsule collection done in 1996 to celebrate the 100th anniversary of the trademark monogram—which included one-off bags by Azzedine Alaïa, Romeo Gigli, Vivienne Westwood, Sybilla and Isaac Mizrahi—by thinking the unthinkable. Not content with small moves like the DJ-inspired messenger bags from the late 1990s, he would improve on the 1896 Monogram by rewriting its genetic code. In effect, the candles were still on the birthday cake when Jacobs press-ganged a compatriot, the late Stephen Sprouse to mess with the Monogram. Rather like countless graffito left by tourists on the casing stones and walls of so many mortuary temples in Egypt, this was equivalent to sacrilege to the lords of *patrimoine*. Jacobs recounts: "we were not allowed to change the Monogram. We were not allowed to do this. We were not allowed to do that. And I had been trying to follow the rules and do what everybody had told me … I had this notion that I wanted to do graffiti on Vuitton bags and I didn't want it to be just anybody's graffiti. I wanted it to be Stephen's graffiti. I'm not a rebellious person, and Stephen was the first person that I worked with who helped me break the rules here."[2]

The effect of all this insistent rule breaking was immediate and jarring. The simple visual conceit—not unlike the doodles made with metallic pens and fluorescent highlighters on the mottled black-and-white covers of notebooks familiar to generations of American

students—proved an enormous hit. Flooding the com- pany coffers and winning Jacobs some brawny friends in the rough-and-tumble of the LVMH schoolyard, the graffiti series also intimated a coming demographic shift in clientele for the brand.

This would be fully realized when Jacobs teamed up with a bespectacled, pony-tailed *otaku* from Tokyo not two years later. Then little known beyond Japan, Takashi Murakami was one of the perpetrators of Superflat, an even more obscure but very consequential movement in Japanese fine art that drew generative vigor from the union of traditional painting and *anime*. With Japan rela- tively unaffected by the crash that nearly took down the rest of Asia in 1997, the domestic luxury market proved remarkably resilient, and by the millennium the country had also reasserted itself to become one of the undis- puted poles of creative production for the hastening global monoculture. Under the visionary leadership of then LV Japan honcho Kyojiro Hata, Tokyo was already a proving ground for an incipient architectural program that had garnered much international praise. More im- portantly, the brisk sales of City Bags imprinted with one of Jacobs' signature innovations, the patent-leather Monogram Vernis in a range of acid colors, also inured the Japanese for the hue of things to come.

Indeed, the 2003 introduction of the Multicolore Mono- gram in all its 33-color splendor was, to a large extent, a *fait accompli* (the hoarding on Louis Vuitton stores un- der construction in Japan at the time was already sport- ing iterations of the new pattern). Success, in this case, was no scandal. Murakami employed the visual language of an inimitable prankster, and soon cartoon eyes, cherry blossoms, and diminutive cherries with eyes would vie for space on tableaux once previously populated by tan, unassuming Ls & Vs. And while it was not at all a gamble, the decision to secure the loyalty of Japanese women by skipping a generation—in effect, by passing the Papillon from grandmother directly to granddaughter—was the stuff of marketing dreams. As a result, the Japanese were responsible for a crucial portion of Louis Vuitton's total market share for the better part of a decade.

Further genetic modification followed in the Multicolore Monogram's wake. In 2007, Richard Prince's series of limited-edition bags heralded one of the most ballyhooed art-and-fashion partnerships of the era, repackaging Murakami's family-friendly jokes into his own take on handbag porn. Replete with hubba-hubba nurses, snappy one-liners, double entendres and thoroughly inappropri- ate cartoons cribbed from vintage issues of *Playboy*, this return to New York incidentally affirmed a strong, trans- pacific axis to these collaborations, and would come full circle with the willing assimilation of Yayoi Kusama into the Louis Vuitton/Marc Jacobs orbit.

But textural and subcutaneous tinkering would soon give way to intense, even savage morphological experi- mentation. Proportions were exaggerated to parody, handles took the form of audio headphones, a red patent-

Owl, above (right) and *Moose*, below (right), sculptures created in 2011 by Billie Achilleos using Louis Vuitton bags and accessories, and shown in the exhibition "Maroquinaris Zoologicae" at the Maison Deyrolle in Paris, October 3, 2011 Photographs by Mazen Saggar, 2011

leather disk resembling the Japanese national insignia is armed with a strap, and some bags grew day-glo foxtails that dragged down to the floor. Sylvie Fleury would cast a Keepall in bronze to form a template for chrome leather blingery. In Fairy Tales, Julie Verhoeven even made literal butterflies, and a Pochette in the form of a shiny green toad.

In time, there would even be a pair of Japanese fairy god- mothers to this story. Expressing her clear intent in the fall of 2008 to "pulverize" the codes of LV, Rei Kawakubo created a Mini HL (a dwarf Speedy) with no less than *eight* handles and a Papillon with its own misshapen off- spring strung out on lanyards. Thanks to Yayoi Kusama, Cinderella 2012 could rock her glass slippers with a *min- audière* in the shape of—what else—a golden pumpkin (or more accurately, a Japanese *kabocha* squash).

PLAYS WELL WITH OTHERS

There had always been cooperation and mutual valida-
tion between fashion designers and their kin in other
disciplines within the applied and fine arts. But these
were almost always one-offs that were never particularly
invested in corporate cycles of supply-and-demand. One
of the prodigious innovations of the late 1990s was the
harnessing of these collaborative efforts into a Taylorite
mode of production, and its roots can be confidently
traced back to the hothouse environments of New York
and Tokyo. With every other H&M designer mash-up now
greeted with a yawn, it is instructive to recall that with
Marc Jacobs as matchmaker and Louis Vuitton as patron,
this methodology achieved some of its most legible and
influential expressions.

Now counting some several thousand examples in both
prototypes and production specimens, the City Bags
represent a corpus whose formal diversity, utility and
aesthetic achievement is on a par with some of the great
collections of industrial design objects from the last
century. In sheer output and diversity, the team at Louis
Vuitton rivals the geniuses at Carrozzeria Pininfarina and
their sensuous creations for Lancia, Ferrari, Volkswagen
and Cadillac in the 1960s–1970s; or those at the Sony
Design Center, who created innumerable production
models of Walkman in the 1980s. But sports cars, office
furniture, consumer electronics and even smartphones
acquire transformation on a much slower timetable than
handbags and shoes. Change in fashion and accessories
suggests something of the furious pace of upgrading,
migrating and evolving software, which, as evidenced by
the near instantaneous documentation of tendencies
in fashion and accessories is most visible—if not entirely
transformative, legible or meaningful—on the Web.
Abetted by the real-time blogging that happens in the
interminable wait between shows in the runways of Paris,
New York and Milan, responses to stimuli are recipro-
cated or repudiated by its end-users in ways that would
not have been possible without the proliferation of
new media platforms. And if envy and imitation are me-
diocrity's tributes to genius—to say nothing of the num-
ber of "replica bag" sites on the internet—Louis Vuitton
is often a victim of its own success, and in the face of a
plague, mutant, hybrid and the typical phenotype are all
equally susceptible to contagion.

To take liberally from Vitruvius, design is a "science that
can be comprehended rationally." As evidenced by the
variegated, and later more corporal adventures in *ma-
roquinerie* elaborated above, the Rationalist tendencies
that ensured the uninterrupted serial production of Louis
Vuitton's most basic bag types were not so much offset
by the Mannerist approach Marc Jacobs and his design
team pursued, but were rather themselves enhanced and
augmented. In truly postmodern fashion, monogrammed
bags in their standard livery of brown impregnated can-
vas and waxed, natural cowhide now happily coexist with
the dizzying concentration of hybrids and mutants in
the storehouses of the New Model Louis Vuitton. Building

on the pioneering if unheralded work of Xavier Dixsaut
in the late 1980s and early 1990s, Jacobs and his principal
accessories designers Nicholas Knightly and Emma
Winter, coupled a provisional attitude to authority with
amazing pop-culture instincts and hitched them to
an ethic of shared invention. Jacobs infamously quipped
that anyone "who says they do everything by themselves
is exaggerating. Doing things by yourself is—well, it's
masturbation. It's not nearly as exciting as doing it with
somebody else."[3] That abiding sense of playing very well
with others proved a bonanza, and Louis Vuitton would
do well to take careful note of what it delivered so far.

A young woman carries
a large Gypsy bag in
blue Monogram
Chèche and a Foxy bag
ornament in
red fox Photograph by
Sebastian Kim,
Interview Magazine,
March 2010

[1] A neologism coined in the lab of pioneering American geneticists in the late
1920s, mutagenesis is itself drawn from two very old words. Similar terms, like
genome (a *portmanteau* of gene and chromosome), began to appear in scientific
literature, and their lexical migration into the applied arts and manufacturing soon
followed (to say nothing of their application to the more flexible vocabulary of
politics and the social sciences).

[2] Quoted by Roger & Mauricio Padilha, *The Stephen Sprouse Book* (New York:
Rizzoli, 2009), pp. 227, 230 and passim.

[3] Quoted by Valerie Steele, "Jacobs, Marc" in *Louis Vuitton: Art Fashion and
Architecture* (New York: Rizzoli, 2009), p. 214.

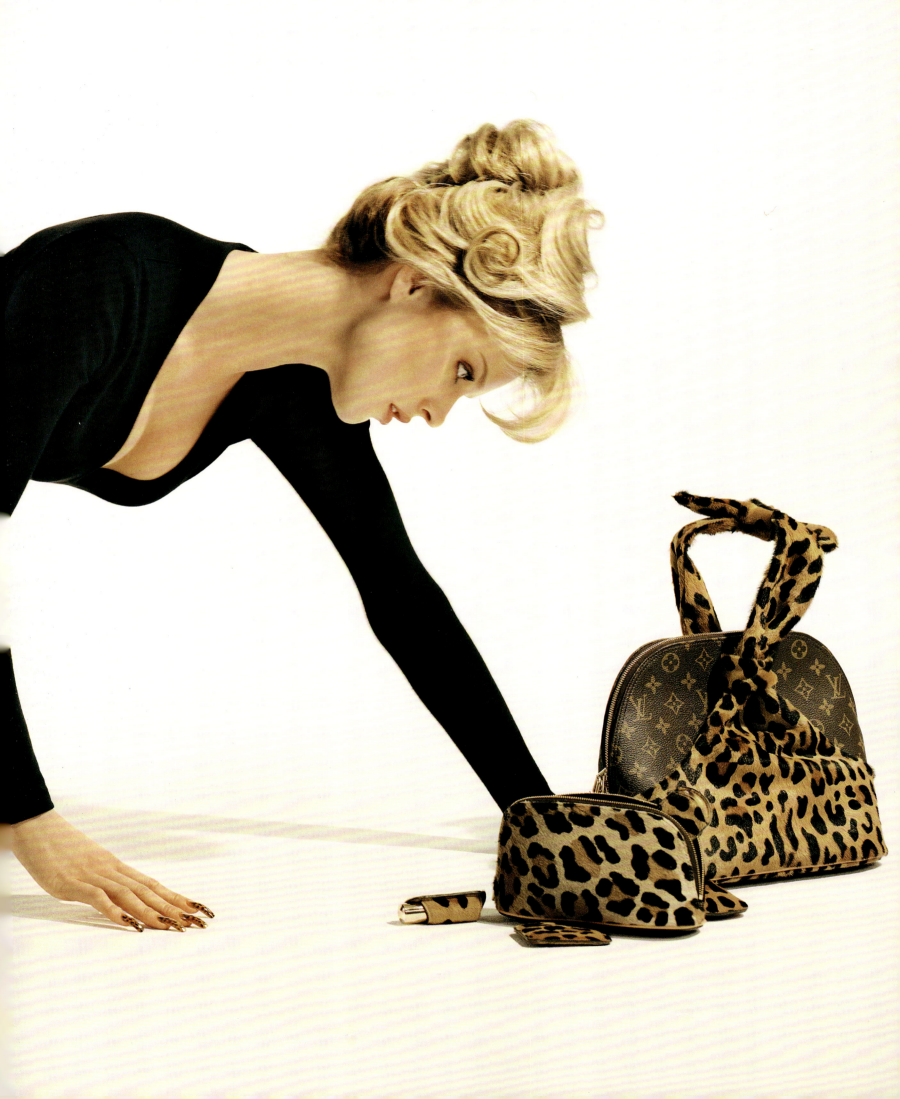

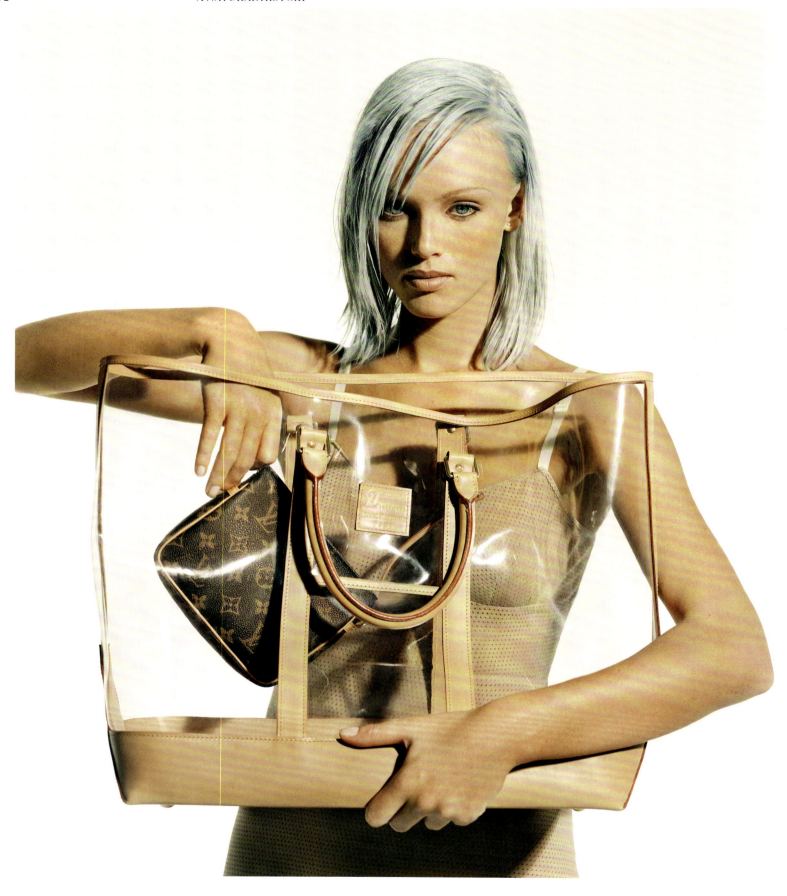

In 1996, Louis Vuitton asked seven fashion designers to create Monogram bags to celebrate the centenary of the famous canvas
launched in 1896: Azzedine Alaïa, Manolo Blahnik, Romeo Gigli, Helmut Lang, Isaac Mizrahi, Sybilla and Vivienne Westwood. For the occasion, the
House organized a series of events throughout the world.

"Louis Vuitton and Mizrahi celebrate the LV Monogram." Advertising campaign featuring a Week-End bag in transparent vinyl and natural cowhide
leather, containing a pochette in Monogram, designed by the American fashion designer Isaac Mizrahi, 1996. Photograph by Guzman, 1996

Preceding double page spread: "Louis Vuitton and Alaïa celebrate the LV Monogram." Advertising campaign with Eva Herzigova for the
centenary of the Monogram featuring a Panthère bag in Monogram canvas and panther printed calfskin leather with matching pochette and accessories
in panther printed calfskin leather, designed by Azzedine Alaïa, 1996. Photograph by Guzman, 1996

THE MONOGRAM CELEBRATES 100 YEARS

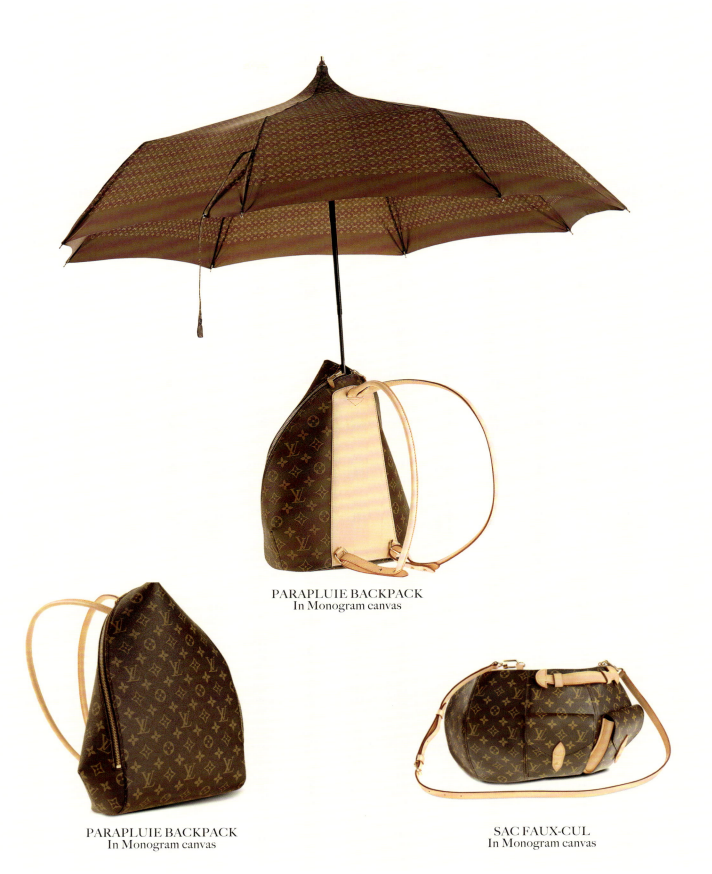

PARAPLUIE BACKPACK
In Monogram canvas

PARAPLUIE BACKPACK
In Monogram canvas

SAC FAUX-CUL
In Monogram canvas

Parapluie (umbrella) backpack in Monogram canvas, 1996, 34 × 35 × 35 cm, seen from behind with umbrella open and from
the front with umbrella closed, bag designed by the Spanish fashion designer Sybilla. Louis Vuitton Collection — Faux-Cul bag in
Monogram canvas, 1996, 50 × 28 × 23 cm, bag designed by Vivienne Westwood. Louis Vuitton Collection

RANDONNÉE

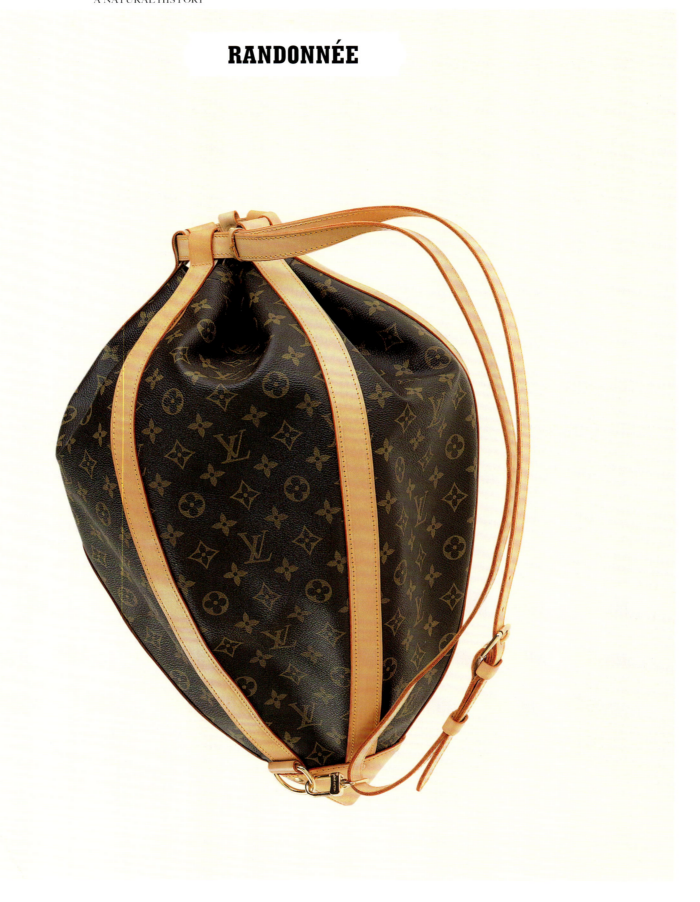

Randonnée in Monogram canvas, 1996, 22 × 50 cm, bag designed by the Italian fashion designer
Romeo Gigli for the centenary of the Monogram canvas in 1996. Louis Vuitton Collection

Opposite: Randonnée in Monogram canvas, bag designed by Romeo Gigli, 1996. Photograph by
Maria Vittoria Backhaus, 1996

ROMEO GIGLI

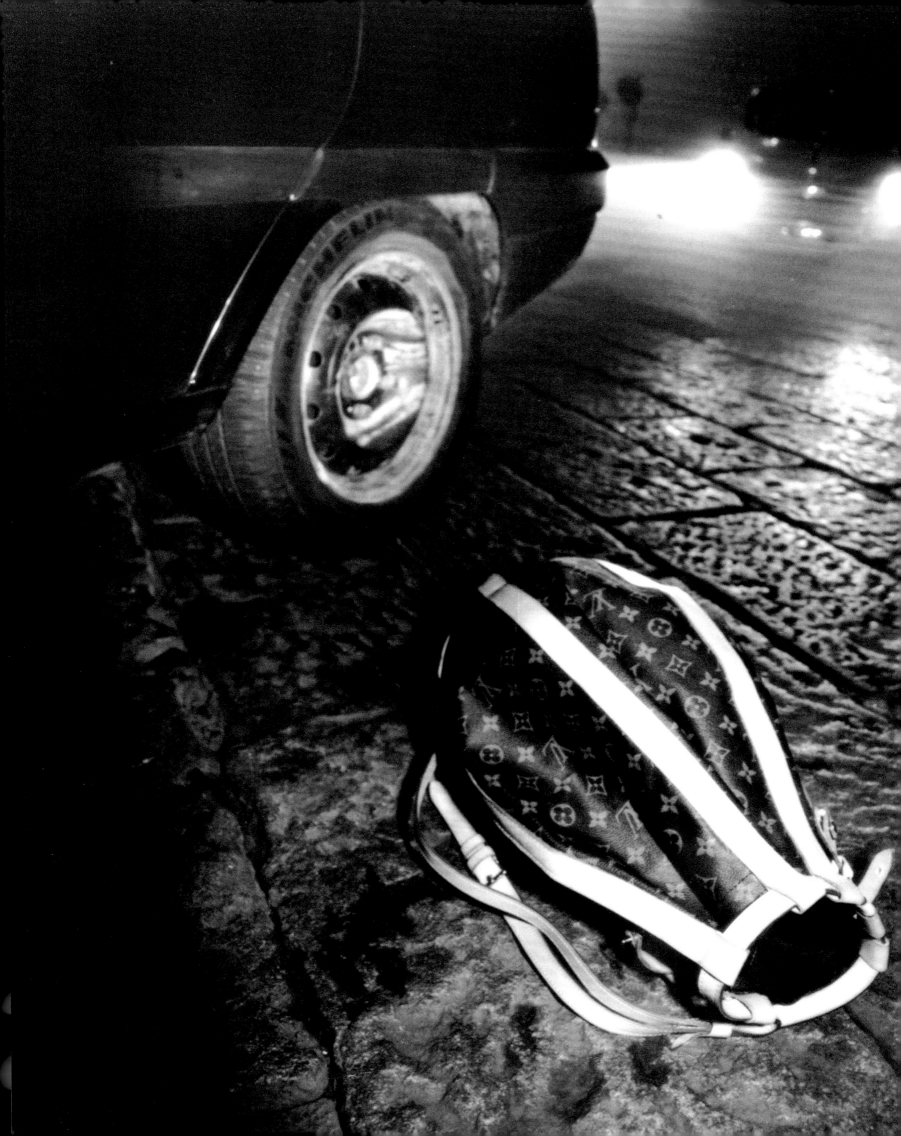

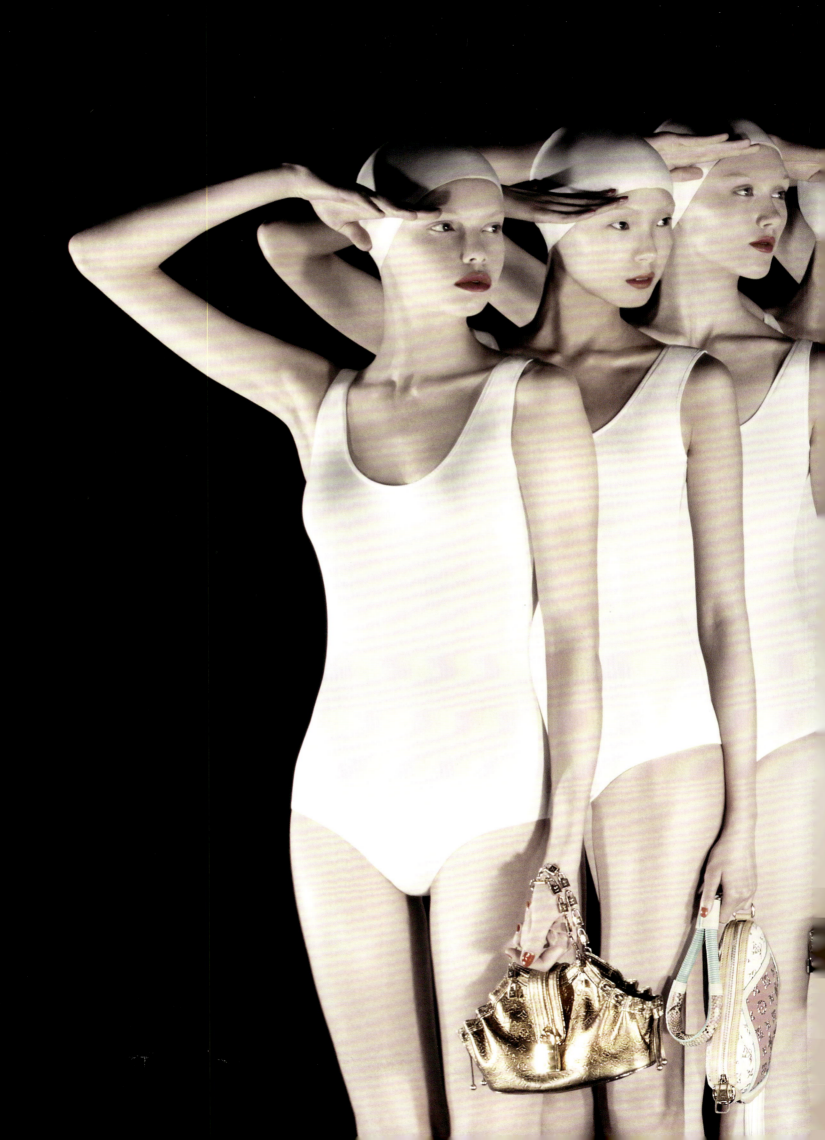

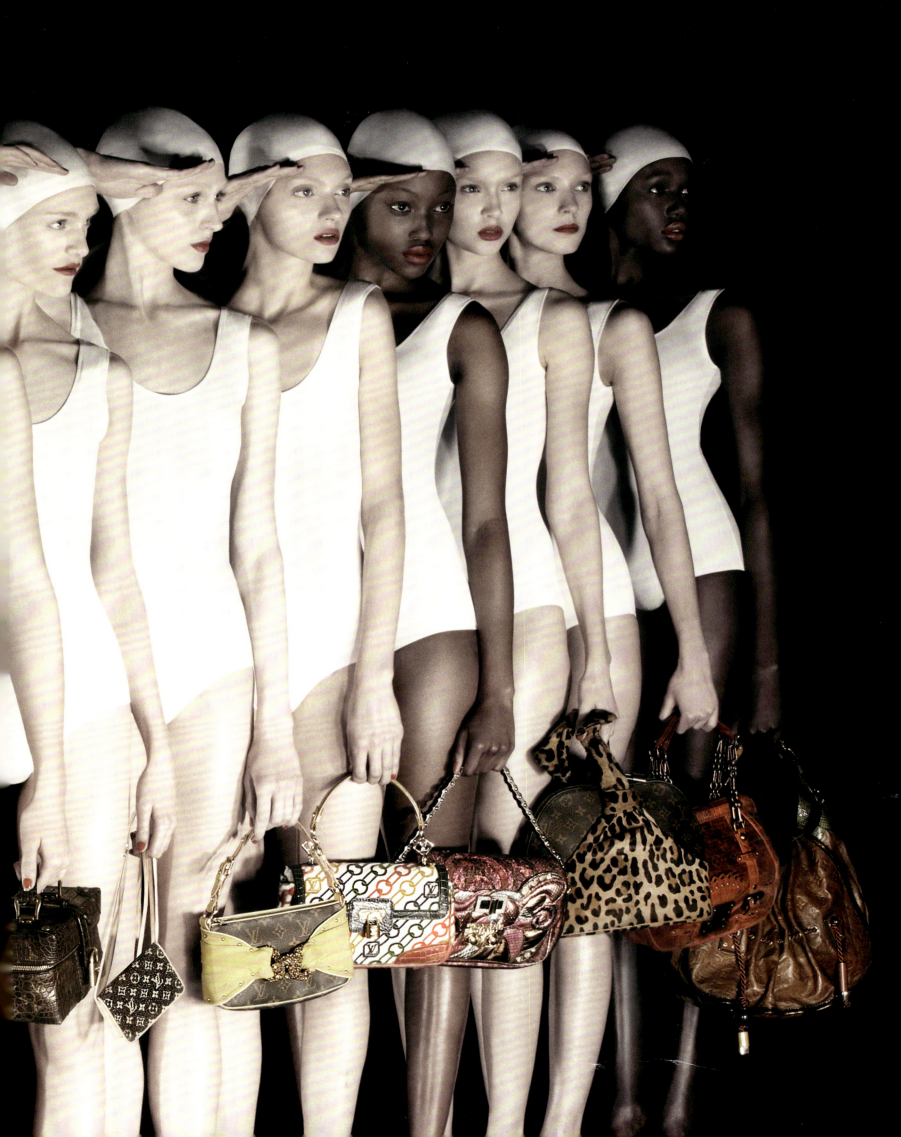

Spring-Summer 2008 runway show. Marc Jacobs concludes the presentation of the collection carrying a video-trunk designed for the show, which is equipped with screens playing the cartoon SpongeBob SquarePants, a character dear to the House's artistic director. Photograph by Chris Moore, 2007

Opposite: Autumn-Winter 1998–1999 runway show, look 01, the model carries a Messenger bag in white lambskin leather, the only bag presented in the first collection designed by Marc Jacobs for Louis Vuitton. Photograph by Alvaro Canovas, 1998

Preceding double page spread: The models carry (from left to right): a small Theda bag in bronze lambskin leather embossed with the Monogram, a Nightbird pochette in purple Monogram Nightbird, a Vanity Alligator in alligator leather with gold screen printed Monogram, a pearled Pochette in Monogram Perlé, a Pochette Accessoires in Monogram Drapée in anis goatskin suede, a Pochette Rabat in Monogram Velvet Chains, a Calliope bag in pink Monogram Brocade, the Panthère bag in Monogram canvas and panther printed calfskin leather designed by Azzedine Alaïa, a medium Gracie bag in red Monogram Velours canvas and alligator leather, a Kalahari bag in masala Monogram Épices. Photograph by Solve Sundsbø, *Love*, February 2012

MARC JACOBS

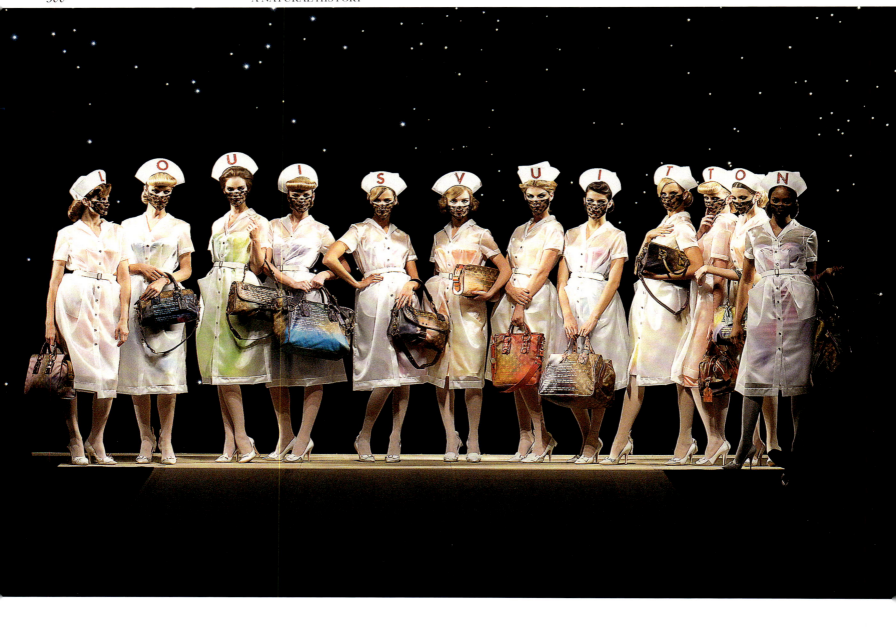

Spring-Summer 2008 runway show. Nurses carry bags from the Monogram Jokes line designed in
collaboration with the American artist Richard Prince. Photograph by Chris Moore, 2007

From left to right and top to bottom: Spring-Summer 2007 runway show, look 39, the model carries a Cirrus bag in Monogram Olympe. Photograph by Ludwig Bonnet, 2006 — Autumn-Winter 2003–2004 runway show, look 20 bis, the model carries a Verty bag in beige alligator leather. Photograph by Frédérique Dumoulin, 2003 — Spring-Summer 2007 runway show, look 40, the model carries a Tinkerbell bag in Polka Dots Fleurs. Photograph by Ludwig Bonnet, 2006 — Spring-Summer 2007 runway show, look 10, the model carries a Tribute Patchwork Collector bag. Photograph by Ludwig Bonnet, 2006

SEASONAL COLLECTIONS

1. Roundy bag in red Monogram Op Art, 2003 — 2. Headphone Bag in black Monogram Vernis and headphones covered in gold alligator leather, 2006 — 3. Pleated Steamer bag in
Monogram Léopard, 2006 — 4. Baia bag and swimsuit case in vinyl and grenadine leather, 2001 — 5. Le Fabuleux bag in white Suhali goatskin leather, 2003 — 6. Small Crochet bag in pale
pink Monogram Crochet, 2005 — 7. Art Déco bag in shagreen, lizard skin and chestnut and red alligator leather, 2005 — 8. Seau bag in yellow Monogram Pastel Glitter, 2005 —
9. Linda Quilted bag in topstitched silk, alligator leather and black shaved calfskin, 2006 — 10. Maxi Bucket composed of thirteen different leathers, 2006 — 11. Small Street Shopper bag
in orange Tressé leather, 2007 — 12. Bowly bag in blue Monogram Denim Patchwork, 2007

HAND BAG MUTANTS

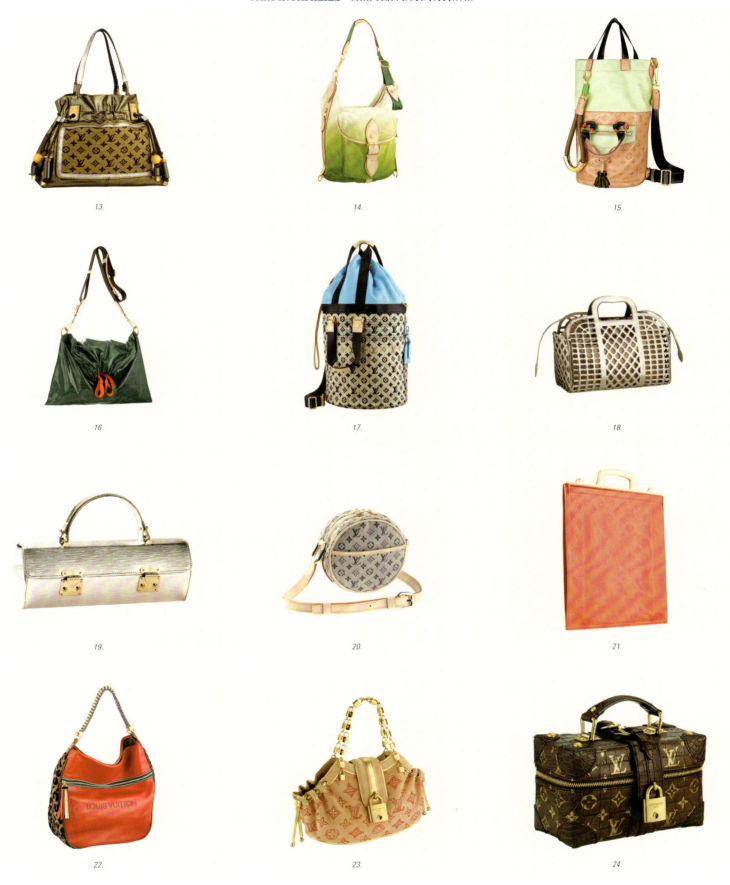

13. Sunbird bag in gold Monogram Lurex, 2009 — 14. Small Sunburst bag in green Monogram Denim, 2010 — 15. Duffle bag in pink Monogram Underground, 2010 — 16. Raindrop bag in emerald patent lambskin leather, 2010 — 17. Large Gypsy bag in blue Monogram Chèche, 2010 — 18. Medium Jelly bag in nougat goatskin leather, 2012 — 19. Galactia bag in metallic silver Epi leather, 2000 — 20. Medium Jeanne bag in blue Monogram Mini, 2000 — 21. Stanton bag in red Monogram Vernis, 1999 — 22. Safari bag in red Flight Bags leather, 2009 — 23. Small Theda bag in pink faux suede with rhinestones, 2004 — 24. Vanity Alligator in alligator leather screen printed with gold Monogram, 2004

BUCKET

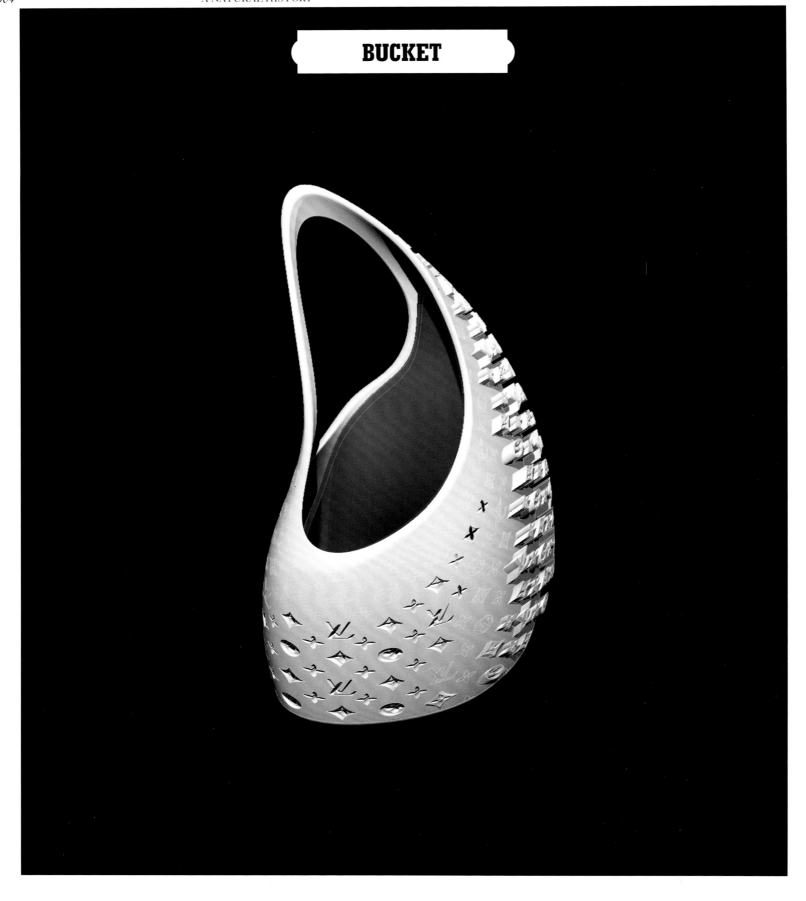

Interpretation of the Bucket, Zaha Hadid, 2006. Louis Vuitton Collection. This sculpture by the Iraqi architect was presented at the Espace Culturel Louis Vuitton on the top floor of the Champs-Élysées store in Paris during the exhibition "Icons" (September 15 to December 31, 2006), which featured reinterpretations of the House's iconic bags by contemporary artists and designers.

Opposite: Preparatory study for *Interpretation of the Bucket*, Zaha Hadid, 2006. Louis Vuitton Archives

ZAHA HADID

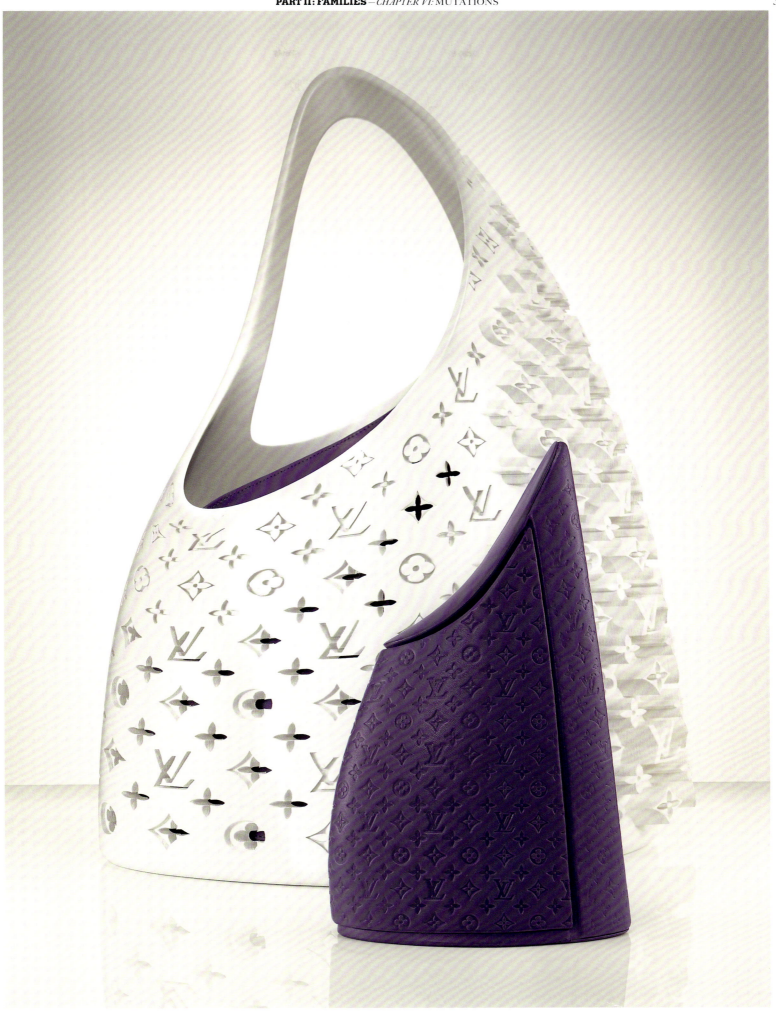

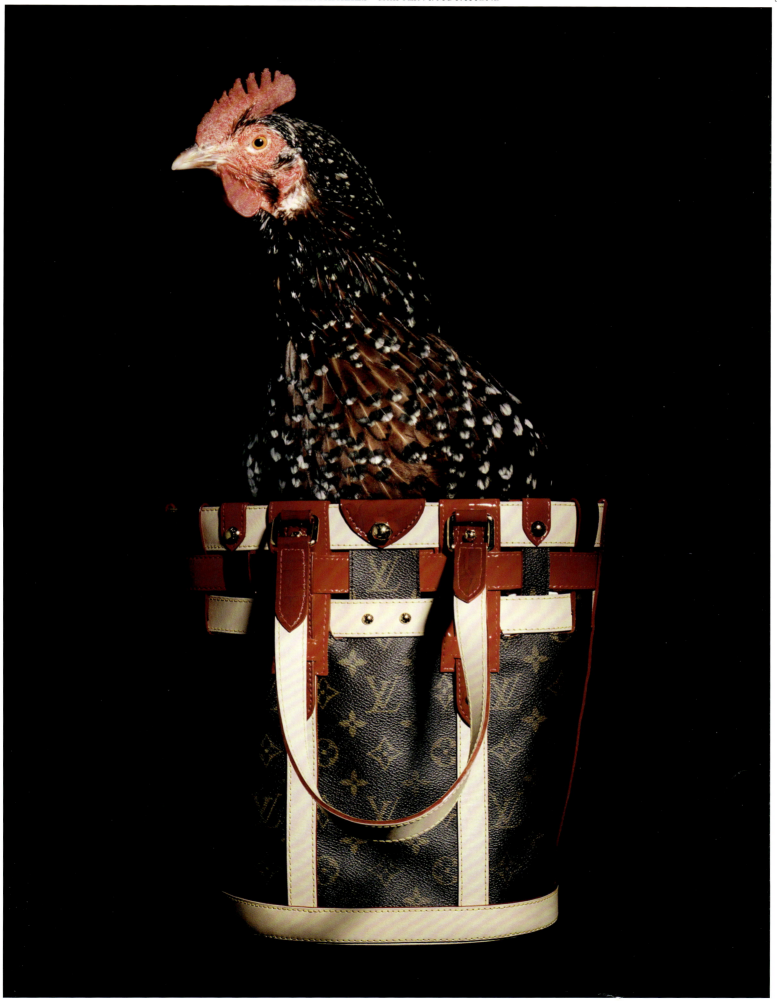

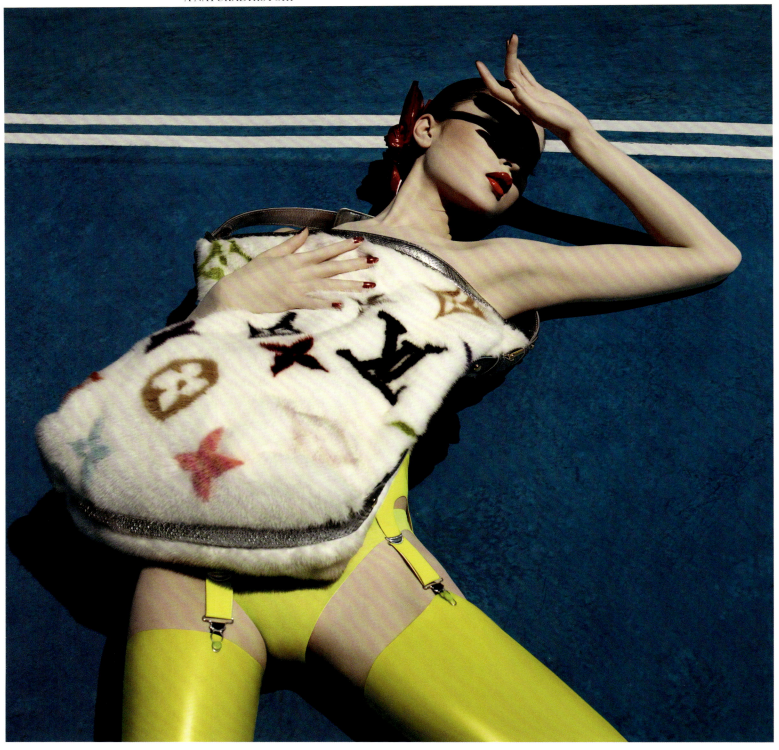

Du Juan carries a Hobo bag in white Monogram Multicolore Mink. Photograph by Mert Alas and Marcus Piggott,
W Magazine, August 2006

Preceding double page spread: A brown bear (*Ursus Arctos*) carries a small SC Bag in white SC calfskin leather, designed
in collaboration with the American director Sofia Coppola in 2010. Photograph by Andrew Durham, 2010

A chicken (*Gallus Gallus Domesticus*) poses inside a Néo Bucket in Monogram Rubis. Photograph by Toby McFarlan Pond,
Pop Magazine, December 2010

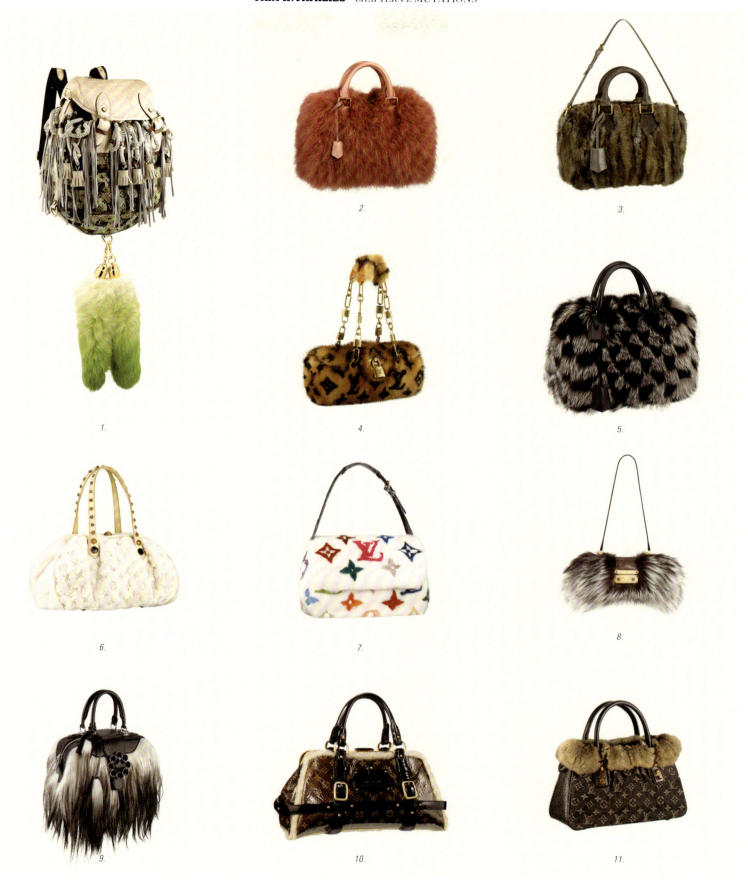

1. New Age Traveller bag in calfskin, alligator and python leathers and jacquard canvas, with a Foxy bag ornament in green fox, 2010 —
2. Speedy 25 Blush in pink imitation marabou feathers, 2013 — 3. Speedy 25 Caresse in gray mink 2013 — 4. Mini Papillon in camel Monogram Vison, 2004 — 5. Speedy 25 in black Damier Clair-Obscur, 2010 — 6. Demi-Lune Cabochons bag in white Monogram Quilted Mink, 2005 —
7. Messenger bag in white Monogram Multicolore Mink, 2006 — 8. Minaudière Trésor in gray fox, 2011 — 9. Small Transsiberian bag in black goat fur, 2012 — 10. Storm bag in Monogram Shearling, 2007 — 11. Small Trapèze bag in black Monogram Denim Chinchilla, 2005

FURRY MUTANTS

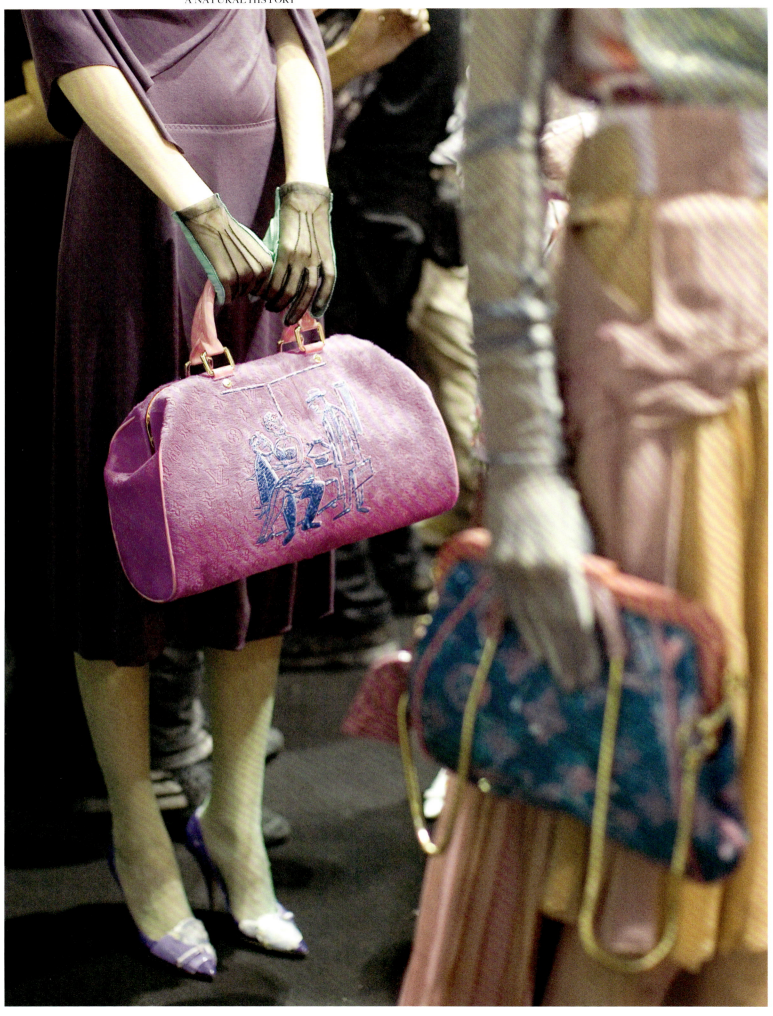

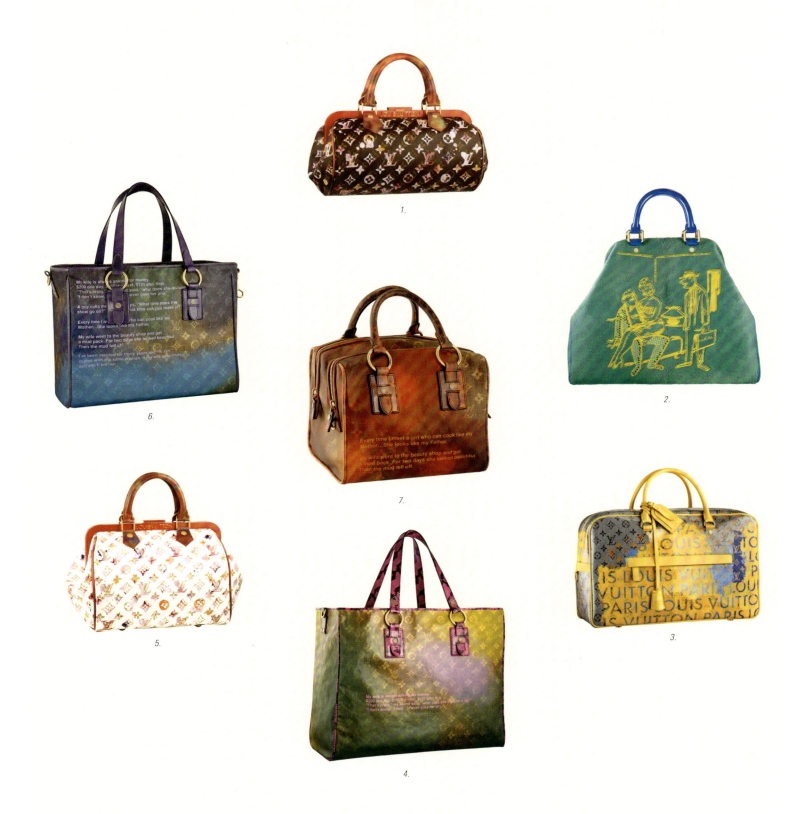

For the Spring-Summer 2008 collection, Marc Jacobs continued his collaborations with innovative contemporary artists, choosing Richard Prince. A renowned American artist and pioneer in the art of provocation, he is inspired by popular culture, creating images that are sensual, facetious, or even upsetting. Four distinct lines resulted from this collaboration: Monogram Jokes, which incorporates put-downs collected from tabloids; Monogram Cartoons, which reproduces humorous illustrations from magazines such as *The New Yorker* and *Playboy*; Monogram Pulp, which superimposes the Monogram over the name of the House; and Monogram Watercolor, which gives the Monogram the appearance of a watercolor painting.

1. Papillon Frame in brown Monogram Watercolor, 2008 — 2. Firebird bag in blue Monogram Cartoons, 2008 — 3. Large Weekender bag in yellow Monogram Pulp, 2008 — 4. Duderanch bag in pink Monogram Jokes, 2008 — 5. Speedy Frame in white Monogram Watercolor, 2008 — 6. Heartbreak bag in iris Monogram Jokes, 2008 — 7. Mancrazy in red Monogram Jokes, 2008

Opposite: Backstage at the Spring-Summer 2008 fashion show, the models prepare for the runway: on the left, the model (look 49) carries a Firebird bag in pink Monogram Cartoons; on the right, the model (look 47) carries a bag in turquoise Monogram Bonbon. Photograph by Mazen Saggar, 2007

RICHARD PRINCE

POCHETTE

POCHETTE PAPILLON
In Framboise Mini Monogram Vernis

POCHETTE HIBOU
In Gold Mini Monogram Vernis

In 2002, Marc Jacobs invited the British illustrator and fashion designer Julie Verhoeven to design a series of bags
for the Spring-Summer collection. The designer's wonderful world invaded the house, and products were covered with snails, apples
and mushrooms, and transformed as if by magic into toads, butterflies and owls.

Papillon pochette in framboise Mini Monogram Vernis, 2002, 22.1 × 15 × 0.4 cm. Louis Vuitton Collection — Hibou pochette in
gold Mini Monogram Vernis, 2002, 19.4 × 15.7 × 0.4 cm. Louis Vuitton Collection

Opposite: "The Princess and the Toad." Spring-Summer 2002 advertising campaign from the series "Fairy Tales." Natalia Vodianova
carries a Crapaud pochette in vert sapin Mini Monogram Vernis. Photograph by Mert Alas and Marcus Piggott, 2002

JULIE VERHOEVEN

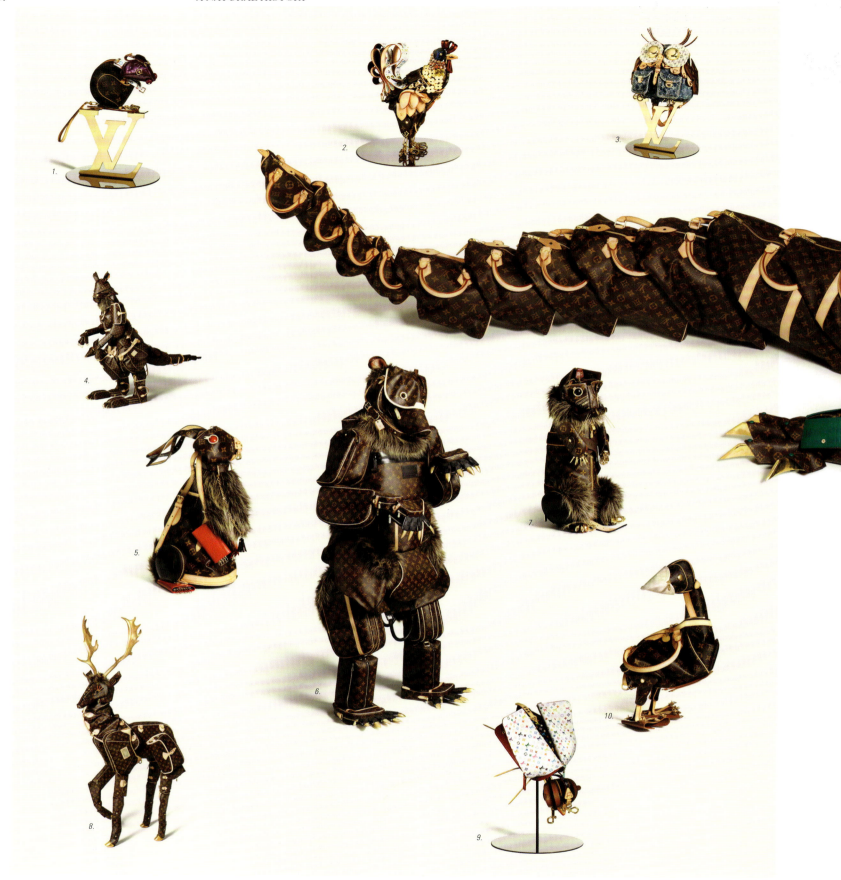

A versatile artist with a degree from Wimbledon College of Art, Billie Achilleos created a collection of about forty animals made entirely out of Louis Vuitton bags and accessories in 2011. His bestiary was presented in the exhibition "Maroquinaris Zoologicae" (October 3, 2011) at the Maison Deyrolle in Paris, which disseminated the artist's works amongst the real animals in this famous taxidermy boutique.

1. Mouse created principally from a Mini Ellipse bag in Monogram canvas, 2010. Louis Vuitton Collection — 2. Rooster created principally from a Mini HL in Monogram canvas, 2011. Louis Vuitton Collection — 3. Owl created principally from a large Sac à Dos in blue Monogram Denim, 2010. Louis Vuitton Collection — 4. Kangaroo created principally from a Bosphore backpack and Sologne, Galliera and Papillon bags in Monogram canvas, 2011. Louis Vuitton Collection — 5. Hare created principally from a Bucket in Monogram canvas, 2010. Louis Vuitton Collection — 6. Bear created principally from an Eva pochette and Évasion, Messenger Bag, Keepall, small Ménilmontant, Saumur, small Reporter, Danube and Mini HL bags in Monogram canvas, 2011. Louis Vuitton Collection — 7. Otter created principally from a Sporty Beaubourg bag in Monogram canvas, 2010. Louis Vuitton Collection — 8. Stag created principally from Eva and Mini Pochette Accessoires pochettes and large and small Montorgueil, Sologne, small Thames, Tivoli, Mini HL and large Papillon bags in Monogram canvas, 2011. Louis Vuitton Collection — 9. Fly created principally from small leather goods, 2010. Louis Vuitton Collection — 10. Goose created principally from a Tivoli bag in Monogram canvas. Louis Vuitton Collection

BILLIE ACHILLEOS—MAROQUINARIS ZOOLOGICAE

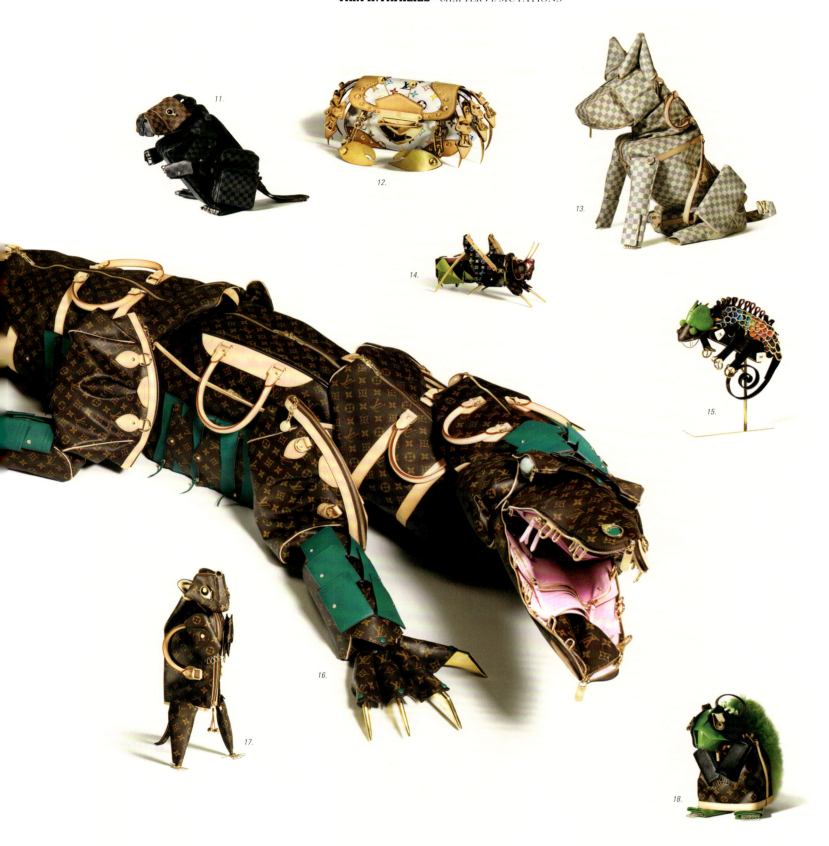

11. Beaver created principally from an Amazone bag in Damier Graphite, 2010. Louis Vuitton Collection — 12. Crab created principally from a Marilyn bag in white Monogram Multicolore, 2010. Louis Vuitton Collection — 13. Dog created principally from a Speedy and a Stresa bag in Damier Azur canvas, 2011. Louis Vuitton Collection — 14. Grasshopper created principally from small leather goods, 2010. Louis Vuitton Collection — 15. Chameleon created principally from a Tulum pochette in Monogram canvas, 2011. Louis Vuitton Collection — 16. Crocodile created principally from Tivoli, Deauville, Keepall, Speedy, Papillon and Mini HL bags in Monogram canvas, 2011. Louis Vuitton Collection — 17. Meerkat created principally from a Popincourt bag in Monogram canvas, 2010. Louis Vuitton Collection — 18. Raccoon created principally from a Petit Noé in Monogram canvas, 2010. Louis Vuitton Collection

PAPILLON, MEDIUM MODEL
In Monogram canvas

MINI HL
In Monogram canvas

In 2008, for the thirtieth anniversary of the first freestanding Louis Vuitton store in Japan, Rei Kawakubo,
designer and founder of the house Comme des Garçons, was invited to play with the bag-maker's codes.
She created six bags on sale exclusively in the ephemeral Louis Vuitton space installed in the Comme des Garçons
store in Kotto-dori from September 4 to December 15, 2008.

Medium Papillon in Monogram canvas, 2008, 26 × 14 × 14 cm. Louis Vuitton Collection — Mini HL in
Monogram canvas, 2008, 15 × 10 × 7 cm. Louis Vuitton Collection

CdG x LV
REI KAWAKUBO

"IT IS IMPOSSIBLE TO OVERSTATE REI KAWAKUBO'S INFLUENCE ON MODERN FASHION. I FIND IT WONDERFUL TO THINK THAT, OVER THIRTY YEARS AGO, THIS IMMENSE TALENT, SOMEONE WHO HAS INSPIRED SO MANY OTHERS, WAS INSPIRED BY LOUIS VUITTON, AND THAT THIS INSPIRATION HAS NOW BEEN REALIZED."
— MARC JACOBS

For nearly four months in the fall of 2008, Rei Kawakubo of Comme des Garçons repurposed the storefront and interiors on the former site of her temporary Tokyo flagship in Kotto-dori, Minami Aoyama to celebrate the 30th anniversary of Louis Vuitton's first freestanding store in Japan. A celebration of the Monogram canvas, the first and second floors of the minimalist space was transformed into a veritable museum of artifacts from the history of the malletier. *Hermetically sealed inside floor-height vitrines or else mounted on plinths wallpapered in gold with the trademark monogram were a range of signature Louis Vuitton bags and trunks, including the assembled portable bed that the explorer Pierre Savorgnan de Brazza took with him to central Africa in 1905. But at the heart of the exhibit was the fruit of an unprecedented collaboration, a collection of six one-off bags that were only available through in-person orders at the store. All clad in the Monogram canvas, four of these are original designs, including two small evening purses with outsized natural leather handles—one with rounded corners, the other angled—that the designer calls her Party Bags. Kawakubo also transformed two classic bags, augmenting a Mini HL with six extra handles, and a Papillon with self-fabric charms hanging off leather lanyards. The collection is rounded out by limited edition reissues of two bags from the 1970s that customers would have likely seen from the first Tokyo shop, the Deux Poches & the Petit Marceau.*

I tried to mix the universe of Comme des Garçons with that of Louis Vuitton in a clever way. The idea came to me in November 2007. Every Christmas, I try to come up with something special for my flagship store in Aoyama, and I had in mind to offer a series of Monogram bags, as reimagined by Comme des Garçons. I'd intended it as a smaller gesture, but it eventually developed into a much bigger collaboration, not only consisting of the customized bags—but a whole, collaborative, pop-up store as well.

I recounted to then CEO Yves Carcelle my memories of the first Louis Vuitton boutique in Tokyo, which, in my opinion, really embodied the spirit of the brand, as opposed to most boutiques these days, which are much too big for my taste, and offer too many choices without much logic. In the course of that conversation, we'd also realized that it would be three decades since it first opened its doors. And so, by mutual agreement—he'd initially refused, but my offer spoke to him—we decided to revive this spirit, but within a radically new context.

To celebrate this anniversary, the concept I then developed for the original bags for "Louis Vuitton at Comme des Garçons" were Party Bags. In designing them, I have hewn close to Louis Vuitton's tradition, but sometimes, two handles become one, sometimes two handles become eight. I also used this strong and beautiful bride image (page 319) from the Comme des Garçons Fall/Winter 2005–2006 "Broken Bride" collection, because a wedding is the ultimate party.

It was a remarkably exciting opportunity for me to have been able to participate in Louis Vuitton's storied heritage. It was a way of maintaining a certain tradition while experimenting with a sense of adventure. Contrary to what one might believe, this fusion is not that contradictory. The Monogram is my image of Louis Vuitton, but I'm constantly trying to create something new, by repudiating received ideas and pulverizing the codes. That's what gets me really going.

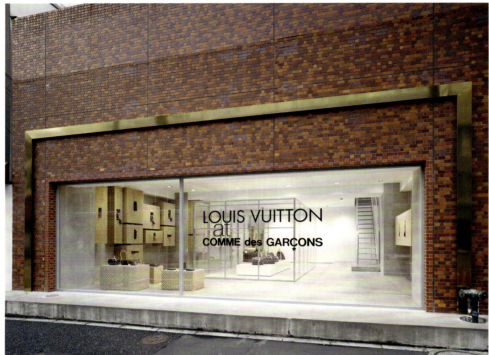

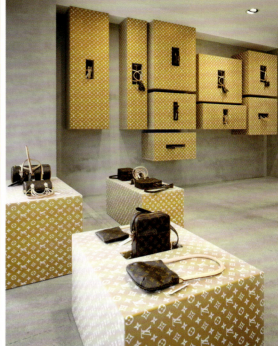

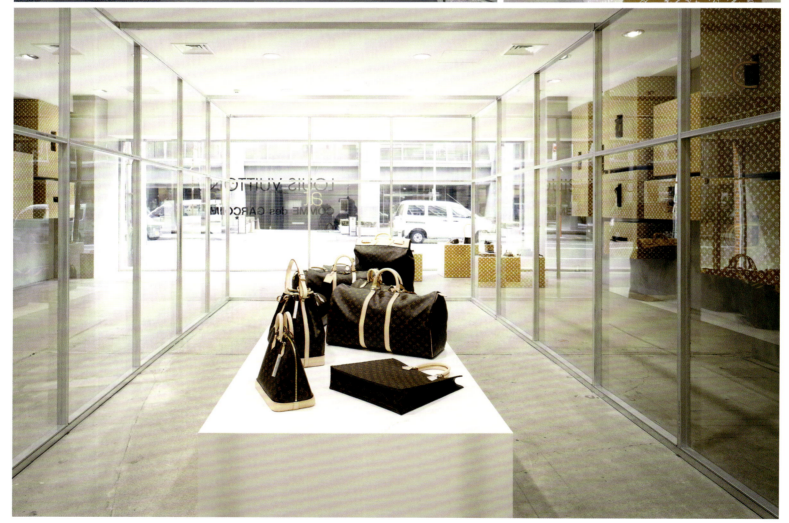

From left to right and top to bottom: Exterior view of the Comme des Garçons store in Kotto-dori, entirely redesigned
by Rei Kawakubo to host a temporary Louis Vuitton space from September 4 to December 15, 2008. View of
the store interior. In the foreground, the Comme des Garçons creations for Louis Vuitton, the Party Bag and the Petit Marceau bag,
are shown. Store interior presenting the House's iconic bags. In the foreground, a Sac Plat, a Keepall, an Alma and a
Noé, all in Monogram canvas, are shown. Photographs by Jimmy Cohrssen, 2008

Opposite: "Broken Bride." Advertising insert. The bride carries a large Party Bag designed in collaboration with Rei Kawakubo in
2008. Courtesy Comme des Garçons, 2008

COMME DES GARÇONS

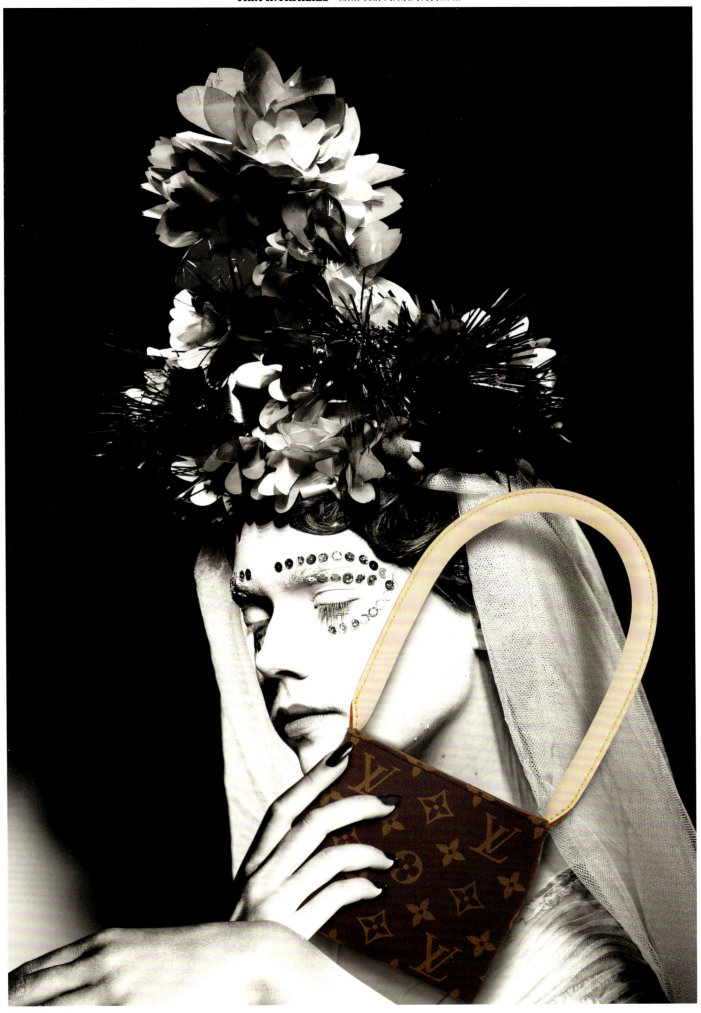

A CONVERSATION WITH YAYOI KUSAMA
WITH ISAO TAKAKURA AND MARIKO NISHITANI

In July 2012, Louis Vuitton announced that its collaboration with Yayoi Kusama would launch in select flagship stores around the globe. The collection, which included a number of iconic bags made out of Kusama's colorful take on the 1896 Monogram, coincided with a traveling retrospective of her work, the first leg of which began at the Reina Sofía Museum in Madrid, then to the Pompidou in Paris, the Tate Modern in London, and concluding at the Whitney in New York. For the better part of the year, it seemed as though the whole world was in the throes of a veritable Kusama "happening." Mariko Nishitani caught up with the artist—and Isao Takakura, the managing director of her Shinjuku studio—in April 2013 to take stock of the last year, and what exactly she had achieved for Louis Vuitton.

Mariko Nishitani: Thank you very much for taking the time to talk to us.

Yayoi Kusama: Excuse me for answering while I work. Interviewers come from all over the world, day in and day out, and I can't concentrate at all. One after another, they come to ask me about my philosophy, my devotion to art and so on, and I never have enough time. So I draw as I answer. Even though I keep drawing like this, they make sense of what I say, transmit it halfway around the world—and soon enough a fine book is made. It always surprises me.

MN: Do please continue. First, I would like to ask you about Louis Vuitton. I heard Marc Jacobs was a fan and he came over to see you. Did he come to this studio?

YK: Yes, Mr. Jacobs was traveling around Japan then, and said he would really like to see me, so he came here and...

MN: —Did you know the name Marc Jacobs?

YK: No, I didn't. I was surprised to hear he traveled so far, and we took a photo together. *(Editor's Note: The photographer Kishin Shinoyama accompanied the pair and took their portrait in June 2006.)*

MN: What kind of conversations did you have? Did you speak of doing something together for Louis Vuitton that time?

YK: No, he just came to see me in the beginning. We showed him around the studio.

MN: Did that grow into a further relationship?

YK: Not really. But we did get flowers from him.

Isao Takakura: That's correct. We did receive flowers for her birthday, but no further exchanges in particular. Kusama had a solo exhibition at Tate Modern not two years ago, and Louis Vuitton offered to support the show. As Marc Jacobs had a strong interest in Kusama already, it was natural that it led into an opportunity for them to work together.

MN: Did you feel at the time that she would like to do something with them?

IT: Well, Kusama has done collaborations with various brands, but none of them were her own initiative. As you can see, she is fully occupied with creating, but many people request her participation in various projects, so we try to do the ones we can.

MN: How did the collaboration proceed in detail? Did Louis Vuitton make specific requests?

IT: We received a sample of the Louis Vuitton [1896] Monogram and were asked to reinterpret it—that became the starting point. We'd seen Takashi Murakami's bag designs before, and the staff imagined it would be something similar to that, but the range of items kept increasing… we ended up to over sixty, seventy items, where we initially thought it would be only bags. There were several designs for bags alone, and there were also small purses and other accessories. We even did pajamas and coats.

We received several bag samples and brainstormed concepts. "How about adding this pattern like this?" Kusama made several suggestions, like "why don't we apply this polka dot pattern like this?" and so on. For the bags, we suggested several designs in various colorways, and submitted around one hundred in total. After some time, Mr. Jacobs contacted us with his own responses to Kusama's ideas, which ultimately became the actual projects.

Yayoi Kusama carries a Neverfull in red Monogram Waves, designed in collaboration with the Japanese artist and Louis Vuitton in 2012
Photograph by Kishin Shinoyama, 2012

MN: Judging by the public reception, Louis Vuitton must have been very happy.

IT: That's what we heard. It was well received all over the world—not only Isetan.

MN: What's amazing is that, at first sight, you can immediately tell they were by her (gesturing to Kusama). The window displays are very dynamic as well. To what extent was she and the studio involved in conceiving them?

IT: It was the same as the bags. We saw precedent from Louis Vuitton, they asked us whether we could collaborate not only with the products but also with the window displays, and we said yes. Kusama would say, "how about an object like this?" or "how about adding something like that?" —and she would then say "wouldn't it be interesting if I, myself, were in them?"

MN: That's interesting. So it was Kusama's idea to have life-size Yayoi Kusama clones for the entrance displays?

IT: Yes, but they came up with the idea of using smaller clones. When I first explained Louis Vuitton to Kusama, I told her that they're a very famous fashion brand, and that they have over 400 stores all over the world. As Kusama's own work deals with multiplication, or rather, infinite expansion, she perked up and said, "I see. So Louis Vuitton knows all about expansion" and began to really invest in the collaboration. That is how she came up with the idea of using a doll of herself as her stand-in since she could not visit every store. To this Mr. Jacobs replied: "Instead of a doll, how about making a more realistic Kusama?" Some engineers from New York then came to make a mold of her, and those "clones" were made. However, I assume there were cost issues involved in making them for all their stores. So much smaller ones were made too.

MN: Was it the first time you've seen a life-size likeness of Kusama?

IT: Yes, we had never had a life-size figure of Kusama before.

MN: The concept of multiplication has been with Kusama from early on in her career, but the idea of multiplying a reproduction of herself is amazing. I initially thought that Kusama connected to the expansive nature of fashion, and how a brand like Louis Vuitton expands in particular. (Addressing Takakura and Kusama) In the past you've sharply critiqued the stock exchange system, and plutocracy has been a special target of your criticism. Louis Vuitton expanded its global business with an unflinching eye on the bottom line. Did you have any reservations there?

IT: She has spoken of this in other contexts, but yes, Louis Vuitton is not cheap. It is actually quite expensive. But Kusama has her own thoughts on why LV is so fascinating to people all over the world, and this motivated her to do a project with them.

YK: Louis Vuitton handbags are extremely expensive, but no one really complains, actually. Instead, there are so many customers who would pay all they have for them. This is because carrying a Louis Vuitton bag instills a unique sensation. The act of wearing a most exquisite handbag or dress connects us to the world of beauty, and elevates us to a higher level of consciousness. I think as people around the world became drawn to the ideology that compels us to wear such clothes regardless of expense, they [Louis Vuitton] developed into such a global business.

MN: On the subject of fashion, I hear you began making your own clothes in the 1950s, when you were a teenager, and you also appear in impressive outfits in portraits from your own publications. For example, you are wearing a sweater with different colors on the right and left, from this photograph dated 1952. Did you make that piece yourself as well?

YK: I used to make clothes since I was fifteen, and would wear them myself. That sweater was red on the left and white on the right, and that one, I asked someone else to knit for me.

MN: There are many other designs as well. You even had a fashion boutique in New York?

YK: Yes, I used to make eccentric things, like dresses with different sleeve lengths and such. I was a teenager when I made a dress with one side sleeveless and the other side with a sleeve. I was a little precocious.

MN: And you made those without seeing any other examples, and invented them yourself? Do you remember what inspired you? Were you relieved because the war was over?

YK: I am still aggrieved by the war, and in order to forget it, I focus on improving my work, so that I can capture everyone's hearts and hope for the happiness of everyone in the world. In this regard, I still have not forgiven the Prime Minister and the Emperor who started the war. It is because I know the devastation of war that I see the importance of living one's life until the end with one sole purpose. This is why I desperately keep drawing for all my worth every day. Terrible incidents still take place every day, but my desire for people over the world to live a splendid life, my endless admiration towards the universe, and my will to assert my spirituality regarding life and death are what compel me to hold exhibitions and draw even to this day.

I have avoided suicide and am still alive because Takakura-san deeply understands me, but as I did not get along with my family when I was a child, I became mentally ill. Yet in order to keep my illness from taking over, I've strived to transform illness into art and communicate my thoughts to the world. Every time I draw, the beauty of this world we inhabit rages within me, and even though I am heading towards death, it drives me all the more to live to the fullest, so long as I am alive.

IT: We're veering off topic a little here, but Kusama has being drawing, or writing novels since she was little, and I believe her ideas about fashion date back to this formative period.

MN: Many artists just concentrate on their art and do not care at all for what they wear, but your portraits from the 1950s and 1960s are quite beautiful and feature innovative fashion.

IT: I've only seen her younger self through her photographs, but I can attest to her unfailing attention to personal attire from working with her for the last 25-plus years. Her everyday clothes are not ready-made pieces either. She used to go shopping for fabrics with some of our staff so she could always wear what she liked. As expected, she prefers polka dots or patterns that repeat themselves, and she has a special preference for color. Even when she receives clothes from her relatives, if the color is on the darker side, she'll inevitably say, "I appreciate the gesture but unfortunately I cannot wear this." As you can see from the photographs of her New York days, she always knew how to wear clothes that were different and pose in unique ways when being photographed.

YK: I also made a piece of clothing that a lot of people could wear at once. The collar would stretch out to accommodate 13 people. Once, I had everyone wear it and jump into the sea all at once. I've also made clothes with very interesting shapes that two people could wear out together. My pieces were also exhibited at Bloomingdale's, where they had a special Yayoi Kusama corner.

MN: When you were in New York you also made the Squid Dress. It was designed with two round holes at the front so that the wearer's breasts would be exposed. Did you feel that if everyone wore this dress, unafraid of their nakedness, it would somehow affect their consciousness?

YK: I've always felt that stripping off your clothes and becoming naked liberates you spiritually.

MN: So even in fashion, you've always hoped to communicate with other people through your clothes?

IT: I suppose it's one of her many forms of expression. For instance, she is painting right now, but she also makes printing and sculptures, which can be anything from soft sculptures to those that require fabrics. I think she wants to do many different things. Her ideas are limitless—they spring up one after another. Naturally, fashion was an indispensable part of her expressions as well. She also sings and makes films…

YK: I recorded a song recently (recites):
Swallow antidepressants and it will be gone / Tear down the gate of hallucinations / Amidst the agony of flowers, the present never ends / At the stairs to heaven, my heart expires in their tenderness / Calling from the sky, doubtless, transparent in its shade of blue /

Window display at the Maison Louis Vuitton on Fifth Avenue in New York. To celebrate the collaboration with the Japanese artist Yayoi Kusama in 2012, window displays with a life-size likeness of the artist were installed in stores around the world. The statue carries a medium Lockit in red Monogram Vernis Dots Infinity
Photograph by Lynn Hughes, 2012

OPPOSITE
FROM TOP TO BOTTOM

Marc Jacobs, on the left,
and the Japanese artist
Yayoi Kusama, next to her
sculpture *Pumpkin*, in
front of the Kusama
Studio in 2006
Photograph by Kishin
Shinoyama, 2006

Gold Pumpkin minaudière,
inspired by the
eponymous sculpture and
designed in collaboration
with the Japanese artist
Yayoi Kusama in 2012
Photograph by Vincent
Gapaillard, 2012

Embraced with the shadow of illusion, cumulonimbus clouds arise / Sounds of tears, shed upon eating the colour of cotton rose / I become a stone / Not in time eternal but in the present that transpires

This song will be released soon. I also have a song dedicated to my late parents; it's about how we could not get along for a very long time. This is what it sounds like (sings with a melody):

Now that you have died / your soul has gone forever / over the clouds of cotton roses / dusted with the rainbow's powder of light
But you and I parted our ways / at the end of never-ending conflicts between love and hatred / with no chance of ever seeing each other again
Born into this world of people / Parting to me is like silent footprints / in the path of flowers
Beyond the sundown clouds / lies tranquility without a sound

That's how it sounds like...

MN: You are reflecting on how you did not have a chance to reconcile with your father and mother before their passing. I see the intensity that resided within every member of your family.

IT: It seems her mother was particularly strict. She would tell her to stop drawing and that if she wanted paintings she should be a collector. Kusama came from a respected family, so having an interest in culture was fine, but their idea of an artist was similar to that of—to use an archaic expression—*kawara-kojiki* (riverbed beggars).[1] They vehemently opposed when Kusama wanted to go to New York, but her father was more inclined to support her secretly.

MN: I see. Lastly, could you provide us with a more detailed explanation of your New York performance, self-obliteration by dots? I think this concept resonates with fashion greatly. Fashion inspires us to dress in a variety of ways, but a part of me feels that we do so in order to obliterate, rather than express, ourselves.

YK: Self-obliteration has always been one of my biggest themes. A polka dot cannot exist alone. Just like the moon, the sun, and even the stars, all things in the universe are interconnected. I've led my own life by adhering closely to this immense, universal philosophy that polka dots suggest: I am a part of the universe—a lone star in the midst of a constellation. And I have a strong desire to self-obliterate into it when I die. The fact of being alive comprises only a single, tiny dot, but that is a symbol of our vast humanity. I was very moved when I realized that I, too, carry such a symbol within me.

I've written many novels and poetry about polka dots. *Distant Are the Stars That Shine on the Pursuit of Truth... More I try to seek truth, farther seems the starlight.* That is just one example of the many poems I've written. I believe collections of my poetry are sold at my exhibitions and various museums around the world.

IT: If you'll allow me to add. At first, I also thought that, because standing in the midst of dots in a dotted outfit causes the outline of your form to disappear, that is what is meant by self-obliteration. But it is much deeper than that. Kusama is very interested in the universe and whenever a new book on the subject is published she asks one of our staff to go buy it. So while she spends her days working here, at night she reads these books. She has an interest in everything that has to do with the infinite, and whenever a new theory appears, she makes sure to read it. In other words everything in this world—water, the stars, the sun, and even we who have gathered here today—comprises one of the many polka dots. We have dots within our bodies—our cells. This makes you wonder if everything in this world is made of polka dots. We live and end our lives within this configuration, and when we pass on we'll once again be buried in polka dots, and disappear.

[1] An old Japanese term used in the Edo period to denigrate kabuki actors and street performers as social outcasts.

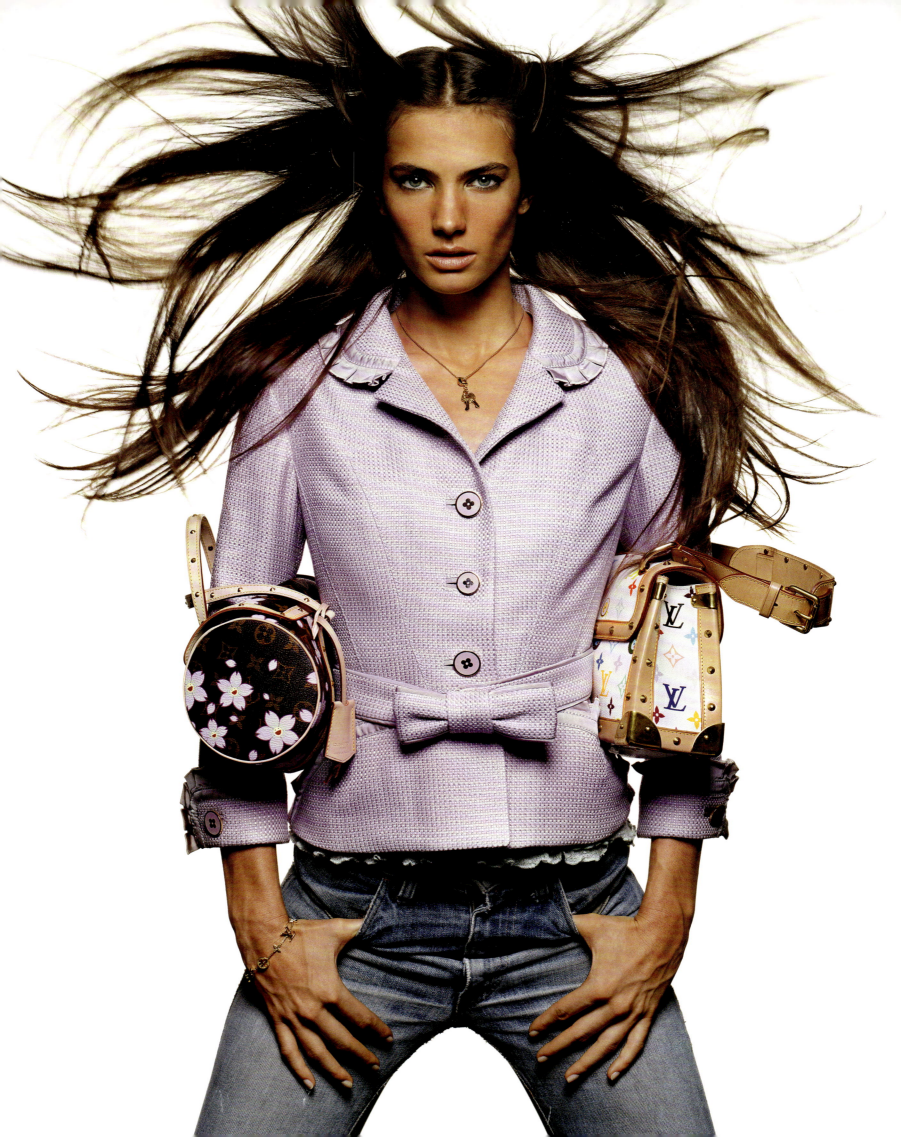

A CONVERSATION WITH TAKASHI MURAKAMI

MARIKO NISHITANI

In 2001 Takashi Murakami's exhibition Superflat, *in which the artist vividly presented the essence of contemporary Japanese art from the early 20th century to anime, began its American tour at the Museum of Contemporary Art in Los Angeles. The tour galvanized Western art critics and journalists, as it forcefully linked the painters of the Edo period with manga, and at once attempted to decipher the present condition of the Japanese psyche. Heralding as it did the explosion in interest of all things Japanese in the first decade of the 20th century, Murakami achieved considerable acclaim in the United States, and soon, in Europe. Over a decade after Louis Vuitton first approached the artist to create a landmark collection of handbags—alleged to have generated sales in the hundreds of millions—Mariko Nishitani called on Murakami at his studio north of Tokyo in May 2013. In the wake of the release of his first feature-length film,* Mememe no Kurage (Jellyfish Eyes), *the artist recounts the initial brief he received from Marc Jacobs—and how their twinned obsessions created a surefire formula for drawing a new generation of Japanese youth into the arms of Louis Vuitton.*

Mariko Nishitani: When did Louis Vuitton approach you about the collaboration?

Takashi Murakami: I received an email from Marc Jacobs' assistant; it was only one day after I had returned to Japan from the opening of an exhibition at the Cartier Foundation for Contemporary Art in Paris [in 2002]. I wasn't sure what was going on, so I asked Louis Vuitton Japan and they contacted Paris on my behalf and confirmed that Marc was indeed asking for me to come see him. So I went back to Paris, just three days after I had returned to Japan. I went all the way back there and then the meeting lasted only about twenty minutes, of which I spent only ten minutes talking to Marc. That was it. I was dumbfounded (laughs).

MN: So they wanted to talk about the collaboration from the beginning?

TM: Yes. At first, Marc said we couldn't do characters. His thought was that with the ubiquity of Hello Kitty and such, that there was already too much of an established image that Japan = Characters. So I asked him what I should do and he replied, "I don't know. It doesn't matter. Do whatever you like." That didn't make it any easier. Anyway, since Louis Vuitton was about to celebrate its 150th anniversary in about three or four years, Marc told me he wanted to try working with the [1896] Monogram. He said something to the effect of "I hear the Monogram

might have originated in Japan; I'll let you handle that since you're Japanese."

After I returned home, I set the Rimpa school[1] as a benchmark and took myself on a visual journey through the history that led to its development. Ultimately, I began looking at patterns and motifs from Bhutan and Indonesia and for about a month and a half, I repeatedly submitted proposals for designs that mixed this aesthetic with the Monogram. Then one day, Marc suddenly sent me a hand-drawn likeness he had made of this Panda-like figure that appeared in my painting *Gerotan*, on view at the Cartier Foundation, and said that the image appealed to him. To be honest, my first thought was "you said no characters," but I figured if he liked it, then I was fine with it. Marc got really excited and asked if we could combine the floral motif from the monogram with characters. That's how we created Flower Hat Man and Onion Head.

He seemed to really love the designs and I thought my work was done, but then he began to say that something still wasn't right. Despite this, he suddenly went off on a three-week summer vacation. His manager explained that you could never contact him while he was away on vacation and so I figured my team and I should take a break as well. We went on a weeklong summer vacation but even during that time, I kept on purchasing and assembling materials, marking them with Post-it notes, and sent him about two, three hundred ideas in total. I figured I should also finish the Panda design, so I brushed it up and made it nice and clean. When Marc returned from his break, he selected the Multicolore design so I brushed that up as well. And though he didn't ask me to, I also tried making the multicolor with a black background, which he ultimately liked. By the time we were finished with this back and forth, we only had two weeks until the fashion show. I became very nervous but when I expressed this to him, he told me: "Don't worry. We'll just print them by hand." The prototype, if I remember correctly, was in fact hand-printed. Anyway, I'm still impressed that Marc managed to pick out that panda character from a painting that was a seven meters in size.

MN: Well, Marc himself might not have known about the details but I'm sure he was aware that with your work at the forefront, an interesting culture was burgeoning in Japan.

TM: Marc's all about inspiration. Really. When something clicks with him, he moves quickly to nail it down. So something must have clicked with him from my work.

Jessica Miller carries a medium Papillon in brown Monogram Cherry Blossom (left) and an Eye Need You bag in white Eye Love Monogram (right). Monogram Cherry Blossom (2003) and Eye Love Monogram (2003) are creations by Takashi Murakami for Louis Vuitton. © Takashi Murakami / Kaikai Kiki Co., Ltd. All rights reserved Photograph by Inez van Lamsweerde and Vinoodh Matadin, *Vogue Paris,* February 2003

MN: What was your first impression of him?

TM: I thought he was a very restless person. Remember, I went all the way to Paris to see him.

MN: That's true. And right after you just came back from Paris, too.

TM: I thought we'd at least go out to grab a bite to eat or something but he immediately was like "so long, gotta run."

MN: Oh no.

TM: I'm like that too, though. It's not as if I always know all about the person I'm collaborating with. It's all about that spark of inspiration. The spark must have been there. Oh, and I remember that Marc had a card with my character Miss Ko^2 on it pinned to his wall. That and these Hawaiian Hibiscus patterns were pinned up everywhere. So I initially thought that maybe he wanted to do something along those lines for our project but he later told me that it had served as an inspiration for runway models at a fashion show. I guess that too must have been something that clicked with him.

MN: Marc's sensitivity is intriguing. By the way, when Louis Vuitton first approached you, what was your impression of the brand?

TM: I didn't know anything about them. The girls on my staff got really excited and when I asked them, "Louis Vuitton? What's that?" they exclaimed "Murakami-san, this is amazing! It's a high end fashion brand. The one every girl dreams about!" I didn't quite know what to make of it and told them that I didn't want to get another long flight, but they insisted: "You absolutely must go. You simply have to do this project."

MN: So you had no image of Louis Vuitton whatsoever…

TM: Zero!

MN: Did you have any of their products?

TM: I still don't have any. For a while, I did have one of the bags with my camouflage design.

MN: Did you know of the name Louis Vuitton?

TM: Nope.

MN: Yayoi Kusama was the same way.

TM: Artists aren't normal. It's the same with me.

MN: Before Louis Vuitton approached you they worked with Stephen Sprouse the previous year. They had him create a piece that looked as if he doodled on the Monogram pattern. The Monogram is sort of like a Japanese *mon* (family crest)—it's very important to the brand. The

fact that they allowed someone to doodle on the monogram riled up many conservative Louis Vuitton fans. But in a way it also led to its notoriety.

TM: Marc is very punk. That's why I think this is his work, not purely my own.

MN: I see. The Multicolore Monogram seems like an extension of the Japanese *mon* so I assumed it was your idea. But I guess it was just one of the many ideas you submitted?

TM: I came up with a great number of designs, from bamboo to those inspired by the Rimpa School; waves and houndstooth checks. I presented it as a narrative so that Marc could understand the history of Japan's design aesthetics but he probably didn't study it very thoroughly, For him, it's all about whether something clicks or not.

MN: It's too bad that some of the designs ended up being used only as test products.

TM: Well, it's that way for all us creators. At the end of the day, it really does come down to whether or not something clicks. I was still a novice then so I didn't fully understand but these days, especially, I get it. The spark is there or it's not.

MN: How did you feel about working in fashion?

TM: I have studied fashion more since then. I think it's only in the last two years that I've finally come to understand it. Just like contemporary art, fashion is about history. It's about how you rendezvous with the contemporary era by drawing inspiration and references from that history. The scale of the project also matters. As an analogy, the view of things you get from a huge luxury liner is very different from what you see when you're on a row boat alone. Louis Vuitton is the former, of course, and something like Japan's Ura-Harajuku movement is the latter. Those are some of the things I learned along the way.

MN: Whenever I read something you wrote about art, I find that it also applies to fashion.

TM: The moment when I finally understood fashion was when I read the publication *100 Years of Menswear*—the one with David Bowie on the cover. Reading it I thought, so that's what David Bowie is about, that's what the Sex Pistols were about—I see it now! Subcultures and specific incidents in various countries mix together to create the atmosphere of an era and that, in turn, begets fashion. In my generation, NIGO® took the world by storm and I often wondered why it had to be him but then I realized that he and I are a lot alike. I turned paintings into anime and he turned fashion into something akin to toys. What we both did was to flip an accepted form of culture on its head or merge different types of culture, betray them perhaps. Japanese culture is very much about gadgets and I think we both belong

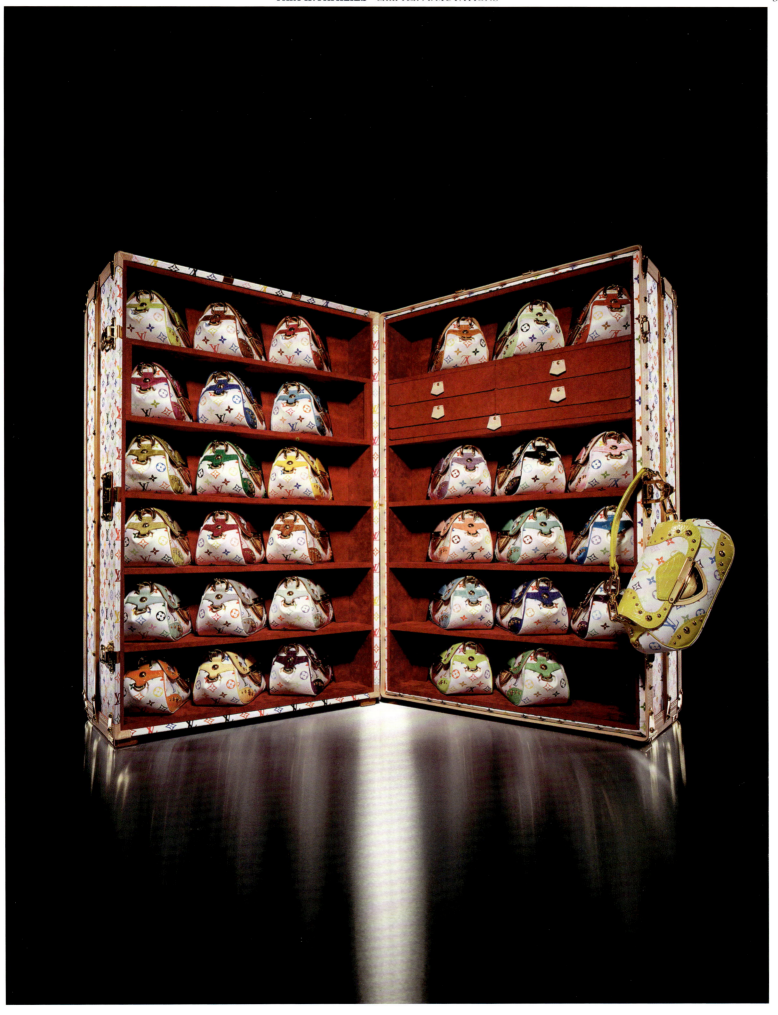

to a generation, the toy generation if you like, when those things were definitely "on." These days, I'm thinking of asking NIGO® to design a line of work-wear for me.
MN: In what other ways did the experience of working with Louis Vuitton empower you, working in fashion?

TM: One of the things I got to experience was the archetypal "social gathering." The dinners they organize have this incredible hierarchal structure. Looking back, I realize that I was given a tremendous seat. I was next to Karl Lagerfeld and Catherine Deneuve, as well as other famous actresses and models. Bernard Arnault was there too. When I think back on it now, I realize that it was around that time that the fashion world began to involve itself more and more in the art scene. The Louis Vuitton Foundation, for instance, is now seriously doing art. On the other hand, social gatherings have become a vital part of the art world as well. I learned that there are formats, or rules, for such occasions. When I was working with them, I had to attend these events at least twice a month, whether I liked it or not.

MN: That's something that you don't like to do?

TM: Well, I like to go barefoot most of the day and yet when these events came around, I had to wear shoes. It felt quite unnatural to me.

MN: By the way, did you have any relationship with the previous president of Louis Vuitton, Kyojiro Hata?

TM: Hata-san is currently an advisor for our company.

MN: I had a chance to interview Hata-san for this book. He was such an honest and articulate person and what he talked about was so interesting.

TM: In my mind, it's no overstatement to say that Hata-san created the conditions that led to Louis Vuitton's international success. He created their global structure. And he's helped us tremendously with a variety of things. Contracts being one example. I can't reveal everything here, but the fact that I was ultimately able to retain the rights to my image designs was thanks to Hata-san's transcendent negotiation techniques. He is an actor and a man of remarkable talents. He's a samurai.

MN: I would love to hear more about that next time, off the record. I'm going to change the subject a little bit. By working with Louis Vuitton, do you think the perception of your work improved in a way that did not exist in the Japanese art world? You often criticize the Japanese art world, but how did the international perception of your work change through your work with Louis Vuitton?

TM: The price of my work at auctions actually went down as a result. To put it simply, the price fell because it was perceived that I took part in consumer culture. On the other hand, the value of my work increased in Japan. Before I knew it, I was walking around in Omotesando and a girl came up to me and said "You're Takashi Murakami!" and I was like "What?" People recognized my face now.

MN: How about in the art scene?

TM: Louis Vuitton supported my ©*MURAKAMI* exhibition in Los Angeles (MOCA) in 2007 by setting up a store within the exhibition. Yves Carcelle was an instrumental part of this, helping me to arrange many different things. That was really a defining moment for me and I am very grateful to them. However, since I sold my work at a museum it stirred a lot of controversy in the United States. I believe the true mechanisms behind my collaboration with Louis Vuitton will only be revealed and understood when I am dead. Part of it has to do with the enormous amount of back and forth regarding the contracts; we worked on them for three years. For me, these contracts are themselves the ultimate artwork of this era. In a sense, they are the result of a hardball collaboration between Yves Carcelle and myself. The great success we had is due to this amazing background, so I am confident that the more you learn about the project, the more nuanced it will become.

[1] Rimpa was a school of painting from the Momoyama through the Edo period that saw the revival of indigenous Japanese tropes and depictions of the natural world from secular and religious literature.

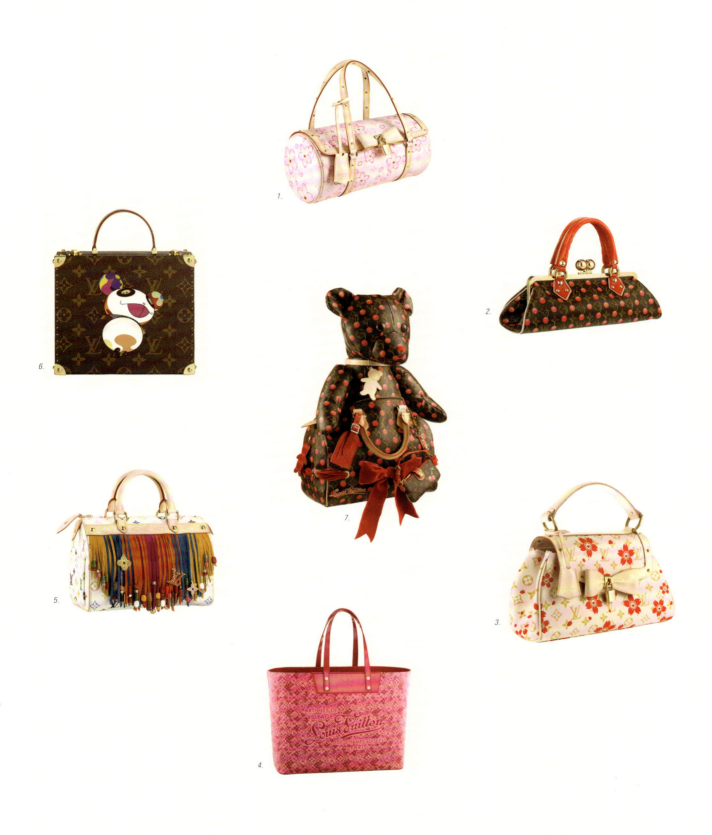

1. Medium Papillon in pink Monogram Cherry Blossom, 2003 — 2. Large Fermoir bag in Monogram Cerises, 2005 — 3. Rétro Bag in Monogram Cherry Blossom, 2003 — 4. Large Cosmic bag in pink Monogram Cosmic Blossom, 2010 — 5. Speedy 30 in white Monogram Multicolore Franges, 2006 — 6. Rigid box in Monogram Panda, 2003 — 7. Speedy 25, Mini Pochette Accessoires and bear in Monogram Cerises, created by Takashi Murakami for a charity sale to benefit the association Paris Tout Petit on May 26, 2005 in Paris. Monogram Cherry Blossom (2003), Monogram Cerises (2005), Monogram Cosmic Blossom (2010), Monogram Multicolore Franges (2006) and Monogram Panda (2003) are creations by Takashi Murakami for Louis Vuitton. © Takashi Murakami / Kaikai Kiki Co., Ltd. All rights reserved.

TAKASHI MURAKAMI

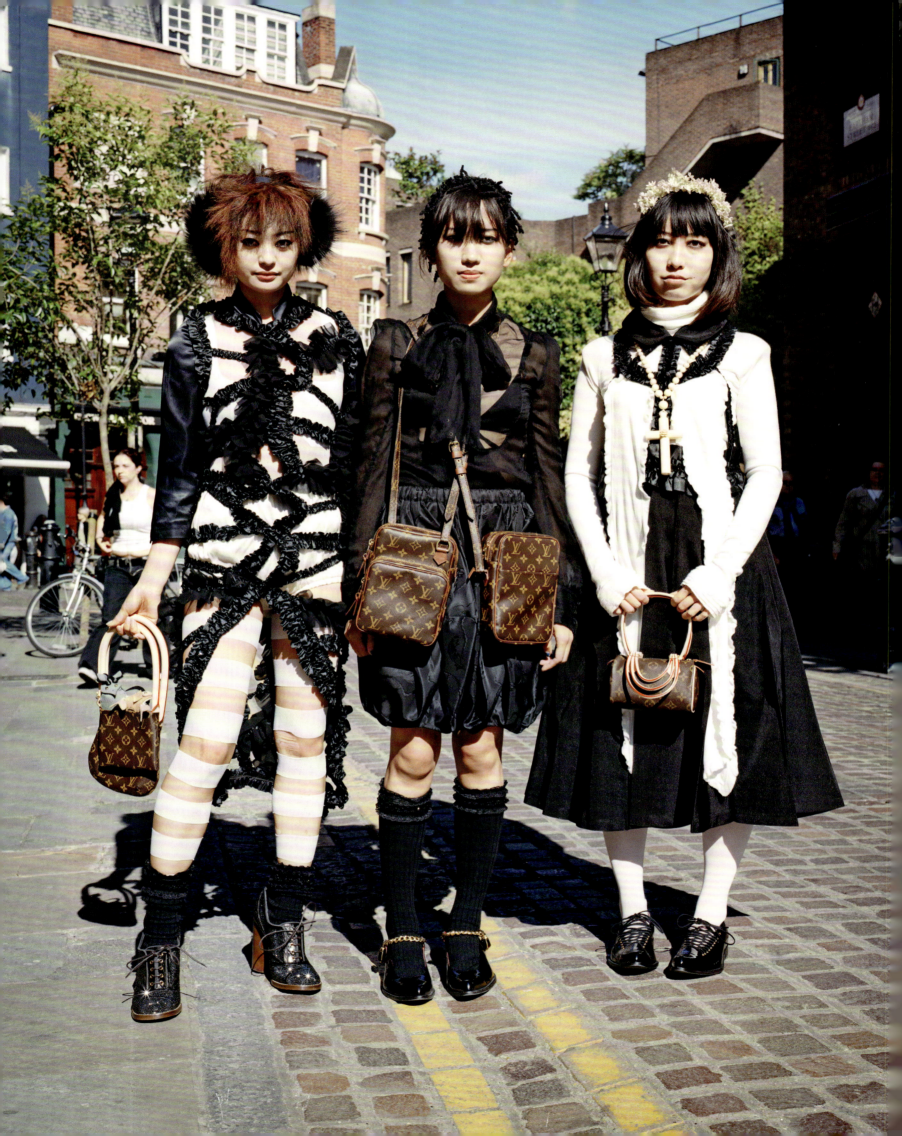

INVASIVE SPECIES:
LOUIS VUITTON IN JAPAN
MARIKO NISHITANI

VISIBLE YET INTANGIBLE

The Louis Vuitton store on Sakaemachi-dori, Nagoya, designed by the Tokyo-based architect Jun Aoki in 1998, is a revolutionary work of architecture. At the inception of an ambitious building program that saw Louis Vuitton collaborate with Aoki on a succession of projects, the Nagoya store materialized as a result of a shift in the architect's thinking. Given the nature of the commission—to design the envelope for a structure but not its interior—it is interesting to consider what Aoki proposed for a design solution: "Since I was unable to work with both the exterior and interior surfaces, I wondered if I couldn't come up with an alternative method. There were two worlds in contact. What would be born of this? A boundary surface. Yet this boundary is intangible. A boundary does not split the world into two: it appears because the two worlds come in contact. Consider the boundary between water and oil—we can see it, but it is intangible. How can we create such a boundary? What I came up with was the *moiré*, known as an 'interference' in physics. Layers of gauze create an undulating pattern. When two fine patterns are layered, a third pattern appears. This third pattern, however, is without substance. We can see it, but it does not exist."[1]

Aoki devised a shell composed of two layers of intricately patterned glass—both inscribed with the brand's 1888 Damier checkerboard—with a gap set in between. The optical distortion caused by the intersection of the two patterns wrapped the building in a *moiré*, creating a façade unlike anything that had been attempted before.

The insight of something that is "visible yet intangible" hints at a larger narrative of luxury and fashion. The journey to explore the secrets of Louis Vuitton's success will prompt us to peer into the intangible, yet clearly observable nature of human desire.

This essay attempts to uncover the reasons behind the Japanese people's love of Louis Vuitton bags and the brand's exceptional success in pioneering a key international market. Upon further investigation, it becomes clear that the reception of Louis Vuitton in Japan comprises several layers. The process is akin to opening a Pandora's box. We'll begin with the story in the prewar years.

A SAMURAI AND HIS NEW BAG

Soon after the opening of Japan following its long period of isolationism, Shojiro Goto of the Tosa domain traveled abroad to survey Paris in 1882. A politician of the newly

Three young women carry creations by Comme des Garçons for Louis Vuitton. From left to right, large and small Party Bags, Deux Poches and Petit Marceau bags, and the Mini HL, all in Monogram canvas Photograph by Chris Brooks, *Pop Magazine*, n.d.

The photographs on the following pages are from *L'Ordinaire n'existe pas* (*The Ordinary Does Not Exist*), a photographic project undertaken by Géraldine Kosiak from 2005 and 2006 carried out on the streets of Tokyo and Kyoto, as well as those of Takayama, Nara, Furukawa, Otsu and Mount Koya. During her first stay in Japan in the autumn of 2005, the young photographer was surprised by the number and diversity of Japanese women carrying Louis Vuitton bags, and decided to catalogue them.

installed Meiji government, he became the first Japanese person to purchase a bag from Louis Vuitton. Taisuke Itagaki, who traveled with him, also purchased a bag. This was a time well before the introduction of the Damier pattern (1888) or the Monogram (1896). Goto's purchase of a large, all-leather trunk is documented in Louis Vuitton's client ledger. According to the same ledger, the army minister Iwao Ōyama (a founder of the Imperial Japanese Army), traveling alongside then Prime Minister Kinmochi Saionji, also purchased a trunk. Even the Showa Emperor, when he was still a crown prince, stopped by a Louis Vuitton store during his travel abroad to Paris in 1921, and according to records, sent back his attendant to shop there.

At a time when their country craved Western culture, the buying habits of these elite political and military figures embodied the incipient exchange of luxury goods between France and Japan. (And when one considers the early Meiji-era politicians' roots in the samurai class, and Japan's participation in the Exposition Universelle, the influence of their *mon*—family crests—on Louis Vuitton's 1896 Monogram seems very likely.) But unlike Commodore Matthew Perry's fleet of Black Ships, which forced Japan's return to the world system—and incidentally coincided with the founding of the *malletier*— Louis Vuitton did not yet invade Japan's shores. Rather, it was politicians and nobles, with their high social status and refined cultural sensibilities, who discovered and liked these products enough to bring them home. There would be a long wait for another awakening—in the form of the postwar economic boom—for more democratizing impulses.

THE DEVELOPMENT OF A CLASSLESS MARKET

In 1970, the opening feature of the inaugural issue of the fashion magazine *Anan* marked the first time the name Louis Vuitton appeared in Japanese fashion media. (A revolutionary publication, the magazine had the advantage of directly importing the latest European fashion through a Japanese special correspondent who was newly installed with a desk in the editorial department of *Elle* in Paris.) Displaying a subtitle that read "Let's travel with Yuri to Paris! To London!," the editorial featured a model at a Parisian airport counter clad in a trendy t-shirt (this era also marked the introduction of the t-shirt as a fashion item) and a thick belt, a long, checkered gilet cut on a bias and pantaloons, a knitted cap in the same color as the t-shirt, and Louis Vuitton's large Steamer Bag and a small Keepall in her hands. While the article did not indicate any credit or price for the products, it nevertheless conveyed a powerful message: "This is what it means to enjoy dressing up!" The young people who laid eyes on the smart, casual attire took to the look.

A month later, the magazine's third issue included a two-page spread that introduced eleven Louis Vuitton products including bags, trunks, and purses in a feature entitled "Yuri's Souvenirs Uncovered." Louis Vuitton

had finally emerged into full view. The featured photo appeared with the following caption: "Right near the Arc de Triomphe you'll find the store Louis Vuitton. All the products in this store are made with the same pattern. From tremendously large clothing trunks, travel luggage, flasks, ashtrays to even dog collars, everything is made of this pattern. To be honest, I also wanted the solid trunk-shaped travel bag too, but with one bag priced around anywhere from fifty to a hundred thousand yen, I couldn't possibly purchase it. The softer bags, like the one I have, cost around twenty thousand yen."

The impact of this article at a time when the majority of Japanese people had never heard of Louis Vuitton, much less the term "monogram," is beyond imagining, especially to a generation whose buying habits were formed when Louis Vuitton's notoriety had all but permeated the entire fabric of the country. Moreover, the exquisite contrast of the fine pattern set against the sophisticated brown of the canvas, and the coordinating tanned leather, seemed remarkably fashionable, and spoke to the Art Deco boom of the era. While many readers yearned for a way to get their hands on these bags, they could neither find a domestic store that sold them, nor pursue them overseas—as they would so easily have done today. Clothing stores specializing in imported goods quickly caught wind of this growing demand, and began to purchase them overseas only to sell them for three or four times the local price. Nonetheless, the products flew off the shelves. Those bewitched by the Louis Vuitton mystique during the early 1970s were people blessed with purchasing power and an acute interest in fashion, but as the Japanese economy grew by leaps and bounds in the late 1970s, the customer base of Louis Vuitton expanded.

Akira Mishima, who was then at the helm of Capsule Corner,[2] the most avant-garde fashion store at the time, analyzed the European luxury goods craze of the late 1970s: "Contrary to the reputation of the late 1970s as a consumer's recession, the consumer preference for a better price zone has begun to sway the mass market. A better price zone indicates a price range that falls between the proper pricing of department and specialty stores and that of ready-to-wear. The greater number of consumers reaching for a price that is a rank above their norm—far from indicating their willingness to pay a higher price— can only mean that they have begun to covet products of a higher quality…. Moreover, as fashion inclined towards the more classic and nostalgic, the interest in European tradition arose and developed into a preference for the world's first-class goods that embodied these trends in prototypical ways. Criticisms against the penchant to hunt for luxury goods are considerable. In Europe, classes who can attain such products are naturally exclusive, and those who dare to shop with little regard of their 'lot' attract disdain. Japan's postwar mass society, on the other hand, managed to create a rare, classless market. Neither a limitation of one's 'lot' nor social constraints exist. This is why the Japanese, abound with curiosity and a progressive temperament, think nothing of spending their every last penny on these products…. Of course,

the instinct to display these items—exemplified by the prototypical lifestyle of the *yakuza* flaunting a Louis Vuitton trunk case, a leisure suit, and a Lincoln Continental—does exist. While such actions are the main cause for criticisms against this trend, the deeper meaning behind the majority of the consumers' pursuit of luxury goods in a better price zone must not be overlooked."[3]

Mishima's mention of the *yakuza* and their attraction to Louis Vuitton ties into the logic of conspicuous consumption exemplified by the leisure class's preference for luxury goods, a thesis first developed by the American sociologist Thorstein Veblen in *The Theory of the Leisure Class* (1899): "Conspicuous consumption of valuable goods is a means of reputability to the gentleman of leisure. As wealth accumulates on his hands, his own unaided effort will not avail to sufficiently put his opulence in evidence by this method. The aid of friends and competitors is therefore brought in by resorting to the giving of valuable presents and expensive feasts and entertainments. Presents and feasts had probably another origin than that of naive ostentation, but they required their utility for this purpose very early… so that their utility in this respect has now long been the substantial ground on which these usages rest."

THE EMERGENCE OF KYOJIRO HATA

Thus in the 1970s, when a steady social infrastructure was yet to take shape in Japan, the name Louis Vuitton —along with a sense of superiority, longing, envy, and repulsion—had already begun to incite the whirlpool of desire within the country. It was against this backdrop that the first president of Louis Vuitton Japan, Kyojiro Hata, entered the scene. A graduate of the School of Economics at Keio University, Hata, after studying abroad in the United States, began his career as a management consultant at the accounting firm Peat Marwick Mitchell in New York and returned to Japan to open their Tokyo office by the fall of 1967. Hata made headway in the computerization of Japanese companies and consulting work for international companies that hoped to break into the Japanese market in the advent of the trade liberalization. In 1976, he connected with Louis Vuitton through a former colleague. The curious incident that brought them together was a sudden surge of Japanese customers who formed long lines in front of the Louis Vuitton flagship store on Paris' Avenue Marceau. The Japanese, who clearly seemed to be vendors, befuddled the Vuitton family.

Hata, who had never heard of Louis Vuitton, was asked to investigate what was taking place. He began by thoroughly researching buyers for privately owned stores and the state of parallel imports that utilized vendors. Since the Louis Vuitton store in Paris was unaccustomed to dealing with international sales, Hata had Japanese department stores with local branches in Paris act as mediators and introduced a "distribution contract" in which department stores and Louis Vuitton could directly transact products—an unprecedented contracting practice in Japan. In addition, as a way to protect the image of the brand,

FROM TOP TO BOTTOM

Kyoto, 16h00. 2005.
The woman carries a Speedy 25 in Monogram canvas

Nara 11h13. 2006.
The woman carries a Trotteur tote in Monogram canvas

Nara, 10h30. 2005.
The woman carries a Mini Pochette Delightful in Monogram canvas

he installed a branch store of Louis Vuitton in Japan and proposed a "management service contract" between the branch store and Japanese department stores to ensure the protection of trademarks and guidelines for advertising.

At this point, other European brands such as Gucci, Hermès, and Loewe had also formed contracts with Japan. Yet Hata's plan, unlike those of other companies that adhered to the commercial practices in Japan, was simple and clear. Instead of a single department store, Hata selected both Takashimaya and Seibu department stores. Furthermore, while Louis Vuitton carried out licensed production in North America at the time, Hata firmly resisted licensing in Japan and recommended instead that they conduct everything from the product's manufacture to sales and take full responsibility for its quality. Louis Vuitton in Paris was impressed with this idea and named Hata branch manager. Although the position was meant to be temporary, Hata went on to lead Louis Vuitton Japan for 28 years from 1978 (he was 40 at the time) to his retirement in 2006. In creating the company's framework, Hata was an indispensable part of Louis Vuitton's success.

The women's fashion magazine *Anan* had kindled the passion for Louis Vuitton in Japan, but once Hata accepted his position as president, Hata set his eyes on well-established men's magazines such as *status* and *50 oku (Five Billion)*. "When I became president in '78, I pondered our advertising strategy and decided that first and foremost, we should communicate that Louis Vuitton is not fashion. Louis Vuitton sells large trunks and our primary business is in travel luggage. Yet the majority of people who purchased Vuitton handbags back then were not aware of this. If we continued on this way, I feared that the true world of Louis Vuitton would not be understood correctly. Hence, instead of fashion magazines we chose to publish advertisements in magazines geared toward male readers; we were highly selective when identifying a medium that resonated with our image. We mostly chose publications with a circulation of 60,000–70,000 and a readership consisting of high-income earners such as doctors and lawyers. We purposely avoided female fashion magazines. It was only in the '80s that we began to advertise in luxury lifestyle magazines for women such as *Kateigaho*, *Mrs.*, and *Fujingaho*."

At that time, the concept of fashion had not yet matured in Japan. Swayed by perceptions of fashion as something that belonged to women that no self-respecting man would be caught tampering with, the concept held little social value. At first glance, Hata's decision may seem to adhere to such stereotypes, but it was Hata's long years abroad in New York and his unique understanding of the utility of fashion that kept him from positioning the company as a fashion brand while Japan was still developing into an economic superpower. In a country steeped in tradition, Hata decided that Louis Vuitton should be widely known for the quality of its products, befitting a historical brand. It was under such a directive that Hata

chose to distance himself from fashion and instead spoke directly to a class of people who would form the center of the brand's clientele in the coming years.

LV FEVER

Louis Vuitton devotees in Japan, however, did not consist solely of people who traveled abroad frequently, understood luxury goods, and utilized them every day in a manner that mirrored their quality. In fact, it was the sheer volume of customers who fell outside of such descriptors that made the brand into such a rare sensation.

Yasuo Tanaka's *Somehow, Crystal*, a novel published in 1980 to immediate acclaim, depicts the everyday life of Yuri, a female college student moonlighting as a model, who "takes action based on tactile sensations" during a materially prosperous time. Replete with footnotes that conjured the names of musicians, popular hangouts in Tokyo, and various fashion brands, the novel functions like a guidebook on leading a cool urban life. Of course, Louis Vuitton makes an appearance as well: "*Naomi wore a pair of faded Lee jeans and a well-tailored linen shirt with a round collar. Her Louis Vuitton bag, packed with makeup and a change of clothes, was much bigger than anything that I had ever seen. Unlike my one-piece dress from Alpha Cubic that I had purchased especially for the occasion of my first job, she exuded ease as a model.*"

The novel's protagonist is a young woman who wishes to do only what makes her feel good. Although she dreams of becoming "the kind of woman who can pull off a Chanel suit" once she turns thirty, she resists Louis Vuitton because she does not find it quite right to live above her means. In spite of this, the novel went on to become an unprecedented million-copy seller and helped trigger the luxury brands boom of the 1980s and spread Louis Vuitton's recognition as its symbolic center.

Ever since the early '80s when the novel was published, Louis Vuitton began to make frequent appearances in Parco department store's *Across*, a magazine that conducted a "fixed point observation" (snapshots of people and a survey of the latest trends) in Shibuya, Shinjuku, and Harajuku. A November 1985 issue reported: "Though once perceived as a transitory trend in decline, Louis Vuitton bags, known for their unique pattern, seem here to stay." A March 1988 issue also documented an interesting shift: "The revival of Louis Vuitton does not owe itself exclusively to the rise of the nouveau riche and conservatives. The bags are no longer a mere status symbol for women who favor lady-like fashion; men and women in casual leather jackets and jeans love them too. With increasing variety in its shape and size, the brand seems to finally be moving from 'status' to 'fashion.'"

Kyojiro Hata solidified the foundation of Louis Vuitton as a status symbol, but it was the mass consumers—along with the media that stirred their desire—who visualized it as a fashion. The fever for Louis Vuitton bags in the '80s enabled the remarkable expansion of their market

in Japan, but as previously described, the structure that supported their popularity was twofold: the products were received simultaneously as a status symbol and a fashion accessory. Louis Vuitton bags were transforming into something that one covets not because they are a chic luxury good from Paris, but because "everyone had one."

According to Hata, the Keepall 50 and the Boston 30 bag known as the Speedy sold well, but the most sought after item was the Pochette. "The strong yen and the rise in income enabled a generation of people to purchase Louis Vuitton products with their allowances. This paved the way for a great expansion of the market. But the products that such customers purchased were not expensive; they used the simple purses originally meant for makeup products as clutch bags, a kind of substitute for handbags. I imagine someone must have used them this way and started a craze. We sold so many of them."[4] With the added benefit of the strong yen, Japanese customers traveling abroad suddenly realized that they could now easily purchase from the previously unattainable Louis Vuitton. Though the company did not sell their products in duty free stores unlike other luxury brands (due to Hata's strong conviction), Japanese customers found that they no longer had to be ridiculed for forming long lines at the Paris store; they could purchase Vuitton bags not only at flagship stores in other countries but also department stores and direct import shops in luxury hotels. Unlike items that quickly fell out of fashion, a Louis Vuitton item could inspire in even the less trend-conscious customers a feeling that they have stepped one rank above the norm. In South Korea and other countries, counterfeit sellers who detected the Louis Vuitton fever in Japan quickly began to manufacture copies. Although the Paris headquarters had reservations about the deluge of additional orders for less expensive items, Hata himself never resisted such young female customers. Contrary to the decisive way he dealt with counterfeit sellers, Hata welcomed young women who were willing to purchase authentic items in whatever price range. Though a part of him may have hoped for the newcomers to eventually graduate into purchasing items in a higher class, he nevertheless kept an extremely fair, neutral stance towards business. Perhaps it was such a philosophy at the top level that inspired Louis Vuitton's flexibility as a brand.

During the late 1980s, the majority of the Japanese considered themselves to be middle class. A Louis Vuitton bag may have compelled them to spend more than they were used to, but the majority of young women probably did not equate this with living above their means. Economic disparity in Japan grew much more pronounced after the year 2000, but during this era, a sense of optimism still pervaded the archipelago. Louis Vuitton started out as a yearning for so many and its development followed the postwar narrative of Japanese fashion that slowly narrowed the distance between Japan and France. But its course was altered as it entered the 1990s.

LOUIS VUITTON AND GIRL CULTURE

What should we make of the seismic shift in Japanese society during the 1990s?

The prosperity that propelled the bubble economy of the 1980s, faced with a variety of economic factors combined with the first Gulf War, suddenly deteriorated in the next decade as land prices fell and unemployment rate rose. In the midst of such economic downturn, the Han-Shin Awaji Earthquake struck in January 1995, destroying expressways and buildings and engulfing the Nagata Ward of Kobe in flames. To make matters worse, in March of the same year the Aum cult's sarin gas attack occurred in Tokyo and just when its effects had begun to dissipate in 1997, the Kobe child murders, in which a 14-year-old boy murdered two elementary school students, shocked the public. After the bubble burst, bad debts caused a succession of major financial institutions to file for bankruptcy. The sudden distrust of things that one had so depended on was now prevalent throughout the society.

It was against such a context of social unrest that street fashion blossomed. While large apparel brands suffered from a recession, indie brands, with Tokyo and Osaka as central hubs, emerged everywhere while young people in unique, unconventional, and self-made clothes sprang up and multiplied in Harajuku and Shibuya like bamboo shoots after the rain. Their pop and punkish culture, captured first by the Italian fashion photographer Oliviero Toscani and assembled as a feature in the magazine *Colors*, soon garnered international attention. Hair dyed in a rainbow of hues and bodies riddled with piercings, these young people affirmed their identity by wearing clothes that made adults frown.

Simultaneously, the now-infamous Japanese high school girls in long, loose socks entered the scene. Like so many *anime* characters, the girls, with a sense of balance unlike anything the fashion scene had witnessed, hiked up their school-issued navy skirts to match their chunky, specially ordered high socks. They inhabited the city while permeating a sense of rebellion everywhere. Loose socks became synonymous with juvenile delinquency, giving rise to the indecent term *enjo kosai* (literally "compensated dating"). I have seen these girls, strutting along with their Keepall bags, which they may or may not have attained through *enjo kosai*, strapped boldly across their torsos. Further research revealed that a majority of these girls belonged to well-to-do families of doctors and college professors, who had grown up wanting for nothing. What then possessed these girls, blessed with looks well above average, to act this way? I will leave such inquiries to psychoanalysts. As for me, I saw in these girls an original sense of aesthetic much like the Harajuku street kids.

Rebelling against family and school, the girls, in asserting their individuality, seemed to carry Louis Vuitton bags for reasons more complex than the simple desire for

conspicuous consumption as elaborated by Veblen. For the first time, I felt as if I had seen individuals who carry Louis Vuitton without capitulating to the brand (They called to my mind the image of Jane Birkin carrying an Hermès bag). Perhaps it may be an overestimation to say that they possess autonomy of a different ilk than feminism, but in Japan, where the society inevitably contorts under enormous oppression, even autonomy manifests itself with a twist. From the high school girl who decides to partake in *enjo kosai* to buy a topaz ring in the film *Love & Pop (1998),* directed by Hideaki Anno and based on Ryu Murakami's novel, to the girls drawn by the artist Yoshitomo Nara, they all seem to express a twisted sense of *kawaii.* Perhaps it was at this time that the truly original fashions of Japan began to reflect the growing sense of national discontent.

MARC JACOBS AND THE NEW DESIRE

During the same era, significant changes also took place in Louis Vuitton's headquarters in France. In 1989, Bernard Arnault assumed the position of Chairman & CEO of LVMH group followed by Yves Carcelle, and finally in 1992, Carcelle selected Jean-Marc Loubier as communication director. Under this triumvirate, and facing unprecedented headwinds, Louis Vuitton took its first steps as an international conglomerate. In a sense, this marked a departure from the company's hereditary legacy.

While Louis Vuitton rarely launched full-scale ad campaigns before, as it entered the 1990s, the company began producing a succession of ad campaigns that moved ever so slightly from an emphasis on tradition to something more contemporary. These included campaigns for the 100th anniversary of the 1896 Monogram (1996); the reintroduction of the Damier canvas (1996); Epi Leather (1997); the "*L'Âme du voyage*" series shot on location in Myanmar (1997); and finally Taiga's *Thomas Crown Affair* series that was geared toward businessmen. What mattered was that Louis Vuitton had made a significant change of course towards fashion from its focus on status. The appointment of Marc Jacobs as creative director in 1997 can also be positioned within this shift. The fact that Louis Vuitton's remarkable development in the coming years would not have been possible without Jacobs is a testament to the company's keen sensibility and foresight.

Japan was still in a mess when Marc Jacobs made his Paris runway debut with his ready-to-wear collection for Louis Vuitton for Autumn-Winter 1998–1999, and strangely enough, the timing coincided with the end of the pedestrian mall that marked the end of Harajuku street fashion. When the car-free pedestrian mall in Harajuku—long a makeshift stage for eccentric youths—was shut down, the young, anarchic men and women who made the place so inimitable slowly disappeared. Moreover, 1998 marked the launch of Uniqlo's Harajuku store, completing its transition from a mass retailer into an urban-style shop with its own unique, image-conscious strategy. This opened the gate to a succession of fast fashion retailers from the West coming into Japan.

About the time Louis Vuitton hired Marc Jacobs, top European luxury goods houses began to appoint talented fashion designers one after another: Tom Ford for Gucci; John Galliano for Dior; Hedi Slimane for Dior Homme; Alexander McQueen for Givenchy; Narciso Rodriguez for Loewe; and Tomas Maier for Bottega Veneta. Under the new order of globalization, they sought to restructure the management of their brands. The beginning of Japanese fashion from the millennium on is characterized by a bipolarization into luxury and fast fashion. Men's fashion, soon after the appointment of Slimane at Dior Homme, saw clientele who heretofore had been obsessed with Harajuku's street fashion gradually converting to luxury goods. In women's fashion, on the other hand, the consumption of luxury goods was more prominent in bags, shoes, and jewelry instead of apparel. In contrast to their expansive interest in cosmetics, spas, travel, and hobbies, women's appetite for fashion was on a decline. A prototypical young woman with an interest in style shopped at fast fashion retailers for clothes while accessorizing with luxury goods. Bags from Dior, Chanel, and Gucci gained attention as fashion items. Marc Jacobs arrived in such a context.

Kyojiro Hata, as he sought to establish Louis Vuitton in Japan, asserted that their products were *not* fashion accessories. With the inclusion of Marc Jacobs, however, there was no denying that stage-two Louis Vuitton, the fashion brand, had emerged. The Louis Vuitton bags, beginning with Marc Jacobs' colorful patent-leather Monogram Vernis, underwent a transformation through collaborations with artists such as Stephen Sprouse, Takashi Murakami, Richard Prince, and Yayoi Kusama, to which the monogram was offered as a blank canvas. The bold reinterpretations, much to the initial reservation of conservative Louis Vuitton fans, sensationalized the public by producing a series of unconventional, rule-breaking monograms. Under a new system that generates new items every half year, even the most innovative and attractive bag, almost as soon as it is presented to the world, has to concede its throne to next season's product and the correlating theme of ready-to-wear. Desire, however, is stirred in part by the brief lifespan of such products. This rule, already familiar in the apparel world, slowly began to change the image of Louis Vuitton in Japan.

Before, Louis Vuitton Monogram bags did not come with instructions on how they should be worn. Whether with a classic suit, a one-piece dress, or a casual t-shirt and jeans, a Louis Vuitton bag could be adapted according to the wearer's sense of style and this versatility—along with its variety that made such versatility possible—defined the brand. However, the beginning of the ready-to-wear collection meant that a specific style, either through a runway photo or a campaign visual, would be determined for every season. Now, when Louis Vuitton bags appeared in fashion magazines, the brand strictly controlled the media so that they matched the Louis Vuitton ready-to-wear. Such methods in turn helped spread the worldview of Louis Vuitton = Marc Jacobs. However, as remarked earlier, the closets of fashion-loving

women had already been saturated. No matter how much their hearts desired LV's new and expensive ready-to-wear, only a relative handful could acquire them. Meanwhile, the hungry eyes of most women with an appetite for beauty continued to gravitate toward bags and accessories.

Moreover, artist collaboration bags incited a desire because, unlike regular bags, they were limited editions with an aura of scarcity stemming from the fact that they would not be available after a season. While apparel comes with expiration dates—an item grows older as the season nears its end—a bag is its complete opposite. Louis Vuitton bags are durable; they will never grow old after a mere six months. Not only can they be used long after a season, they come installed with a speculative value and a potential to be a darling of the vintage market. Some customers purchase a Takashi Murakami or Yayoi Kusama bag in the same manner that they would their art pieces. Today, instead of formal stores, only "recycle shops" and online sellers deal in vintage bags. Komehyo, a representative example of secondhand stores that operates branches in Aoyama and Ginza, revealed that of the many luxury goods they handle, Louis Vuitton's bags suffer the least depreciation in value.

In these ways, Marc Jacobs' strategy, even in the midst of a recessionary era, succeeded in resuscitating a new desire for fashion. Moreover, Jacobs' exquisite selection of artists garnered a warm reception in Japan. Takashi Murakami and Yayoi Kusama, both with long careers in New York, are artists who first attained acclaim overseas. Jacobs, rather than treating them as artists to whom he simply submits materials, sent them out into the world as new fashion icons. For Kusama, her collaboration with Louis Vuitton generated a synergistic effect as the brand's global network overlapped with the conceptual theme—multiplication—of her own production. This alone is proof of Marc Jacobs' remarkable insight.

On July 18, 2012, when the brand's collaborative effort with Yayoi Kusama was released, a long line snaked its way to the specially installed popup shop at Isetan, Shinjuku. Those in line included both the stylish fashion aficionados who desired to purchase the most exciting product on the market as well as passionate, art-loving fans of Kusama, and perhaps even vendors who speculated on the product's potential price hike. In short, they were a far cry from the lines of ill-fitting Japanese customers with little understanding of Louis Vuitton that Kyojiro Hata had witnessed back in Paris. How would Hata, who now resides in Hawaii, feel if he saw the new customers today? I wonder if he would think nostalgically of the curious incident 35 years ago that led him to play—aided by his own precise judgment, the current of the times, and the character of the Japanese—a crucial role in the creation of the Louis Vuitton empire, one unlike any other in the world today.

Let's double back to the words of architect Jun Aoki with which this story began. A boundary surface is intangible. A boundary does not split the world into two. A boundary

appears because the two worlds come in contact. 130 years have passed since the introduction of Louis Vuitton to Japan. The years tell the history of Japan's attempt to reconcile Western civilization with itself. Two world wars occurred during that period, and the confusion of values wrought by the country's defeat in the Pacific War left an indelible mark. Instead of a simple dichotomy between those with wealth and those without, and those with status and those without, multiple axes of conflict—between those who value Japanese tradition and those who yearn for Westernization as well as that between conservatives and rebels—came into play. After taking on the post of President of Louis Vuitton Japan, Kyojiro Hata made the wise decision to focus on reliable craftsmanship instead of Japan's old longing for the West—and would, in time, remake Louis Vuitton in its own image. The two distinct worlds of status and fashion that existed in the 1980s are no longer in opposition. This is due in part to the maturity of fashion in Japan, as well as the skill of Marc Jacobs, who—through the mediation of talents such as Takashi Murakami and Yayoi Kusama—repainted the color of status. The boundary surface, born of two worlds coming into contact, has delineated a variety of *moiré* patterns over the years. Today, the pattern in emergence recalls the gentle, soft waves of the sea.

FROM LEFT TO RIGHT, TOP TO BOTTOM

Kyoto, 17h00. 2005.
The woman carries a large Joséphine bag in blue Monogram Mini Lin

Kyoto, 18h30. 2006.
On the left, the woman carries a small Alma in Monogram canvas; on the right, the woman carries a Ribera mini bag in Damier Ébène canvas

Otsu, 14h53. 2005.
The woman carries an Alma in Monogram canvas

Kyoto, 08h45. 2005.
On the left, the woman carries a Speedy in Monogram canvas

Nara, 08h45. 2006.
The woman pulls a Pégase 50 suitcase in Monogram canvas and carries a Speedy 30 in white Monogram Multicolore. Monogram Multicolore (2002) is a creation by Takashi Murakami for Louis Vuitton. © Takashi Murakami / Kaikai Kiki Co., Ltd. All rights reserved.

Tokyo, 08h30. 2005.
The woman carries a Bosphore pochette in Monogram canvas

Tokyo, 15h09. 2006.
The woman carries a Géronimos pochette in Damier Ébène canvas at her waist

[1] Excerpt from Jun Aoki, *Jun Aoki 1991–1999* (Tokyo: Kenchiku Bunka, November, 1999), n.p.
[2] Designed by Shiro Kuramata, Capsule Corner opened in 1968 and operated out of the Seibu department store in Shibuya.
[3] Akira Mishima, quoted in *Fashion Business Shinjidai*, 1978, n.p.
[4] Interview with Kyojiro Hata, March 2013.

PART III: CODES

N° 437.171 Société Vuitton et Fils Pl. unique

Fig. 1.

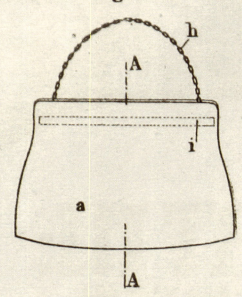

Fig. 4.

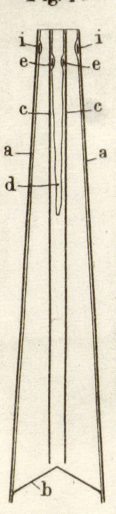

Fig. 2.

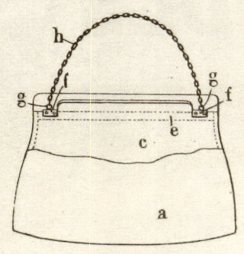

Fig. 3.

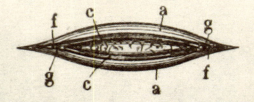

HONEST ERROR
DEYAN SUDJIC

The word design has two distinct meanings. They represent related, but different ideas about the relationship between the maker and the user. The older of them has its roots in those forms of craftsmanship that evolved into the decorative arts. They range from glass blowing and silversmithing, to leather work. A craftsman with the right skills can create an every-day artifact, such as a chair, a pair of shoes, a fork, or even a trunk, that has been shaped by the particular needs of a specific individual. Objects made in this way can exist in the mind of the maker without the need for any drawings or prototypes before they take on a physical incarnation. They take shape through a combination of memory and intuition, and are based on traditional forms and shared ideas, gradually adapted and modified from generation to generation.

But skill and tradition on their own are not enough to produce what might be described as luxury objects. To make artifacts that have charisma, patrons would commission artists to transform functional objects, to embellish them, and so give them a symbolic significance beyond their ostensible purpose. The artist would be asked to provide a drawing or drawings—in Italian, 'disegno,' the root of the English word design—for the craftsman to work from. Like a composer who creates a score for a musician to perform, the artist made a model or a design that could provide decorative detail, or iconography, or representations of the human figure, or a color scheme.

It's a path that precisely describes the evolution of Louis Vuitton. The House emerged from the unselfconscious craft tradition of apprenticeship and the culture of the workshop. It subsequently assumed the status of a manufacturer of luxury products, in part through its association with the fashion industry—its luggage was used to ship wardrobes, and with the decorative arts. At the same time, it retained a sense of authenticity based on the skills of its craftsmen.

Sketch illustrating the design patent number 437.171 for a handbag without clasp, approved for the company Vuitton et Fils and registered February 10, 1911.

P. 342
Detail of the Square Mouth travel bag in crocodile leather, 1931, 63 × 40 × 34 cm, 8.5 kg.
Louis Vuitton Archives

There is another version of design. The industrial revolution decisively broke the old relationship between the maker and the user. And from this rupture came another definition of design. Rather than producing patterns, or decorative motifs for craftsmen to follow, as artists once did in the pre-industrial period, the designer in the modern sense became responsible for shaping objects in such a way that they could be made in large numbers by machines, rather than in limited editions or batches by craftsmen. It is a design practice that took the word, from the older tradition, but gave it a different character, and introduced the specialist designer in a dominant role. Machines do not require the skills, the eye, or the muscle of a craftsman to achieve the consistency and finish that traditionally signified quality. They do not require as much hand finishing, or manpower. But they do need blueprints and prototypes, and the emergence of the specialist designers who provide them. Investing in machines that can bend, mould, extrude, and sew is expensive, but once the investment has been made, large numbers of identical objects can be manufactured at affordable prices.

Industrial design in its early period involved going back to first principles in an almost innocent way. Later design was to become much more knowing. When entirely new categories of objects emerged, the Bakelite rotary dial telephone for example, or the typewriter, even the sports car, the designer had to find an appropriate form that would allow users to understand what these objects were, and how to use them. Design in this sense was concerned with innovation rather than with tradition, and required continual experimentation with new materials and processes. By definition, traditional skills are based on the use of traditional materials. Substituting new materials for them is disruptive of these traditions, and has often had pejorative associations. These associations have diminished over the decades. Thus carbon fibre has a much more positive image now than plastic did when it was still a novel material.

The rise of industrial design was a development that represented a challenge to the traditional crafts. Perceptions of quality in craftsman made objects are based to a considerable extent on the apparent difficulty of executing a particular technique, or a detail, and the consistency with which it is carried out. When we know that it has taken one hundred hours to make something, we cannot help but look at it differently from an object that can be stamped out, molded or extruded in minutes or seconds. But the relative amount of time expended on two tasks is no objective criterion with which to measure the quality of one against the other.

We are used to understanding 'hand finished', or 'hand work', as guarantees of quality. This is an idea that comes originally from the writings of William Morris and John Ruskin, 19th-century romantics who were appalled by what they saw as the deadening lifelessness of the machines that were putting craftspeople out of work, or turning them into mindless factory fodder. But if quality

is based on perfection and consistency, then machines which do not get tired, and which can be programmed to precise paths, do a better job at guaranteeing it than human hands. Ruskin looked for creativity and inspiration in the imperfection of hand work, in contrast to the straightjacketed perfection of what the machine was capable of creating. Ruskin's essential point was summed up by Charles Rennie Mackintosh in an observation in his notebook made in his characteristic script. "There is hope in honest error, none in the icy perfection of the mere stylist."

It was an observation that led to the paradox of industrially manufactured objects carefully made in such a way as to be just a little imperfect. The imperfection was there to suggest that they had been made by hand, and so were somehow of a higher quality, by being less than formally perfect. But the material and tactile qualities of objects remain an essential aspect of their character. It is the pursuit of these qualities that still underpins Louis Vuitton's approach to its production. What has changed is the context in which those qualities are experienced. In a digital world, some skills maintain their relevance, and their power, and some don't. In its current catalogue, Louis Vuitton offers its products in a range of leathers and hides, of escalating rarity and price. They include, among others, milled grained calf leathers, which have a characteristic even consistency that can be used to make a bag that is as homogenous as possible: a quality that is more normally associated with an

Order specifications for a Round Bag in purple Morocco leather, lined with purple shot silk, 40 × 17 × 17 cm, February 1, 1936
Louis Vuitton Archives

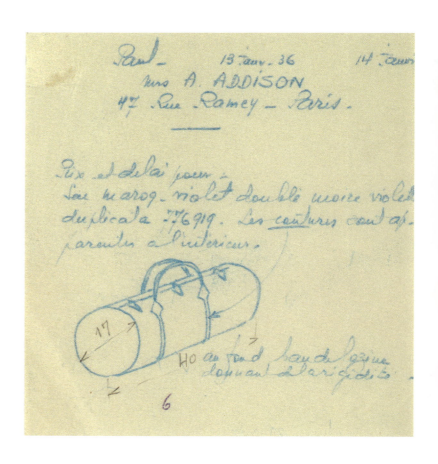

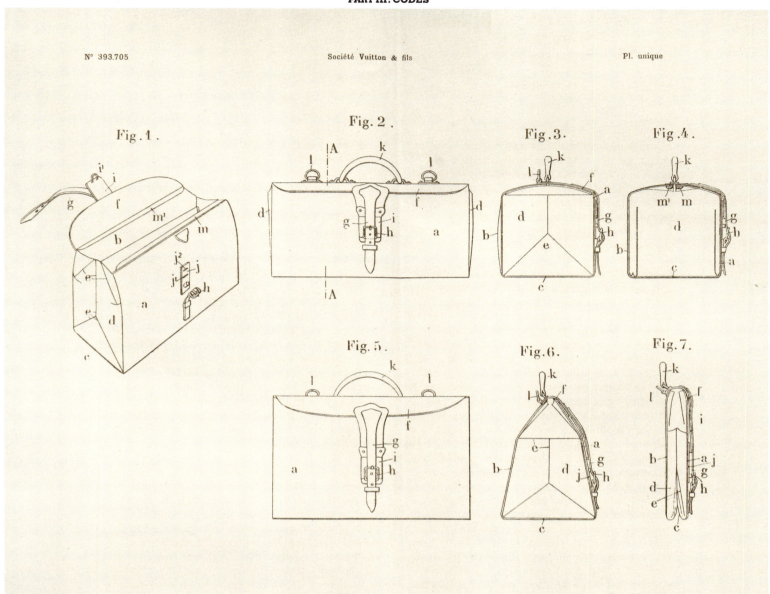

Fig. 1. Fig. 2. Fig. 3. Fig. 4.

Fig. 5. Fig. 6. Fig. 7.

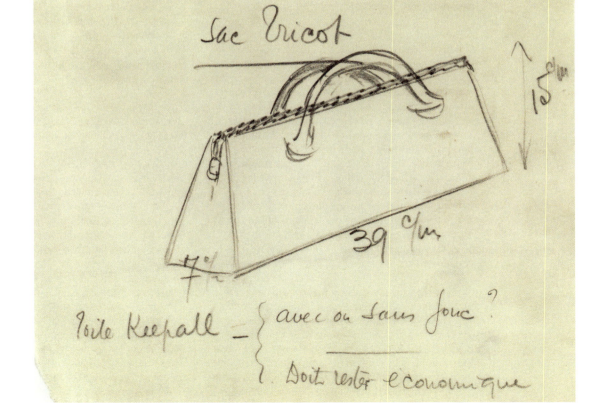

FROM TOP TO BOTTOM

Sketch illustrating the
design patent
number 393.705 for a
folding handbag
approved for the
company Vuitton et Fils
and registered
November 2, 1907.

Order specifications for
a Tricot bag in cotton
canvas, 15 × 39 × 7 cm,
May 15, 1940
Louis Vuitton Archives

industrial material than a naturally occurring one. Louis Vuitton also uses kid leather, lined with silk, as well as lambskin leather, that is supple enough to fit the body, goat skin, alligator and crocodile. These are materials that have the kind of physical qualities that have retained their charm. But in the contemporary context Louis Vuitton has moved beyond working only in a language derived from craft precedents.

Design in the modern sense works with a wider range of influences and inspirations, and seeks to convey a more nuanced message. Louis Vuitton began his career just at the point that one production system was being overtaken by a new one. The company has flourished through an exceptional ability to maintain its links with the crafts tradition, but to operate with all the sophistication of a more modern definition of design. It has given old skills a continuing relevance, and at the same time established a new kind of business by tapping the latent demand in an affluent world for luxury, which is no longer confined to a small elite, but has taken on an industrial scale. Louis Vuitton entered the global economy with the benefit of a high degree of credibility and brand authority based on a century or more of its heritage. In its heritage, it had an exceptionally fertile asset on which to build. Louis Vuitton has more than its initials, and its Monogram to work with. It is an unusual example of a company that has a product in physical form for its brand, like Coca-Cola with its bottle. Louis Vuitton has a number of products from the Speedy onward with a distinctive form that are in themselves essential parts of its identity. And it also has materials, such as its Monogram canvas and its Damier pattern, that are equally distinctive.

Louis Vuitton came to Paris as a 16-year-old in 1837 to start his apprenticeship with Romain Maréchal, a traditional box-maker and shipper in an establishment that was carrying on a craft that had hardly changed in its essentials since the Italian box-making guilds of the 14th-century. There are paintings that show them at work with the same kind of specialist tools that were still in use in Maréchal's workshop when Louis Vuitton was apprenticed there. And when Louis Vuitton opened his own workshop, they were still there. Louis Vuitton variously described his premises in Asnières-sur-Seine, just outside Paris, as a usine and a fabrique. In a famous 19th-century engraving of its interior, you see work benches that have the descendants of the same coopers' planes and awls and anvils on them that you can see in paintings from the 1320s depicting the guild of Venetian box-makers.

Asnières was run as a workshop, not a production line. The craftsmen spent their days working on the ground floor. The floor-to-ceiling windows provided all the daylight they needed to be able to see what they were doing. They worked at benches, with rows of trunks all around them, waiting to be covered in Louis Vuitton's patented fabric. Finished products were moved away, to be stacked three levels high on the two upper galleries, above the craftsmen's heads, to provide the stock that allowed customers to buy off the shelf, as well as to special order.

Louis Vuitton wasn't making bags in those earliest days. The House was still exclusively working with trunks. But when it did make the move into this new product category, it used the same approach to manufacturing, and the same visual language. Louis Vuitton is a company that has worked with some sophistication in the territory between the two definitions of design. It has managed through its various incarnations, first as a family owned business, and then as a part of one of the most innovative modern fashion companies, to maintain its connection with traditional skills of craftsmanship while at the same time making itself synonymous with contemporary creativity. When injection molded plastic can make an object as glossily perfect as Joe Colombo's Universale chair (1965), it is hard for a craftsman working in wood who is trying to make a handmade chair not to be influenced by the aesthetic of modernity, and to attempt to coax wood into directions in which it is not naturally comfortable.

Louis Vuitton embraced the modern world, in a way those critics of industrialization such as Morris and Ruskin, who saw machines as being evil in themselves for the way in which they diminished the craftsman's skills, did not. Morris and those who thought like him wanted to produce objects that referred back to the medieval past, which as they saw it, represented the high point of artistic achievement. Louis Vuitton draws on its archives and its traditions to renew its products, but has also continued to look forward. It has even replicated the relationship of the artist and the craftsman that was the original definition of design, through its collaborations with a number of contemporary artists, most notably Stephen Sprouse, Takashi Murakami, Richard Prince and Yayoi Kusama, initiated by the company's creative director, Marc Jacobs.

These are projects that have brilliantly played with the conventions of the brand, without compromising its sense of authority and authenticity.

Louis Vuitton has been able to adjust to changing social and technological circumstances, just as the box makers who were once part of the shipping industry were able to reinvent themselves as makers of luggage working with the modern art of travel. For artifacts that are based on the use of traditional skills to go on appearing as relevant luxuries, those skills need to be put to work in ways that respond to the changing visual climate. That climate is in part shaped by developments in industrial design. The color palette, the formal vocabulary, the material finishes used by industrial designers from the days of Olivetti to Braun and now Apple to produce typewriters, calculators, laptops and smartphones, cannot but impact the way that craftsmen-made objects are perceived. The aesthetics of stealth bombers, pilotless drones and Formula One cars shape our visual perceptions, as much as the art of Damien Hirst and Jeff Koons.

If Louis Vuitton had remained rooted in the visual sensibilities of mid- to late-19th-century France, it could never have become the global force that it is. It has grown and thrived by making itself open to creative energy from all over the world and from emerging generations.

Louis Vuitton was ready to be part of the modern world, to produce objects in relatively large numbers, but also maintained the tradition of the made to special order, in the tradition of bespoke, rather than ready to wear. The bags that made the company grow were designed as responses to modern forms of travel: the transatlantic steamship, the motor car, and very soon, air travel. The results were objects beyond fashion, the products of unselfconscious attempts to meet functional needs, and yet because they were associated with affluent pursuits and the world of fashion, they became in themselves the signifiers of the fashionable. Louis Vuitton had and has particular ways of doing things, of reinforcing a corner, of attaching a leather handle to the body of a bag, and particular forms. These have become part of the identity of the company.

Louis Vuitton is not a family business anymore, but that does not mean that it lacks a sense of imagination and rapid innovation. It is fiercely protective of its heritage and its trademarks, but it is prepared to be playful with the way that it uses them. It took courage to allow Murakami to parody and metamorphose the marks that have come to be associated with the brand. A more conservative company would not have attempted it. Louis Vuitton did and it had the effect of building the strength of the brand, and growing the business spectacularly. Perceptions of quality and luxury do not remain static. There is a fine line that divides the aura of tradition and luxury from the hidebound and the outdated. Just as the student rebellion of Paris in 1968 made conventional ideas of couture look hopelessly irrelevant for years, so the artifacts that constitute luxury do not stay static. The fountain pen, once a luxury but now slipping down the desirability scale, is one victim of this process. The Swiss watch industry has had to invest heavily in promoting its products to ensure that it does not suffer the same fate.

The task facing the design team that produces the new lines at Louis Vuitton involves an intriguing negotiation between the two meanings of design. In the Paris studios there are designers working alongside the craftsmen who make the patterns and maquettes to visualize their work. They provide a link with the larger workshops when their work goes into production. But the design team also works within the tradition of modern industrial design: This is not simply about the functional basics, it is also intimately concerned with the need to make new things which belong to the gene pool that Louis Vuitton has built up over the last century and a half.

In an anonymous warehouse on the outer edge of Paris, the company has built up an archive of its production since the first days. It's not entirely comprehensive: so many of its products were made to order to the specific requirements of individual customers.

But it is a vital starting point for the design team today, to explore the essence of the Louis Vuitton way of doing things. While the special collaborations and the accessories shown on the runway are led by Marc Jacobs, the head of design for the leather goods that are still at the heart of Louis Vuitton's production is Nicholas Knightly.

Knightly, who has led the team since 2004, came from a fashion background. He was producing his own collections after graduating in London, and selling them in America, before he moved to Margaret Howell, a label that is based on the subtle exploration of traditional languages of fashion. It was only then that Knightly moved into designing bags. This is a different kind of design from that practiced by a contemporary industrial designer. The bag is intimately connected to the body and is worn as much as it is carried. It is shaped by gender as much as garments are. In the 19th-century, when Louis Vuitton began his business, he had no need to consider whether or not his products looked like Louis Vuitton designs. Now his successors can do nothing else. Every piece that comes from Knightly's studio needs to reflect its roots. One analogy is with breeding racehorses: does a Louis Vuitton bag demonstrate the genetic inheritance? Is the handle attached in the right way? Are the corners strengthened as they should be? But there are also the inherent qualities of materials to consider.

Under the umbrella of the brand, it offers a range of approaches. There are bags aimed at men, characterized for the most part by darker colors, and at women—with a more vivid palette. There are products designed for those who look for less formality, woven fabric bodies, with aluminum fittings, and those that are more elaborate. Louis Vuitton has developed a number of design families, some based on materials, the various forms of leather, or on canvas. But Louis Vuitton also works on product typologies that appear in each of the different material families, Epi leather from 1985 for example, which downplays Louis Vuitton branding, in favor of celebrating the quality and finish of the leather that is used. In the last two decades, the motifs and materials developed by the company have given the design team the starting point for a fresh approach. The Damier pattern was brought back at a range of scales and in new colors. Murakami's version of the Monogram comes in bright, silkscreened colors. The company maintains its tradition of customizing. It offers personalized monograms that recall Richard Prince's distressing of the finish. The perfection of a product that meets the quality standards, is distressed, or made unique by a red stripe emblazoned across it.

Louis Vuitton has become a model for the contemporary design lead business. A company which can convey style with so much resonance and assurance as a Louis Vuitton product will continue to shape the future at a moment when the digital revolution has made so many categories of consumer objects redundant.

Ducey Ateliers I and II, Lower Normandy,
established in 2002 and 2006

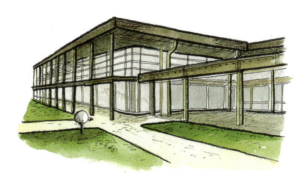

Sainte-Florence Ateliers I and II, Pays de la Loire, es-
tablished in 1999

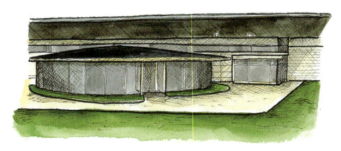

Issoudun and Condé Ateliers, Centre,
established in 1988 and 2002

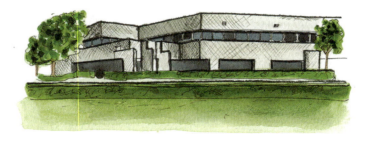

San Dimas Ateliers I and II, California,
established in 1991 and 2011

Drawings by Martine Rupert, 2013

THE MAP OF LOUIS VUITTON LEATHERCRAFT ATELIERS

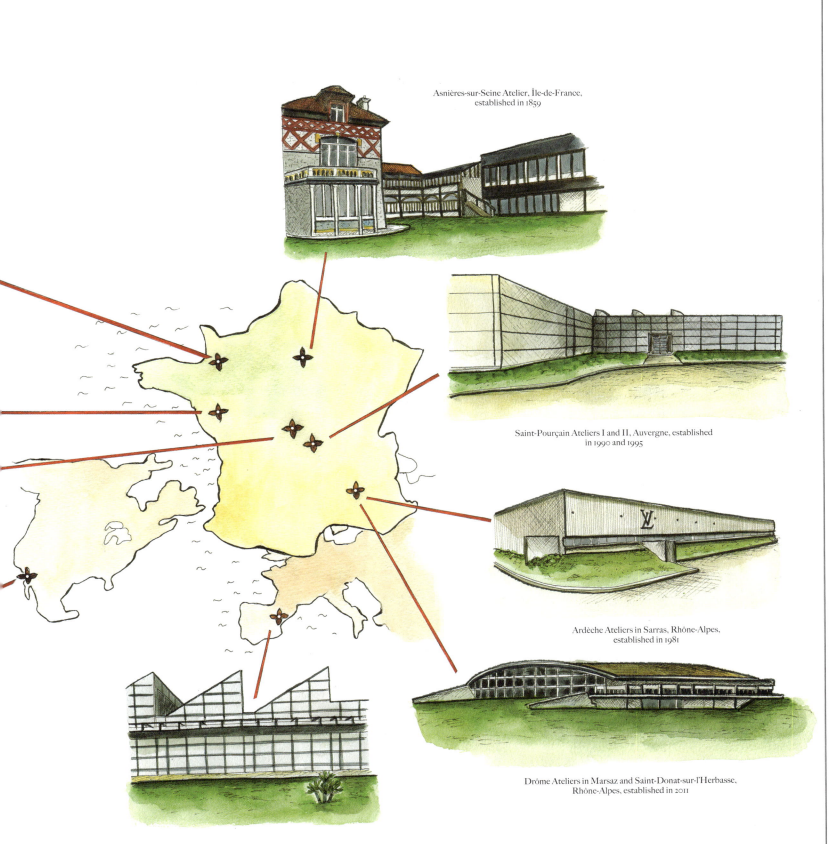

Asnières-sur-Seine Atelier, Île-de-France,
established in 1859

Saint-Pourçain Ateliers I and II, Auvergne, established
in 1990 and 1995

Ardèche Ateliers in Sarras, Rhône-Alpes,
established in 1981

Drôme Ateliers in Marsaz and Saint-Donat-sur-l'Herbasse,
Rhône-Alpes, established in 2011

Barberà del Vallès Ateliers I and II and Girona Atelier,
Catalonia, established in 1991, 2002 and 2012

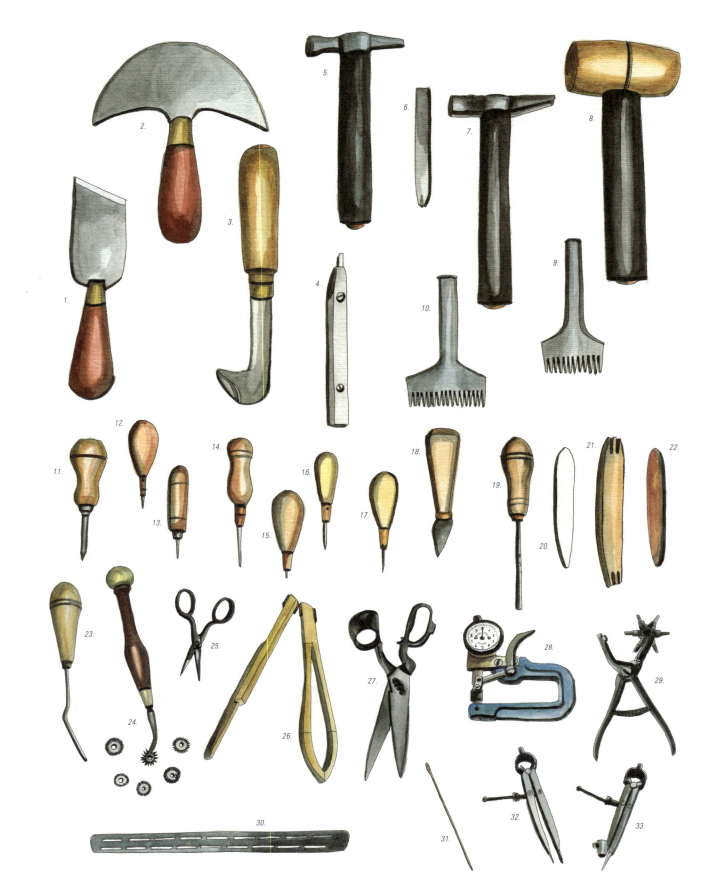

1. Paring knife, used for paring the leather. Paring consists of reducing the thickness of the leather in order to facilitate edge folding and assembly — 2. Half-moon knife, used for cutting leather — 3. and 23. Edge shave, used for softening the edges of the leather — 4. and 18. Punches, used for piercing leather — 5. and 7. Hammers, used for setting rivets and beating the waxed thread stitches into the leather — 6., 9. and 10. Pricking irons, used for marking the placement of stitches — 8. Boxwood mallet, used for beating the tools and reinforcing their impact on the material — 11. Punch, used for marking or piercing leather — 12. to 17. Awls, used for piercing leather and sewing preparation — 19. Scorer, used for deeply marking the leather to facilitate folding — 20. and 22. Bone folders, used for evening out minor flaws in the leather, softening it and smoothing stitches — 21. Wooden scorer, used for marking leather — 24. Pricking wheel and wheels, used for marking stitching placement — 25. Scissors, used for cutting thread — 26. Stitching clamp, used for holding a piece of leather firmly in place to facilitate hand sewing — 27. Scissors, used for cutting leather — 28. Dial caliper, used for measuring the thickness of the leather — 29. Revolving punch, used for perforating leather. Six different attachments allow for a choice of diameters — 30. Edging ruler, used to ensure the regularity of the edge folding — 31. Needle, used for stitching leather — 32. and 33. Compass, used for tracing sewing lines, parallel lines or piercing equidistant holes. Drawings by Martine Rupert, 2013

TOOLS

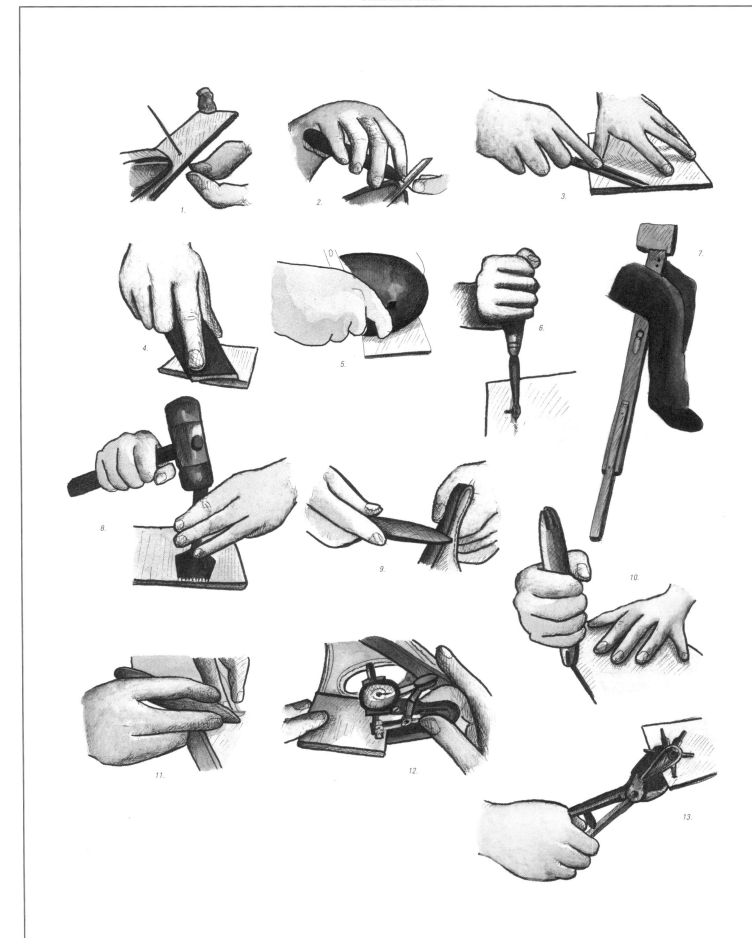

1. Passing a needle through leather — 2. Perforating the leather with an awl — 3. Marking a line on the leather with a compass — 4. Paring the leather with a paring knife — 5. Cutting the leather with a half-moon knife — 6. Marking the stitching points with a pricking wheel — 7. Positioning the stitching clamp between the leather craftsman's legs — 8. Marking the sewing points with a pricking iron and a mallet — 9. Smoothing the stitches with a bone folder — 10. Marking a line on the leather with a wooden scorer — 11. Smoothing the leather with a wooden tool — 12. Checking the thickness of the leather with a dial caliper — 13. Perforating the leather with a revolving punch. Drawings by Martine Rupert, 2013

TECHNIQUES

ANIMALES DOMESTICI

1. 2. 3. 4. 5. 6.

7. 8. 9. 10. 11. 12.

A.

B.

COW
Bos Taurus Taurus
Epi, grained, Nomade and natural cowhide leathers

VACHETTE
(juvenile female cow) *Bos Taurus Taurus*
Nomade vachette leather

C.

D.

E.

CALF
Bos Taurus Taurus
Bougie, Box, Écorce and Soie calfskin leathers

BULL CALF
Bos Taurus Taurus
Caviar bull calf leather

GOAT
Capra Hircus
Morocco, Frisson and Suhali goatskin leathers

1. Natural cowhide leather, used since the late 19th century in the design of trunks and soft luggage (A) — 2. Cognac Nomade *vachette* leather, of which a version in dyed natural cowhide leather has existed since 1988 (B) — 3. Fuchsia Epi cowhide leather, line launched in 1985 (A) — 4. Black Box calfskin leather (C) — 5. Grège Orfèvre calfskin leather (C) — 6. Navy Bougie calfskin leather (C) — 7. Brown Soie calfskin leather (C) — 8. Bleu canard Cachemire calfskin leather (C) — 9. Gris souris Écorce calfskin leather (C) — 10. Ocre Caviar bull calf leather (D) — 11. White Suhali goatskin leather (E) — 12. Grenade Frisson goatskin leather (E). Drawings by Martine Rupert, 2013

ANIMALES EXOTICI

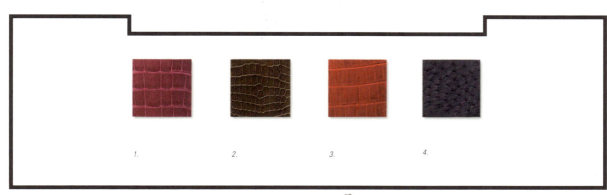

1. 2. 3. 4.

F.

OSTRICH
Struthio Camelus
Ostrich leather

G.

H.

I.

STINGRAY
Dasyatis Pastinaca
Shagreen

LIZARD
Varanus Salvator
Lizard leather

PYTHON
Python Reticulatus
Python leather

J.

K.

ALLIGATOR
Alligator Mississippiensis
Matte and brilliant alligator leathers

CROCODILE
Cocodylus Porosus
Matte and brilliant crocodile leathers

1. Fuchsia brilliant crocodile leather (K) — 2. Brown matte crocodile leather (K) — 3. Red brilliant alligator leather (J) — 4. Navy ostrich leather (F).
Drawings by Martine Rupert, 2013

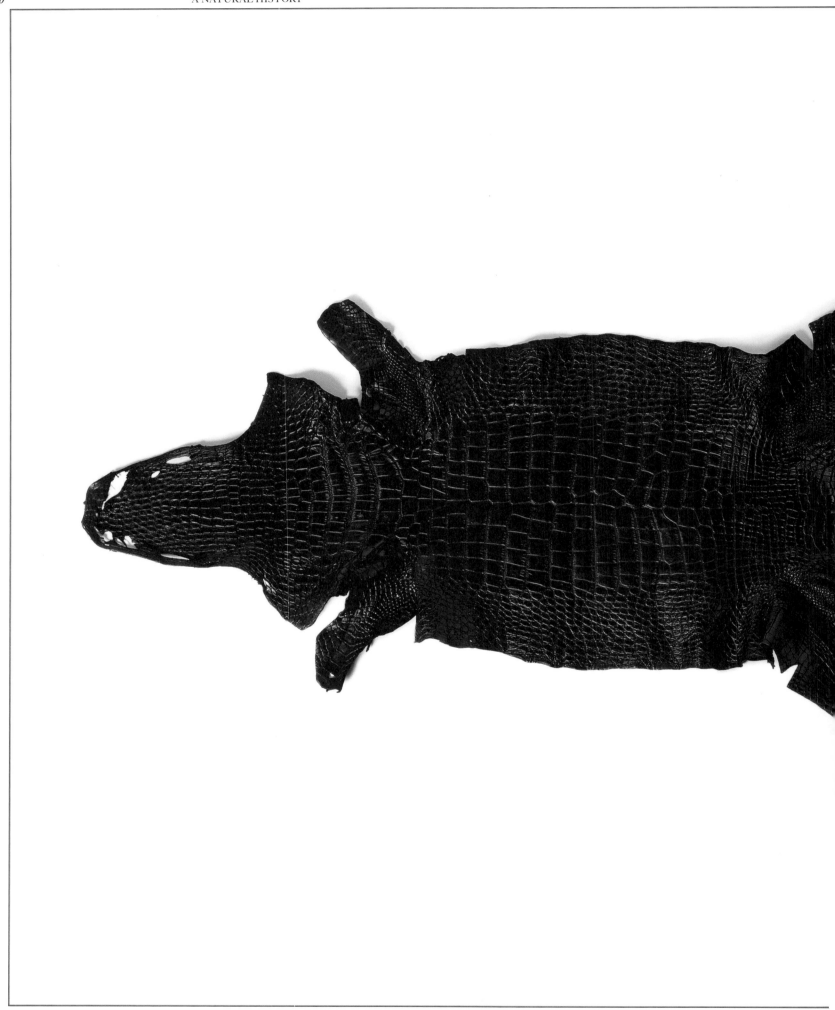

ALLIGATOR MISSISSIPPIENSIS

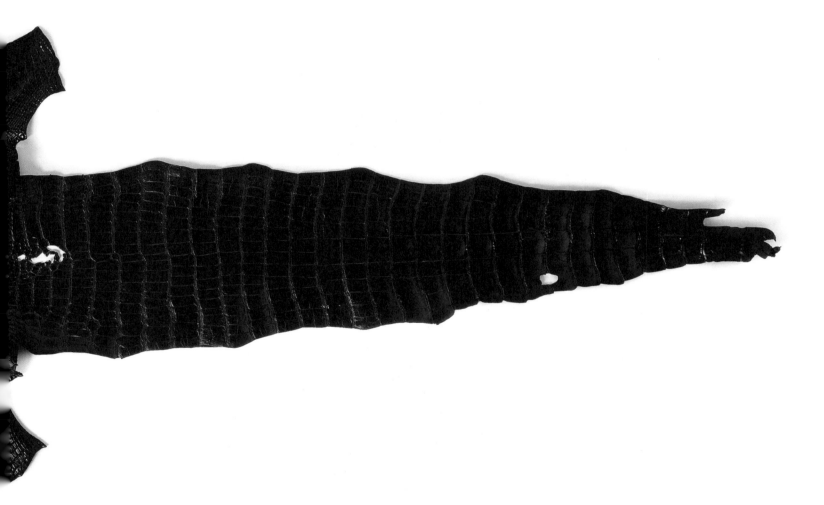

Alligator skin, dyed black with matte finish. See p. 355, (J)

EXOTIC LEATHERS

DASYATIS PASTINACA

Stingray skin, known as shagreen, dyed in bleuet. See p. 355. (G)

EXOTIC LEATHERS

VARANUS SALVATOR

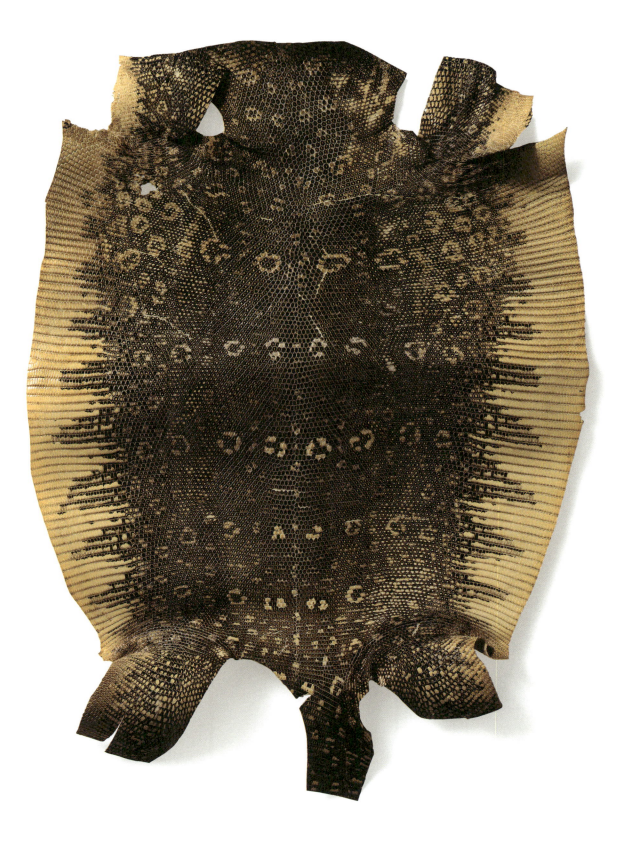

Lizard skin, natural color with brilliant finish. See p. 355. (H)

VEGETABLE TANNING

RECEIVING THE HIDES
The tannery receives the raw hides, which have been preserved in salt at the abattoir.

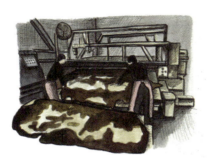

CUTTING
The hides, still raw, are cut for the first time.

TANNING
The prepared hides are placed in a vat and bathed in a solution of tannins and water. Modern tanning drums allow for each step of the chemical process to be closely monitored.

PLANT TANNINS

Mimosa

Quebracho

Chestnut Bark

OPENING AND SEPARATING THE HIDES
The hides, still folded and stuck together, are opened and prepared for the preliminary processes.

WASHING
The first phase of tanning consists of preparing the hides. These "beamhouse operations" allow the material to be cleaned and rehydrated through a series of washings that eliminate all impurities. This process makes the color of the hides uniform.

THE TANNED LEATHER
The hides become supple and will no longer spoil. The leather takes on a slightly beige tint that bears witness to the quality of the material and is the signature of Louis Vuitton's natural cowhide leather. It will develop a more amber patina with time.

Tanning is a process that transforms the animal hide into a supple and resistant material: leather. In the vegetable tanning process, organic substances of natural origin called tannins are used to protect the hides from spoilage. The quality of the skins is rigorously checked at each stage, and only the very best of these treated leathers is selected to become a Louis Vuitton product.
Drawings by Martine Rupert, 2013

LEATHER PROCESSING

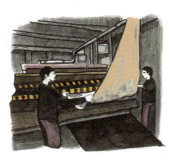

WRINGING
The leather is wrung out using presses and prepared for nourishing.

THE NOURISHING VATS
The leather is nourished with oils, increasing the flexibility and softness of the material. This phase is fundamental for the resulting leather, since an infinite variety of textures can be achieved.

DRYING AND SMOOTHING
The hides are dried slowly in the fresh air for several days. They are then smoothed to make the grain uniform and obtain a shiny finish.

SORTING
The task of selecting leather is an age-old skill that requires great expertise. The hides are inspected by hand to identify the natural qualities, roughness and natural or tanning flaws. The color and aspect (softness, weight, texture) must also be consistent. This phase guarantees the quality of Louis Vuitton's products: only the finest leathers are sent to the leathercraft ateliers.

CHECKING THICKNESS
The thickness of the selected hides is measured with a dial caliper, as this is one of the aspects that distinguishes different leathers from one another.

MEASURING
The area of the hides is measured before sending them to the leathercraft ateliers.

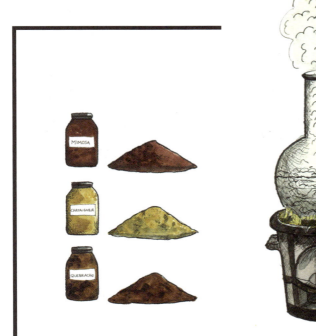

THE TANNING RECIPE
The components of the tanning solution distinguish and identify each tannery. The House's leathers are only tanned with natural substances: extracts of chestnut bark, quebracho and mimosa, and demineralized water at a temperature that varies according to the season. The natural vegetable tanning process for cowhide leather takes several days.

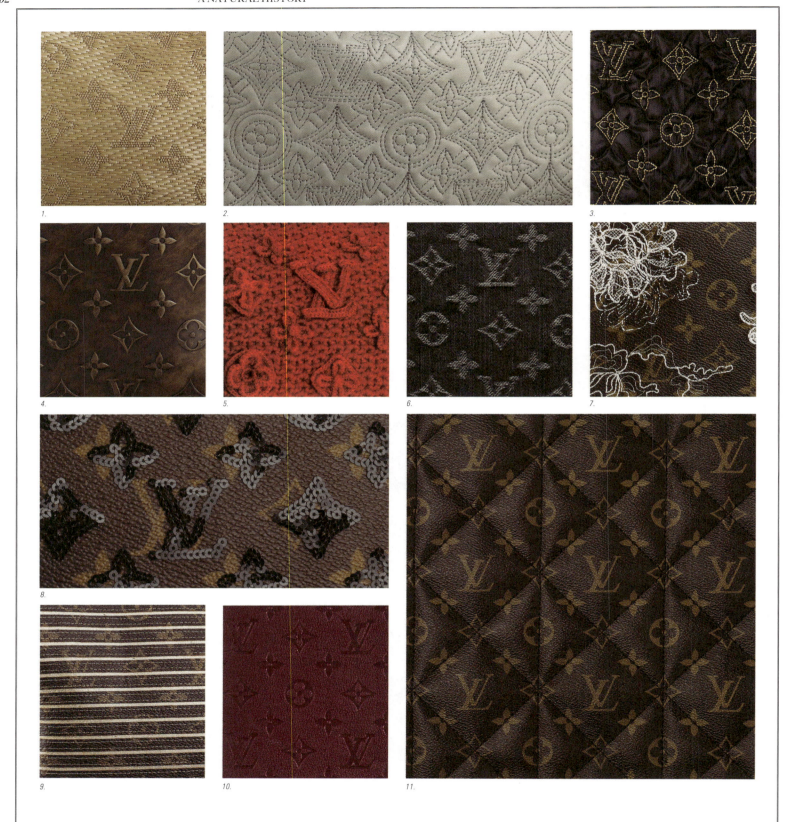

1. Monogram Amalfitana, natural raphia — 2. Pale gray Monogram Antheia, embroidered lambskin leather — 3. Black Monogram Brodé, hand embroidered and quilted satin — 4. Monogram
Bronze, debossed calfskin leather — 5. Red Monogram Crochet, hand embroidered nylon — 6. Grand bleu Monogram Denim, denim canvas — 7. Silver Monogram Dentelle, Monogram
canvas embroidered with lurex — 8. Black Monogram Éclipse, Monogram canvas embroidered with sequins — 9. Silver Monogram Eden, lambskin leather embroidered with bands of Monogram
canvas in pearlescent tones — 10. Aurore Monogram Empreinte, embossed calfskin leather — 11. Monogram Étoile, quilted Monogram canvas — 12. Black Monogram Fleur de Jais,
screen-printed Monogram canvas decorated with microfiber and embroidered with sequins — 13. Sepia Monogram Idylle, jacquard woven canvas — 14. Nougat Monogram Guipure, lambskin
leather embroidered with satin guipure — 15. Silver Monogram Limelight, laminated jacquard woven canvas — 16. Gold Monogram Lurex, jacquard woven canvas in lurex —
17. Sable Monogram Mahina, perforated calfskin leather — 18. Bleu pétrole Monogram Métal, leather studded with metal — 19. Indigo blue Monogram Métisse, embroidered silk satin

THE MONOGRAM

12.

13.

14.

15.

16.

17.

18.

19.

20.

21.

22.

23.

24.

25.

26.

27.

28.

29.

30.

31.

32.

33.

20. Black Monogram Mirage, screen-printed Monogram canvas — 21. Silver Monogram Miroir, embossed vinyl — 22. Monogram, grained treated canvas, motif created by Georges Vuitton in 1896 — 23. Navy Monogram Motard, quilted and embroidered lambskin leather — 24. Green Monogram Mousseline, silk mousseline embroidered with pearls, glass and mohair — 25. Pale gray Monogram Olympe, quilted and embroidered lambskin leather — 26. Turquoise Monogram Flore, perforated Monogram canvas — 27. White Monogram Quilted Mink, quilted and embroidered mink — 28. Beige Monogram Rayures, screen-printed Monogram canvas — 29. Green Monogram Révélation, debossed calfskin leather — 30. Black Monogram Satin, jacquard woven satin — 31. Menthe Monogram Sorbetto, embroidered lambskin leather — 32. Pink Monogram Stone, washed cotton canvas — 33. Aragosta Monogram Suède, perforated calfskin suede — 34. Khaki Monogram Sunshine Express, felted wool embroidered with sequins — 35. Sable Monogram Tahitienne, cotton canvas — 36. Moutarde Monogram Fascination, embroidered lambskin leather — 37. Red Monogram Velours, tufted Monogram canvas — 38. Peppermint Monogram Vernis, embossed and varnished calfskin leather — 39. Red Monogram Vernis Fleurs, embossed patent calfskin leather decorated with patent leather flowers — 40. Grand bleu Monogram Ikat, jacquard woven canvas — 41. Gray Monogram Vison, printed mink — 42. Transparent Monogram Vinyle, tote from a numbered, limited edition of 500 to celebrate 500 years since the discovery of Brazil in 2000 — 43. Bordeaux Monogram Volupté, treated jacquard woven canvas

THE MONOGRAM

CHOOSING THE MODEL
The Speedy, Keepall and Neverfull bags in particular can be personalized
with Mon Monogram (My Monogram). The product and the motif are
chosen directly by the client in the store.

CHOOSING THE MOTIF, THE INITIALS
AND THE COLORS
The design comprises a vertical or diagonal band in two colors.
The letters composing the owner's initials are also
printed on the canvas, in the same color combination as the band.

The Mon Monogram service allows the client to personalize their Louis Vuitton bag. The Monogram canvas is made to
order and screen-printed with the selected motif and initials. This personalization follows in the tradition of marking the steamer
trunks created by the House since its inception. Drawings by Martine Rupert, 2013

MON MONOGRAM

SCREEN-PRINTING
Today, the screen-printing for Mon Monogram is carried
out using a printer equipped with
advanced technology that guarantees a durable result.

DRYING THE CANVASES
The canvases are air-dried.

QUALITY CONTROL
Each canvas is checked by hand to guarantee that it meets Louis Vuitton's
quality standards before being sent to the atelier and made into a bag.

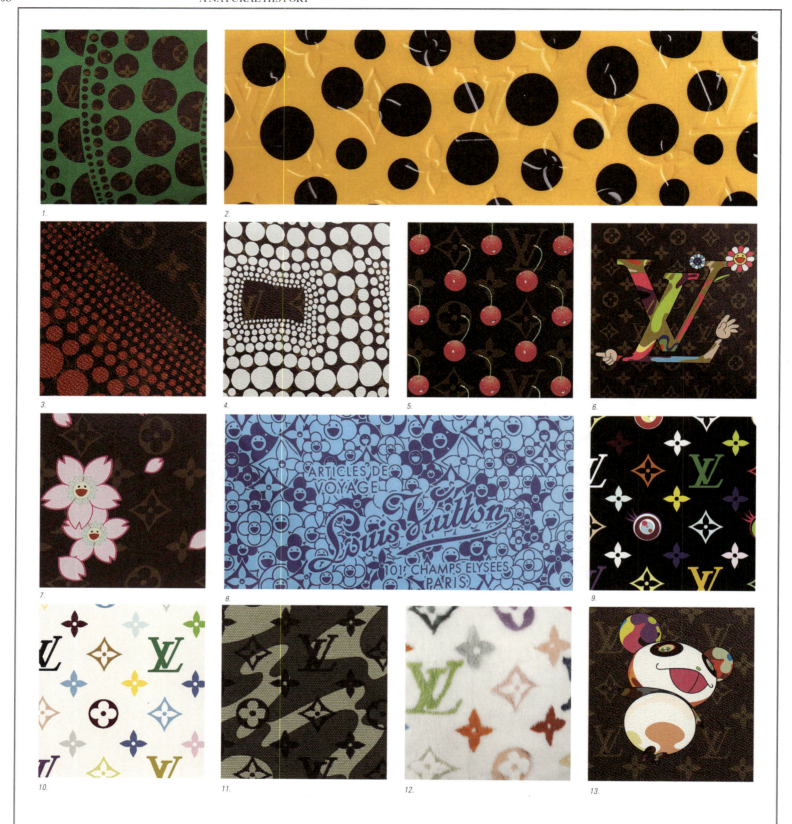

ARTISTIC VARIATIONS OF THE MONOGRAM

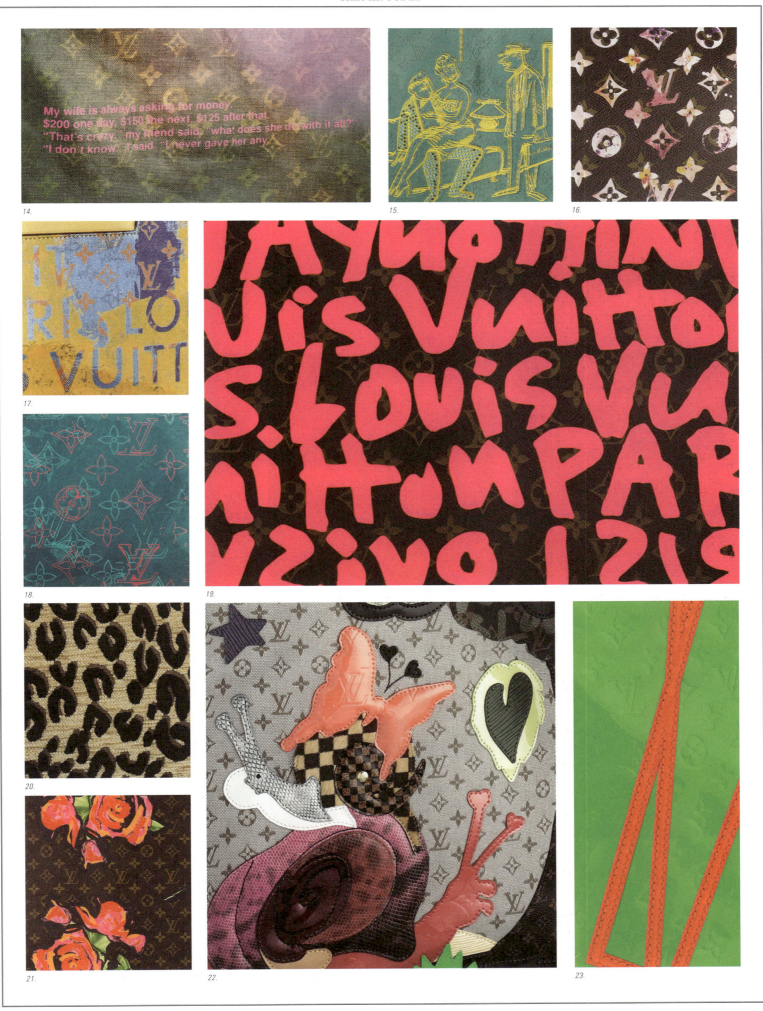

14.

15.

16.

17.

18.

19.

20.

21.

22.

23.

1.

2.

3.

4.

5.

6.

7.

8.

9.

The Monogram Cerises canvas is the result of a collaboration with the Japanese artist Takashi Murakami in 2004.
The motif is printed with a screen-printing technique: using a stencil, the design is reproduced on a framed screen before being applied to the canvas.
Several frames are required to obtain the final motif.

Alternative version of the Monogram Cerises canvas, "pair of smiling cherries."

Opposite: Making the Monogram Cerises canvas "pairs of surprised and smiling cherries": 1. Tracing used for reproducing the design on the screen:
the round cherry forms — 2. Tracing used for reproducing the design on the screen: the cherries' eyes and mouths — 3. Tracing used for reproducing
the design on the screen: the stems — 4. The canvas after the first screen-printing: the round cherry forms — 5. The canvas after the second screen-printing:
first color shading on the round forms of the cherries — 6. The canvas after the third screen-printing: second color shading of the round forms
of the cherries — 7. The canvas after the fourth screen-printing: the cherries' eyes — 8. The canvas after the fifth screen-printing: the stems and the reflections —
9. The final canvas after the sixth screen-printing: the mouths. Monogram Cerises (2004) is a creation by Takashi Murakami for Louis Vuitton.

MAKING THE MONOGRAM CERISES CANVAS

1. Damier Ébène, grained treated canvas, motif created by Georges Vuitton in 1888 — 2. Damier Azur, grained treated canvas — 3. Black Damier Vernis, embossed patent calfskin leather — 4. Cream Damier Facette, glazed embossed calfskin leather — 5. Camel Damier Facette, glazed embossed calfskin leather — 6. Fauve Damier Sauvage, dyed imitation foal calfskin leather — 7. Brown Damier Cubic, calfskin leather tufted with fabric — 8. Gray Damier Cubic, calfskin leather tufted with fabric — 9. Green Damier Cubic, calfskin leather tufted with fabric — 10. Yellow Damier Mosaic, braided and topstitched calfskin leather — 11. Black Damier Prisme, squares of onyx on metal armature — 12. Black and white Damier Optic Satin, satin embroidered with sequins — 13. Blue Damier Paillettes, Damier canvas embroidered with sequins — 14. Yellow Damier Fleur Illusion, calfskin suede decorated with a Damier flower in tufted fabric

THE DAMIER CHECKERBOARD MOTIF

Transparent nylon mesh embroidered with brown or yellow sequins (depending on the model) which, when lined with silk, creates the Damier Optic Résille, notably used in 2013 on the Speedy in its Cube version. On the right, ogival sides are used in the Speedy, whereas the squares on the left are used for the front and back of the bag.

1. Cotton and polyester lining fabric in rouge fauviste — 2. Cotton and polyester lining fabric in amaranth — 3. Polyester microfiber lining in orange — 4. Polyester microfiber lining in rubis — 5. Red striped cotton and polyester lining fabric — 6. Cotton and polyester lining fabric in brown — 7. Polyester microfiber lining in chocolat — 8. Polyester microfiber lining in miel — 9. Navy striped cotton and polyester lining fabric — 10. Cotton and polyester lining fabric in chocolat — 11. Polyester microfiber lining in prune — 12. Polyester microfiber lining in taupe — 13. Khaki striped cotton and polyester lining fabric — 14. Cotton and polyester lining fabric in red — 15. Polyester microfiber lining in green — 16. Polyester microfiber lining in black — 17. Black twill lining — 18. Cotton and polyester lining fabric in gray — 19. Polyester microfiber lining in safran — 20. Polyester microfiber lining in gray

BAG LININGS

From left to right, top to bottom: Liberty lining with blue flowers, roses and lilacs — Monogram lining fabric in beige cotton —
Cotton and polyester lining fabric in fusain with stripes and Monogram flowers — Cotton and polyester lining
fabric in sepia with stripes and Monogram flowers — Micro Monogram lining fabric in gray polyester — Infinity Net lining fabric
in red polka dotted cotton, designed in collaboration with the Japanese artist Yayoi Kusama in 2012

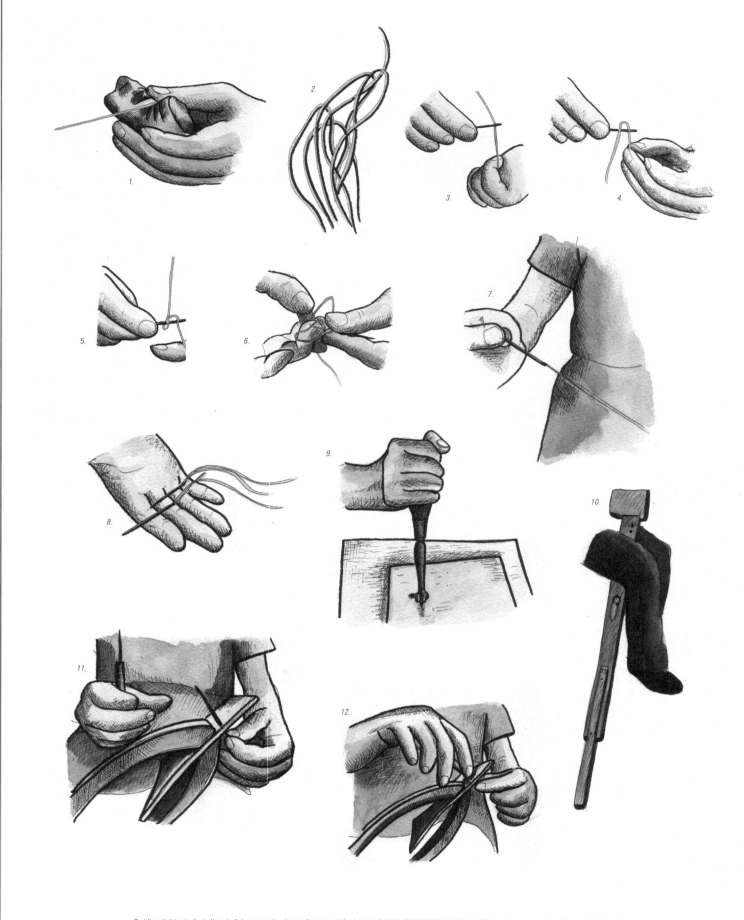

Saddle stitching is the hallmark of the master leather craftsman, and is characterized by slightly inclined stitches. This technique guarantees the product's longevity and refined finish. 1. Waxing the thread: A linen thread is waxed by passing it repeatedly along a block of natural beeswax. Doing so ensures that the stitching points will be robust and waterproof — 2. The waxed thread: The thread's yellow color is a distinctive hallmark of Louis Vuitton products — 3. to 7. Threading the needle: A specific technique allows the craftsman to thread the needle in such a way as to prevent losing the thread during the hand sewing process — 8. Preparing for sewing: Two needles are threaded onto the same thread — 9. Marking the sewing lines: The placement of the stitches is marked using a pricking wheel. The regularity of the stitching points is strictly monitored — 10. Preparing for sewing: The piece of leather is fixed to a stitching clamp, which is held steady between the craftsman's legs — 11. Perforating the leather: The leather is pierced with an awl in order to facilitate the passage of the needle.

THE SADDLE STITCH

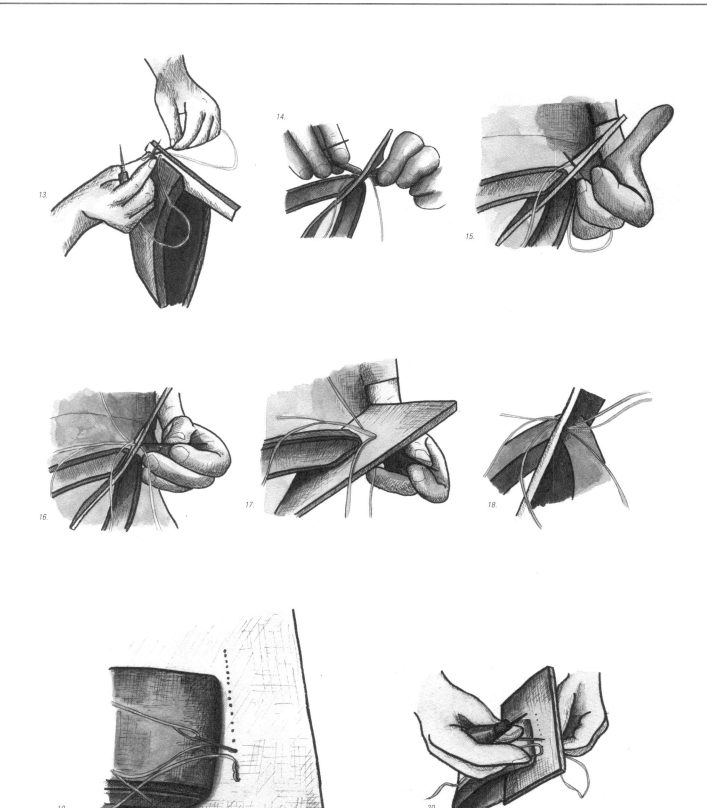

12. and 13. Positioning the thread: One of the two needles is passed through the first hole in the sewing line. Half of the thread's length is slipped through it so that there is an identical length of thread, and one needle, on either side of the piece of leather — 14. Using an awl to perforate the leather: The second hole in the stitching line is pierced using an awl. The craftsman holds the awl and the two needles in his hands, which requires a certain amount of dexterity — 15. Passing the first needle through the hole: The first needle is passed through the second hole in the stitching line — 16. Passing the second needle through the hole: The second needle is passed through the same hole as the first in such a way that the thread crosses itself — 17. and 18. Creating a stitch: The thread is pulled in two directions — 19. and 20. The sewing takes shape: The sewing should be consistent and natural and the back stitch must be concealed. Drawings by Martine Rupert, 2013

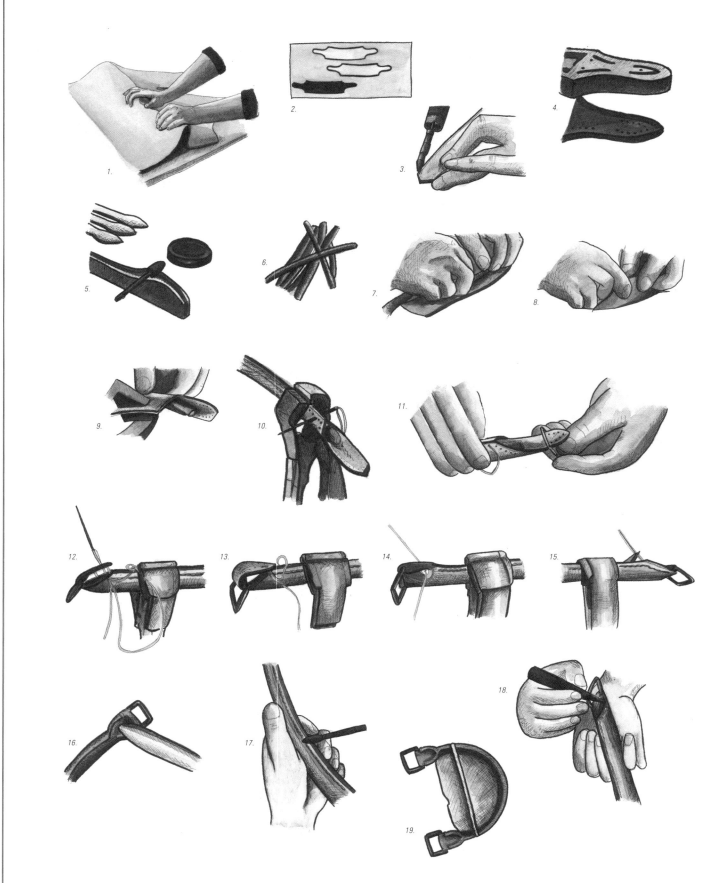

1. Selecting the natural cowhide leather: A supple leather is selected in order to guarantee a resistant handle — 2. Cutting the leather: The Toron handle is creating using a single piece of leather — 3. Creasing: A hot stamped line marks the edges of the leather — 4. Perforating the stitching line: Hot stamped marks indicate the placement of the stitches — 5. Dyeing the edges: The edges of the handle are dyed red, according to the Louis Vuitton tradition — 6. Hemp cords: A natural hemp cord forms the core of the Toron handle. With use, the plant fibers take shape around the hand, adapting the handle to the owner's individual grip for optimal comfort — 7. to 9. Making the handle: The hemp cord is placed exactly at the center of the piece of leather. The edges are then held together with a clamp before being sewn — 10. Preparing for sewing: the handle is placed in a stitching clamp to facilitate hand sewing — 11. Fitting the square metal rings: The two square metallic rings that attach the handle to the bag are put in place before sewing begins — 12. to 15. Sewing the edges: The edges of the handles are hand sewn using a particularly resistant waxed thread — 16. Smoothing the stitches: The stitches are worked with a bone folder in order to ensure that the chapes appear convex — 17. and 18. Varnishing the edges: A layer of varnish guarantees that the edges are homogenous in color and gives a precise finish — 19. Rounding the handle: The Toron handle is fixed to a curved supporting structure and placed in an oven in order to obtain a rounded form. Drawings by Martine Rupert, 2013

MAKING THE TORON HANDLE

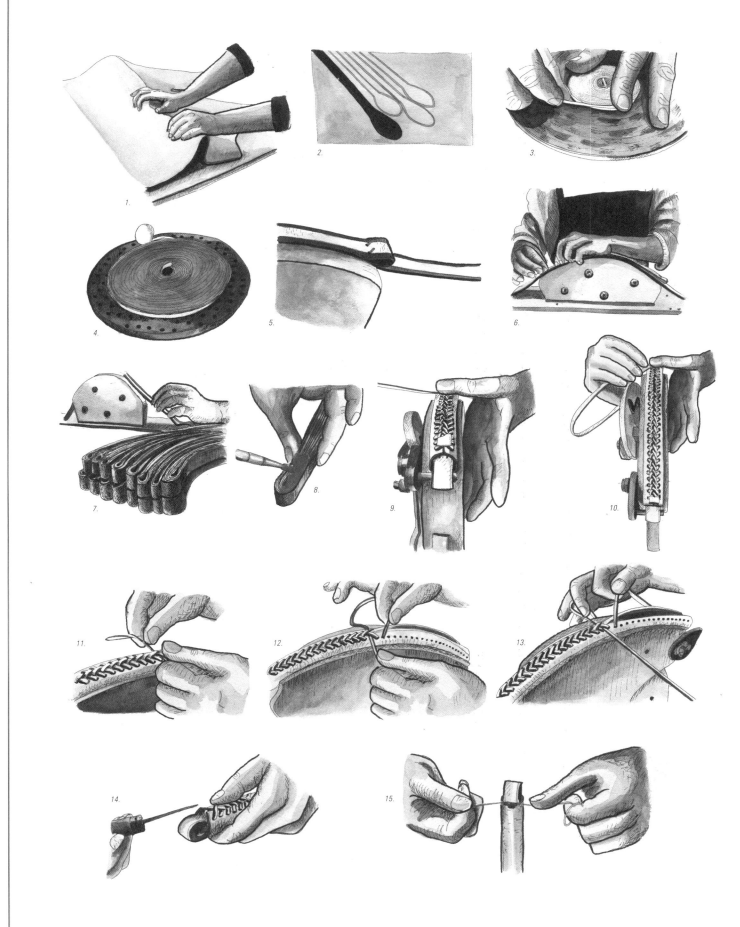

1. Selecting the natural cowhide leather: The distinctive Artsy handle requires a particularly soft and elastic leather — 2. Cutting the leather: The Artsy handle is composed of three parts: a core made of a long band, a piece that envelopes it and a 2.7-meter strap — 3. and 4. Dyeing the strap: The edges of the leather strap are dyed and varnished in red, according to the Louis Vuitton tradition — 5. to 7. Making the core of the handle: The extremities of the leather band are folded inwards on a curved supporting structure — 8. Dyeing the edges: The edges are also dyed on the core of the handle. The color varies depending on the material: red for natural cowhide leather, or according to the color for dyed leather — 9. to 13. Weaving: To assemble the handle, the leather strap is woven by hand. This process requires two hours' work — 14. and 15. Finishing: The staples used to facilitate weaving are removed and two stitches fix the extremities of the handle. Drawings by Martine Rupert, 2013

MAKING THE ARTSY HANDLE

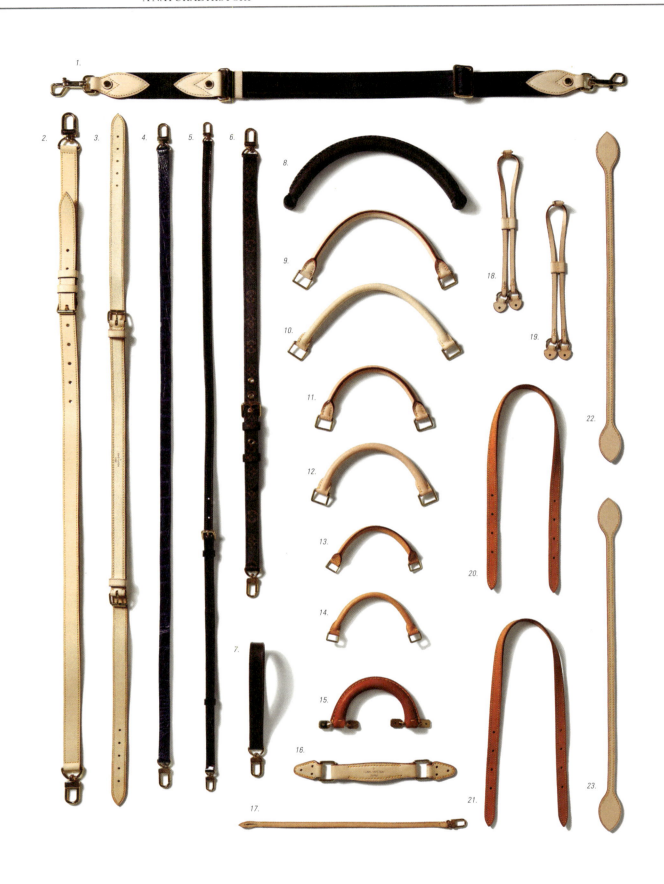

1. Shoulder strap in natural cowhide leather and fabric, used for the Speedy in Monogram Eden — 2. Two-piece shoulder strap in natural cowhide leather, used for the
Alma and the Porte-Documents Voyage — 3. Handle in natural cowhide leather, used for the Noé — 4. Shoulder strap in brilliant alligator, used for the Alma BB —
5. Shoulder strap in patent leather, used for the Monceau BB — 6. Shoulder strap in Monogram canvas, used principally for the Eden bag and for the Métis pochette —
7. Wrist strap in dyed natural cowhide leather, used for the Marly pochette — 8. Artsy handle in dyed natural cowhide leather, used for the Artsy — 9. and 10.
Toron handles in natural cowhide leather, used for the Sac Plat — 11. and 12. Toron handles in natural cowhide leather, used for the Speedy — 13. and 14. Toron handles
in natural cowhide leather, used for the Mini HL — 15. Handle in natural cowhide leather, used for the Cotteville — 16. Flat handle in natural cowhide leather, used
for the Vanity Case — 17. Strap in natural cowhide leather, used for the Pochette Accessoires — 18. and 19. Drawstrings in natural cowhide leather, used for the Neverfull —
20. and 21. Handles in natural cowhide leather, used for the Bucket — 22. and 23. Handles in natural cowhide leather, used for the Neverfull

HANDLES AND SHOULDER STRAPS

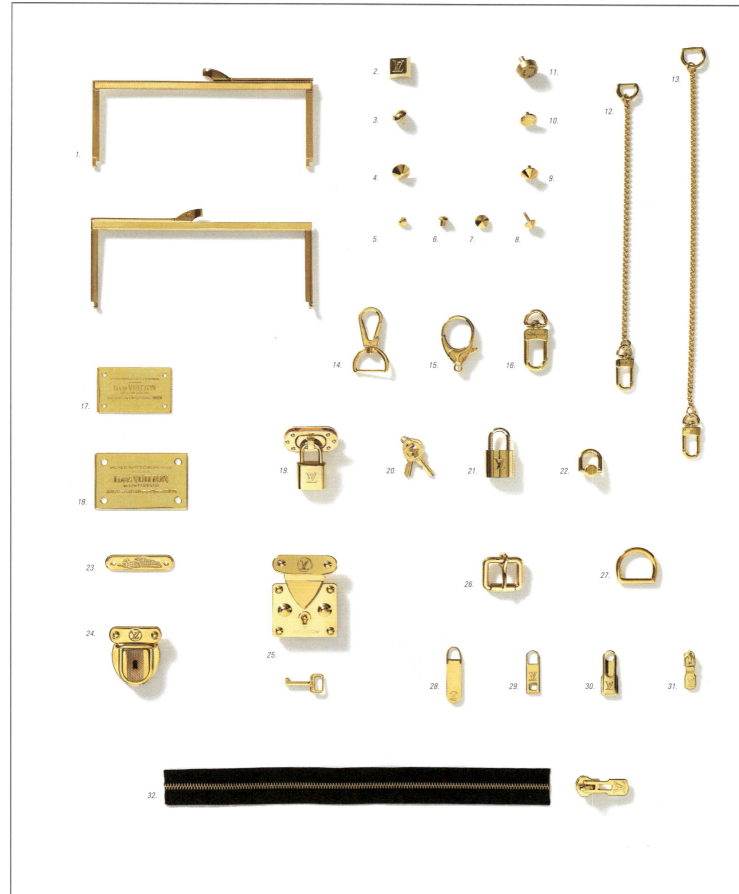

1. Viennese clasp — 2. Square bottom studs — 3. and 6. Rivets — 4., 5., 7. and 9. Conical nails — 10. Flat rivet — 11. Conical bottom studs — 12. Small chain for Pochette Accessoires — 13. Large chain for Pochette Accessoires — 14. D-ring snap hook — 15. Round snap hook — 16. Snap hook with round fastening ring — 17. Small "Louis Vuitton Inventeur" plaque — 18. Large "Louis Vuitton Inventeur" plaque — 19. Padlock clasp — 20. Padlock keys — 21. Security padlock — 22. Revolving strap attachment — 23. "Louis Vuitton" plaque — 24. Tuck clasp — 25. S-Lock clasp and key — 26. Roller buckle — 27. Fastening ring for strap or D-ring — 28. to 30. Zipper pull — 31. Slider for zipper — 32. Zipper with slider

METALLIC HARDWARE

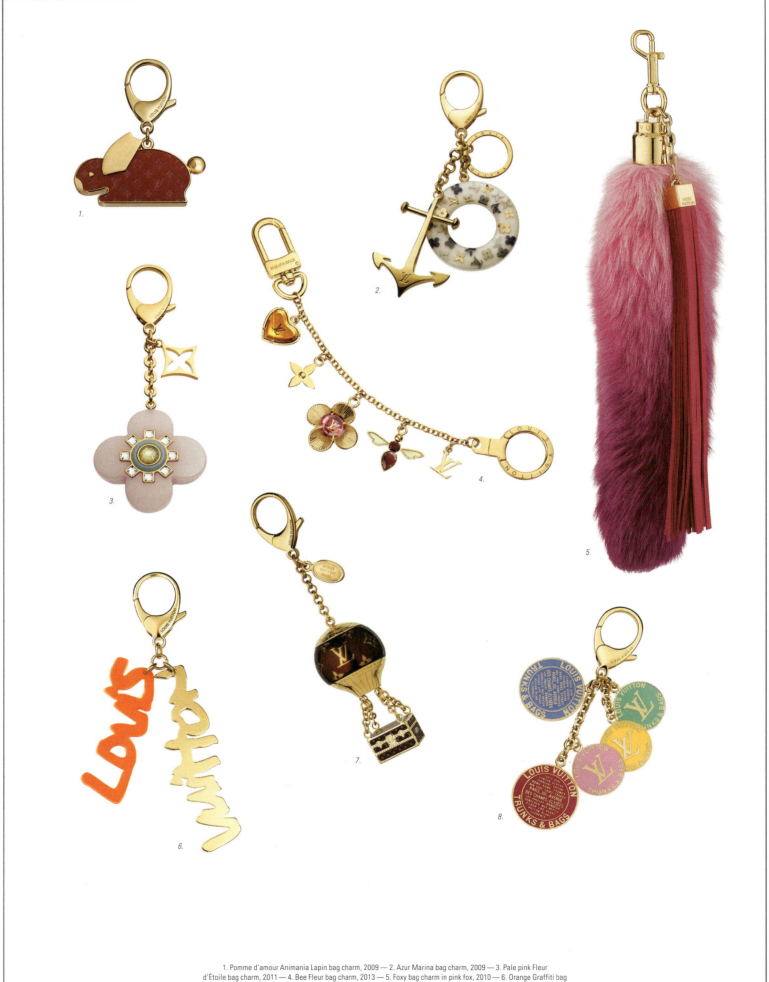

1. Pomme d'amour Animania Lapin bag charm, 2009 — 2. Azur Marina bag charm, 2009 — 3. Pale pink Fleur
d'Étoile bag charm, 2011 — 4. Bee Fleur bag charm, 2013 — 5. Foxy bag charm in pink fox, 2010 — 6. Orange Graffiti bag
charm, 2009 — 7. Montgolfière bag charm, 2011 — 8. Globe Charms bag charm, 2008

BAG CHARMS

1.

2.

3.

4.

5.

6.

7.

8.

9.

1. Interior label of the Poids Plume 27 bag in ficelle Trianon canvas, 2004 — 2. Interior label of the small Enveloppe bag in brown Damier Mosaic, 2013 — 3. Exterior label in turquoise flattened ostrich leather for the medium Overnight Bag in ficelle Trianon canvas, 2004 — 4. Interior label of the large Flat Bag in leather, c. 1910. Louis Vuitton Collection — 5. Exterior label in natural cowhide leather for the medium LV Globe Shopper tote in cotton canvas and linen, 2006 — 6. Interior label on natural cowhide leather from the inside of the limited edition bags designed in collaboration with the Japanese artist Takashi Murakami in 2003 — 7. Interior label in black Ayer snakeskin from the Aumônière in black Monogram Satin, 2006 — 8. Interior label in iris Karung snakeskin, from the Heartbreak bag in iris Monogram Jokes, designed in collaboration with the American artist Richard Prince in 2008. The artist's signature is reproduced on the label — 9. Interior label in brown alligator leather from the Irvine bag in tan Monogram Velours, 2004

PATTERN: NOÉ

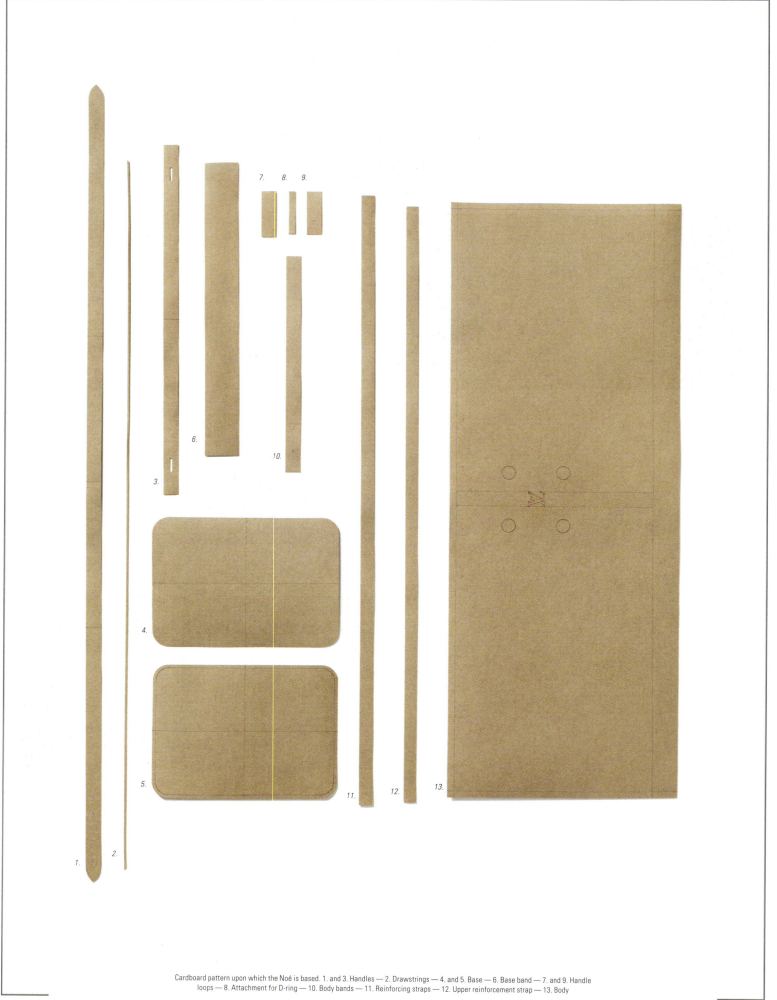

Cardboard pattern upon which the Noé is based. 1. and 3. Handles — 2. Drawstrings — 4. and 5. Base — 6. Base band — 7. and 9. Handle
loops — 8. Attachment for D-ring — 10. Body bands — 11. Reinforcing straps — 12. Upper reinforcement strap — 13. Body

PATTERN: NOÉ

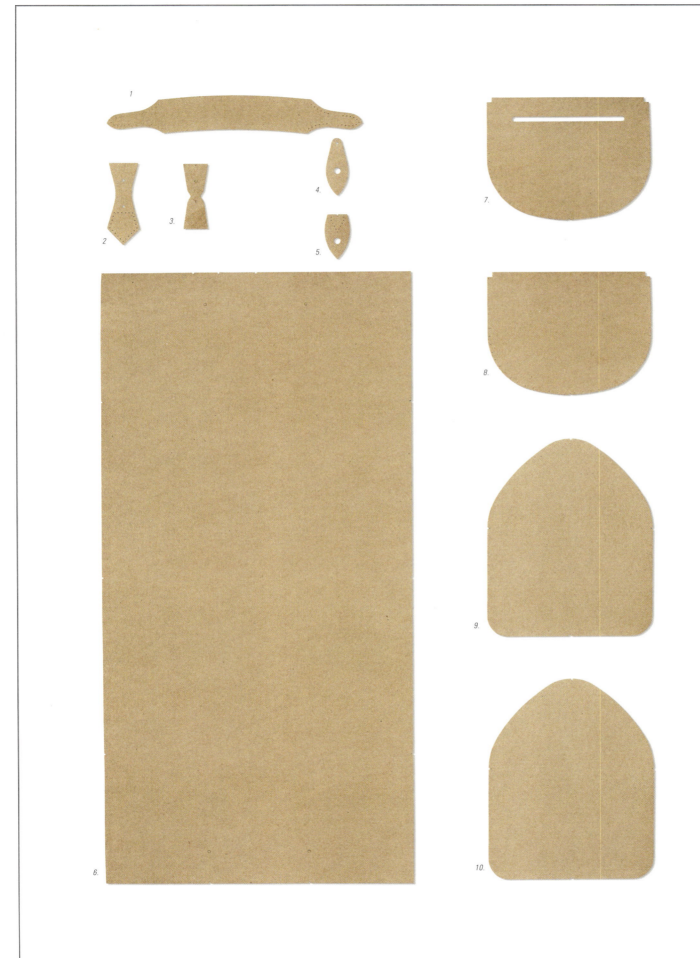

Cardboard pattern upon which the Speedy is based. 1. Toron handle — 2. Chapes — 3. Attachment for D-ring — 4. Zipper
pull — 5. Side tab — 6. Body — 7. and 8. Flat inside pocket — 9. and 10. Sides

PATTERN: SPEEDY

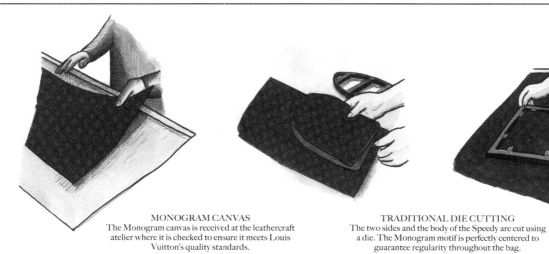

MONOGRAM CANVAS
The Monogram canvas is received at the leathercraft atelier where it is checked to ensure it meets Louis Vuitton's quality standards.

TRADITIONAL DIE CUTTING
The two sides and the body of the Speedy are cut using a die. The Monogram motif is perfectly centered to guarantee regularity throughout the bag.

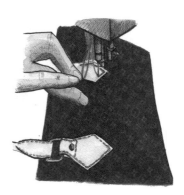

STITCHING THE SIDE TABS
The side tabs in natural cowhide leather are sewn onto the sides of the Speedy. The Louis Vuitton signature, subtly hot-stamped on the leather, is a guarantee of authenticity.

ASSEMBLING THE PIPING ALONG THE EDGES
Piping in natural cowhide leather reinforces the bag's edges.

ATTACHING THE HANDLES
The chapes of the two Toron handles are sewn to the body of the bag using a saddle stitch. The sewing machine guarantees a perfect consistency in the stitches.

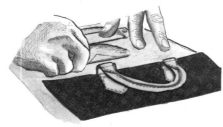

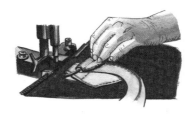

ATTACHING THE HANDLES
A rivet reinforces the chapes to give them greater resistance.

ASSEMBLING THE INSIDE POCKET
An interior flat pocket is sewn into the Speedy. Equipped with a zipper, it is a practical solution for storing small personal items.

INSTALLING THE ZIPPER
A zipper protects the contents of the Speedy. A security padlock is then attached to reinforce it.

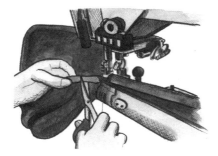

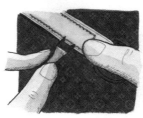

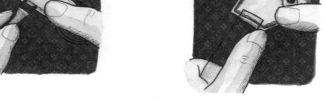

ASSEMBLING AND SEWING THE BODY
The Speedy is assembled and sewn inside out. Once the procedure is finished, it is reversed and shaped. Suppleness is one of the principal characteristics of this model.

QUALITY CONTROL
Each bag is inspected before being sent to the store. The Louis Vuitton standards require that the smallest details are meticulously controlled: distance between stitches, aspect of the materials, positioning of the metallic attachments, etc.

Drawings by Martine Rupert, 2013

MAKING THE SPEEDY IN MONOGRAM CANVAS

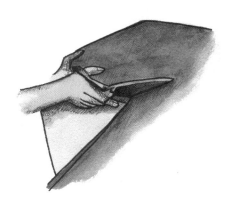

SELECTING THE NOMADE LEATHER
The leather is received at the leathercraft atelier where the grain is examined again to guarantee perfection.

DIE CUTTING
The pieces that compose the bag are cut using different dies.

ASSEMBLING THE BODY
The different parts of the bag's body are assembled prior to sewing.

STITCHING THE HANDLES
The chapes of the two Toron handles are stitched onto the body of the bag.

ASSEMBLING AND STITCHING THE BASE
The rigid base of the Lockit is shaped before being machine-sewn to the body of the bag.

FITTING THE LINING
A honey colored microfiber lining protects the inside of the bag. It is one of the distinctive characteristics of the Nomade line.

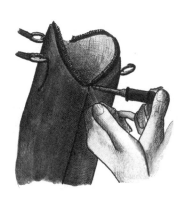

FINISHING THE STITCHING
At the end of each stitching line, the sewing threads are burned to ensure their solidity and hide the back stitches.

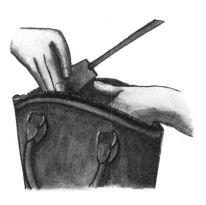

FITTING THE ACCESSORIES
The last phase is the fitting of the accessories. This is the key holder that contains the keys for the security padlock on the bag's zipper.

Drawings by Martine Rupert, 2013

MAKING THE LOCKIT IN NOMADE LEATHER

RESISTANCE OF A PIECE OF
LEATHER TO TWISTING
The test examines a leather sample's resistance to
deformation by subjecting it to transverse rotation.

THE BALLY TEST
Resistance to folding and flexing:
The test is carried out on a sample of leather or canvas,
which is folded and affixed to a flexometer. A mobile
clamp records the vertical back-and-forth movement.

VISUAL VERIFICATION OF
MATERIALS IN A LIGHT BOOTH
This test allows the inspector to observe the uniformity of
color in a piece of leather or canvas.

COLORFASTNESS MIGRATION TEST
This test examines the resistance of the dye in a piece of leather or
canvas. The sample is attached to a base and then placed in a closed
artificial environment adjusted to a temperature of 50°C and a
humidity level of 95%.

ABRASION ENDURANCE
This test is undertaken on a sample of leather or
canvas, and simulates the damage caused by
abrasion over time. The sample is rubbed against
an abrasive wool in circular movements.

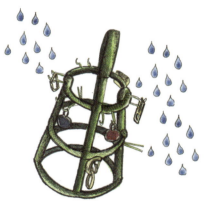

RESISTANCE OF METALLIC ATTACHMENTS
TO SYNTHETIC PERSPIRATION
This test examines the resistance of pieces exposed to
cotton soaked in synthetic perspiration. The test pieces are
deposited in a vat with the soaked cotton and then placed
in a steamer heated to 55°C.

RESISTANCE OF METALLIC ATTACHMENTS
TO HUMID HEAT
This test examines the pieces' resistance to a hot
and humid atmosphere. The artificial environment is set
to a temperature of 55°C and a humidity level of 95%.

RESISTANCE OF METALLIC ATTACHMENTS
TO SALINE MIST
This test examines the metallic attachment's
resistance when placed in an enclosure into which a
neutral saline mist is continuously pumped.

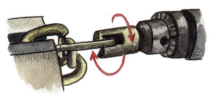

THE TURBULA TEST
This test examines the effects on an element's surface
treatment caused by abrasions. The test is carried out
on pieces of leather or canvas, and on metallic
attachments. The sample is inserted in a receptacle
with stones and demineralized water. The Turbula
mixer makes many rotations per minute.

RESISTANCE OF A CHAIN
LINK TO TWISTING
This test examines the resistance to twisting of
metallic elements, for example a link in a chain.
The sample is held in a vice at one extremity and
twisted until it is deformed, or an opening or
rupture is observed in the piece.

RESISTANCE OF A SNAP HOOK TO
REPEATED OPENING AND CLOSING
The sample is affixed to a device that opens
and closes the mobile arm on the piece.

Drawings by Martine Rupert, 2013

QUALITY TESTS

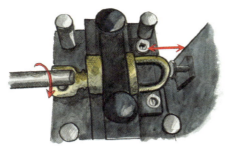

RESISTANCE OF A PADLOCK TO REPEATED OPENING AND CLOSING
This test determines a padlock's resistance. The sample is affixed to a device that opens and closes the lock by turning the key.

GRID PATTERN TEST FOR FINISH RESISTANCE
This test verifies the adhesion of a varnished or galvanized finish on a metallic piece. A grid of orthogonal incisions is created on a metal plaque. A piece of adhesive tape is applied to the zone and then checked after removal for any particles of finish that may have come unstuck.

RESISTANCE OF A ZIPPER TO REPEATED OPENING AND CLOSING
This test determines a zipper's resistance. The endurance device performs a back-and-forth movement.

RESISTANCE OF A CLASP TO REPEATED OPENING AND CLOSING
This test determines a clasp's resistance. The sample is affixed to a device that opens the clasp by pressing on the release button and then closes it again.

THE "TUMBLING CAGE" TEST
This test allows the inspector to check the resistance of finished products to damage caused by accidental impact. The "tumbling cage" was created by the Quality Control Lab to simulate the fall of an object. The sample is dropped from the top of the "tumbling cage" a total of ten times, bumping from one level to another before hitting a cement floor.

RESISTANCE OF FINISHED PRODUCTS TO HUMID HEAT
This test allows the inspector to observe the resistance of finished products to a hot and humid atmosphere. The artificial environment is set to a temperature of 55°C and a humidity level of 95%.

THE "PICKING UP AND PUTTING DOWN" TEST
This test evaluates the resistance of finished products to repeated picking up and putting down by simulating the daily usage of the bag. The sample, filled with a weight relative to its size, is fixed by its handles or its strap to a device that creates an up-and-down movement.

THE HANDLE RESISTANCE TEST
This test checks the resistance of the Neverfull's two handles to vertical traction, and simulates the carrying of heavy objects in the bag. Each handle must be able to support the weight of at least 105 kg.

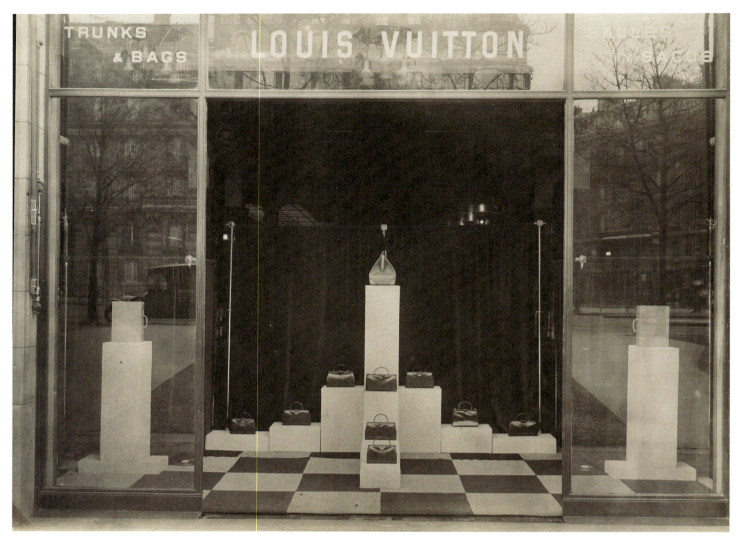

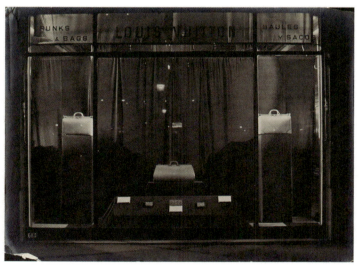

From left to right, top to bottom: Window display in the Louis Vuitton store at 70, avenue des Champs-Élysées in Paris, featuring a bag with inset clasp, flat bags and two small cases. Photograph taken in 1925. Louis Vuitton Archives — Design for the window display in the Louis Vuitton store at 70, avenue des Champs-Élysées in Paris, featuring two wardrobes, two open suitcases and an ensemble of bags. Drawing by Gaston-Louis Vuitton in graphite pencil, colored pencil and black ink, dated Saturday June 6, 1926. "Window displays 1925-1926." Sketchbook of window display designs by Gaston-Louis Vuitton. Louis Vuitton Archives — Window display in the Louis Vuitton store at 70, avenue des Champs-Élysées in Paris, featuring an Overnight Bag, two bags with inset clasps and three ladies' pochettes. Photograph taken early 1925. Louis Vuitton Archives

Opposite, from top to bottom: Design for the window display in the Louis Vuitton store at 70, avenue des Champs-Élysées in Paris, featuring an ensemble of fitted suitcases, pochettes, ladies' handbags, small bottles and covers. Design in watercolor and gouache with graphite, attributed to Gaston-Louis Vuitton, around 1920. Louis Vuitton Archives — Window display in the Louis Vuitton store at 70, avenue des Champs-Élysées in Paris, featuring an ensemble of fitted suitcases, pochettes, ladies' handbags, small bottles and covers. Photograph taken in 1925. Louis Vuitton Archives

HISTORICAL WINDOW DISPLAYS

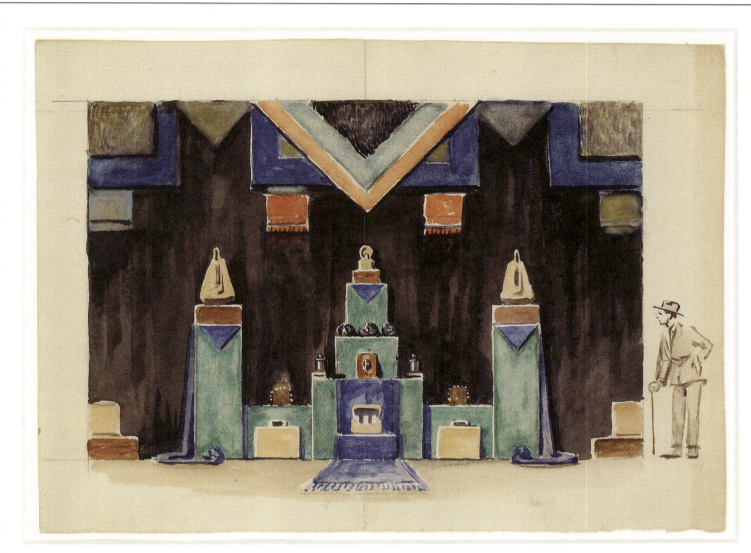

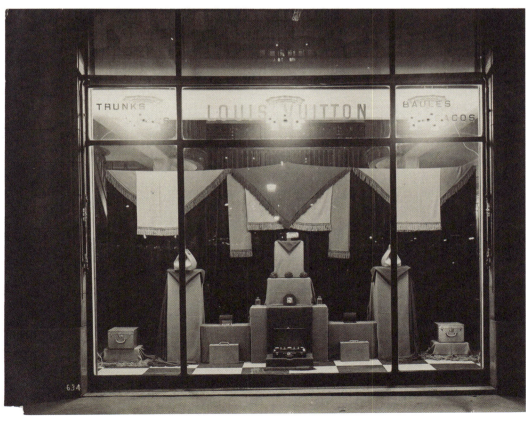

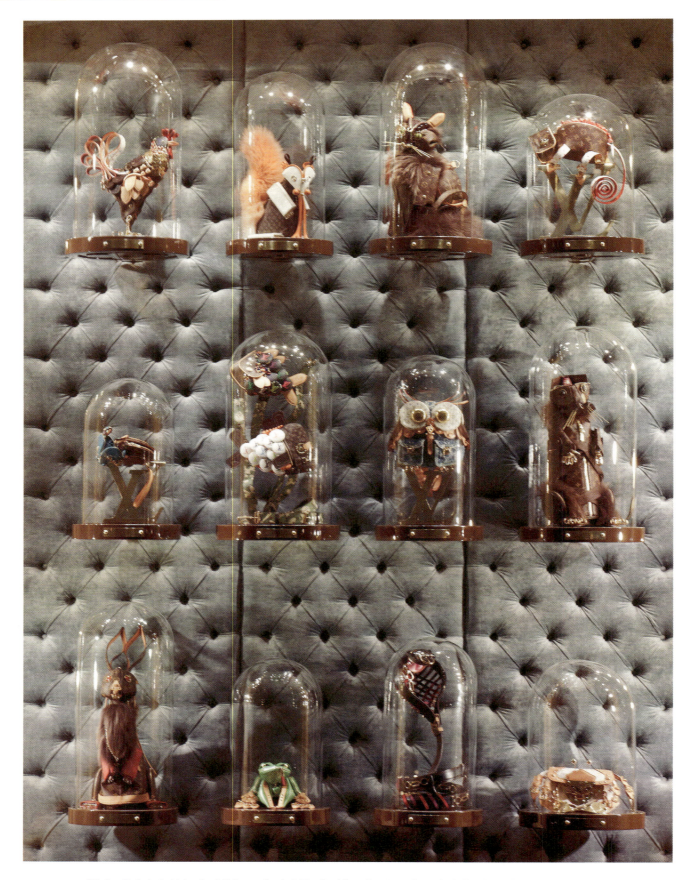

Window display in the Maison Louis Vuitton on London's New Bond Street featuring sculptures by the British artist Billie Achilleos made from
Louis Vuitton bags and accessories. From top to bottom and from left to right: *Rooster, Squirrel, Cat, Chameleon, Mouse, Fishes, Owl, Otter, Hare, Frog,
Cobra, Crab*. Photograph by Stéphane Muratet, 2010

Opposite, from left to right, top to bottom: Window display in the Speedy Concept Store at the Louis Vuitton store in Selfridges, London featuring Speedy 35s in
Monogram canvas and a Speedy 35 in silver Monogram Miroir. Photograph by Stéphane Muratet, 2009 — "Captivating" window display in the Louis Vuitton
store on the Avenue Montaigne in Paris featuring, in particular, a Rodeo Drive bag in pomme d'amour Monogram Vernis on the top left and a small Bellevue bag
in pomme d'amour Monogram Vernis in the center. Photograph by Stéphane Muratet, 2010 — "Ostrich" window display in the Maison Louis Vuitton on
London's New Bond Street featuring a medium Alma in olive ostrich leather. Photograph by Vincent Melvyn, 2010 — Christmas window display for the store
at the Galeries Lafayette in Paris featuring, in particular, two Speedy 30s in bordeaux Monogram Sunshine Express and two Speedy 30s in bordeaux Golden
Arrow. Photograph by Stéphane Muratet, 2012 — Christmas window display for the store at the Galeries Lafayette in Paris featuring, in particular, three
Epi leather Eden bags in piment on the left, fuchsia in the center and indigo on the right. Photograph by Stéphane Muratet, 2012

CONTEMPORARY WINDOW DISPLAYS

IDIOMATIC EXPRESSIONS AND COMMON PROVERBS

	EXPRESSION	SUBJECT	LITERAL TRANSLATION	MEANING
CHINESE *IDIOMATIC EXPRESSIONS*	无所不包	*bag, sack*	nothing is left outside except that which is included (it's all in the bag)	all understood
	草包		sack of straw	a fool
	脓包		a bag of pus	a good for nothing
	掉包		to have more than a trick in the bag	to swap something secretly
	红包		a red envelope	a good luck gift
	包容		someone who contains one's emotions	magnanimous
	大包大揽		big package, big load	eyes bigger than one's stomach
	包在我身上		the bag's on me	you can rely on me, I'll take care of it
PROVERBS	纸包不住火		paper can't hold back fire	the truth will come out
ENGLISH *IDIOMATIC EXPRESSIONS*	a bag of bones	*bag*		to be emaciated
	a bag of tricks			to employ an arsenal of devices and conceits/a magical, monogrammed bag owned by one Felix the Cat
	an old bag/bag lady			an unpleasant or ill-tempered woman/crone/hag/a homeless woman
	could not find his way out of a paper bag			clueless/an inability to accomplish a task/to peform badly
	to be left holding the bag/left holding the baby			to be left with an unenviable task or circumstance/to be left to a significant disadvantage
	in the bag			a sure thing
	to have bags under the eyes			to have dark circles under the eyes/exhausted/lacking sleep
	half in the bag			intoxicated/drunk
	to pull something out of the bag			a sudden reprieve/to do something as a last resort to avert a bad outcome
	a mixed bag			sundry or random collection of things or individuals
	to pack up one's bag			to leave and never return
	papa's got a brand new bag			to find one's groove (cheifly from a two-part 7" single released by James Brown in 1965)
	to let the cat out of the bag			to let out a secret/to reveal priviliged information
	hit the sack	*sack*		to sleep
	get the sack			to get fired from a job
	great in the sack/to bag somebody	*sack, bag*		a self-serving boast about one's sexual prowess/to have sex
	to hold the purse strings	*purse*		to control the finances of a household or a business concern
	to purse one's lips			to pucker one's lips, usually in response to tasting something sour
PROVERBS	You can't make a silk purse out of a sow's ear.			you cannot make superior things from inferior materials
	Little and often fills the purse.			a little bit of money and frequently will add up
	A good bargain is a pick-purse			at a good bargain, think twice
	A proud mind and a beggar's purse, agree ill together.			ambition without resources (or at the very least resourcefulness) will end in tears
	An empty sack cannot stand upright	*sack*		a hungry person cannot function properly
FRENCH	en avoir dans son sac/n'avoir rien dans son sac	*bag*	to have something in the bag/to have nothing in the bag	to be clever/simple minded
	avoir le sac		to have the bag	to be rich
	épouser le gros sac		to marry the big handbag/purse	to marry a rich woman
	avoir plus d'un tour dans son sac		to have more than one trick in the bag	to have more than one trick up one's sleeve
	avoir son sac et ses quilles		to have one's bag and skittles	to be fired
	donner le sac		to give the sack	to be shown the door/to be sent away
	éternuer dans le sac		to sneeze in the sack	to be guillotined
	être habillé comme un sac		to be dressed like a sack	to be badly dressed
	gens de sac et de corde		people of bags and ropes	miscreants
	il faut voir le fond du sac		it is necessary to see the bottom of the bag	to scrutinize, examine closely
	l'affaire est dans le sac		the matter's in the bag	it's in the bag/it is bound to succeed
	manger son avoine en son sac		to eat the oats in one's bag	to be selfish/to refuse to share
	mettre dans le même sac		to put in the same bag	to put in the same bracket/consider to be similar
	s'en mettre plein le sac		to fill one's sack	to eat one's fill
	prendre (ou être pris) la main dans le sac		to catch (or be caught) with one's hand in the bag	to catch (or be caught) in the act/redhanded
	prendre son sac et ses quilles		to take one's bag and skittles	to flee
	se couvrir d'un sac mouillé		to cover oneself in a damp bag	to make a poor excuse/to lie
	un sac à malices		a bag of tricks	clever person with impressive skills
	un sac à vin		a sack of wine	a drunk
	un sac d'os		a bag of bones	an emaciated person
	un sac de nœuds		a bag of knots	a tricky/difficult situation
	le sac et la cendre		sackcloth and ashes	penitence
	un sac percé (un panier percé)		a perforated (money)bag/basket	a wasteful person/spendthrift
	vider son sac		to empty one's bag	to say everything one is thinking/to let off steam
	faire son balluchon	*bundle*	to make up one's bundle	to leave
	être réduit à la besace	*backpack*	to be reduced to one's backpack	to be financially ruined
	être jaloux comme un coquin de sa besace		to guard something as jealously as a beggar guards his backpack	to be fiercely possessive
	avoir la bourse bien ferrée	*purse*	to have a purse full of iron	to have a lot of money
	être un marquis de la bourse plate		to be a marquis with a flat purse	to be penniless
	loger le diable dans sa bourse		to have the devil living in one's purse	to have no money in one's purse
	couper la musette	*bag (pipes)*	to puncture the bagpipes	to cut the throat/to kill

	EXPRESSION	SUBJECT	LITERAL TRANSLATION	MEANING
GERMAN *IDIOMATIC EXPRESSIONS*	aus eigener Tasche bezahlen	*bag, pocket*	to pay out of one's own pocket	to use one's own means to pay
	alle in die Tasche stecken		to put everyone in one's pocket	to be stronger than everyone
	mit vollen Taschen		with full pockets	to have money
	eine Plaudertasche		a bag that never stops talking	a gossip, a person who talks a lot
	tief in die Tasche greifen müssen		to be forced to ransack the bottom of the handbag/purse	to pay a high price
	jemandem auf der Tasche liegen		to be put on someone's bag	to be supported financially
	etwas in der Tasche haben		to have something in the bag	to have one more card to play
	die Hand auf der Tasche halten		to keep one's hand on the handbag/purse	to be frugal
	einen Igel in der Tasche haben		to have a hedgehog in one's bag	to be very frugal, miserly
	es in der Tasche haben		to have it in the pocket	to be rich
	jemandem das Geld aus der Tasche ziehen		to take all the money from someone's handbag/purse	to profit financially from someone
	den Papst in der Tasche haben		to have the Pope in the bag	to be lucky
	sich selber in die Tasche lügen		to tell lies in the sack	to deceive oneself
	einen toten Vogel in der Tasche haben		to have a dead bird in the bag	to feel ill, to pass wind
	die Faust in der Tasche ballen		to clench one's fists in one's pocket	to swallow one's anger
	in die Tasche greifen		to carry one's hand in one's pocket	to spend
	tief in die Tasche griefen		to put one's hand deep into the pocket	to pay a very high price
	ein Pfeffersack	*bag, sack*	a sack of pepper	a rich miser who loves power
	mit Sack und Pack		with one's bag and luggage	with all one's worldly goods
	die Katze im Sack kaufen		to buy the cat in the bag	to buy something without examining it
	die Katze aus dem Sack lassen		let the cat out of the bag	to reveal a secret
	Heiliger Strohsack!		Holy straw sack!	
	der Fresssack		a sack of food	a glutton
	ein fauler Sack sein		to be a lazy sack	to be workshy
	luft im Sack haben		to have air in the sack	to lose one's cool
	das Ding ist im Sack		the thing is in the bag	it is in the bag/it is almost achieved
	der Hahn im Korb	*basket*	the rooster in the basket	to be the only man within a group of women
	einen Korb bekommen		to be given a basket	to be rejected (by a woman)
	einen Korb geben		to give a basket to someone	to reject someone
PROVERBS	Da geht mir das Messer in der Tasche auf.	*bag, pocket*	that's like opening a knife in my bag	that really annoys me
	Ein Stück Brot in der Tasche ist besser als eine Feder auf dem Hut.		it's better to have bread in one's pocket than a feather in one's hat	the essentials of life are more important than the luxuries
	Besser eine leere Tasche als ein leerer Kopf.		better an empty pocket than an empty head	it is better to be poor than ignorant
	Aus einer fremden Tasche ist gut zahlen.		it's easier to pay out of someone else's pocket than one's own	it's easy to spend someone else's money
	Mit dem Klammersack gepudert sein	*bag*	to be powdered by a bag of clothespegs	to be insane
	Ein Sack voll Flöhe ist leichter zu hüten als ein Weib.	*bag, sack*	it's easier to hold on to a bag of fleas than a woman	anything's easier than keeping hold of a woman
ITALIAN *IDIOMATIC EXPRESSIONS*	mettere mano alla borsa	*purse*	to put one's hand in one's purse	to pay
	tenere la borsa stretta		to keep one's purse closed	to be mean
	mungere la borsa di qualcuno		to milk someone's purse	to rob someone
	la borsa o la vita !		your purse or or your life	your money or your life!
	farina del proprio sacco	*sack*	flour from its own sack	original work
	colmare il sacco		to fill the sack	surpass expectations
	un sacco di patate		a sack of potatoes	a clumsy person
	reggere (o tenere) il sacco		hold the sack (for someone)	to aid a robber, to act as accomplice
	essere sorpreso con le mani nel sacco		to be surprised with one's hand in the sack	to be caught redhanded
	tanto è ladro chi ruba che chi tiene il sacco		not only is the person who steals a thief, but also the person holding the sack	guilt by association is still guilt
	fare le cose con la testa nel sacco		to do something with one's head in a bag	to be distracted
	piacere un sacco		to be happy to fill the sack	to please greatly
	vestirsi di sacco		to wear sackcloth	to be penitent
	un sacco e una sporta		a sack and a shopping basket	a good amount and then some more
	riempirsi il sacco		to fill the sack	to fill the belly, to eat a lot
	mettere nel sacco		to put in the sack	to deceive somebody
	mettere nello stesso sacco		to put in the same sack	to become accomplice
	vuotare il sacco		to empty the sack	to reveal all that one knows, to let off steam
PROVERBS	Chi fa (o chi sbaglia) di testa paga di borsa	*purse*	if one doesn't think with one's head, one will pay with one's purse	use your head or pay for it!
	A chi fa casa (o s'accasa) la borsa resta rasa		if one sets up a home, one's purse stays empty	if one sets up a home, one's purse stays empty
	Amici cari e borsa del pari		between good friends, the purse is the same	good friends share everything
	Beltà porta seco la sua borsa		beauty goes away with the purse	the beautiful don't have money worries
	Buon pagatore, dell'altrui borsa è signore		the good payer is master of other people's purses	pay your debts and you will always be rewarded
	Chi gioca di piè, paga di borsa		the person who leaves pays out of his purse	settle up before leaving
	Chi non ha denaro in borsa, abbia miele in bocca		the person who has no money in their purse needs to have honey in their mouth	if you don't have money, you need the gift of the gab
	Miele in bocca, guarda la borsa		honey in the mouth, watch your purse	watch out for your money when you meet a smooth talker
	Le buone derrate vuotano la borsa		good commodities empty the purse	quality nevers comes cheap
	Chi va a Roma ne mula zoppa ne borsa floscia		a person who goes to Rome can not have a lame mule nor an empty purse	Rome is expensive so make sure you have plenty of money
	Chi va al mercato e mente, borsa sua lo sente		if you go to market and lie, your purse is going to feel it	a dishonest tradesman will always be found out
	La lite vuol tre cose, piè leggero, poche parole e borsa aperta		litigation demands three things: a light foot, few words and an open purse	
	Tal ti guarda la coppa, che non ti vede la borsa		if he's staring at your breast, he's not looking at your purse	
	Chi ha quattro e spende sette, non ha bisogno di borsette		if you've only got four and hand out seven, you scarcely need a purse	
	È meglio avere in borsa che vivere di speranza		it is better to have money than to live in hope	
	Mostra la borsa e ti sarà rubata		if you show off your (money) bag, you'll cause annoyance	if you show off your money, you will soon be relieved of it
	Risparmia quando la borsa è piena che quando sarà vuota sarà tardi		economize when your purse is full because it's too late when it's empty	save money when you have it because you won't be able to when you don't (mend the roof when the sun shines)
	Tornare con le pive nel sacco	*sack, bag*	come back with bagpipes in the bag	return empty-handed
	Sacco vuoto non sta ritto		an empty sack cannot stand upright	one cannot work if one does not eat
	Non dire gatto se non l'hai nel sacco		don't talk about the cat unless it's in the bag	don't jump the gun!
	Chi ha il grano non ha la sacca, e chi ha la sacca non ha il grano		the person with the sack hasn't got the grain and the person with the grain hasn't got the sack	people with ideas don't have the means, and people with the means don't have ideas

	EXPRESSION	SUBJECT	LITERAL TRANSLATION	MEANING
JAPANESE *IDIOMATIC EXPRESSIONS*	胃袋 (ibukuro) 知恵袋 (chiebukuro) 堪忍袋 大風呂敷を広げる	*bag* *(furoshiki) traditional Japanese bundle*	stomach the wellspring of knowledge patience has its limits to spread the great furoshiki	 to tell lies
	袋のねずみ お袋 (ofukuro) 袋小路 (fukurokouji) 手袋 (tebukuro) 袋叩き 小袋 袋綴じ 袋縫い	*bag (fukuro)*	a mouse in a bag mother blind alley; cul-de-sac; impasse; dead-end street gloves; mittens hit inside a bag small bag; pouch covered binding (of a book) a French seam	to be trapped to gang up on somebody and beat him up; to join in giving somebody a thrashing
	包み	*bundle, package (tsutsumi)*	to wrap away	to conceal; to hide
	包み隠す 財布 財布が軽い 財布の紐を緩める 財布の底をはたく 財布を握る	*purse (saifu)*	a light purse to clutch/hold the purse	to be short of money to loosen one's purse strings to spend one's last penny to manage the family's money affairs (finances)
PORTUGUESE *IDIOMATIC EXPRESSIONS*	encher o saco estar com o saco cheio farinha do mesmo saco saco de batata saco de gatos despejar o saco meter a viola no saco	*sack, bag*	fill the sack to be full like a sack it's flour from the same sack a sack of potatoes a bag of cats to empty the sack to put one's violin in the bag	 it makes no difference to look like a sack of potatoes a hotch-potch to let off steam
PROVERBS	Jacaré que fica parado vira bolsa	*bag*	the crocodile that never moves ends up in the bag	
RUSSIAN *IDIOMATIC EXPRESSIONS*	кот в мешке	*bag*	a cat in a bag	something bought unseen
	от сумы да от тюрьмы не зарекайся лето пролежишь, так зимой с сумой побежишь	*bundle*	nothing offers protection from poverty, not even prison someone who spends their summer doing nothing spends their winter begging	 a lazy summer leads to harsh winter/if you are idle, you will pay for it later
PROVERBS	красавица без ума что кошелек без денег Умом туп, да кошелем туг	*purse*	a beautiful woman without brains is like a purse without a penny empty head but a full purse	a foolish woman is like an empty purse, shape without substance a fool does not understand the value of money
	Брюхо не мешок: в запас не поешь.	*sack*	the stomach is not a sack; you can't fill it in advance	
	Перед богом ставь свечку, перед судьею - мешок.		bring a candle to church and a purse to the judge	God will notice your piety, the judge will notice your money
SPANISH	¡la bolsa o la vida! sin aflojar la bolsa tener/llevar bien herrada la bolsa tener alguna cosa como en la bolsa/tener como en la bolsa alguna cosa	*purse*	your purse or your life! without loosening the purse to have a purseful of iron (metal) to have something as if it's in one's purse	your money or your life! without spending to be rich to be sure of obtaining something
	eso es harina de otro costal.	*sack*	this is flour from another sack	another story altogether/to compare two things and say that one is very different from the other/to say that something is quite different from that which is being discussed
	estar hecho un costal de huesos/Ser un costal de huesos no parecer costal de paja vaciar el costal	*bag*	to be like a bag of bones not to resemble a sack of straw to empty one's grain sack	to be emaciated to please, to be attractive to empty one's sack/to tell everything
	el hombre del saco Variantes : el viejo del saco el viejo del costal el hombre de la bolsa el viejo de la bolsa	*purse, sack, bag*	the sack man	the bogeyman/the big bad wolf
	la avaricia rompe el saco./La codicia rompe el saco. no caer en saco roto/no echar una cosa en saco roto un saco de malicias un saco de mentiras un saco roto		avarice breaks the purse don't fall into a broken sack/don't throw anything into a broken bag a bag of tricks /a bag of malice a sack of lies a broken bag	greed never pays Remember everything so you can use it at the right moment/to not waste an opportunity/to heed advice to employ an arsenal of devices and conceits an abundance of deliberately misleading or malicious information to be a spendthrift

ILLUSTRATION CREDITS

© ABC Photo Archives/Getty Images, p. 185;

© Mert Alas & Marcus Piggott, with kind permission of Raquel Zimmermann (DNA), pp. 144–145;

© KT Auleta, with kind permission of Abbey Lee (NEXT), p. 284;

© David Bailey/*Vogue UK*, p. 30;

© Galen Berry/MarbleArt: Cover, endpapers, pp. 17, 65, 343;

© Chris Brooks/Trunk Archive, p. 332;

© Theseus Chan/WORK/ASHU, illustration & art direction, p. 150;

© Henry Clarke/2013 Artists Rights Society (ARS), New York/ADAGP, Paris, p. 46;

© Comme des Garçons, p. 319;

© Patrick Demarchelier, with kind permission of Ana Cláudia Michels (Ford), p. 147;

© Hecht/Camera Press London, with kind permission of Catherine Deneuve, p. 93; Muhammad Ali Enterprises, LLC. The image and likeness of Muhammad Ali are used with permission, p. 92;

© Steve Hiett/Trunk Archive, pp. 96–97, with kind permission of Caroline Ribeiro (Marilyn Model Management), pp. 244–245;

© David James from the film *Nine* (2009), used with kind permission of Penelope Cruz, with thanks to the Weinstein Company, p. 22;

© Mikael Jansson/Trunk Archive, with kind permission of Anja Rubik (NEXT), p. 275;

© Michel Jeanneau/*L'Illustration*, with kind permission of Anne and Kirk Douglas, p. 184;

© Sebastian Kim/Jed Root, Inc., p. 289;

© William Klein/*Vogue Paris*, pp. 36–37;

© Géraldine Kosiak, 2005–2006, pp. 335, 337, 340;

© Martin Lidell/De Facto, with kind permission of Frida Gustavsson (IMG), p. 91;

© Greg Lotus, with kind permission of Alejandro Nestares, Cody Young-Sherwood (DNA Models) & Ryan McDonald (Front Management), pp. 56–57;

© Toby McFarlan Pond/Trunk Archive, p. 307;

© Alasdair McLellan, with kind permission of Jorduan Dunn (Women) & Darryl Sharp (D1 London), p. 269;

© Steven Meisel/Art + Commerce, with kind permission of Raquel Zimmermann (DNA), p. 232;

© Kourtney Roy, with kind permission of Mathilda Sundqvist (New Madison), pp. 140–141;

© Sacha, p. 31 top right;

© Kishin Shinoyama, with kind permission of Yayoi Kusama, pp. 320, 325 top;

© David Sims, with kind permission of Isabeli Fontana (Women Model Management), p. 183;

© Andrea Spotorno, Courtesy of *Self-Service*, pp. 94–95;

© Bert Stern/Condé Nast Archive/Corbis, with kind permission of Twiggy Lawson, pp. 72, 252;

© Sølve Sundsbø, with kind permission of Daphne Groeneveld (Supreme), pp. 200–201; with kind permission of the following models (in no particular order) Hedvig Palm (NEXT), Lida Fox (NEXT), Magda Laguinge (NEXT), Melissa Stasiuk (NEXT), Marihenny Pasible (New York Model Management), Nyasha Matonhodze (Marilyn), Josephine Skriver (Marilyn), Sharon Kavjian (Wilhelmina), Morgane Warner (The Lions), Tilda Lindstam (IMG), Xiao Wen Ju (IMG), Ajak Deng (IMG), Caitlin Lomax (IMG), Kati Nescher (DNA) and Sara Blomqvist (DNA), pp. 296–297;

© Tania et Vincent, p. 276;

© Luciana Val and Franco Musso, courtesy of *Numéro*, with kind permission of Anna-Mariya Urajevskaya (Viva London), p. 159;

© Louis Vuitton Archives D.R., pp. 24–27, 28 top and center, 29, 31 bottom left, 34, 35, 64, 74 bottom, 75, 124–125, 168, 170 top and bottom left, 171 top, 186, 208, 210 center left and bottom left, 211 top, 228–229 (labels), 254, 255 center, 256–259, 346, 347 bottom, 390, 391;

© Louis Vuitton Archives/INPI, pp. 344, 347 top;

© Louis Vuitton Archives/Erica Lennard, p. 31 top left;

© Louis Vuitton Archives/Pascal Louis, p. 171;

© Louis Vuitton Archives/Georges Saad, p. 28 bottom;

© Louis Vuitton Archives/Seeberger, pp. 122, 187;

© Louis Vuitton Malletier, pp. 8–16, 38–41, 50–52, 54, 55, 74 top and center, 78–80, 82, 84, 85, 88–89, 100, 110, 111, 112 bottom, 113, 128-130, 132, 136, 137, 146, 151, 154, 155, 156 bottom, 157, 158 bottom, 170 center and bottom right, 174–176, 178, 180, 190, 192, 193, 196, 197, 198 bottom, 210 top, center right and bottom right, 211 bottom, 214–216, 218, 222, 224–225, 226–227, 228–229 (photographs), 236, 240, 241, 242 bottom, 243 bottom, 255 all but center, 262–265, 272, 273, 277, 280, 293, 294, 302, 303, 309, 311, 313, 316, 329, 342, 354–359, 362–365, 368–375, 380–385;

© Louis Vuitton/Billie Achilleos, pp. 314, 315;

© Louis Vuitton/Mert Alas & Marcus Piggott: with kind permission of Eva Herzigova (One Management), pp. 70–71, 107; Richard Prince, with kind permission of Claudia Schiffer (One Management), pp. 270–271; with kind permission of Scarlett Johansson, pp. 278–279; with kind permission of Du Juan (IMG), p. 308; Julie Verhoeven, with kind permission of Natalia Vodianova (DNA), p. 312;

© Louis Vuitton/Maria Vittoria Backhaus, p. 295;

© Louis Vuitton/Shigeru Ban, pp. 108–109;

© Louis Vuitton/Ludwig Bonnet, pp. 142, 143, 234, 301 top left and bottom left and bottom right;

© Louis Vuitton/Clayton Burkhart, with kind permission of the French Communist Party, Paris, p. 231; p. 233;

© Louis Vuitton/Alvaro Canovas, p. 298;

© Louis Vuitton/Jimmy Cohrssen, p. 318;

© Louis Vuitton/Bruno Dayan, with kind permission of Dorota and Zora Star (models), pp. 250–251;

© Louis Vuitton/Patrick Demarchelier, with kind permission of Isabeli Fontana (Women Model Management), p. 230;

© Louis Vuitton/Frédérique Dumoulin, pp. 235 bottom right, 301 top right;

© Louis Vuitton/Andrew Durham, p. 306;

© Louis Vuitton/Vincent Gapaillard, pp. 104, 325 bottom;

© Louis Vuitton/Patrick Gries, pp. 32–33, 44, 45, 53, 58, 61, 63, 76–77, 81, 83, 126–127, 131, 133, 172–173, 177, 179, 212–213, 217, 219, 260, 261, 274;

© Louis Vuitton/Guzman: with kind permission of Claudia Mason, pp. 166–167; with kind permission of Eva Herzigova (One Management), pp. 290–291; with kind permission of Anne Pedersen, p. 292;

© Louis Vuitton/Zaha Hadid, pp. 304–305;

© Louis Vuitton/Lynn Hughes, p. 323;

© Louis Vuitton/Philippe Jumin, p. 105;

© Louis Vuitton/Jean Larivière, p. 90, 182;

© Louis Vuitton/Dan Lecca, pp. 149, 235 top right and bottom left;

© Louis Vuitton/Steven Meisel/Art + Commerce: Natalia Vodianova (DNA) & Christy Turlington (United Talent), p. 98; Daniel Buren/ADAGP-Paris & DB, with kind permission of Nykhor Paul (Red Model Mgt), Tian Yi (Fusion), Magdelena Jasek (Marilyn), Ji Hye Park (Elite NY), Ajak Den (IMG) & Bria Condon (DNA), p. 99; with kind permission of Karen Elson (Elite NY); with kind permission of Elena Bartels (DNA), Magda Laguinge (NEXT), Hedvig Palm (NEXT), Mackenzie Drazan (Supreme), Marie Piovesan (Marilyn), Ros Georgiou (Marilyn), Harina Heiden (Wilhelmina), Erjona Ala (Ford), Franzi Mueller (IMG) & Julia Nobis (DNA), pp. 114–115; with kind permission of Zuzanna Bijoch (NEXT) & Fei Fei Sun (Women Management), pp. 120–121; with kind permission of Kati Nescher (DNA) & Daria Strokous (Women Model Management), pp. 160–161; with kind permission of Madonna, p. 189; with kind permission of Lara Stone (IMG), p. 199;

© Louis Vuitton/Vincent Melvyn, p. 393 center left;

© Louis Vuitton/Chris Moore, pp. 102, 103, 187, 235 top left, 299, 300;

© Louis Vuitton/Martin Mörck, Cover, jacket, gatefold, pp. 42–43, 47, 66, 68–69, 86–87, 112, 116, 118–119, 156, 158, 162, 164–165, 198, 202, 204–205, 220–221, 242, 243, 246, 248–249;

© Louis Vuitton/Takashi Murakami/Kaikai Kiki Co., Ltd. All rights reserved. Monogram Multicolore (2002), Monogram Cherry Blossom (2003), Monogram Panda (2003), Eye Love Monogram (2003), Monogram Cerises (2004), Monogram Multicolore Franges (2006), Monogramouflage (2007), Monogram Cosmic Blossom (2010) are a creation by Takashi Murakami for Louis Vuitton, pp. 54, 100, 106, 107, 110, 111, 148, 149, 192, 193, 197, 240, 241, 273, 309, 314–315, 326, 329, 330, 331, 368, 370, 371, 383;

© Louis Vuitton/Stéphane Muratet, pp. 282–283, 392, 393 all but middle left;

© Louis Vuitton/Angelo Pennetta, p. 237;

© Louis Vuitton/Fabrizio Plessi, pp. 238–239;

© Louis Vuitton/Ugo Rondinone, Courtesy Matthew Marks Gallery, New York, p. 153;

© Louis Vuitton/Martine Rupert, pp. 350–355, 360, 361, 366, 367, 376–379, 386–389;

© Louis Vuitton/Mazen Saggar, pp. 108–109, 286, 287, 310;

© Louis Vuitton/Sofia Sanchez & Mauro Mongiello/Trunk Archive, with kind permission of Masha Novoselova (Marilyn), pp. 138–139;

© Louis Vuitton/Mark Segal, with kind permission of Karlie Kloss, p. 101;

© Louis Vuitton/Inez van Lamsweerde & Vinoodh Matadin/Trunk Archive: with kind permission of Maggie Rizer (Trump Model), pp. 206–207; with kind permission of Kate Moss (Storm), p. 268; with kind permission of Jessica Miller (IMG), p. 326;

© Louis Vuitton/Nick Veasey, pp. 48, 49, 134, 135, 181, 191, 223, 266, 267;

© Louis Vuitton/Tim White-Sobieski, p. 152;

© Louis Vuitton/Robert Wilson, pp. 194–195